Artist's
Complete Problem Solver

Landscapes • Flowers • Animals

Trudy Friend

D&C
David and Charles

A DAVID & CHARLES BOOK
Copyright © David & Charles Limited 2010

David & Charles is an F+W Media, Inc. company
4700 East Galbraith Road
Cincinnati, OH 45236

First published in the UK and USA as *Drawing and Painting Landscapes
Problems and Solutions* in 2007, *Drawing and Painting Flowers Problems
and Solutions* in 2007 and *Drawing and Painting Animals Problems and
Solutions* in 2006.

This compilations edition published in 2010

Text and illustrations copyright © Trudy Friend 2010

Trudy Friend has asserted her right to be identified as author of this
work in accordance with the Copyright, Designs and Patents
Act, 1988.

A catalogue record for this book is available from
the British Library.

ISBN-13: 978-0-7153-3759-2 paperback
ISBN-10: 0-7153-3759-9 paperback

Printed in China by Toppan Leefung Printing Limited
for David & Charles
Brunel House, Newton Abbot, Devon

Publisher Stephen Bateman
Senior Acquisitions Editor Freya Dangerfield
Editor Sarah Callard
Project Editor Diana Vowles
Art Editor Martin Smith
Production Controller Kelly Smith

David & Charles publishes high quality books on a
wide range of subjects. For more great book ideas
visit: **www.rubooks.co.uk**

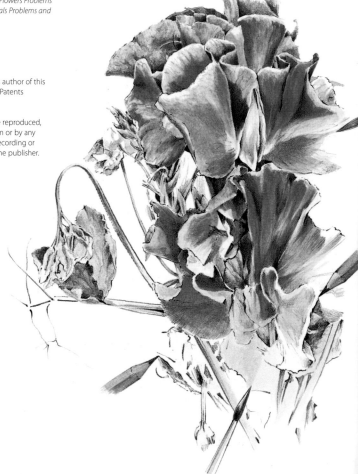

Contents

Introduction

Landscapes, Animals and Flowers

This book combines the drawing and painting of landscapes, animals and flowers with an emphasis on pencil, pen and brush exercises that will help you understand the techniques used.

After the introductions to each of these subjects – where media and methods are explained – you will find that each section shows typical problems that may be encountered and, on the opposite page, how to overcome them.

Media exercises at the beginning of each theme will help you to master the techniques demonstrated within that section.

Texture, tone and colour mixing are some of the areas covered, with exercises to help the achievement of accurate drawing and guidance on how to develop observational skills using your 'artist's eye'. The latter is an aid to the skill of simplifying by noticing negative shapes and the method of using guidelines selectively will help the positioning of those shapes.

Landscapes

From monochrome to full colour representations in a variety of media, the landscape section of this book offers guidance in drawing techniques and brushwork. Stroke applications are explained in the form of media exercises to practise before embarking upon the final images and step-by-step demonstrations clarify the techniques.

Spreads on pictorial composition and editing in and editing out will help you achieve a balanced picture that leads the viewer's eye to the focal point, while advice on how to rescue your drawings and paintings or correct mistakes will give you confidence.

You will find sections on the interpretation of skies and clouds, how to achieve the effect of water, creating images of mountains and hills, bridges and buildings, country, city and urban landscapes, as well as the popular trees and woodlands.

Animals

Although many of the animal studies are shown with a limited background or none at all, you will find that techniques covered in many areas of the landscape section will help you include a setting for the animal image.

One of the important considerations for animal representations is to be aware of angles as part of the structure: remember that there is a skeleton beneath even the softest curved forms. This is shown particularly in relation to the image of a duck.

Just by looking at many animals you will naturally feel that a

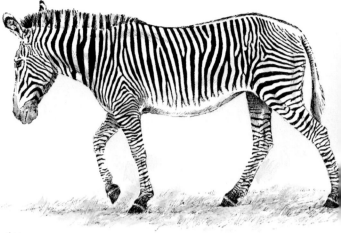

certain media will suit their depiction more
than another. For example, the softness
of a rabbit's fur may suggest the use of
watercolour as the chosen medium, with
wet in wet brush applications creating the
desired effects.

Water soluble graphite may seem an obvious
choice for the stripes of a zebra, where just a sweeping
stroke of a brush dipped in clean water will blend the
graphite sufficiently to create instant areas of cast shadow. Pen
and ink work that receives vibrant watercolour washes emphasises the
striking pattern of a tiger's fur and numerous exercises within this section
will help you to create textures like hair, skin and feathers, with examples
of colour mixing in various media.

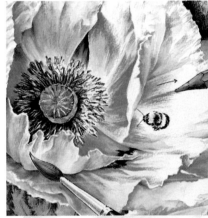

Flowers

Grasshopper and butterfly images from the animals section can be related
to plant forms in this part of the book. The inclusion of a bee hovering
above poppy petals is an example of this kind of relationship.

Negative shapes have been emphasised in both the landscape and
animals sections and their importance is explained again in relation to
plant forms.

A variety of limited supporting background treatments are shown, as
well as detailed botanical studies that stand in their own right.

Although vibrancy of colour is a natural and important consideration for
this subject, emphasis has also been placed upon tonal drawings and the
creation of a three dimensional impression by the use of contrasts in
line and tone.

Demonstrations at the end of each section include guideline
drawings that help achieve accuracy, observation of negative shapes
to place components in relation to one another and the progression
from initial investigative drawings through to the completed images in
full colour.

You will be able to compare the various stroke exercises connected with
the portrayal of plant forms with those demonstrated in the landscape
and animal sections – noticing similarities in their application even
though the subjects being depicted are very different.

Whatever your choice of subject or media for your artworks, the
considerations explained in this book will help you develop an
awareness of various aspects involved in the creation of your
drawings and paintings.

Materials
Pencils

Graphite pencils
The ones suitable for drawing are soft and range from a grade B through to the much softer 9B.

Watersoluble pencils
These are ideal as a sketching medium as well as for detailed drawings; they also combine well with watercolour paint in mixed-media works.

Charcoal pencils
These are made from particles of natural charcoal mixed with fine clays, encased in round cedarwood barrels. The grades – light, medium and dark – offer a useful range of tones, but because the charcoal is very powdery, the pencils have to be handled carefully and finished drawings need to be fixed to prevent smudging.

Graphite sticks
Similar in appearance to pencils, these are made from solid graphite, sometimes protected by paper or thin plastic which can be peeled away as the sticks are used. Chunky graphite blocks are uncased, which means that both the tips and sides can be used.

Compressed charcoal
Smooth natural charcoal, made in the shape of a convenient rounded chunky stick, can be used as an alternative to more delicate and unevenly shaped natural charcoal sticks.

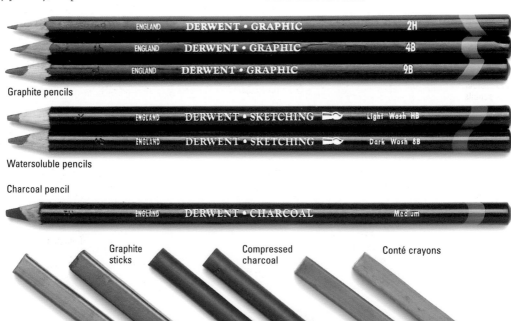

Graphite pencils

Watersoluble pencils

Charcoal pencil

Graphite sticks

Compressed charcoal

Conté crayons

Pastel pencils

Effective used on their own, particularly upon a tinted or coloured surface, these also work well used alongside soft pastel sticks: the sticks can cover large areas, with the sharpened pencils providing fine detail.

Artists' and studio coloured pencils

The artists' variety are of larger diameter than studio pencils, and the colour strip is slightly waxy, making them useful for blending and superimposing colours. The studio ranges are ideal for fine, detailed work, as they are slimmer and their hexagonal barrels are helpful when executing delicate work. They are formulated not to crumble during use, which makes them reliable.

Watercolour pencils

When used dry on dry paper, these produce a soft effect; when water is lightly washed over the marks, the images swiftly become a painting. Further drawing can be overlaid when the pigment has thoroughly dried, and this combination of drawing and painting is an appealing one.

Woodless watercolour sticks

Used in a similar way to watercolour pencils, these have the added advantage of having no casing, which means that they can be broken into suitable lengths and be used lengthways for broad strokes of colour.

Pens

A wide range of pens is available for drawing, including Profipens, which come in a number of nib sizes to produce everything from very fine to quite broad lines. Depending on the tooth of the paper on which they are used, they can create solid or broken, textured lines. They can be used in combination with another medium, often watercolour paint. Italic pens have a chisel shape which allows a widely varying breadth of line from a single pen.

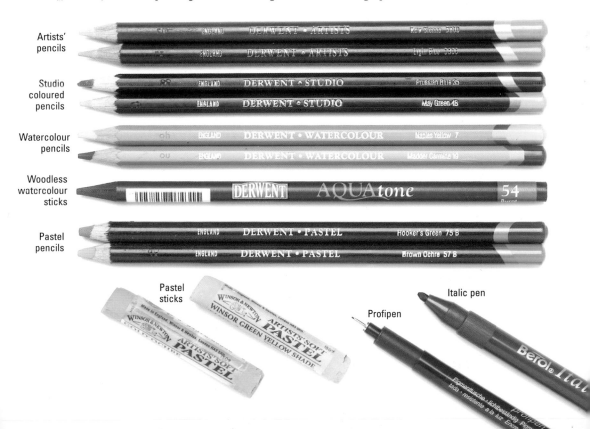

Artists' pencils

Studio coloured pencils

Watercolour pencils

Woodless watercolour sticks

Pastel pencils

Pastel sticks

Profipen

Italic pen

Watercolour

Paints

Watercolour paints are available in both tubes and pans; the former are good for pigments you will use a lot. Rather than buying a manufacturer's paintbox with a set of pigments, it is a better idea to purchase a box or tin to hold pans or tubes and then choose individual colours to create your own range of hues. Working in monochrome or with a limited palette is advantageous when starting out, so it is not necessary to fill the container all at once, which means that you can purchase artists' quality paints when you can afford them rather than settling for a cheaper quality. Pocket-size watercolour boxes, which sometimes contain an integral brush and water pot, are useful for working on location.

Brushes

As with paints, it is preferable to have one or two good-quality items rather than an array of indifferent specimens. Sable brushes are the finest quality and I often complete an entire painting using only one brush, as long as it possesses the necessary attributes for my personal style: good water-holding capacity, flexibility (hairs that spring back into place after the application has been made), and a fine point.

A versatile starting set of brushes would be Nos 3, 6 and 8 round; I occasionally make use of a flat brush as well, for drybrush overlays (see page 25) and wash overlays.

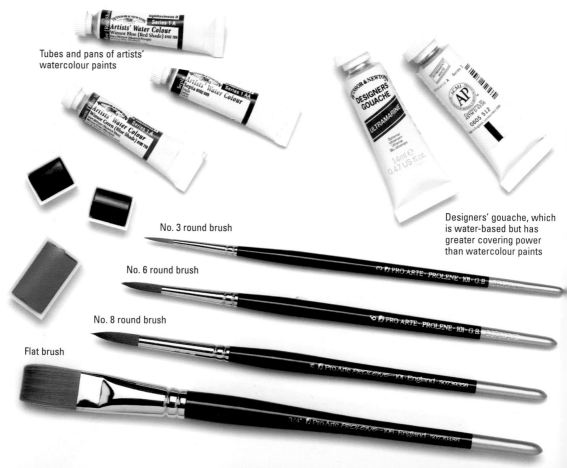

Tubes and pans of artists' watercolour paints

No. 3 round brush

No. 6 round brush

No. 8 round brush

Flat brush

Designers' gouache, which is water-based but has greater covering power than watercolour paints

Other Equipment

Water pots

To preserve the shapes of your brushes, use a water pot that allows them to be supported, with the tips facing downwards, around the edge of the pot. The drip tray, which doubles as a lid when not in use, catches the drips, and the brushes retain their points.

Palettes

I always use ceramic palettes, as they are easy to clean and do not stain; this allows each new colour or mix to remain clear and not be influenced by what has been in the palette well beforehand.

Sharpeners

My preference is to use a Stanley knife rather than a craft knife or pencil sharpener; the metal version is better than a plastic one, as the extra weight helps with the execution of movements that take off slivers of wood and graze the lead to produce fine pencil points.

Erasers

A putty eraser can be kneaded into various shapes, which makes it useful for lifting soft pastel and charcoal marks. For erasing graphite pencil marks or cleaning drawing paper surfaces, a variety of other erasers, including plastic ones, is available from art or office suppliers.

I prefer to use erasers as little as possible, and draw very lightly at first, adding intensity of tone by applying more pressure, only correcting as the images develop. I feel that many of the most interesting drawings are those where you can understand how the artist developed the work by observing the underlayers.

Working on location

Try to be as comfortable as possible and have all your materials to hand. A lightweight 'sketching' easel, on which a plastic water jar may be hung, is a help if you find working on a watercolour block (or pad) on your lap too awkward. A lightweight folding seat with a back rest may be preferable to a stool and a field or pocket box of paints (brush included) with tissues or kitchen roll will complete a watercolour kit.

When you are painting out of doors the weather conditions may influence your work to such an extent that you will need to consider how you intend to deal with them. Warm clothes are needed if it is chilly, and a sun hat should be used for protection should the opposite apply.

Because you will need to consider changes in cast shadows as the hours pass, photographic reference or sketchbook drawings depicting the position of shadows where they enhance the composition are a great help.

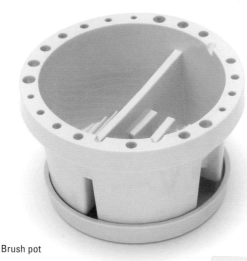

Ceramic palette

Brush pot

Putty eraser

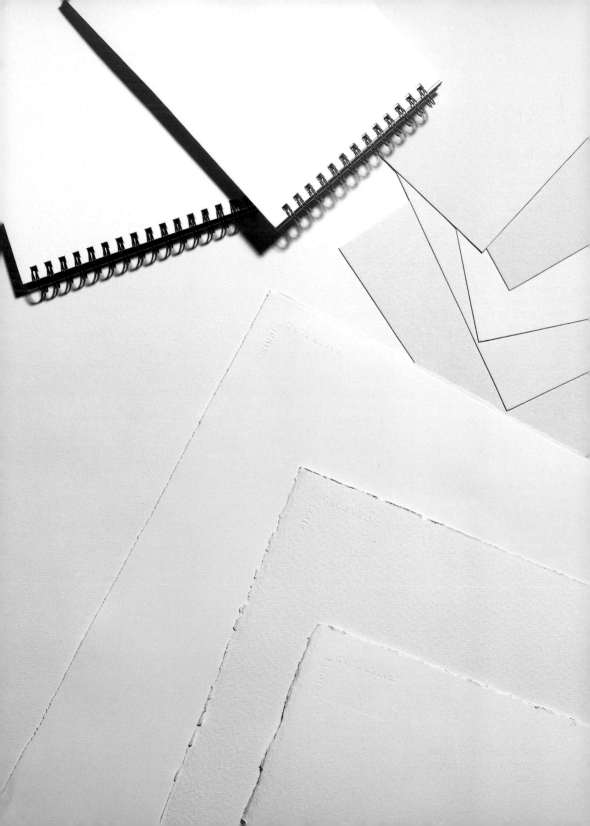

Paper

Drawing paper

Standard office copier paper is ideal for sketching and preliminary layouts; you can also practise drawing techniques on this inexpensive support – but remember to use the thin sheets in the form of a pad, as it is otherwise easy to pick up texture inadvertently from the board or table on which the paper is placed.

For more permanent drawings there is a wide range of quality cartridge paper of differing weights available, and it is a good idea to experiment with various combinations of paper and drawing media to find out which best suits your individual style and requirements.

Watercolour paper

HP (Hot-Pressed) watercolour paper is suitable for drawings, and allows you to happily combine pencil drawing with watercolour painting, without the cockling effect that sometimes occurs with lighter-weight cartridge papers.

With its forgiving painting surface, Bockingford is an economical watercolour paper that is ideal for practise exercises as well as completed paintings. Also available in a variety of tinted surfaces – blue, eggshell, cream and oatmeal – and in an extra-rough version, the Bockingford range may be all you need to get started.

I have used Saunders Waterford NOT (Cold-Pressed) watercolour paper for a number of the illustrations in this book, and it is one of my favourite surfaces. Where a rough surface is required, Saunders Waterford Rough is ideal.

Other papers and sketchbooks

The papers described above can be used with a variety of media, including watercolour, pen and ink, pencil, gouache, acrylic, charcoal and pastels. When using the latter, a heavyweight Rough paper with a watercolour wash underpainting makes a very good surface. Pastels also respond well to the Somerset Velvet range, and can be used on pastel board and, for a really textured surface, sandpaper.

A tinted surface (also available in the Somerset Velvet range) is an ideal support for drier methods of paint application, such as gouache and acrylic.

Stretching Paper

When working on lightweight watercolour papers, it is advisable to stretch the sheet on a board to avoid cockling when areas of wash are applied. Make sure that the paper size is less than that of the board, allowing sufficient margin for the gummed strip to adhere evenly around the edges

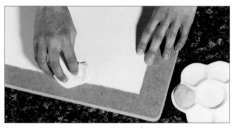

1 Cut four strips of gummed paper to length, approximately 50mm (2in) longer than the paper edges. Immerse the paper in a tray (or bath) containing enough water to cover the sheet, and leave for a few moments before lifting it out and allowing the water to run and drip off. Lay the sheet gently on the board, making sure that the edges run parallel to the board and the margins are even. Use a sponge to gently smooth the paper to eliminate any air bubbles and blot off excess moisture.

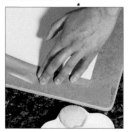

2 Dampen the gummed strips and secure all the edges of the paper to the board; overlap the paper edges by about 12mm (½in), and allow about 25mm (1in) to spare at the corners.

3 Use crumpled kitchen paper to gently smooth along the edges until they are flat and the moisture is even across the whole sheet. Dry flat at room temperature – angling the board can cause moisture to accumulate at the base and the gummed paper to lose its adhesion.

Drawing Techniques

Mark-making

There is such an exciting choice of pencils available to the artist that it would be impossible to include everything here. Instead, I have demonstrated a few from this vast selection in order to show some of the marks they make and how you can try out materials that may be new to you.

Rather than making just abstract marks, I like to start immediately to imagine in what context they may be used. The marks on these pages were made on a smooth, white paper. The same movements and pressures will almost certainly appear different on other surfaces, so experiment and see what happens.

Graphite pencils

The hard 2H is ideal for drawing with a wandering line

A 2B pencil, for general-purpose drawing, allows you to enrich your tones

The soft 9B lends itself to a more painterly approach

Coloured pencils

Studio pencils have a slim colour strip, and are ideal for more detailed work

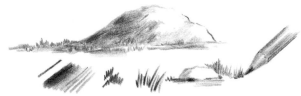
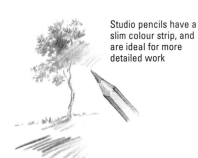

Artists' pencils have a thick strip of colour, encouraging a looser interpretation

Graphite sticks

Soft sticks create rich, dark tones. They are easily smudged, so an early application of fixative is required

The darks from medium sticks are not as deep, but are compensated for by being easier to work with

With a twisting/turning application of a hard stick, a crisp effect, useful for depicting distant reeds or grasses, can be achieved

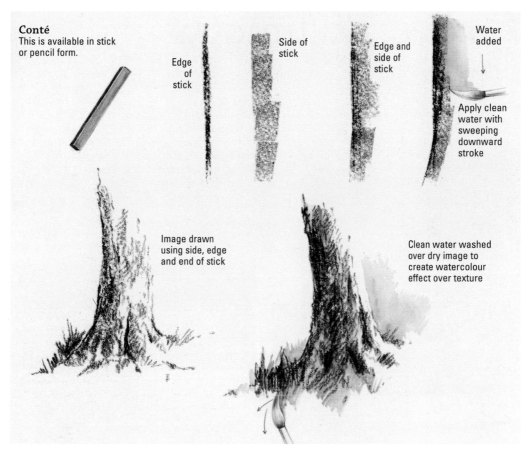

Conté
This is available in stick or pencil form.

Edge of stick

Side of stick

Edge and side of stick

Water added

Apply clean water with sweeping downward stroke

Image drawn using side, edge and end of stick

Clean water washed over dry image to create watercolour effect over texture

Soft charcoal pencil
This medium is very responsive to the application of water. Experiment by drawing on to a wet surface for richer darks.

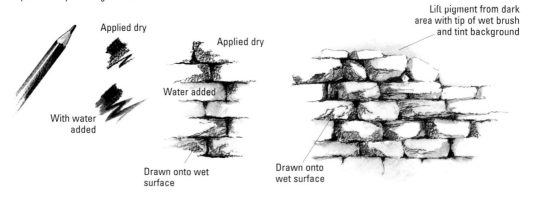

Applied dry

Applied dry

With water added

Water added

Lift pigment from dark area with tip of wet brush and tint background

Drawn onto wet surface

Drawn onto wet surface

Pastels

There is a wide selection of pastel-based products available; for this page, I have concentrated on soft pastel sticks and pastel pencils.

Supports for pastels

All pastels require a surface that has some texture, and are most effective when used on a coloured or tinted ground. Pastel paper, where one side is smoother than the other, is available in assorted colours. Pastel board possesses more texture; as always, try out a variety of supports to find one that suits you.

Pastel sticks

Pastel sticks can be used on their sides for broad strokes, and the edges of the blunt ends provide a crisp line for more detailed areas.

Pastel pencils

Pastel pencils can be used as an individual medium or combined with pastel sticks. Pastel pencils are also very useful for monochrome work, and, being water soluble, can be used alone in this context as well as part of mixed-media techniques.

Contrasts with pastel sticks
Using a black surface allows you to see strong contrasts of pale hues and exciting textures where the ground is visible through lightly applied pastel strokes.

Side dragged horizontally produces wide lines

Edge of blunt end produces finer lines

Side used in a downward movement for area of texture

Reinforcing stroke creates thicker pigment

Side used in up-and-down movement

Combination of strokes

Bricks with sticks
Using the side of a pastel stick to create a shape such as a brick gives you a base upon which to build other colours and marks.

Horizontal movement/ stroke with side

Limited range of hues

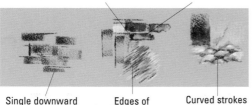

Single downward stroke with side

Edges of blunt ends

Curved strokes for pebbles or cobbles

Pastel pencil
Applying a range of greens using short, curved strokes allows the black ground to enhance the image.

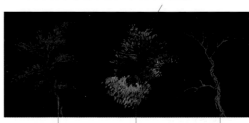

Use one colour to create pale silhouette, concentrating on directional stroke application

Place a light background using a different application of directional strokes

Twisting the pencil produces interesting structures

Pencil colouring
Pastel pencils allow you to create both lines and blocks of colour easily by turning them as you work.

Erratic application of pencil creates textured bark effect

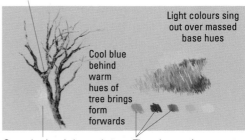

Light colours sing out over massed base hues

Cool blue behind warm hues of tree brings form forwards

Ground colour is integral part of overall impression

Three base colours create a mass upon which other hues can be applied

Pen and Ink

From the very fine nib of a mapping pen to wide italic nibs, there has always been a variety of pen choice. Experiment with as many different pens as possible, using both permanent and watersoluble inks, and vary the surfaces upon which you draw; this will encourage diversity of application and techniques.

Movements and marks

Just as the use of varied pressure of a pencil or brush on paper creates variation and interest of line and tone, so can you do this with a pen. Again, in the same way as pencil and paint react in different ways to different surfaces, so do pens.

Water work

A fountain pen need not be just for writing.

Drag the nib gently over textured watercolour paper in sweeping strokes. To blend, apply water in the same way.

A feeling for foliage

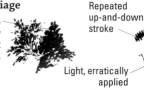

Water added to increase intensity over non-permanent ball-pen ink

Repeated up-and-down stroke

Small hooked strokes

Light, erratically applied structure strokes

Cobble contours

Very lightly applied curved lines follow form of cobble

For shadow (recess) shape, pen gently touches surface of paper with limited movement for negative shape

Italic pens

The chisel shape of italic pens provides three alternatives for use. Flat pressure produces solid or textured bands (depending upon the pressure exerted); with the nib turned, the thin strip contributes to a variety of fine lines; and by turning to the point you will be able to draw as if using a fine-tipped pen.

Tree-trunk texture

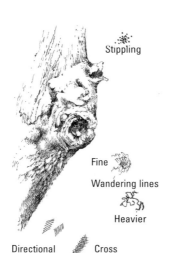

Stippling

Undulating pressure lines

Fine

Wandering lines

Heavier

Directional lines

Cross hatch

Demonstration stroke using firm application of pen

Lifting pressure creates texture on Bockingford surface

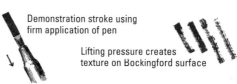

Chisel side applied with horizontal and zigzag movements to suggest reflections on water surface

Short stroke using chisel side

Long stroke using narrow side

Point end of chisel achieves tail

Head of rush created with series of short overlapping block strokes

Wide part of leaf created using same movement as demonstration stroke

Watercolour Pencils

Watercolour pencils are a very versatile medium – there are numerous ways in which they can be used upon tinted or white paper surfaces, either on their own or combined with other mediums.

Working on a tinted ground

A straightforward application of watercolour pencils is to draw the image onto watercolour paper and then gently disturb and blend the pigment with a little clean water on the tip of a brush. This effect is enhanced by working on a tinted surface, and can look very effective executed in monochrome. Bockingford tinted papers are ideal for this method, and were used for the exercises on this page. Choose a coloured pencil that complements the tint of the paper and subject, and if fine detail is important for the overall effect, make sure you retain a sharp point on the pencil throughout the drawing process.

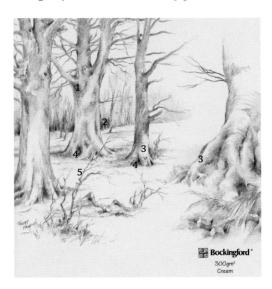

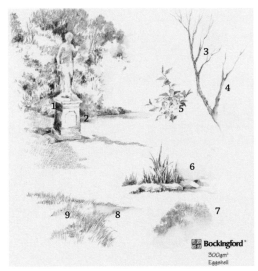

Woodland trees

The images on the left show the spacing of the dominant trees in the foreground, with other trees gathered close together in the background. On the right is a detailed close-up study showing tree roots, rocks and grasses.

1 Dark shadow area in front of light background
2 Darks behind light form
3 Leave some areas of untouched paper
4 Create rich dark areas of contrast
5 Superimpose delicate drawing in foreground to help create feeling of distance

Garden setting

The solid stone statue contrasts with a more delicate depiction of background foliage. The other little detail studies give an opportunity for close observation and experimentation with texture and water application.

1 Dark in front of lighter background
2 Dark background behind light form
3 Dry on dry
4 Blended with water
5 Detailed interpretation of individually drawn/toned leaves
6 Study depicting contrasts of tone, shape and texture
7 Adding water to foliage mass
8 Water gently brushed over surface
9 Dry on dry

Exercises

An exciting way to depict interesting textures on some rough surfaces, and to conserve your pencils, is to sharpen the pencils onto dampened paper. Wet an area with a brush of sufficient size to hold enough water for quick coverage. Sharpen your pencil – being careful not to encroach upon the wood – onto the wet surface. Watch the pigment spread, then with either the tip of your pencil (where lines drawn upon contact will bleed) or a fine-tipped brush, guide the resulting marks/textures into the desired shapes. 'Happy accidents' can easily occur with this method, and it is also possible to blend pale washes of colour over the textured areas after the area has dried.

To create pale washes in your palette, sharpen the chosen coloured pencil into the well, add water, and mix to achieve your wash.

Playing with texture

Suitable effect for tree foliage

Wet paper, place tip of pencil upon wet surface and lift – repeat over area to be covered

Blending occurs where the pencil meets the very wet surface

Sharpenings method
This method is useful for stone walls and other rough surfaces.

A derelict site in an urban landscape may be suitable subject matter for this treatment

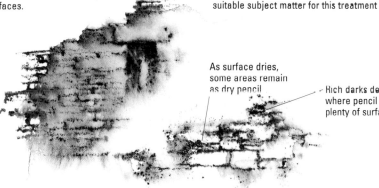

As surface dries, some areas remain as dry pencil

Rich darks develop where pencil meets plenty of surface water

Pencil sharpenings on wet surface

This quick dry-on-dry sketch was touched with clean water from a brush. Note how some texture remains visible beneath the tonal wash area

Landscapes

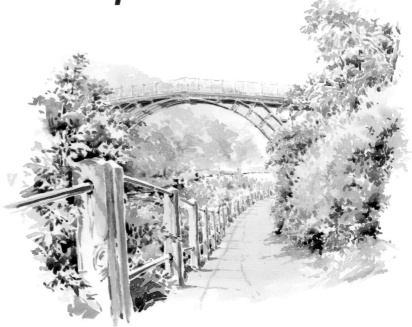

You may regard your art as a total commitment or an invisible thread woven into the fabric of your day-to-day life – or anything between the two. It is primarily a matter of an awareness of the part you wish your art to play, and where you choose to let it blossom and flourish.

Colour, texture, line and form can work together or individually, depending upon the way you incorporate them into your artwork, but the 'artist's eye' needs to be nurtured and developed as an integral part of the whole. Throughout this book I have endeavoured to reaffirm what artists throughout the ages have experienced, and to impart some of the excitement I feel for my subjects.

Colour

On page 30 you will learn about basic colour theory and discover the relationship between colours so that you can handle them successfully in a painting. Working with a limited palette (page 31) encourages you to explore how much you can find from each colour by making simple but subtle mixes from just two or three pigments.

Texture

Observing and appreciating the variety and interest of surface textures is of great importance when creating convincing interpretations of landscapes – tree bark, stone walls, foliage and water effects, for example, would lose their impact if they were all treated in the same way. Textures can be achieved by using techniques such as blotting off (page 23), drybrush (page 25) and wax resist (page 26); and very often it is the support that is most important when creating textures.

Line

Line drawing is very useful for sketchbook work – for example using a 'wandering line' to capture impressions of moving objects, and combining line with tone in pencil sketches and either watercolour pencil or ink and wash studies. This offers the options of drawing first and applying a tonal overlay (page

93), painting in washes first and bringing the picture together with a drawing (page 94), or working the two together (page 95).

Form

Contour lines help find form in order to create a three-dimensional impression on a two-dimensional surface. These lines may be the important underdrawing, lightly applied as a guide and then absorbed within the tonal images of the final interpretation. They can also be attractive in their own right.

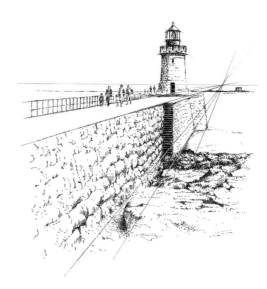

opportunities that may lead to new discoveries of techniques and ideas, and you will never tire of the endless possibilities they present, allied with your powers of observation.

The themes

Each theme commences with basic pencil marks that relate to the following pages, and concludes with a demonstration in one or more of a variety of mediums, giving you an opportunity to study them in more depth. Within the themes the various mediums are used in a number of ways and with different styles, techniques and subject matter, so that you can become more aware of some of the vast array of choices at your disposal.

Play and exercise pages

As children we learn from play, and there is no reason not to continue to enjoy playing as part of the learning process with art; so part of the introduction to each theme consists of a few relevant exercises with brush or pencil, which can be regarded as enjoyable warming up prior to the more serious work that follows.

I use the word 'serious' because I regard discipline as an important factor, especially in the early stages when learning the basics. This will ensure that a firm foundation for artwork is established – but there should also be an element of fun and a desire to take advantage of 'happy accidents', as well as flexibility of approach and application. Look for unexpected

Discipline leads to freedom

Establish the basic disciplines of drawing, observation and methods of application, and you will enjoy the freedom to create your own style – detailed and controlled, or loose and free – in the sure knowledge that you fully understand what you are trying to achieve, and are developing the confidence that will enable you to achieve it.

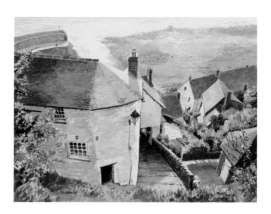

Watercolour Techniques
Making Marks – Brushstrokes

When practising brushstrokes in watercolour, because the marks are important in these exercises, it is helpful to work either with neutral hues or in monochrome. The marks here demonstrate how to mix useful neutrals.

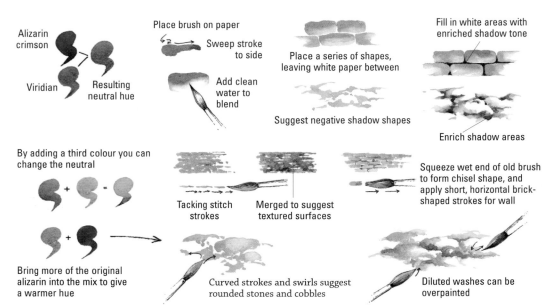

Alizarin crimson

Viridian

Resulting neutral hue

Place brush on paper

Sweep stroke to side

Add clean water to blend

Place a series of shapes, leaving white paper between

Suggest negative shadow shapes

Fill in white areas with enriched shadow tone

Enrich shadow areas

By adding a third colour you can change the neutral

Tacking stitch strokes

Merged to suggest textured surfaces

Squeeze wet end of old brush to form chisel shape, and apply short, horizontal brick-shaped strokes for wall

Bring more of the original alizarin into the mix to give a warmer hue

Curved strokes and swirls suggest rounded stones and cobbles

Diluted washes can be overpainted

Foliage impressions

In depicting everything from areas of countryside, through town and village gardens, to city parks and tree-lined avenues, you need to consider how to give the impression of foliage mass or individual leaves.

Demonstrated here is a series of foliage brushstroke movements, shown in relation to the structure of trunks and branches. By working solely in monochrome you will be able to concentrate upon the direction of stroke application and the variations in tone.

Introducing structure

Push strokes upwards

Pull strokes out and down

Suggest drooping foliage

Practise longer up and down strokes

Place an area of tone each side of a slim strip of white paper

Push the edges outwards to create interesting silhouettes

While blotted area is still damp, drop in darker tones

Add water in places to reduce depth of tone

Slim strip between wider areas

Start with strong pigment

Blot gently to produce paler tone

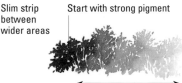

Add a little more water to each new area

Foliage mass using a variety of strokes, with longer up-and-down movements introducing structure effects

Exercises

The best way to develop drawing and painting skills is to make learning fun, and to create little exercises that you really enjoy.

Sometimes if a painting goes wrong, once you have accepted what has happened you can then play about with it, knowing you cannot spoil what has already turned out badly. This attitude can lead to a new freedom of expression.

It is also possible to play with marks on a clean sheet of paper. This 'play time' is an opportunity to develop knowledge, understanding and, as a result of these, confidence in your art.

Go for a globule

Place a globule of strong pigment mixed with plenty of water ⬤

Push the globule upwards and outwards using the tip of your brush

Create interesting and uneven edges to establish a foliage mass silhouette

Gather the globule and pull downwards from the main mass with individual strokes

Mixture should accumulate at base to form reservoir

Increase side of area covered by impression of foliage mass

Add strokes to indicate branches and twigs

Continue downwards with globule

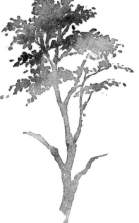

Before the image has dried, blot gently using a scrunched sheet of kitchen roll, pressing lightly and unevenly when you blot. Some areas will blot dry (pale) and others will retain moisture and a darker tone

On Rough-surface watercolour paper you can retain control of your globule and need only guide it gently

Retain a strong gradient for the angle of the board

Push globule using tip of brush

Globule viewed from side – note prominence

Washes

The examples of washes shown here rely upon the paper being supported at a sufficient angle to allow liquid to form a reservoir at the lower edge of each horizontal stroke in order that it may be taken into the next stroke across. The brush needs to be reloaded before the reservoir has diminished to ensure even application and the achievement of a totally flat wash.

Note that it is essential to mix enough water with your pigment to retain fluidity throughout.

Laying a wash

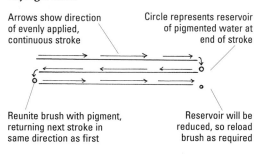

Arrows show direction of evenly applied, continuous stroke

Circle represents reservoir of pigmented water at end of stroke

Reunite brush with pigment, returning next stroke in same direction as first

Reservoir will be reduced, so reload brush as required

Flat wash

When practising a flat wash, remember to mix sufficient pigment with your water to produce the density of colour required, as colours will appear lighter when dry than when applied. It is also advisable to mix more in your palette than you think you will require, to avoid running out while the wash is being applied.

Laying a wash is a continuous process from which you cannot break off or go back over any area during its application. To do so would prevent it from being a truly flat wash.

When the final horizontal stroke has been placed, lift the remainder of the reservoir by squeezing out your brush and placing it gently along the base of the stroke to absorb excess moisture.

Flat wash

Gradated wash

A gradated wash is achieved by the addition of clean water to each brushstroke of your palette of colour as you progress down the paper.

Gradated wash

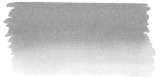

Variegated wash

A variegated wash is achieved by using a number of colours. Where the colours blend into each other, ensure your palette wells contain enough of each different colour before you start, and that the pigment-to-water ratio is correct for your needs.

Variegated wash

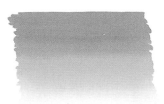

Work in the same way as for the gradated wash, but instead of clean water add the next colour

Wash exercise

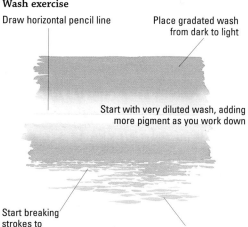

Draw horizontal pencil line

Place gradated wash from dark to light

Start with very diluted wash, adding more pigment as you work down

Start breaking strokes to suggest surface of water

Lowest strokes are much shorter and in the form of one-stroke marks

Blotting Off

Blotting off can be used to achieve and enhance texture, as shown in the foliage exercises, or to remove pigment completely, for example in creating cloud formations.

Surfaces for blotting off

It is important to understand that different effects can be achieved upon different surfaces of watercolour paper, and you should experiment with various papers to note the reactions of the method on a number of surfaces. Some papers are more absorbent than others and may produce problems if blotting off only removes extra moisture, leaving a flat area of tone.

Spontaneity of approach

This method of producing texture requires a swiftness of execution that allows the image to retain enough moisture to ensure that blotting with crumpled kitchen paper produces some areas that are not completely covered. The effect relies upon the darker pigment that is dropped in working its way and bleeding into and along some still-damp areas.

Experiment with mark-making in the form of a foliage mass on a barely absorbent surface

Working quickly and freely, create interesting arrangement of marks to suggest foliage

Immediately drop in some dark pigment to spread into still-damp areas

Gently blot whole area while still quite wet

As the image dries, enhance the darks while retaining the lighter areas that have already

Blotting for clouds
To achieve untextured images, the illustration demonstrates how to create cloud formations within a flat wash.

While a flat wash was still wet, a dampened, screwed-up tissue was firmly pressed onto the surface to absorb as much pigment as possible

For crisper, clearer images, a dry tissue was pressed very firmly on to the wet paper

Lifting off for highlights

To achieve the effect of highlights by lifting off, you need plenty of pigment in your mixture, as the method relies upon pigment being absorbed into the hairs of a damp brush placed upon a wet surface. If the pigment does dry, apply a damp brush to the paint and agitate the hairs to disturb the pigment, prior to either blotting or reapplying more clean water.

Highlighting a dry image

Agitate the surface with a brush that has been dipped in clean water to lift off some of the pigment and create a highlighted area

Creating highlights on a damp surface

When stonework is dry, fill in between stones with dark colour to suggest shadow recess lines and shadow shapes

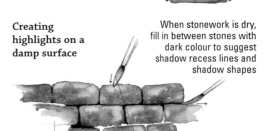

Loosely paint series of brick-shaped stones using plenty of pigmented water

With brush dipped into clean water and squeezed dry, place hairs against wet paint to lift off moisture and absorb pigment

Wet-into-Wet

Two ways in which the wet-into-wet method may be approached are demonstrated here – by working on a wet or dampened surface; and by dropping in additional tone or colour on a wet or damp painted surface, such as within an image or background area.

Working on a damp surface

A simple example of this method is to paint a sky by dampening the paper surface with clean water before painting blue areas, retaining white paper shapes that indicate cloud formations.

A more complex example of this method is shown in the tree trunk against foliage. Although this painting is in monochrome (a mix of blue and brown to create a neutral hue), there has been some colour separation, which enhances the effect.

Simple sky

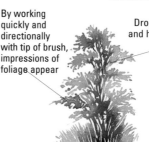

Apply blue pigment to dampened paper, pushing it directionally around white cloud areas

Tree trunk against foliage

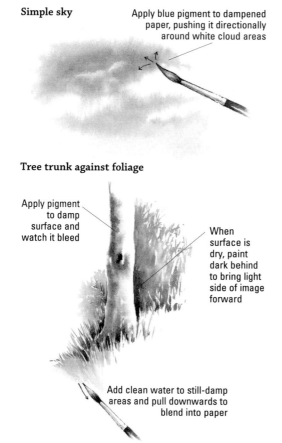

Apply pigment to damp surface and watch it bleed

When surface is dry, paint dark behind to bring light side of image forward

Add clean water to still-damp areas and pull downwards to blend into paper

Dropping in

A quick and freely applied image can be enhanced by dropping in additional colours/tones while still wet to enhance the dark, shadow areas. This is useful to achieve richness in shadow recesses at the base of a form.

Direction of movement
Work with your board angled to encourage pigment to flow downwards at all times

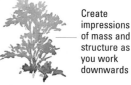

Mix plenty of water with pigment to create reservoir of liquid

Create impressions of mass and structure as you work downwards

Darkest tones will accumulate at base

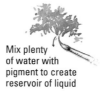

By working quickly and directionally with tip of brush, impressions of foliage appear

Drop in darker tones and hues while image is still damp

Note separation of colour

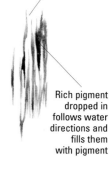

Richest darks provide strong contrasts against untouched white paper as they flow down

Exercise

The image shown left was made by drawing a quick impression with a brush using clean water only. To indicate where the water has been applied, angle the paper away from you from time to time so you can see the sheen upon the paper's surface. Gently drop in pigment against the wet areas only, from where it swiftly spreads outwards into other wet areas so that pigmented shapes appear.

Clean water applied to paper with swift up and down movements

Rich pigment dropped in follows water directions and fills them with pigment

Drybrush and Wet on Dry

Drybrush

When the pigment on a brush has almost dried before it is applied to the paper's surface, it produces a textured effect. Dragging a brush prepared in this way across a flat surface can create interesting treatments for impressions of sparkling water and texture on wood and stone.

Laying a flat texture

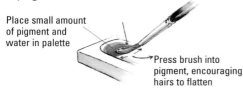

Place small amount of pigment and water in palette

Press brush into pigment, encouraging hairs to flatten

Drag pigmented, flattened hairs swiftly across textured surface of the watercolour paper

Laying a contoured texture

Paint wood image in varied tones

When image has dried, drag drybrush across surface to create textured effect

Wet on dry

A good way to practise this approach is using monochrome. By working onto a background area that has been painted and allowed to dry, using wet pigment as an overlay of shapes, you can suggest depth with a variety of tones.

Texture on stone

Produce images in pale tones

Allow to dry

Using short-haired, stiff brush, scumble and stipple texture over surface

Combined methods

This illustration demonstrates both methods combined. A stone statue with a textured surface was depicted using the drybrush treatment, and was placed in front of a foliage background depicted in monochrome using the wet-on-dry method.

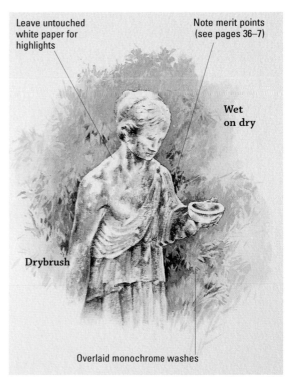

Leave untouched white paper for highlights

Note merit points (see pages 36–7)

Wet on dry

Drybrush

Overlaid monochrome washes

Resists

A resist method is when part of the paper's surface is coated with a substance that prevents any overlaid washes of pigment reaching the paper underneath. However, the resist methods shown here can sometimes create problems as well as solving them.

Candle wax

Applying candle wax to the paper causes the surface to resist application of pigment to the extent that a textured effect is achieved. It is ideal for use in the depiction of sparkling water and many other effects, and the method is shown here as an aid to achieving the impression of a light snow covering on an otherwise bare mountain.

With a bulky mark-making object such as a candle you may experience difficulty at times when trying to depict delicate shapes, and a solution using a sharp craft knife is included in the illustration.

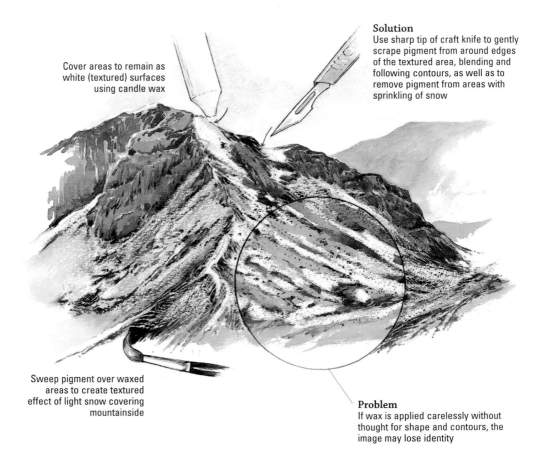

Solution
Use sharp tip of craft knife to gently scrape pigment from around edges of the textured area, blending and following contours, as well as to remove pigment from areas with sprinkling of snow

Cover areas to remain as white (textured) surfaces using candle wax

Sweep pigment over waxed areas to create textured effect of light snow covering mountainside

Problem
If wax is applied carelessly without thought for shape and contours, the image may lose identity

Masking fluid

This liquid, which is rubbery when dry, is applied to the paper using an old brush, a pen nib or the special applicator attached to a plastic bottle containing the fluid. When the paint has thoroughly dried, you can remove the rubbery substance gently by passing a finger across the surface or, in some instances, actually pulling it away. It is not always easy to achieve fine lines with masking fluid, and the illustration demonstrates the kind of problem that can occur, and how to solve it.

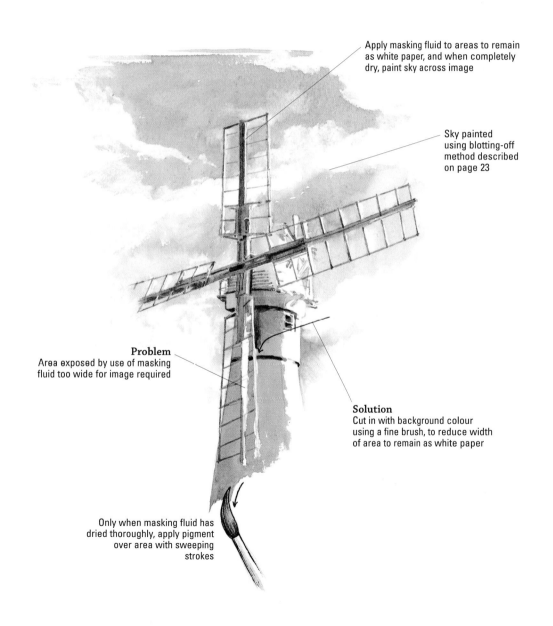

Apply masking fluid to areas to remain as white paper, and when completely dry, paint sky across image

Sky painted using blotting-off method described on page 23

Problem
Area exposed by use of masking fluid too wide for image required

Solution
Cut in with background colour using a fine brush, to reduce width of area to remain as white paper

Only when masking fluid has dried thoroughly, apply pigment over area with sweeping strokes

Mixed-media Techniques

Introducing Gouache

In addition to being enjoyable as a medium in its own right, gouache, or body colour, can also be used effectively with other mediums.

Unlike pencil and watercolour techniques – where the white paper often plays an important part in the depiction of highlights and white areas – gouache benefits from being used on a tinted or coloured ground, which means that white and light pigments create exciting contrasts when they are applied on the darker hues.

Extending the drybrush technique (see page 25) into gouache on a dark support produces interesting textures when combined with normal paint coverage. When used to depict a variety of textured surfaces, this combination of techniques, incorporating the hue of the support as part of the method, can be used with or without the addition of other mediums.

Gouache on a coloured support

Here, an old boat, which could be part of an inland scene as well as by the coast, is used to demonstrate the use of gouache on a coloured support. This is an opportunity to add gouache to other water-based mediums.

Working on 600gsm (300lb) Saunders Waterford Rough paper, I applied a wash of dark olive watercolour and allowed it to dry before drawing the boat using zinc white gouache with a fine pointed brush. For the white planks I used a small flat brush.

For the build-up of colour a limited palette, of Winsor blue, Winsor green, French ultramarine, yellow ochre and burnt sienna, was mixed together as washes or with white, to cover the coloured ground. This support colour plays an important part in unifying (harmonizing) the hues.

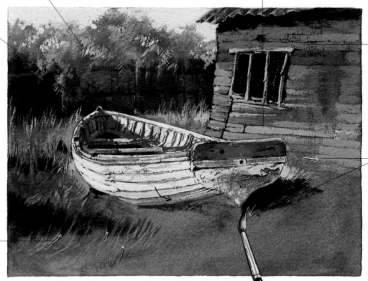

Important negative shapes through which sky is visible

Flat brush, applying paint horizontally, enables easy depiction of planks

Darkest dark (tone and colour) against lightest light for maximum contrast

Note drybrush technique over support hue

Top arrow indicates direction of strokes for planks; bottom arrow strokes suggest growth of long grasses

Arrows show direction of brushstrokes

Sweeping strokes, using round brush, contrast with shorter, flat brushstrokes depicting planks

Gouache with charcoal pencil

There are many coloured supports available that are suitable for use with gouache – here, I used a grey-tinted Bockingford 300gsm (140lb) paper.

Trees provide interesting subject matter for a delicate approach using gouache, where texture and linear work combine with looser brushwork that requires the addition of more water than the gouache method shown opposite. Where the texture on the boat was achieved by the build-up of dryer paint over the coloured ground, here it is the charcoal drawing, beneath a watery application of paint, that produces the effects.

The use of a soft charcoal pencil necessitated the application of a layer of fixative prior to painting, as well as during the painting process, when more drawing was used to enhance certain areas. The subtle tint of the ground was used to enhance the effect by being retained within the painting. The drawing was made using minimum pressure and with frequent sharpening of the pencil.

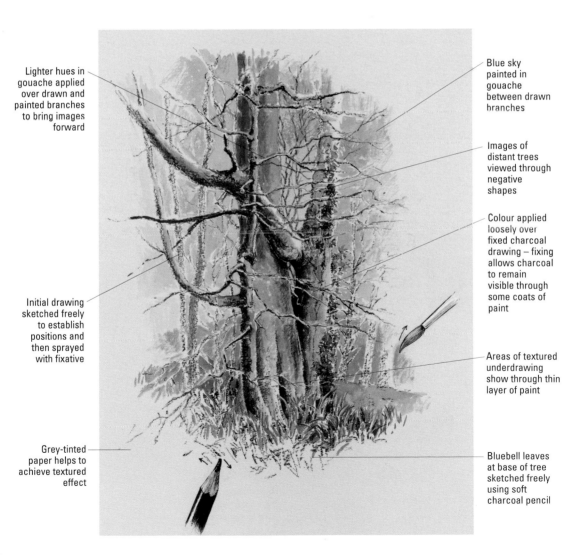

Lighter hues in gouache applied over drawn and painted branches to bring images forward

Initial drawing sketched freely to establish positions and then sprayed with fixative

Grey-tinted paper helps to achieve textured effect

Blue sky painted in gouache between drawn branches

Images of distant trees viewed through negative shapes

Colour applied loosely over fixed charcoal drawing – fixing allows charcoal to remain visible through some coats of paint

Areas of textured underdrawing show through thin layer of paint

Bluebell leaves at base of tree sketched freely using soft charcoal pencil

Colour

Colour in your paintings will help you express mood and atmosphere, and the mixing of colours should be a considered activity, rather than a random one. Your choice of colours, and how many you consider necessary for use in a particular painting, will benefit from acquired knowledge and understanding of colour. The best way to gain both of these is through exercises and experimentation, and, like any learning experience, this can be enhanced if there is an element of fun.

Colour wheels

The basic colour wheel contains the three primary colours – red, blue and yellow – with their secondaries of purple, green and orange. The tonal colour wheel above far right demonstrates a gradation towards the central area to show the relationship of the paler hues.

Balloon into colour!

Because there are no reds, blues or yellows that are actually primary – instead, there are warm and cool reds, blues and yellows – I have created a colour balloon to help you understand the differences.

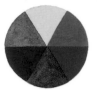

Basic colour wheel Tonal colour wheel

The top area of the balloon contains the cool primaries and their secondaries, while the lower part consists of the warmer hues. Imagine that there is cool air above the balloon (cool colours) and a warm rush of air from the flames beneath (warm colours).

The area in between shows some useful neutral hues, obtained by mixing the primaries together in different proportions. The neutrals are applied in a way that introduces an impression of subtle texture, and the highlights and shadows add interest.

Groups of warm and cool primary colours, in the form of balloons on either side of the main image, relate the hues to those in the main balloon.

Primary cool colours

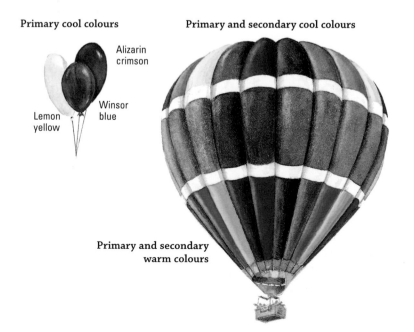

Alizarin crimson

Winsor blue

Lemon yellow

Primary and secondary cool colours

Primary and secondary warm colours

Primary warm colours

Scarlet lake

French ultramarine

Cadmium yellow

Choosing a Palette of Colours

You may feel the process of choosing a suitable palette from the vast range of colours available to be rather daunting. If so, start by working with a limited palette, which will encourage you to be more resourceful.

Limited palette

The challenge of working with a limited palette gives you an opportunity to discover colour permutations that might otherwise remain unknown to you. Restricting your palette to three, or even two, colours can encourage you to produce some exciting results.

Below, a monochrome interpretation of a window in an old building shows how a mix of raw sienna and French ultramarine produces a useful hue that is ideal for depicting this type of subject matter.

By introducing a third colour, you will discover a very pleasing range with which to work. I use these three colours initially in the form of a controlled exercise and then demonstrate how they work within a little study of a church. The white paper also plays an important part for much of the main image, with the neutral hue enhancing the shadow areas.

Simple colour-mixing exercise

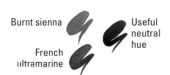

Burnt sienna

French ultramarine

Useful neutral hue

Without drawing image first, lay supporting lines directly onto paper with brush

Add further structure lines

Build around structure in layered washes, and add rich tones within shadow areas using full range of tones

Controlled colour-mixing exercise

Burnt sienna

Useful neutral hue

French ultramarine

Controlled shapes showing colour permutations

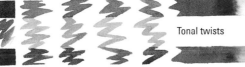
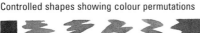

Tonal twists

Finish the strips after changing the position of the two colours

Colour ribbon

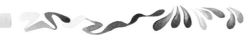

A palette of only two colours can produce a range of hues. Add a third, and you will discover endless opportunities to create exciting hues. Try blending the colours in a controlled way to experiment with abstract shapes.

Three-colour painting

The colours used here are those in the colour ribbon, showing that a painting of rich colours can be developed from a very few hues.

Correcting and Repairing Mistakes

Apart from using an eraser to delete errors, there are other ways of correcting mistakes.

When working on a drawing that requires the surface to remain pristine for final presentation, it is advisable to avoid mistakes by careful pre-planning and tentative application of the drawing material in the first stages. You can then build up the images slowly and with great care, gently erasing errors as they occur and reinforcing the drawing in controlled layers.

For bold, spontaneous work and freely applied sketched images, there are other options where even the methods by which drawings or sketches are altered and corrected become part of the work itself and enhance its development. For any delicate and detailed work,

the importance of preliminary, pre-planning stages cannot be over-stressed. The exercise in accuracy (see pages 36–7) should help with this approach.

Freely applied pencil and charcoal

When mistakes occur in pencil and charcoal work, as well as in mixed-media techniques, the two methods of correction shown here are blocking out the area to be corrected using white paint, and cutting and tearing a new piece of paper to be taped in place over the error, or from the back of the paper if the area of error has itself been cut or torn out. It's best to try out these methods on scrap paper first.

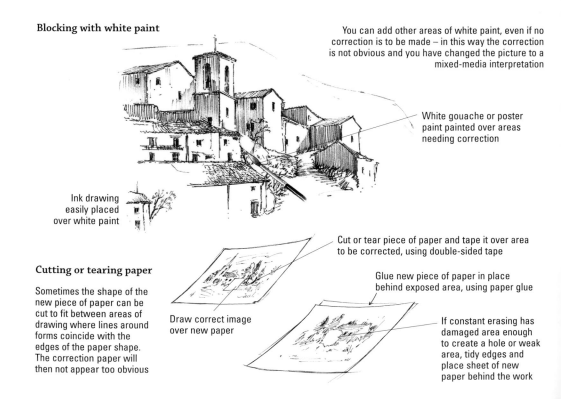

Blocking with white paint

You can add other areas of white paint, even if no correction is to be made – in this way the correction is not obvious and you have changed the picture to a mixed-media interpretation

White gouache or poster paint painted over areas needing correction

Ink drawing easily placed over white paint

Cutting or tearing paper

Sometimes the shape of the new piece of paper can be cut to fit between areas of drawing where lines around forms coincide with the edges of the paper shape. The correction paper will then not appear too obvious

Draw correct image over new paper

Cut or tear piece of paper and tape it over area to be corrected, using double-sided tape

Glue new piece of paper in place behind exposed area, using paper glue

If constant erasing has damaged area enough to create a hole or weak area, tidy edges and place sheet of new paper behind the work

Repairing mistakes in watercolour

When using heavyweight watercolour paper, some mistakes are easy to repair using the following methods.

Sponging off

Gently applying a sponge soaked in clean water to the paper to remove most of the offending pigment (unless it is a strong staining colour) allows you to repaint when the area has dried. Sometimes gently agitating the pigment using a brush containing clean water can also achieve this effect.

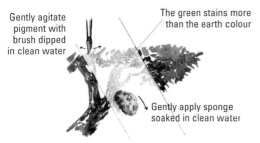

Gently agitate pigment with brush dipped in clean water

The green stains more than the earth colour

Gently apply sponge soaked in clean water

Scraping off

Heavier papers permit you to gently lift the unwanted pigment from the surface by scraping or scratching with a sharp craft knife. However, once the paper has been affected by this method it might not always be possible to add more pigment over the area successfully. Practise the method as an exercise to understand its limitations.

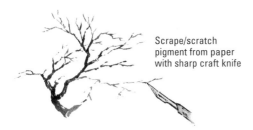

Scrape/scratch pigment from paper with sharp craft knife

Rescue methods

If the composition of your drawing or painting is not developing to your satisfaction, cut a viewfinder to suitable proportions and isolate a part of the picture with which you are pleased. This area can then be cut out and mounted, and the unwanted pieces can be discarded.

Whether it is a drawing or a painting that is not progressing in the way you anticipate, it is worth considering the option of turning it into a mixed-media work in order to preserve and develop it.

Cut viewfinder and isolate part of picture

Developing details

When drawing a sketch from life and limitations of time, weather or comfort inhibit your interpretation, it is worthwhile sketching a few details of some of the confused areas, using the space around the main image. Sketchbook work is a valuable learning experience and teaches you to be observant as well as encouraging the development of drawing skills. We do not always produce sketches with a view to turning them into paintings at a later date, but when areas of a sketch become confused, it is a good idea to redraw around the main image in the form of details.

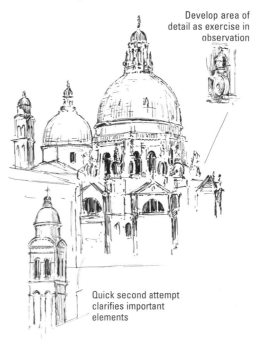

Develop area of detail as exercise in observation

Quick second attempt clarifies important elements

Perspective in Composition

Composing a picture involves numerous considerations, among them placing a focal point, guiding the observer's eye through the picture to maintain interest, juxtaposing shapes, using contrasts (of shape as well as tone), what to include and what to leave out (see pages 38–9) and creating a feeling of movement.

This last does not refer just to obvious movement – for example, a waterfall – but to movement of the observer's eye through and within the picture, rather than using perspective lines that cut through the composition from one side to the other.

The way a picture is divided into areas of sky and foreground (a third of one against two-thirds of the other works well), and placing the components are two other important factors; but we shall deal with perspective first.

Perspective in buildings
This diagram covers some of the straightforward aspects of perspective lines used on a building where parts of two sides are visible. Taking a strong horizontal line through at eye level, you can see how the lines converge at two separate vanishing points.

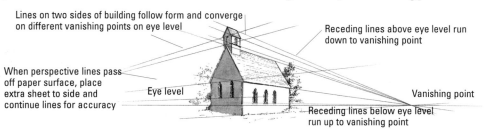

Lines on two sides of building follow form and converge on different vanishing points on eye level

Receding lines above eye level run down to vanishing point

When perspective lines pass off paper surface, place extra sheet to side and continue lines for accuracy

Eye level

Vanishing point

Receding lines below eye level run up to vanishing point

Perspective relationships
This illustration works towards considerations of pictorial composition involving elements at the outer edges of the picture. The relationship of a strong vertical tree formation against the horizontal rectangle of a boat seen as a perspective angle, and a semicircular form of a little bridge in the distance, provides interesting contrasts of shape that are the essence of successful composition.

You do, however, need to consider the format carefully, whether it is to be viewed within a landscape or portrait presentation. The subject of this sketch is suitable for either format.

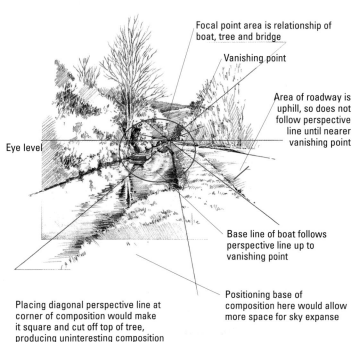

Focal point area is relationship of boat, tree and bridge

Vanishing point

Area of roadway is uphill, so does not follow perspective line until nearer vanishing point

Eye level

Base line of boat follows perspective line up to vanishing point

Positioning base of composition here would allow more space for sky expanse

Placing diagonal perspective line at corner of composition would make it square and cut off top of tree, producing uninteresting composition

Thumbnail sketches

Drawing thumbnail sketches is one of the best ways to plan your compositions. They are quick to produce due to their size – the originals of those shown on this page are about 63 x 88mm (2¹/₂ x 3¹/₂in) – which will enable you to work out areas of contrast, tone, form and movement.

Many beginners do not feel the necessity to avail themselves of this introduction to their final composition. For this reason, the series of sketches here should encourage experimentation with this useful and essential stage.

Combining observation methods

After creating a series of thumbnail sketches, you may find on drawing an enlarged image on another sheet of paper that you are experiencing doubts concerning the accuracy of the perspective. In this case it is a good idea to place a sheet of tracing paper over your drawing and add perspective lines in pencil to establish your accuracy.

You can enlarge your sketch (making a few alterations as necessary) by copying it to fit a larger sheet of paper, or, if more accuracy is required, squaring up. You can even enlarge from your small sketch using a photocopier for convenience and then using tracing paper or the window method (see page 37).

Using the guidelines method illustrated on pages 36–7 also reduces the possibility of problems with perspective.

Image placing
This sketch shows how easy it is to fall into the trap of placing the focal point centrally.

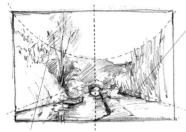

Observer's eye taken into and straight through picture, rather than being encouraged to wander through composition

Note semicircular feel to placing of tree formations

Looking for shapes

More interesting area of sky

Circle and diamond relationship

Suggestion of another path leading into picture

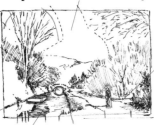

Reflections, shadows and open areas determine visual shapes created

Viewfinder image diagram

Note some of the abstract shapes created within the composition

Adjusting image placing

Void is unsatisfactory central area

Focal point moved off centre

Arrows indicate consideration for direction within composition

Figure introduced to break up empty expanse created by moving bridge

Composition is visually divided – you need to decide if you are happy with this type of development when it occurs

Alternative view
Using a viewfinder concentrates your attention on a particular area, rather than taking in too much of the view at one time

Small area of sky left as simple, light area, contrasting with busy foliage areas

Area treated in a neutral way to rest the eye

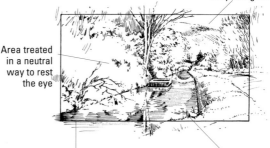

Interesting tonal contrasts placed effectively within mount

Small reflection of sky in contrast to darker areas of water surface

Exercise in Accuracy

This demonstration is an exercise, a set of mark placings designed to improve your observation skills and drawing ability – where to start and in what sequence to move from one area to another as you piece together the image(s) you have chosen to depict. This way of working may be applied to any subject, and it may be helpful to approach the drawing through a series of check points – they refer to this particular picture, but you can adapt the sequence to your own picture.

- Start with the strongest vertical; a vertical line drawn down the side of a dominant form, or a guideline, can be established vertically as a basis from which to work. In the views here, the strongest vertical is down the shadow side of the distant tower.
- Once the line is drawn, think of it as a drop line and extend it below the base of the tower, down into the water. You can then use it to help position other parts of the picture.
- The next guideline is to be drawn along an important horizontal, in this case the obvious waterline.
- To start relating the shapes below the horizontal line, extend two guidelines from either side of the tower downwards, crossing the horizontal line, and start looking for negative shapes and shapes between.
- Negative shapes are the ones we see between objects. I have indicated (right) a negative shape (yellow area) between two vertical poles and a piece of canvas on a gondola. Between the two poles you can see the water beyond.
- A shape between is the shape drawn on the paper that is between some parts of objects and a guideline. Shown here in green, it helps place objects in relation to each other.

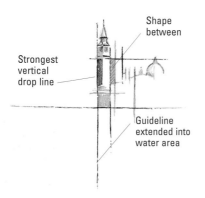

Shape between

Strongest vertical drop line

Guideline extended into water area

Scaffolds

With this method of observation drawing you are erecting a scaffold of structure lines upon which your images may be built. To avoid getting lost among the scaffolding, it is a good idea to tone some areas as solid shapes – in this scene the poles are an obvious choice for this treatment – as well as a few tonal blocks for distant buildings. This will give you points of reference.

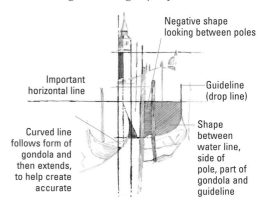

Negative shape looking between poles

Important horizontal line

Guideline (drop line)

Curved line follows form of gondola and then extends, to help create accurate

Shape between water line, side of pole, part of gondola and guideline

Merit points

To encourage enjoyment you can give yourself merit points along the way. On the illustration opposite above I have indicated 'mini merits' and 'merit shapes'. A mini merit is where you recognize a tiny shape between and note it with a view to establishing relationships within your scaffold lines. A merit shape is a larger, more obvious (three-sided) shape, usually with two sides from an object and the third in the form of a guideline.

Contact points

Contact points can be visual – where two objects cross behind or in front of each other visually, although in fact they are some distance apart – or physical, where they do actually touch. I have placed large dots on the illustration opposite above to show some instances. Look along the relevant guideline between these contact points plus other lines that occur in between, to see how the objects relate using the vertical and horizontal scaffold. You now need to train your eye and practise drawing shapes accurately – squares and rectangles mainly, with curved lines crossing them at certain points – and in this way, you can create your own grid to construct a pictorial composition.

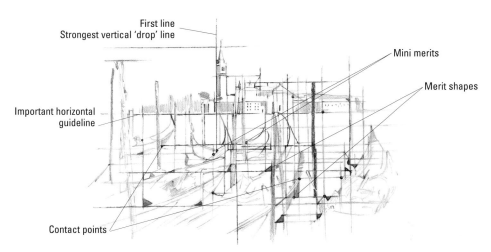

First line
Strongest vertical 'drop' line

Mini merits

Merit shapes

Important horizontal guideline

Contact points

Solving perspective problems

Using guidelines correctly should remove problems with perspective. If every shape and line drawn is in the correct relationship with the others within the basic scaffold, you need only remove the structure lines of the scaffold to have a drawing that works.

Removing the scaffold

Whether placed as part of an accuracy exercise or swiftly positioned to help establish main areas in relation to each other as part of a looser interpretation, guidelines need only be obvious for the initial part of the drawing, where you rely on them for accurately placing the components. If guidelines are drawn lightly, overworking with bolder lines and tones as the drawing progresses will cause them to become absorbed and finally lost by the time the work is complete.

Alternatively, guidelines can be established boldly on layout or copier paper and corrected or altered repeatedly until you are pleased with their placing. Then it is only a matter of tacking your drawing to a window, placing a clean sheet of paper over the top, and taking off (tracing) the main, important areas onto the new sheet of clean paper, omitting the guidelines. The final stage is to develop your drawing in line and tone, using the lightly traced image on a new sheet of paper.

When you have trained your eye and learnt how to depict shapes between accurately, the perspective within your composition will also be accurate.

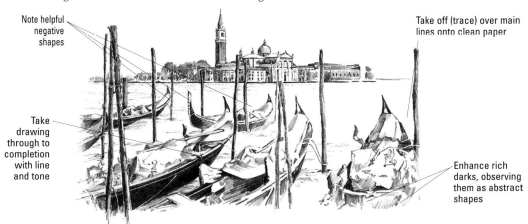

Note helpful negative shapes

Take off (trace) over main lines onto clean paper

Take drawing through to completion with line and tone

Enhance rich darks, observing them as abstract shapes

Editing In and Out

Artist's licence

Creating a pictorial composition is more involved than simply choosing a viewpoint and, using a viewfinder, selecting an area on which to concentrate.

The term 'artist's licence', used literally, means that you can choose to disregard conventions for effect – to the extent that you are free to do as you wish with the content of your pictorial compositions. Alternatively, you can interpret it in another way by adding content or taking objects or areas out of the view, in order to compose a better picture. These pages show examples of editing in and editing out.

Editing in

This tranquil scene provides a pleasing composition, with an interesting building, the pattern of a rotting wooden construction in the foreground and a variety of textures in the relationships of building, foliage areas, sloping ground and water. The two boats add interest in the middle ground, but the foreground is empty.

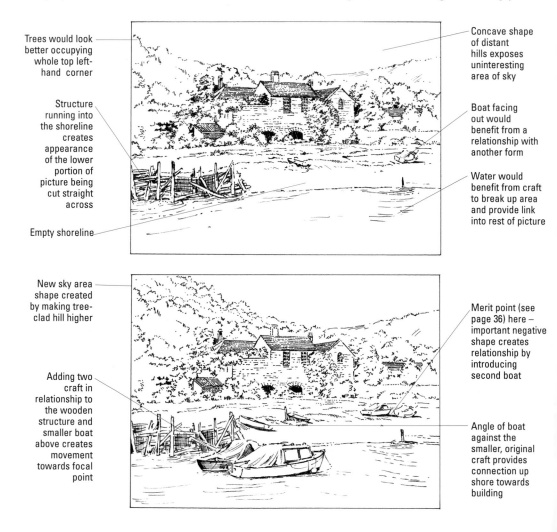

Trees would look better occupying whole top left-hand corner

Structure running into the shoreline creates appearance of the lower portion of picture being cut straight across

Empty shoreline

Concave shape of distant hills exposes uninteresting area of sky

Boat facing out would benefit from a relationship with another form

Water would benefit from craft to break up area and provide link into rest of picture

New sky area shape created by making tree-clad hill higher

Adding two craft in relationship to the wooden structure and smaller boat above creates movement towards focal point

Merit point (see page 36) here – important negative shape creates relationship by introducing second boat

Angle of boat against the smaller, original craft provides connection up shore towards building

Editing out

This more complex angle, looking down upon a row of cottages and featuring a tree-clad hillside with more buildings above, requires a different set of considerations.

Using a viewfinder, as with the scene on page 35, to isolate two or three cottages, may be the answer to this overcrowded landscape. You can, therefore, edit out certain aspects to simplify the view.

This quick pen and ink layout shows positions of all buildings seen in the view

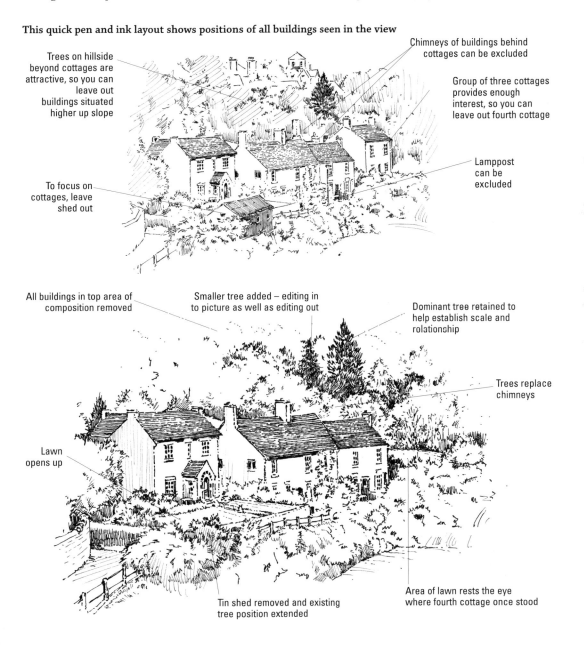

Trees on hillside beyond cottages are attractive, so you can leave out buildings situated higher up slope

Chimneys of buildings behind cottages can be excluded

Group of three cottages provides enough interest, so you can leave out fourth cottage

To focus on cottages, leave shed out

Lamppost can be excluded

All buildings in top area of composition removed

Smaller tree added – editing in to picture as well as editing out

Dominant tree retained to help establish scale and relationship

Trees replace chimneys

Lawn opens up

Tin shed removed and existing tree position extended

Area of lawn rests the eye where fourth cottage once stood

Aerial Perspective

One of the problems often experienced by beginners in landscape paintings is that of avoiding the depiction of aerial perspective in situations where it is not intended. Knowing that a pond is round when viewed from above, they endeavour to show this as much as possible, even when, from the angle they view it when standing on the ground, the shape they actually see is totally different, and features nothing that suggests roundness.

Seen from above

For this reason two different interpretations of aerial perspective are shown here, to illustrate how much (and how little) we are able to see certain objects and features when viewed from above.

Seen from a plane, as below, the countryside shows buildings at a perspective angle that is very similar to those that are observed when standing on a cliff top

and looking down at the roof tops of seaside houses built against the cliff.

Viewing a wide river and skyscrapers from above will give you an idea of extreme distance, with the landscape stretching as far as the eye can see.

Rural patterns

Fields and pastures resemble the appearance of a patchwork quilt, with each area offering different colours, textures and tonal variations, the latter quite often affected by cloud formations. Well-grazed fields often have a mottled appearance, whereas ploughed fields contain linear patterns. Lush green pastures appear as a more uniform rich green. Each area, surrounded by borders of hedge or fence and interspersed with occasional groups of houses, gives the appearance of ordered tranquillity.

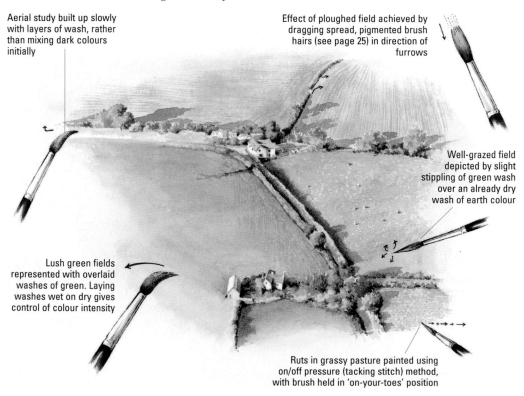

Aerial study built up slowly with layers of wash, rather than mixing dark colours initially

Effect of ploughed field achieved by dragging spread, pigmented brush hairs (see page 25) in direction of furrows

Well-grazed field depicted by slight stippling of green wash over an already dry wash of earth colour

Lush green fields represented with overlaid washes of green. Laying washes wet on dry gives control of colour intensity

Ruts in grassy pasture painted using on/off pressure (tacking stitch) method, with brush held in 'on-your-toes' position

Urban patterns

City and town patterns consist mainly of horizontal and vertical forms arranged in close proximity. Although these may be broken in places by areas of parkland and massed tree formations, the effect often relies upon a wide river to provide an area within the composition that rests the eye. The placing of bridges will help retain unity within the picture, and cloud formations in the sky can be used to soften what may otherwise appear a very angular scene.

For distant areas pencil pressure needs to be as gentle as possible for first strokes to maintain control of intensity

Tower block focal point provides strongest vertical guideline (see page 36), from where horizontal and vertical reference lines relate to rest of composition

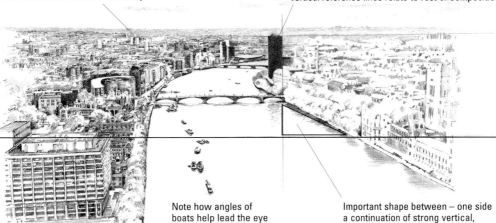

Note how angles of boats help lead the eye into important crossover (unifying) movement, to connect both sides of river up to focal point

Important shape between – one side a continuation of strong vertical, and second giving the riverbank angle – on third side leads the eye to important relationship with prominent building

Close observation, patience and practice help control marks in complex areas

Pencil exercises

To achieve an accurate, controlled line

Place short stroke first, going back over it, working over it again and continuing beyond

Create horizontal line in same way

Series of parallel lines

Place short, continuous application line then others parallel to it and contoured edges

Sharp pencil moved up and down before the main downward line creates darker tone

Leaving gaps

This series of curved edge lines started as continuously placed parallels. A gap was left and the lines were applied with shorter strokes to increase the gap size.

Complex patterns

More complex shapes suggest walls, windows, bridges and so on

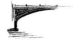

Working Outdoors

Using photographs

The best way to use photographs successfully is alongside, and as a back-up for, sketchbook work. There is a spontaneity in drawing from life that is lost in a direct copy from a photograph, yet photographic reference can be a great support for your artwork. It captures the mood of the moment, immobilizes movement (especially helpful with water) to allow you to analyse shapes and forms, and gives you the opportunity to capture a scene quickly if your time is short or the weather conditions doubtful. It also enables you to compose the scene through the lens and swiftly record it from a variety of viewpoints. Written notes alongside your drawings can then be made in haste or at leisure, and colour notes all form a reference library that is unique to you.

Sketchbook work

Draw with sincerity – with a deep desire to put on to paper not just what you think you see, but what you feel about what you see. It is not as difficult as it sounds.

When you start the first marks, do not be concerned about how they will look on paper. Start by observing the subject – really look at it. Absorb it, both the subject(s) and the surroundings. Note relationships, perspective, scale, textures and so on. This is your 'thinking time', and is an invaluable part of any work of art.

Ask yourself why you have chosen this subject in the first place – you will be spending your valuable time working to portray it on paper, so what attracts you to it? This will help you understand where to put emphasis in your portrayal of the view, object(s) or whatever, and by doing this you will be starting to make it unique to you.

Using photographs and sketchbooks

A photograph, being a record of what is in front of you at the time you take the picture, is just that – a record. A sketch, or more detailed drawing, however, may contain areas where you have decided to look and record far more closely – or areas that you have chosen to simplify or even leave entirely untouched. Wherever possible, if you intend to work from your sketches at a later date, do take a series of photographs to enhance your memory, but try not to rely solely upon these.

Fill your sketchbook in every conceivable way, with small studies, larger impressions, experimental marks, detailed observations, quick movements using a variety of tools – anything. It will become the way you see and feel about your surroundings and will influence your finished artwork in an exciting and unique way.

Learn your lines

In a 'working' sketch – one from which you will later work – a pencil can be used freely, with wandering lines travelling loosely over the paper with light pressure, heavier pressure for shadow lines, diagonally applied lines to suggest tonal blocks, and so on.

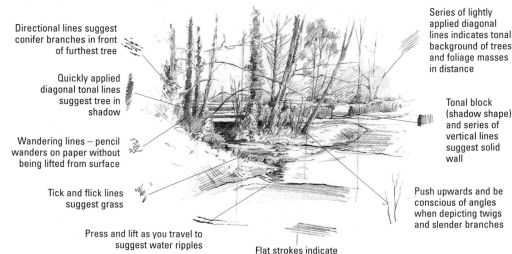

Directional lines suggest conifer branches in front of furthest tree

Quickly applied diagonal tonal lines suggest tree in shadow

Wandering lines – pencil wanders on paper without being lifted from surface

Tick and flick lines suggest grass

Press and lift as you travel to suggest water ripples

Series of lightly applied diagonal lines indicates tonal background of trees and foliage masses in distance

Tonal block (shadow shape) and series of vertical lines suggest solid wall

Push upwards and be conscious of angles when depicting twigs and slender branches

Flat strokes indicate surface of ground

The photograph as reference

This more detailed sketch demonstrates how the back-up photograph – taken at the same time as the working sketch opposite was made – is referred to at the same time as the initial sketch to develop a pictorial composition from the scene. The artist composes a picture, which is a very different process from copying a photograph.

The watercolour interpretation of this second sketch demonstrates how the first tonal washes were applied and, in the same areas, progresses to adding richer hues and tones.

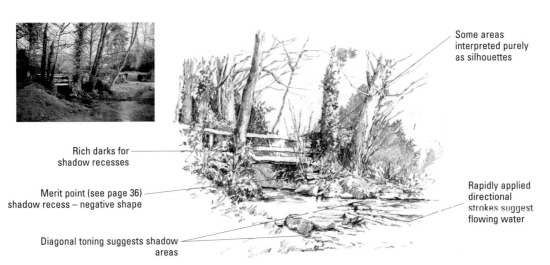

Some areas interpreted purely as silhouettes

Rich darks for shadow recesses

Merit point (see page 36) shadow recess – negative shape

Diagonal toning suggests shadow areas

Rapidly applied directional strokes suggest flowing water

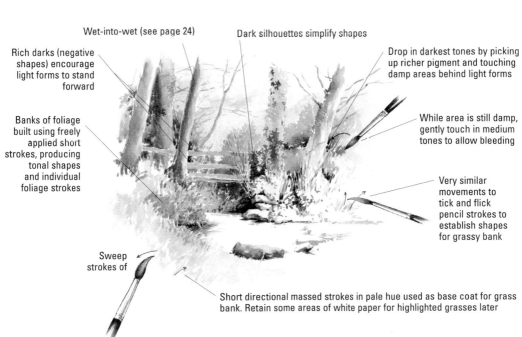

Wet-into-wet (see page 24)

Dark silhouettes simplify shapes

Rich darks (negative shapes) encourage light forms to stand forward

Drop in darkest tones by picking up richer pigment and touching damp areas behind light forms

Banks of foliage built using freely applied short strokes, producing tonal shapes and individual foliage strokes

While area is still damp, gently touch in medium tones to allow bleeding

Very similar movements to tick and flick pencil strokes to establish shapes for grassy bank

Sweep strokes of

Short directional massed strokes in pale hue used as base coat for grass bank. Retain some areas of white paper for highlighted grasses later

SKIES AND CLOUDS

Drawing Exercises

The direction in which you apply any pencil stroke requires careful consideration. Successful images often require a certain amount of hand, arm and body movement – especially when directing contours and angles.

The exercises on these pages are designed to encourage the flexibility of your wrist, and it is helpful to practise them using as many directions as possible in order to loosen yourself up.

4B pencil

Contoured tonal blocks

Create a curve using individual strokes

Mass strokes gently to form a contoured shape

Practise movement of hand and arm and analyse directions with firm strokes

Open strokes and give thought to their application

Close strokes and practise contoured shapes in other directions

Choosing Contour Marks

Contour lines, whether broken or continuous, need consistency if they are to achieve accurate representation. The marks you make may be gently toned or firmly placed, but you do need to be in control of them and be aware beforehand of your intended impression.

Practice exercises, approaching the depiction of contour marks from different directions, are essential for developing personal skills.

Long and short contour strokes with even pressure

Contour stroke lines achieved with a series of dashes and on/off pressure

Toned contour shape and light tone overlay using firm pressure with light pressure for overlay

Work outwards from dark-toned central block

Introduce tone within contour shape

Leave light edges to pale-toned contour shapes

Pen and ink

Stippling, although time-consuming, can be very rewarding when a stippled image is complete and viewed as a whole. With the pen held vertically against the paper, place each pressure dot individually and clearly. Do not be tempted to rush, or you will spoil the effect. If you tire during the process, just place your work to one side and return to it later.

Stippling

Place a series of dots holding pen vertical to paper

Mass dots in areas where more tone is required

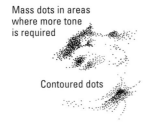

Contoured dots

Dots into dashes

Place a series of dot/dash contour lines

Curve contour 'lines' into recognizable shapes

Watercolour pencils

Monochrome images, which rely on tonal application and variation, are very effective for depicting skies, and are easily achieved by the use of varied pressure.

The important thing to remember is that you need to gain an understanding of the subject in order to know where to place pencil pressure and where to leave white paper.

Working from the negative shape or sky seen between cloud formations

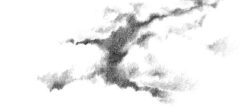

Gentle toning defines edge of cloud

Arrows indicate direction of strokes to work out into contoured edges of clouds

Retain areas of white paper

Medium charcoal pencil

A medium charcoal pencil is useful for quick studies of clouds, giving more depth of tone than a light pencil and being better for delicate areas than a dark one.

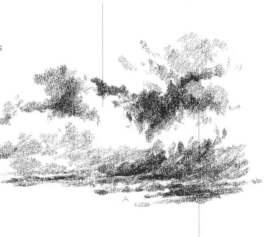

Diagonally applied strokes for sky

Single stroke with on/off pressure – strokes horizontally applied to create effect of receding clouds

Curved strokes on shadow sides of clouds

Watercolour exercises

In the same way that you need to consider contours in ink and pencils, it is by depicting contours with the sweep of a brushstroke that cloud images appear. This is an occasion when the concept, 'It is not just what you paint in that is important, but also the areas you choose to leave out!' should be your guiding principle.

These exercises are intended to help you understand how to observe and depict cloud formations before treating them in a style that is personal to you.

Three-colour mix

Practice movements

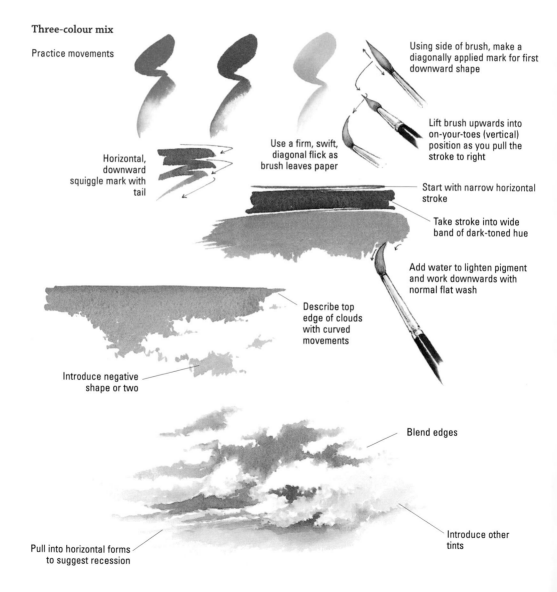

Using side of brush, make a diagonally applied mark for first downward shape

Lift brush upwards into on-your-toes (vertical) position as you pull the stroke to right

Use a firm, swift, diagonal flick as brush leaves paper

Horizontal, downward squiggle mark with tail

Start with narrow horizontal stroke

Take stroke into wide band of dark-toned hue

Add water to lighten pigment and work downwards with normal flat wash

Describe top edge of clouds with curved movements

Introduce negative shape or two

Blend edges

Introduce other tints

Pull into horizontal forms to suggest recession

Three different approaches

On this page are three methods for you to experiment with as you familiarize yourself with this fascinating subject. Using the same colour mix as on the opposite page, paint in monochrome for these exercises.

Wet-into-wet

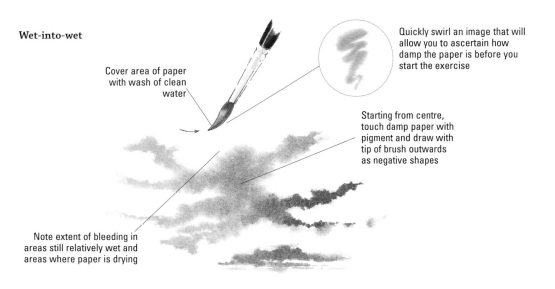

Cover area of paper with wash of clean water

Quickly swirl an image that will allow you to ascertain how damp the paper is before you start the exercise

Starting from centre, touch damp paper with pigment and draw with tip of brush outwards as negative shapes

Note extent of bleeding in areas still relatively wet and areas where paper is drying

Wet on dry

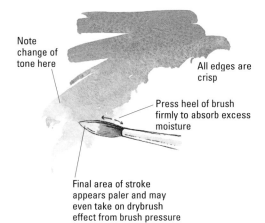

Note change of tone here

All edges are crisp

Press heel of brush firmly to absorb excess moisture

Final area of stroke appears paler and may even take on drybrush effect from brush pressure

Fast and free

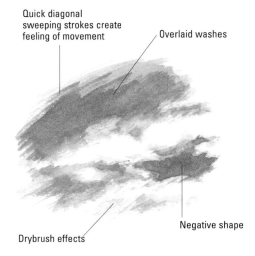

Quick diagonal sweeping strokes create feeling of movement

Overlaid washes

Negative shape

Drybrush effects

Problems

Cloud Formations

Cloud formations are so diverse, and the colours found within skies are so varied that your choice of representation is limitless. Skies portray moods and atmospheres with an exciting range of tonal variations. They can be tranquil or full of movement, and it can help to consider their depiction through directional strokes – whether in pencil or brush – with cloud contours against a flat area of blue.

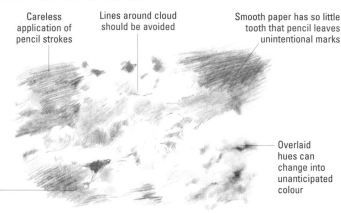

Careless application of pencil strokes

Lines around cloud should be avoided

Smooth paper has so little tooth that pencil leaves unintentional marks

Overlaid hues can change into unanticipated colour

Application of different areas of colour suggests lack of understanding of cloud formations

Tonal drawing

Start with a straightforward tonal drawing, choosing a sky that gives the opportunity to shade from the darkest to the lightest tones (white paper) with the use of subtle blending of one tone into, and against, the other.

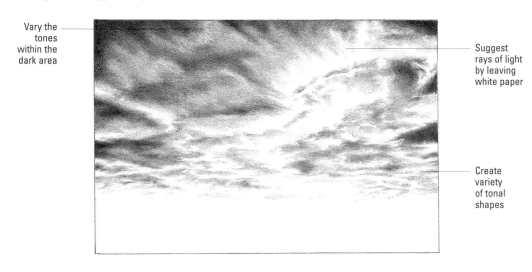

Vary the tones within the dark area

Suggest rays of light by leaving white paper

Create variety of tonal shapes

Trying Your Tones

Starting with diagonal strokes, practise gentle blending, then use crosshatching and strokes that follow the contours of clouds.

2B pencil

Start with simple diagonal stroke tonal block

Eraser taken through pencilwork to remove mistakes easily

Crosshatching

Contour strokes

Solutions

Remember that clouds float in front of the blue beyond. On this illustration, made with Derwent Studio pencils, I placed the blue negative shapes in position first, before contouring the clouds with shadow areas and leaving the lightest areas in front of everything else.

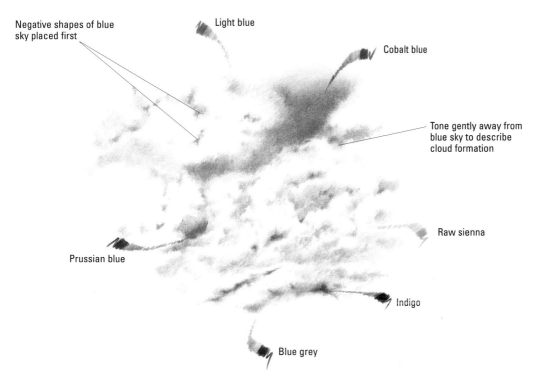

Negative shapes of blue sky placed first

Light blue

Cobalt blue

Tone gently away from blue sky to describe cloud formation

Raw sienna

Prussian blue

Indigo

Blue grey

Colours

Select your colours and use each in turn as a practice exercise in order to familiarize yourself with the pencil and the response of the paper to its application, as you vary your pressure upon the coloured strip. This is an excellent opportunity for you to loosen up and create tonal contours and masses with a variety of strokes.

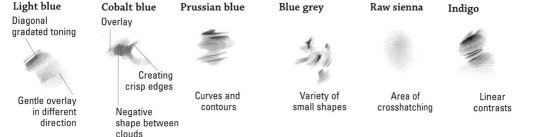

Light blue
Diagonal gradated toning

Gentle overlay in different direction

Cobalt blue
Overlay

Creating crisp edges

Negative shape between clouds

Prussian blue

Curves and contours

Blue grey

Variety of small shapes

Raw sienna

Area of crosshatching

Indigo

Linear contrasts

Problems

Mood and Atmosphere

Skies have many changes of mood; I have illustrated two contrasting atmospheres on this spread to help you understand different treatments of the subject. They both rely on the effect of light. On this page you can see how a tranquil sky, viewed at the end of the day, shows strong light behind the horizon, adding a warm glow. On the opposite page the cold light of a stormy sky gives the impression of movement and turbulence.

Clouds outlined

Not enough thought and control given to wet-into-wet method

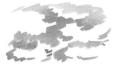

Unconsidered approach

Thoughts on paper

One of the problems faced by beginners is how to avoid giving a completely flat impression of a sky when cloud formations should be suggesting a third dimension.

This division of foreground, middle ground and distance shows the effect created when the largest clouds appear directly above in the foreground, and similar formations appear to recede as they pass into the distance.

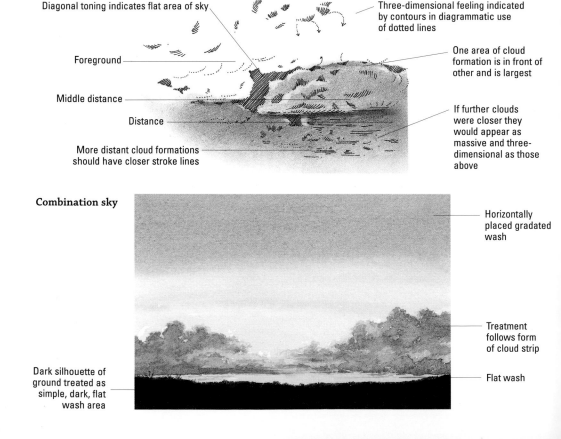

Diagonal toning indicates flat area of sky

Three-dimensional feeling indicated by contours in diagrammatic use of dotted lines

Foreground

One area of cloud formation is in front of other and is largest

Middle distance

Distance

If further clouds were closer they would appear as massive and three-dimensional as those above

More distant cloud formations should have closer stroke lines

Combination sky

Horizontally placed gradated wash

Treatment follows form of cloud strip

Dark silhouette of ground treated as simple, dark, flat wash area

Flat wash

In order to create a strong sense of atmosphere, you need to introduce stronger contrasts, both of texture and of tone/colour. The smooth washes in the negative shapes of a darkened sky make a striking contrast with the bright, light edges of fluffy clouds as they move swiftly across the dramatic sky.

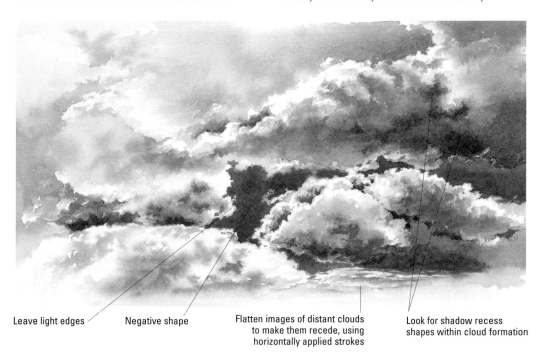

Leave light edges Negative shape Flatten images of distant clouds to make them recede, using horizontally applied strokes Look for shadow recess shapes within cloud formation

Gradation

Practise graded washes, both for colour and tonal variation. The effect of clean water added at the base can create impressions of filtered light in the sky.

Practice exercises

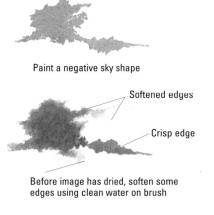

Paint a negative sky shape

Gradated wash

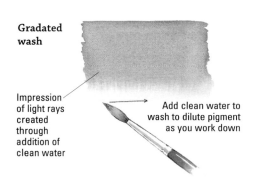

Impression of light rays created through addition of clean water

Add clean water to wash to dilute pigment as you work down

Softened edges

Crisp edge

Before image has dried, soften some edges using clean water on brush

Problems

Tighter Approach

Cloud formations lend themselves to depiction in paint, pastel, charcoal, pencil and a loose application in pen and ink, but when considering a tighter, more detailed approach using the latter, problems can occur. Working with pen and ink, various methods can be practised as warm-up exercises, where it is not only the type of pen and the way it is used that is important, but also the paper upon which we choose to work. Some methods, where the ink is lightly grazed across the surface in order to achieve certain effects, may require a slightly textured surface – a paper that has tooth. This method requires practice to be successful, however.

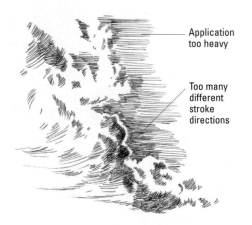

Application too heavy

Too many different stroke directions

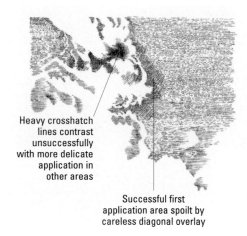

Heavy crosshatch lines contrast unsuccessfully with more delicate application in other areas

Successful first application area spoilt by careless diagonal overlay

Let your strokes follow the form you see – whether it be horizontal application to suggest flat sky areas or curved strokes following the forms of clouds. Practise contoured lines and on/off pressure parallel lines, as well as crosshatching, on different paper surfaces to find out what works best for you.

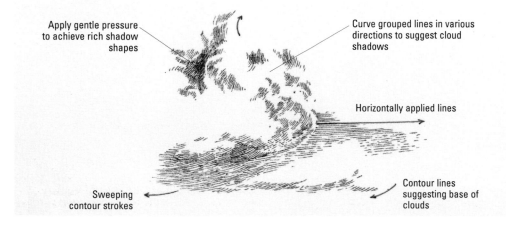

Apply gentle pressure to achieve rich shadow shapes

Curve grouped lines in various directions to suggest cloud shadows

Horizontally applied lines

Sweeping contour strokes

Contour lines suggesting base of clouds

Solutions

Artist's pen

Contoured crosshatch

Crosshatch

Solid pigment

Contour

Basic vertical dot/dash line

Lift pen from paper while continuing movement and before reapplying to complete stroke

Graze surface for effect

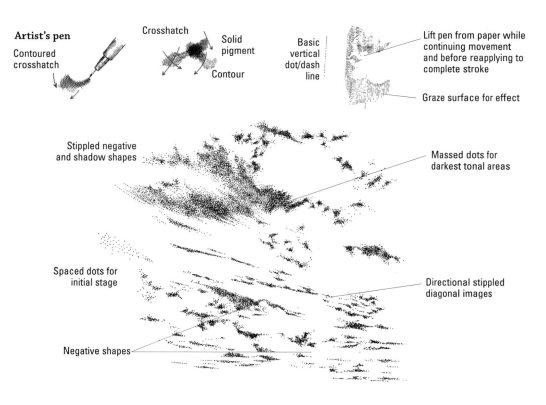

Stippled negative and shadow shapes

Massed dots for darkest tonal areas

Spaced dots for initial stage

Directional stippled diagonal images

Negative shapes

Formations in the sky
Five applications

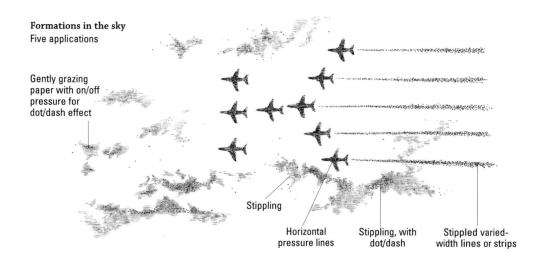

Gently grazing paper with on/off pressure for dot/dash effect

Stippling

Horizontal pressure lines

Stippling, with dot/dash

Stippled varied-width lines or strips

Demonstration

Mixed Sky

A mixed sky of cumulus and cirrus clouds is more interesting to paint when viewed at the end of the day, when there may be brilliant colours and strong tonal contrasts. The foreground silhouettes of trees upon a dark base frame the activity above, and pastels are an ideal medium for this subject.

Planning the composition

If you look through a viewfinder you can position the focal point or point of interest in such a way as to lead the eye into your picture. In the two preliminary sketches, the annotations explain why the sketch below right was chosen as a base from which to work.

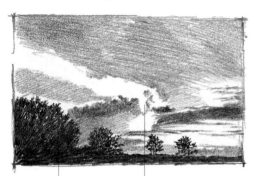

Uninteresting large tree silhouette takes up too much foreground

Focal point, main cloud formation, is too central

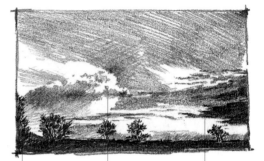

Large tree gives strength of tone to frame part of foreground

Focal point, main cloud formation, relates to trees in foreground

Shadow clouds help guide eye into picture

Practising Strokes

I keep a supply of old watercolour paper offcuts to use for testing colours or techniques. One of these offcuts was used for practising suitable strokes for the demonstration on these pages. It is a good idea to think your way into your proposed work in monochrome,

and this exercise in charcoal can be regarded as a warm-up. I used a cotton-wool bud to blend the charcoal in a similar way to that used in the pastel painting opposite.

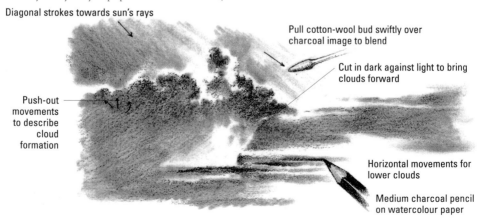

Diagonal strokes towards sun's rays

Pull cotton-wool bud swiftly over charcoal image to blend

Cut in dark against light to bring clouds forward

Push-out movements to describe cloud formation

Horizontal movements for lower clouds

Medium charcoal pencil on watercolour paper

Pastel study

After consideration, I decided to change the shape slightly from my original sketch by elongating the landscape format. As you can see this has the effect of enhancing the horizontal clouds, enabling them to contrast strongly with the main cloud formation. The pale tint of the pastel board could also be incorporated within the painting if necessary.

Diagonal application of blue and white pastel sticks into yellow

Curved, push-out movements to describe clouds

White pastel pencil detail

Detail drawing in pastel pencil defines narrow clouds over horizontal strokes of pastel sticks

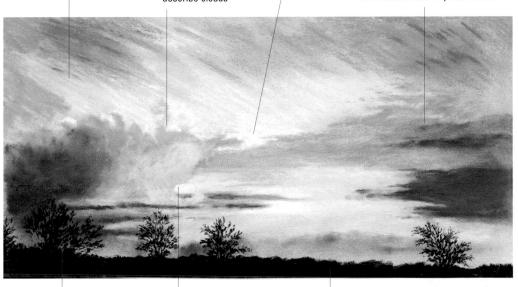

Sharp black pastel pencil depicts delicate tracery of foreground tree silhouettes

Cut in white sky against yellow cloud

Solid block of indigo pastel stick

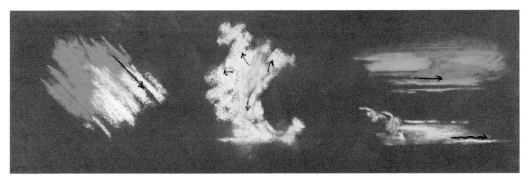

Diagonally applied pastel sticks, moving strokes towards the sun's rays

Strong pressure on pastel stick follows the form of the cloud formation

Horizontal pastel pencil strokes using delicate lines

WATER

Drawing exercises

These pencil exercise strokes are applied in different ways, using various angles of the pencil. Those on this page are basic marks, made with a soft, 6B pencil, while those opposite develop the basics and use a variety of mediums in order to produce different effects.

Side-to-side varied-pressure strokes

Wide edge of pencil Narrow edge of pencil

Tonal block **Slurp stroke**

Angled on/off-pressure zigzag strokes

Drop and splash

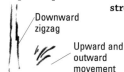

Downward zigzag

Upward and outward movement

Combination of strokes

Combination of strokes and pressures

Squiggles

Swiftly applied in a downward movement

Combinations

Varied pressure shapes (strokes) – dots and dashes

For this line, some strokes passed back over themselves before continuing, to increase tone

Choosing Paper

The drawing paper used for the majority of the pencil strokes has a surface that, while allowing some rich dark tones to be created, also produces a strong, textured effect when flat areas of tone are applied. You can reduce this by using a smoother surface, for example Bristol board. It is a good idea to experiment with different surfaces in order to discover which surfaces best suit your own particular style and the effects you want to achieve.

Using paper textures

Swift, continuous, side-and-back shaded area enhances texture of paper

Dot-and-dash lines

Single dot-and-dash line

For less texture on same paper surface, gently draw a series of lines

Play with permutations

Using Bristol board

For less texture you can also use a smoother-surface paper, which also gives the chance to create different effects.

Artists' pencils

This is an ideal medium for creating contours and curves in your drawing, suitable for moving water.

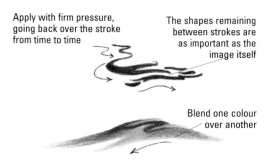

Apply with firm pressure, going back over the stroke from time to time

The shapes remaining between strokes are as important as the image itself

Blend one colour over another

When depicting water, always be conscious of movement

Watersoluble ball pen

Used dry and then wetted with clean water and a brush, this is an ideal medium for creating rich contrasts.

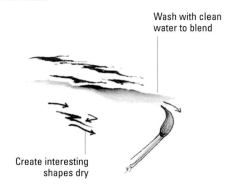

Wash with clean water to blend

Create interesting shapes dry

Watercolour pencils

In this exercise, be conscious of the difference between rich, dark reflections on the water's surface and the paler shadows created by undulating ripples.

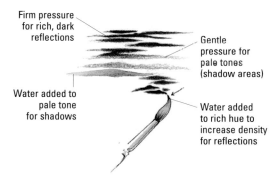

Firm pressure for rich, dark reflections

Gentle pressure for pale tones (shadow areas)

Water added to pale tone for shadows

Water added to rich hue to increase density for reflections

Used dry and then wet as with a watersoluble ball pen (see above right), watercolour (or watersoluble) pencils can be used for distant reflections.

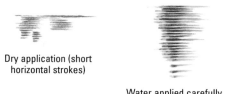

Dry application (short horizontal strokes)

Water applied carefully in horizontal strokes

Watersoluble graphite pencil

After making the basic drawing, use a brush and clean water for a monochrome effect that is particularly useful for falling water.

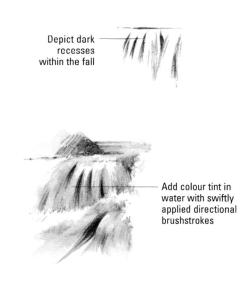

Depict dark recesses within the fall

Add colour tint in water with swiftly applied directional brushstrokes

Watercolour exercises

Like the pencil exercises on the previous spread, these watercolour exercise strokes are applied in different ways and with different angles of the brush.

Not only do you need to experiment with different pressures and angles of approach as you master these basic strokes, but it is also an idea to vary the surfaces upon which you work. Three different papers were used to demonstrate these brushstroke exercises – Rough, Cold-Pressed (NOT) and Bockingford.

Slurp stroke

This stroke is applied with a loose wrist movement in the direction of the arrows, holding the tool in a normal writing position.

For the side-to-side strokes of varied pressure, concentrate on keeping your brush/pencil stroke direction horizontal as you touch the paper, press as you travel to expand the stroke, and gently lift off, all in a continuous, smooth movement.

Arrows show direction of brush movement

Stroke applied at angle to suggest it is lapping against hull of boat

Each stroke may vary in thickness at different points

Side-to-side strokes of varied pressure

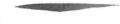

Wide and narrow in one stroke

Drop and splash

The quickly applied downward zigzag of the drop and splash stroke is erratic in movement, using uneven pressure on the strokes. You may also travel back over an existing mark/shape to make the image stronger.

Quickly applied uneven zigzag strokes

Be swift and bold in your movement down

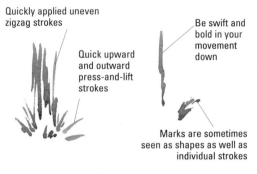

Quick upward and outward press-and-lift strokes

Marks are sometimes seen as shapes as well as individual strokes

Mixture of on/off pressure ripple strokes and zigzags

Applied at angle with extreme variations of pressure

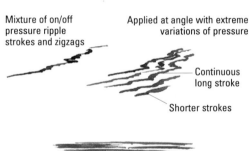

Continuous long stroke

Shorter strokes

Rapid sideways strokes, some single, others turning back on themselves

Apply in medium-to-light tones and with care and consideration for the areas of white paper that remain

Before paint has dried, drop in darker pigment where reflections from images will appear

Ocean waves
Similar to the slurp stroke, this one is longer and it produces a more solid effect.

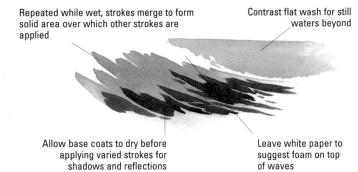

Repeated while wet, strokes merge to form solid area over which other strokes are applied

Contrast flat wash for still waters beyond

Allow base coats to dry before applying varied strokes for shadows and reflections

Leave white paper to suggest foam on top of waves

Flat wash
A flat wash will give you the impression of a glass-like surface on a still lake.

Sparkling water surface
To achieve the effect of light dancing on water, leave some areas of untouched paper among the continuous on/off dot-and-dash lines.

Allow pigment to merge in places

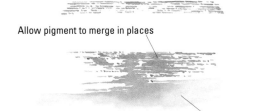

Experiment by washing clean water in and blending out

Watercolour ripples

Basic ripple (one-stroke) shapes

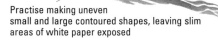

Practise making uneven small and large contoured shapes, leaving slim areas of white paper exposed

Combination exercise
These exercises show how you can build up these techniques and use them in combination with each other to create different effects.

Varied pressure/stroke line

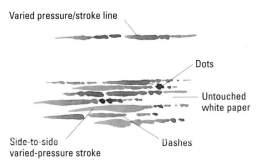

Dots

Untouched white paper

Side-to-side varied-pressure stroke

Dashes

Squiggles
You can use squiggles to depict reflections in still or moving water, varying the pressure on the brush to give the effect of perspective and distance.

Rapid, downward squiggle stroke

Short, brush-shaped horizontal strokes

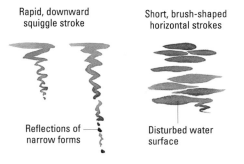

Reflections of narrow forms

Disturbed water surface

Problems

Canal Scene

Creating contours using a dry medium such as coloured pencils – where varied pressure enhances tonal contrasts – will give you the opportunity to compare the treatment of quite different surfaces.

The solid structures of buildings are so completely different from the elements of water (a colourless, clear liquid), yet in juxtaposition each affects the other. It is possible to see light that has been shed upon water mirrored in the walls adjacent to buildings, and even more obvious are the reflections from buildings upon the surface of the water.

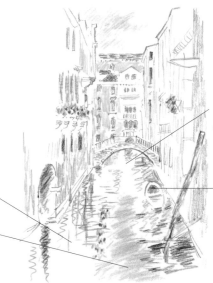

Important area of tiny ripples has been ignored

Angle of boat does not relate to water

Too much white paper in densest area of reflection

Intensity of sky reflection does not relate in treatment to other areas

Monochrome pencil study

Compare tonal values by using a monochrome medium, for example a soft drawing pencil, where you may almost 'paint' with the tool by exerting a variety of pressures as it is applied.

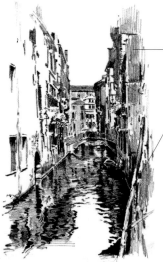

Swift up-and-down strokes suggest sheer sides of buildings

Darkest darks against lightest lights to achieve maximum contrast

Colour notes

Making small (thumbnail) colour sketches of different angles and scenes will help you decide upon a pleasing composition. Practise with a limited palette of colours to prepare for the final interpretation.

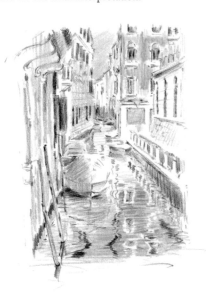

Solutions

The reflections of sturdy structures above disturbed water will appear as an assortment of contours and curves. For the early stages of learning, this static, 'caught-in-time' appearance can best be studied by using photographic references to help gain the understanding that will develop your confidence in drawing.

Main tonal blocks indicated lightly in pencil

Guidelines establish relationship of buildings

Overlay colours to achieve rich shadow areas

Basic reflection shapes established with side-to-side swirls and tonal blocks of burnt umber

Unified with overlay of green earth hue

Colour palette

Burnt umber

Darkest tone

Basic ripple shape

Spruce green

Spruce green over burnt umber

Narrow reflection

Green earth

Green earth over spruce green

Wide reflection

Ash blue over green earth

Sunset gold

Rust

Juniper green

May green

Geranium lake

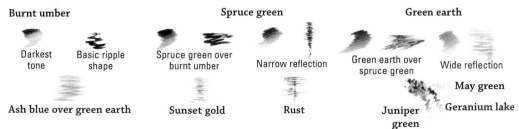

Problems

Harbour

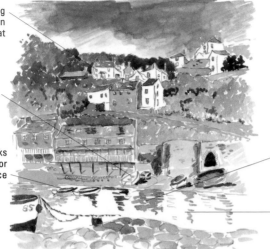

Wrong perspective in square format

Boat inaccurately drawn

Ripple marks too large for distance

Should have been left as white area

Ripple marks and reflections don't match

The effect of ripples upon the surface of water in a sheltered harbour can appear very similar to that of ripples upon the surface of an inland river. Both are affected by buildings and boats on or near the surface, and it is important to be aware of the positions of light areas (for example the hulls of white or light-coloured craft/buildings) as well as the necessity for rich dark shapes.

Monochrome study
Working in monochrome is very helpful in order to analyse tonal variations, but the addition of limited colour provides more overall interest.

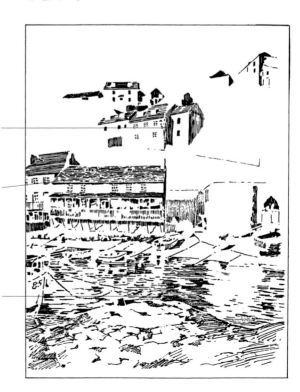

Downward movement of brush for vertical sides

Side-to-side movement for roof

Side-to-side movement for ripples on water

This painting demonstrates how the effect of colour can be reduced by using more neutral hues. For the reflections in the surface of the water, the majority of ripple marks were depicted with a neutral hue, made by mixing burnt umber and French ultramarine; different strengths of the mix produced variations.

L-shaped mount indicates effect of crisp edges

As scale of boats is small, white paper has been retained for lightest areas. White paper also used to indicate highlights on water surface

Images blended off at edges

Light edge to post ensures shape of shadow side is not lost against dark reflection in water

Rich darks reflect shadow areas

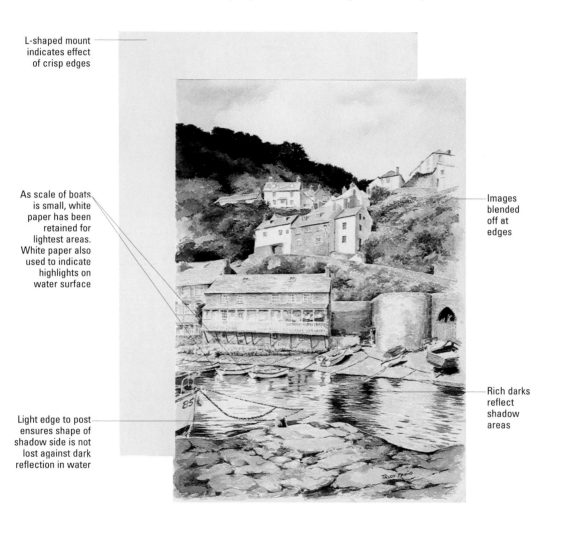

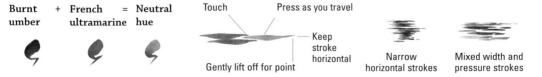

Burnt umber + French ultramarine = Neutral hue

Touch — Press as you travel

Keep stroke horizontal

Gently lift off for point

Narrow horizontal strokes

Mixed width and pressure strokes

Problems

Boat on the River

Whether you depict a large boat travelling sedately along a stretch of river or a small yacht ploughing through choppy water, it is the effect of the ripples that tells the story. Ripples in the wake of any boat are influenced by the weight of the craft, its speed of propulsion and the width of the river, as well as the weather conditions. When depicting these effects, be aware of the importance of horizontal lines as well as the direction of movement within the turbulent areas.

Scale of people and boat incorrect

Green too bright

Shapes created by ripples not observed correctly

Too many random lines drawn without thought for creating distance

Pencil study
This quick sketch uses guidelines to determine the angle of the yacht to the water, and to set the dimensions and proportions accurately.

Using vertical and horizontal guidelines against curve of sail creates small shape between

Important guidelines

Larger shapes between curve of sail and guidelines

Tiny shape between establishes angle of boat

Abstract shape drawn accurately establishes angle of sails

Solutions

I depicted the erratic movement of a small yacht on a narrow waterway using watersoluble graphite and watercolour pencils. Loose-tinted drawing achieves the sense of movement of a small craft on water.

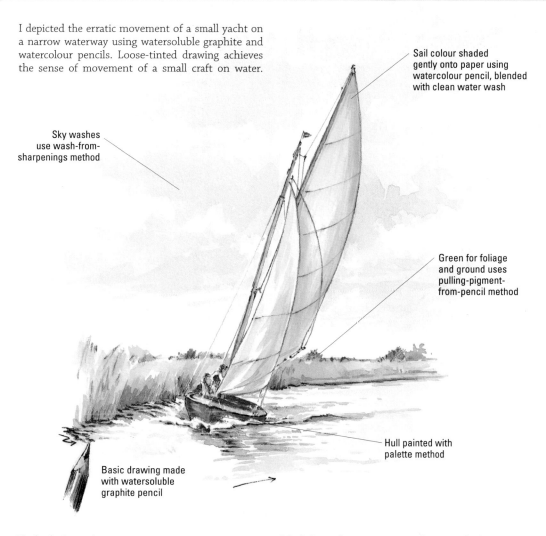

Sail colour shaded gently onto paper using watercolour pencil, blended with clean water wash

Sky washes use wash-from-sharpenings method

Green for foliage and ground uses pulling-pigment-from-pencil method

Hull painted with palette method

Basic drawing made with watersoluble graphite pencil

Methods for yacht

Watersoluble graphite pencil

Erratically drawn directional lines

Pulling pigment from pencil

Flick pigment from pencil down into reservoir to create pigmented water

Use wet brush

Start with reservoir of clean water

Wash from sharpenings

Sharpen pencil into dry, clean palette

Add clean water to create pigmented liquid

Palette method

Create pat of hue by shading area with watercolour pencil

Touch wet brush onto pigment and use as watercolour paint in pan

Demonstration

Waterfall

Whether portraying a large, spectacular waterfall cascading over a cliff, or the smaller variety tumbling over and through rocks and boulders, an artist is faced with the challenge of expressing directional movement when tackling this subject.

This is best analysed and understood by observing less hectic falls, and in this demonstration I have isolated various aspects for the artist's consideration. The drawing opposite was made using watersoluble graphite pencil and watercolour.

Sketching from life *(below)*
When sketching from life prior to developing a watercolour painting, using watersoluble graphite is helpful as the same medium can also be used with watercolour in the final work.

Diagrammatic sketch
After the spontaneity of initial sketches, closer observation, with more controlled drawing, reveals the structure and direction of movement within the composition.

In this diagrammatic representation a little extra width has been added to some areas of water. The superimposed arrows show my thoughts on paper with regard to the directional brushstrokes I will use to depict the rush of water.

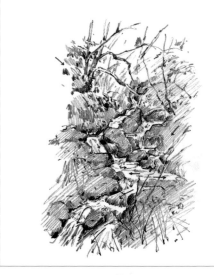

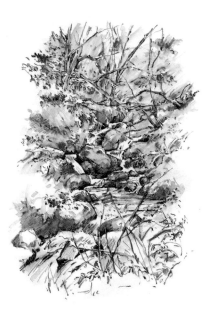

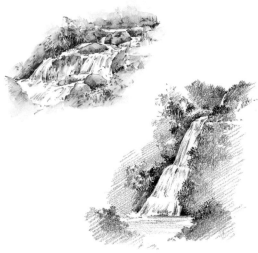

Planning the composition *(right)*
Consider the format for your composition, whether portrait – where water tumbles vertically – or landscape, where you may also introduce horizontal pooling and placement of rocks and boulders.

First stage *(right)*

I used smooth drawing paper for the sketches and studies shown opposite, but switched to Saunders Waterford Cold-Pressed (NOT) 300gsm (140lb) paper for the painting, as it suited both the pencil and watercolour.

Developing the painting *(below)*

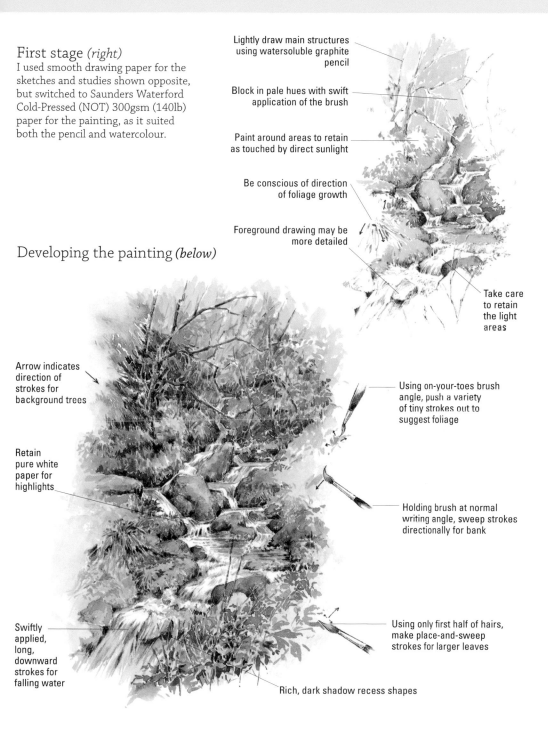

Lightly draw main structures using watersoluble graphite pencil

Block in pale hues with swift application of the brush

Paint around areas to retain as touched by direct sunlight

Be conscious of direction of foliage growth

Foreground drawing may be more detailed

Take care to retain the light areas

Arrow indicates direction of strokes for background trees

Retain pure white paper for highlights

Swiftly applied, long, downward strokes for falling water

Using on-your-toes brush angle, push a variety of tiny strokes out to suggest foliage

Holding brush at normal writing angle, sweep strokes directionally for bank

Using only first half of hairs, make place-and-sweep strokes for larger leaves

Rich, dark shadow recess shapes

MOUNTAINS AND HILLS

Drawing exercises

These strokes demonstrate how to achieve contrasts of rough, jagged movements and smooth, gradated tone. For an aggressive use of tone to suggest hard, uncompromising shapes, lines of a similar nature can be introduced. Smoothly applied, gentle gradated toning requires more care and a sympathetic approach.

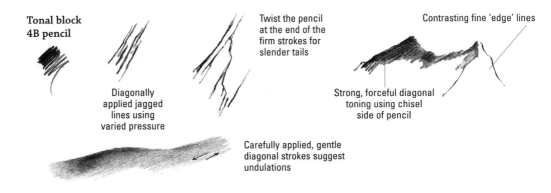

Tonal block 4B pencil

Diagonally applied jagged lines using varied pressure

Twist the pencil at the end of the firm strokes for slender tails

Carefully applied, gentle diagonal strokes suggest undulations

Contrasting fine 'edge' lines

Strong, forceful diagonal toning using chisel side of pencil

Choosing Pressures

The amount of pressure placed upon your pencil when making a variety of strokes needs careful consideration. To avoid areas of pale toning appearing too dark (for example when depicting distance) and areas with strong contrasts of dark against light (white) appearing too grey (foreground images in strong light), practise the different pressures in advance. Increase the pressure upon your pencil to the maximum without breaking the lead, and then decrease it to the minimum, to just graze the paper's surface and encourage the pale tone and white paper to blend imperceptibly into each other.

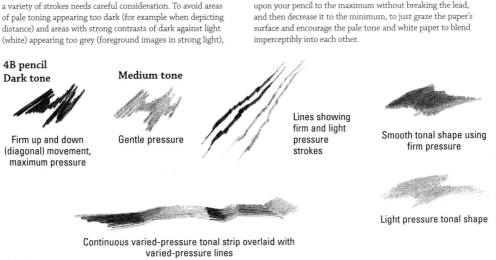

4B pencil Dark tone

Medium tone

Firm up and down (diagonal) movement, maximum pressure

Gentle pressure

Lines showing firm and light pressure strokes

Smooth tonal shape using firm pressure

Light pressure tonal shape

Continuous varied-pressure tonal strip overlaid with varied-pressure lines

Pen and ink

The clarity of marks made with pen and ink offers opportunities for varied strokes to work effectively together – for example, combining straight and curved parallel lines with dots, dashes and solid tonal (block) shapes.

From line into tonal shape

From line into dots

Varied pressure and width lines

Lines depicting grass and rocks

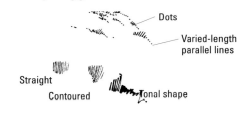

Dots

Varied-length parallel lines

Straight

Contoured

Tonal shape

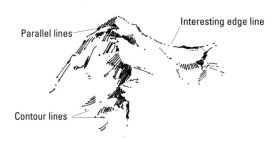

Parallel lines

Interesting edge line

Contour lines

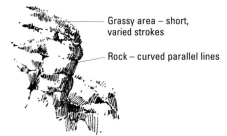

Grassy area – short, varied strokes

Rock – curved parallel lines

Watercolour pencils

Watercolour pencils are very effective when used dry on different paper surfaces. Here, they have been used on a heavy cartridge paper, where they produce a soft effect.

Movement used to depict area of grassy bank

Lemon cadmium

Arrows indicate direction of pencil movement

May green

Olive green

Cedar green

Tone dark behind to bring light side forward

To depict certain bush or tree shapes, the same method can be used as for grass

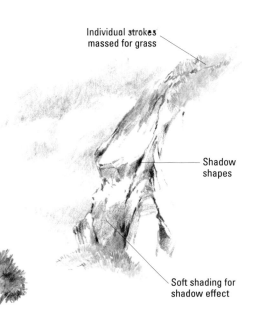

Individual strokes massed for grass

Shadow shapes

Soft shading for shadow effect

Watercolour pencils

In the same way that the pencil exercises on the previous pages rely to a great extent upon varied pressure strokes, those shown here also depend upon pencil pressure to achieve their effects.

Leaf mass impressions comprise abstract shapes, as only a few leaves appear in their entirety when viewed en masse. It is more usual to see the overlapping leaves as an overall abstract image.

Abstract shapes

Arrows indicate directions in which pencil is firmly pushed in different directions to establish shapes

Recognizable representation

Established leaf and leaf mass shapes joined by structure lines of twigs

Zigzags

Simple zigzag application in movement of fan shape starts process of depicting distant trees on hillsides

Arrows indicate direction of pencil movements

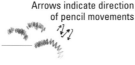

Dry on dry

Leave some white paper to depict light areas

Introduction of clean water to blend

Wet tip of pencil and transfer swiftly to paper to achieve rich darks

For a more diverse image, wet the paper first and press the tip of the pencil firmly onto the damp surface

Sweeping strokes

Large expanses of fields and hillsides require sweeping strokes. Watercolour pencils can be used in much the same way as watercolour washes. Three different methods of use are illustrated here – practise them all to see how each one works.

Palette method

Place wetted brush onto pigment and transfer to artwork with sweeping strokes

Press dry colour firmly onto paper, making dense tonal block

Dry pencil method

Shade pencil dry on dry over area to be coloured

Wash clean water over pigment to blend

Touch-tip-of-pencil method

Touch tip of pencil with brush dipped in clean water

Transfer to artwork for smooth washes

The longer the brush moves on the pigment, the darker the tone

Dry, wet and dry approach

Images can be blocked in position dry, and a clean water wash can then be placed over them. This achieves an area of solid colour/tint with a smooth appearance. When this is dry, fine detailed drawing can be overlaid to follow form and create texture.

Controlled textures

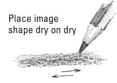

Place image shape dry on dry

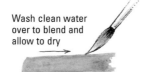

Wash clean water over to blend and allow to dry

Draw directionally dry on dry to follow form and suggest contoured texture

Watersoluble graphite

Watersoluble graphite is useful for sketchbook work. Images may be swiftly sketched on site and elaborated upon at home, using watercolour pencils. The subjects can be interpreted in detail or in the form of tonal blocks and shapes.

Do not assume that the whole image is safely fixed in position once it has been washed with water. There may be small areas that you have unintentionally missed, and these will blend into each new application of a clean colour – however, you may wish for this random effect to happen.

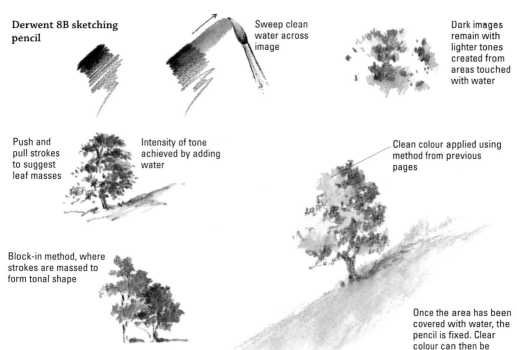

Derwent 8B sketching pencil

Sweep clean water across image

Dark images remain with lighter tones created from areas touched with water

Push and pull strokes to suggest leaf masses

Intensity of tone achieved by adding water

Clean colour applied using method from previous pages

Block-in method, where strokes are massed to form tonal shape

Once the area has been covered with water, the pencil is fixed. Clear colour can then be painted over the image

Problems

Locations and Views

Low hills, found in gently undulating countryside, are often clad in a variety of trees, and the rounded forms of deciduous trees contrast with the pointed tips of conifers. Distant buildings, either dotted amongst the trees on the hillside or grouped at its base, can offer contrasting shapes to the expanses of fields and open spaces. The latter in their turn provide an interesting patchwork effect, and if all this is reflected in the surface of a winding stream or river, there is much for the eye to take in.

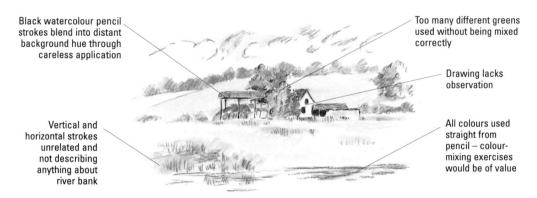

Black watercolour pencil strokes blend into distant background hue through careless application

Too many different greens used without being mixed correctly

Drawing lacks observation

Vertical and horizontal strokes unrelated and not describing anything about river bank

All colours used straight from pencil – colour-mixing exercises would be of value

View up river

On location it is possible to make a number of sketches from one position and then change the view entirely by turning to the right or left. This sketch shows tree-clad hills with an assortment of buildings grouped along their base, following the bank of a river.

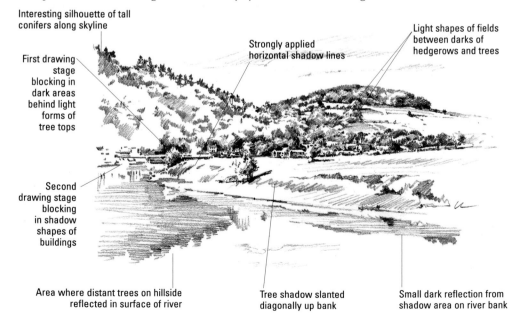

Interesting silhouette of tall conifers along skyline

First drawing stage blocking in dark areas behind light forms of tree tops

Strongly applied horizontal shadow lines

Light shapes of fields between darks of hedgerows and trees

Second drawing stage blocking in shadow shapes of buildings

Area where distant trees on hillside reflected in surface of river

Tree shadow slanted diagonally up bank

Small dark reflection from shadow area on river bank

Solutions

These two watercolour-pencil views across the river show a Dutch barn. This view, with wide expanses of water in the foreground, allows the inclusion of foliage on a tree on the nearside bank, depicted mainly by dark silhouettes. Watercolour pencils were used delicately dry on dry before clean water was gently washed over the images to blend them. After the first layer had dried, subsequent layers were built. Saunders Waterford Rough paper was used for both these demonstrations.

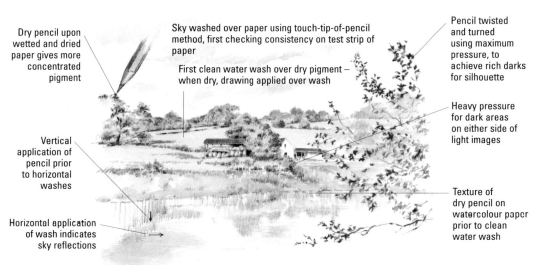

Dry pencil upon wetted and dried paper gives more concentrated pigment

Sky washed over paper using touch-tip-of-pencil method, first checking consistency on test strip of paper

First clean water wash over dry pigment – when dry, drawing applied over wash

Pencil twisted and turned using maximum pressure, to achieve rich darks for silhouette

Heavy pressure for dark areas on either side of light images

Vertical application of pencil prior to horizontal washes

Horizontal application of wash indicates sky reflections

Texture of dry pencil on watercolour paper prior to clean water wash

Low hills as backdrop

Moving in closer to the focal point and using the hills as a backdrop, this drawing shows a looser approach to the scene. All the underdrawing was executed in watersoluble graphite pencil prior to freely applying watercolour pencil washes using the palette method.

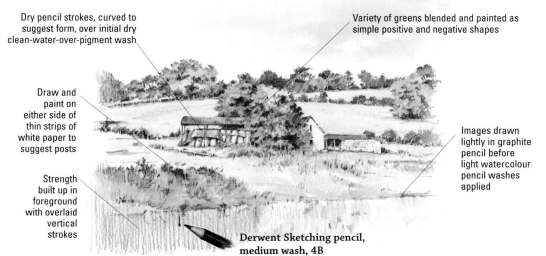

Dry pencil strokes, curved to suggest form, over initial dry clean-water-over-pigment wash

Variety of greens blended and painted as simple positive and negative shapes

Draw and paint on either side of thin strips of white paper to suggest posts

Images drawn lightly in graphite pencil before light watercolour pencil washes applied

Strength built up in foreground with overlaid vertical strokes

Derwent Sketching pencil, medium wash, 4B

Problems

Larger Hills

From the gently undulating hills on the previous pages, we now look at higher structures whose scale is emphasized by the presence of small islands in the area of water. From this distance the water seems undisturbed, and it can be suggested by a simple, flat wash reflecting a blue sky. Working with tinted washes over a drawing executed in either permanent or watersoluble media encourages a looser approach.

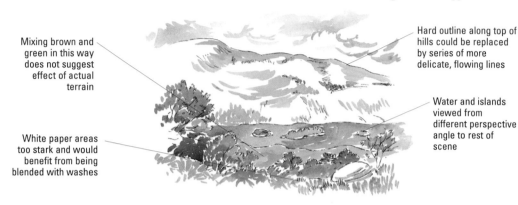

Mixing brown and green in this way does not suggest effect of actual terrain

White paper areas too stark and would benefit from being blended with washes

Hard outline along top of hills could be replaced by series of more delicate, flowing lines

Water and islands viewed from different perspective angle to rest of scene

Working in pen and ink

A few images that may be found in this type of setting have been arranged here with method suggestions for you to practise and put into effect in your own studies.

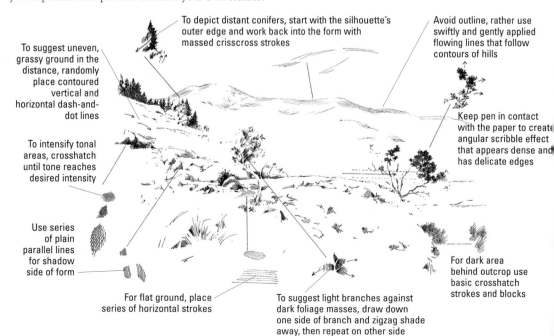

To depict distant conifers, start with the silhouette's outer edge and work back into the form with massed crisscross strokes

Avoid outline, rather use swiftly and gently applied flowing lines that follow contours of hills

To suggest uneven, grassy ground in the distance, randomly place contoured vertical and horizontal dash-and-dot lines

Keep pen in contact with the paper to create angular scribble effect that appears dense and has delicate edges

To intensify tonal areas, crosshatch until tone reaches desired intensity

Use series of plain parallel lines for shadow side of form

For dark area behind outcrop use basic crosshatch strokes and blocks

For flat ground, place series of horizontal strokes

To suggest light branches against dark foliage masses, draw down one side of branch and zigzag shade away, then repeat on other side

Solutions

I used an old sheet of paper for this painting, to encourage freedom of thought, as it prevents one from feeling the work is too precious, releases inhibitions and increases confidence; and I treated this scene as a learning exercise in which the methods shown on the opposite page could be put into practice.

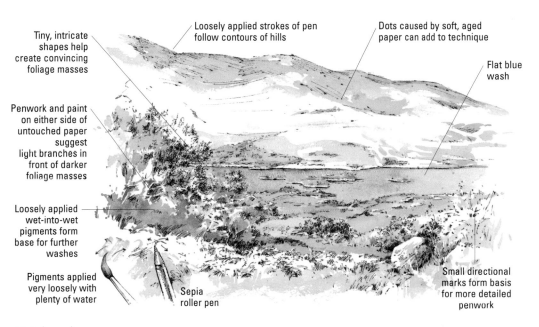

Tiny, intricate shapes help create convincing foliage masses

Loosely applied strokes of pen follow contours of hills

Dots caused by soft, aged paper can add to technique

Flat blue wash

Penwork and paint on either side of untouched paper suggest light branches in front of darker foliage masses

Loosely applied wet-into-wet pigments form base for further washes

Pigments applied very loosely with plenty of water

Sepia roller pen

Small directional marks form basis for more detailed penwork

Trial and error

Observing rocks close up helps you to understand the subject and how it relates to other components within the view. Using charcoal pencil marks as the underdrawing encourages a looser approach. In addition, I suggest you sometimes use old watercolour paper offcuts for a trial-and-error exercise – a learning experience rather than a careful study, as in the drawing above. The first stage is to draw shadow lines on rocks and then gently apply clean water over these directionally to fix them.

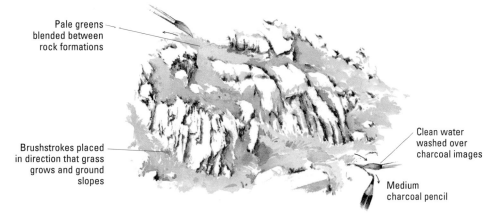

Pale greens blended between rock formations

Brushstrokes placed in direction that grass grows and ground slopes

Clean water washed over charcoal images

Medium charcoal pencil

Problems

Mountains

Snow-capped mountains often have grassy areas against the sheer rock face, lower down, where the air is warmer. The cool blue greys of upper slopes in shadow are replaced in lower regions by warmer hues in the rocks and bright, soft greens where fresh young grasses spring to life among the crevices as well as over larger expanses. The stark contrasts of lights against darks bring this type of scenery to life.

Too-even placing of certain images produces unsatisfactory composition

Wrong choice of green in watercolour pencils

Not clear if this is shadow shape or area of rock

Worm-like lines do not suggest craggy shadow lines along cracks in rocks

Second stage: clean water brushed over dry pigment to blend

Third stage: fine, detailed drawing over dry paper using sharpened watercolour pencil over first washes

First stage: image drawn in neutral hue

First stage: grassy areas depicted by dry application of green

Fourth stage: draw around any images with direct sunlight falling across them

Fifth stage: enrich dark (shadow) areas by increasing pressure on pencil

Consider composition

It is important to compose your picture, even if it is only a study of details. Using just two watercolour pencils – representing grass and rock, respectively – a drawing can be made interesting simply by considering the angle at which the area is viewed and looking for textures as well as tones in the scene.

Some of the drawing was executed upon paper that was still slightly damp from a wash. This results in less texture in the drawing.

Solutions

Although this exercise was executed in watercolour, you can easily follow exactly the same methods using watercolour pencils. Either touch the tip of the pencils with clean water to lift pigment prior to application, or, in order to mix colours, use the palette method mentioned on page 65.

Remember to let your brushstrokes follow directions suggested to you by the form of the subject, for instance sweep strokes down and swirl them around to suggest the open area of grass.

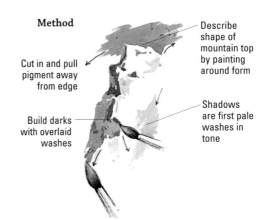

Method

Describe shape of mountain top by painting around form

Cut in and pull pigment away from edge

Shadows are first pale washes in tone

Build darks with overlaid washes

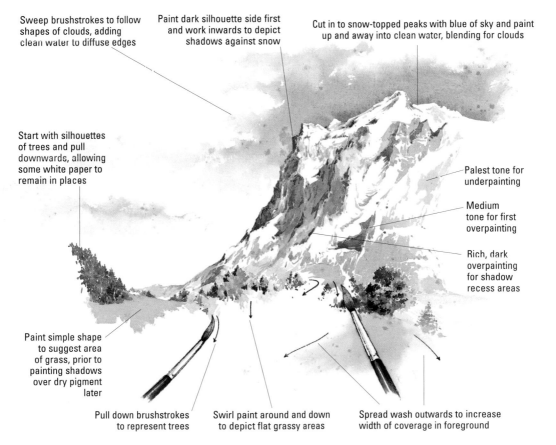

Sweep brushstrokes to follow shapes of clouds, adding clean water to diffuse edges

Paint dark silhouette side first and work inwards to depict shadows against snow

Cut in to snow-topped peaks with blue of sky and paint up and away into clean water, blending for clouds

Start with silhouettes of trees and pull downwards, allowing some white paper to remain in places

Palest tone for underpainting

Medium tone for first overpainting

Rich, dark overpainting for shadow recess areas

Paint simple shape to suggest area of grass, prior to painting shadows over dry pigment later

Pull down brushstrokes to represent trees

Swirl paint around and down to depict flat grassy areas

Spread wash outwards to increase width of coverage in foreground

RURAL AND URBAN LANDSCAPES

Drawing exercises

These tonal and linear pencil exercises demonstrate two extremes of use, and can be used alone or combined within a drawing. In this theme I refer to a method that tones up to, and away from, light edges, as well as the use of tonal blocks on either side of a light strip. Wandering lines help to describe form when creating loose sketches.

Tonal block with 6B pencil

Up to and away strokes

6B pencil

3B pencil

Wandering line and follow form strokes

Combination of directions without lifting pencil from paper

Wandering line

Overlaid texture strokes

First tonal block laid with repeated downward strokes

Overlaid, firm pressure (close zigzag) stroke

Close zigzag stroke

Lines that follow forms

Varied pressure vertical and horizontal lines

Choosing Strokes

You need to carefully consider the direction and application of strokes for each subject you depict until their use becomes a natural habit. The more you can practise and experiment with angles, pressures, contours and so forth the easier they will become.

Vertical varied pressure ↑↓

Normal writing position

Fanning out ↑↓

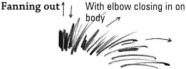

With elbow closing in on body ↗

Vertical outward gradation

↓↑ →

Angle of hand achieved by keeping your elbow out and away from body

Cut in and tone away

Pencil held above image with elbow on same line as pencil tip

Tip of pencil in cut-in position – elbow at side for push up, out and away strokes

Watercolour pencils

This versatile medium can be used both dry and wet to create interesting textures.

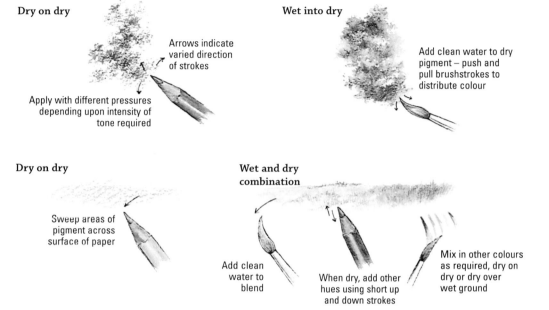

Dry on dry

Arrows indicate varied direction of strokes

Apply with different pressures depending upon intensity of tone required

Wet into dry

Add clean water to dry pigment – push and pull brushstrokes to distribute colour

Dry on dry

Sweep areas of pigment across surface of paper

Wet and dry combination

Add clean water to blend

When dry, add other hues using short up and down strokes

Mix in other colours as required, dry on dry or dry over wet ground

The palette method

This is an ideal method for tinting pen-and-ink work where pale-tinted washes are required.

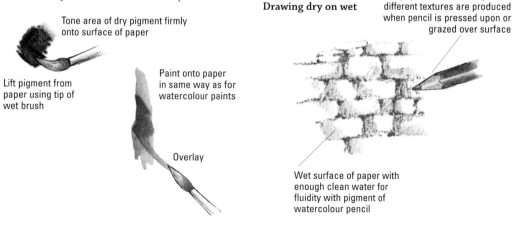

Tone area of dry pigment firmly onto surface of paper

Lift pigment from paper using tip of wet brush

Paint onto paper in same way as for watercolour paints

Overlay

Drawing dry on wet

As paper surface slowly dries, different textures are produced when pencil is pressed upon or grazed over surface

Wet surface of paper with enough clean water for fluidity with pigment of watercolour pencil

Watercolour pencil exercises

Watercolour pencil colour strips can be sharpened into
a palette and mixed with water to create different hues.
You can work in monochrome by applying the tip of a
brush dipped in clean water to the colour strip of the
pencil. Lift the pigment with the wet brush and paint
it on the paper. Dry-on-dry images can be enhanced by
adding water in sweeping strokes, blending the pigment
to produce tinted washes over a softened image.

Clear water strokes

First draw the image dry on dry, then sweep clean
water swiftly and lightly across your drawing.
Experiment with the amount of water required so as
not to erase the image by applying too much, or to
smudge it by applying too little. Also practise leaving
areas of white paper untouched where you wish to
feature contrasting highlights.

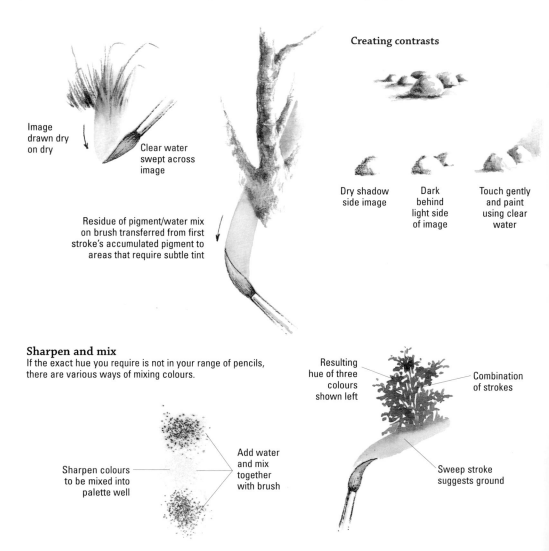

Creating contrasts

Image
drawn dry
on dry

Clear water
swept across
image

Residue of pigment/water mix
on brush transferred from first
stroke's accumulated pigment to
areas that require subtle tint

Dry shadow
side image

Dark
behind
light side
of image

Touch gently
and paint
using clear
water

Sharpen and mix
If the exact hue you require is not in your range of pencils,
there are various ways of mixing colours.

Resulting
hue of three
colours
shown left

Combination
of strokes

Sharpen colours
to be mixed into
palette well

Add water
and mix
together
with brush

Sweep stroke
suggests ground

Touch tip and paint

Describe edge

Transfer the resulting pigment to paper and create images using a variety of strokes

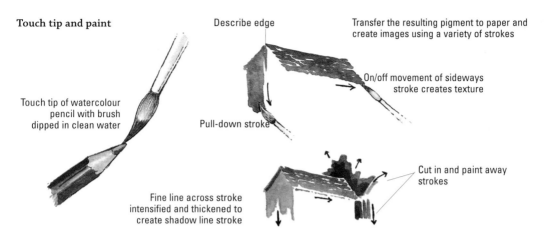

Touch tip of watercolour pencil with brush dipped in clean water

On/off movement of sideways stroke creates texture

Pull-down stroke

Cut in and paint away strokes

Fine line across stroke intensified and thickened to create shadow line stroke

Varied width strokes

Different widths of stroke can be achieved easily if you shape your brush prior to making a stroke. Press a medium-size brush (No. 8 or 9) into a pigment mix in the palette well, flattening the hairs to form a chisel shape, then use the narrow side you have created to produce very fine lines.

Normal (round shape) sweep-down stroke

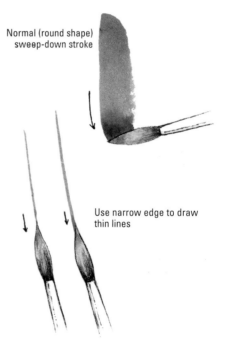

To create thin strokes

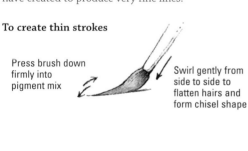

Press brush down firmly into pigment mix

Swirl gently from side to side to flatten hairs and form chisel shape

Use narrow edge to draw thin lines

Versatility of medium-size brush

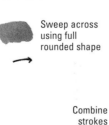

Pull down using the thin edge established by creating chisel side

Sweep across using full rounded shape

Combine strokes

Problems

Historic Building

Half-timbered buildings tend to be associated with the countryside, but they may also be found within urban landscapes and historic towns. Sometimes the pattern of the woodwork may be superficial and only a façade, but whether they are an integral part of the structure or for cosmetic purposes only, the attractive patterns make interesting subjects for drawings and paintings. Watercolour pencils are ideal for depicting this subject, as they can be used alone – wet or dry – or with another medium. They enable underdrawing and overpainting to work well together without the use of a second medium, such as graphite pencil.

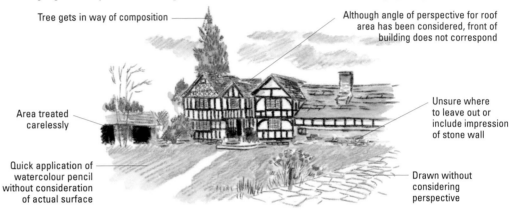

Tree gets in way of composition

Although angle of perspective for roof area has been considered, front of building does not correspond

Area treated carelessly

Unsure where to leave out or include impression of stone wall

Quick application of watercolour pencil without consideration of actual surface

Drawn without considering perspective

Mixed-media study

Making a monochrome study in mixed media – here, ivory black watercolour pencil and ink – enables you to pay attention to the drawing, which encourages close observation and helps with the placing of the dark timbers.

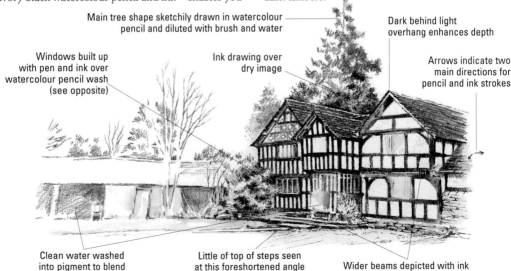

Main tree shape sketchily drawn in watercolour pencil and diluted with brush and water

Dark behind light overhang enhances depth

Windows built up with pen and ink over watercolour pencil wash (see opposite)

Ink drawing over dry image

Arrows indicate two main directions for pencil and ink strokes

Clean water washed into pigment to blend

Little of top of steps seen at this foreshortened angle

Wider beams depicted with ink lines over watercolour pencil base

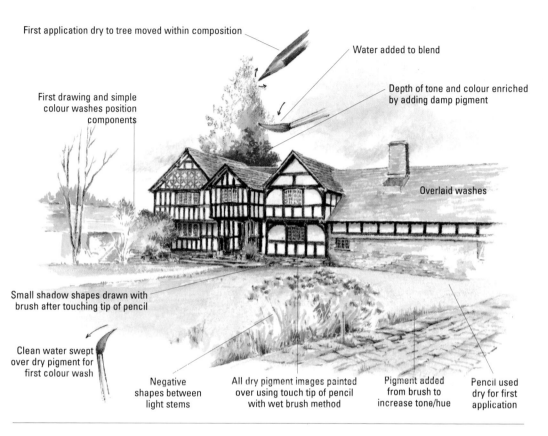

First application dry to tree moved within composition

Water added to blend

First drawing and simple colour washes position components

Depth of tone and colour enriched by adding damp pigment

Overlaid washes

Small shadow shapes drawn with brush after touching tip of pencil

Clean water swept over dry pigment for first colour wash

Negative shapes between light stems

All dry pigment images painted over using touch tip of pencil with wet brush method

Pigment added from brush to increase tone/hue

Pencil used dry for first application

Building window image

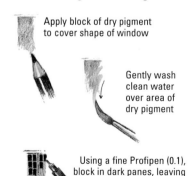

Apply block of dry pigment to cover shape of window

Gently wash clean water over area of dry pigment

Using a fine Profipen (0.1), block in dark panes, leaving washed pencil to indicate glazing bars

Wet and dry methods

Touching pencil tip

Touch tip of pencil with wet brush to lift pigment

Flicking from pigment strip

Flick downwards (towards palette or piece of practice paper) to drop diluted pigment for use from reservoir

Wetting dry pigment on paper

Draw image dry directly onto paper

Dilute pigment with clean water on brush

Scale and Movement

Viewing city buildings from a distance, without the movement suggested by the inclusion of people and traffic, can present an uninteresting, static landscape. If you are looking to create a feeling of movement, this can be achieved by choosing an angle that relates to disturbed water or a busy sky. When depicting the scale of tower blocks, it is useful to consider how this may be indicated, both at a distance and within the complex itself. You may also suggest a feeling of movement if you position your observation point in relation to water.

Watercolour study

Moving the observer's eye into your composition is important, and this sketch indicates how this can be achieved by the use of strongly angled forms – pathways and walls, etc. The same group of buildings as above right, viewed from a slightly different position, here introduces strong perspective angles that guide the eye into the picture.

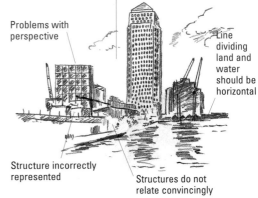

No thought given to negative shape between buildings

Problems with perspective

Line dividing land and water should be horizontal

Structure incorrectly represented

Structures do not relate convincingly

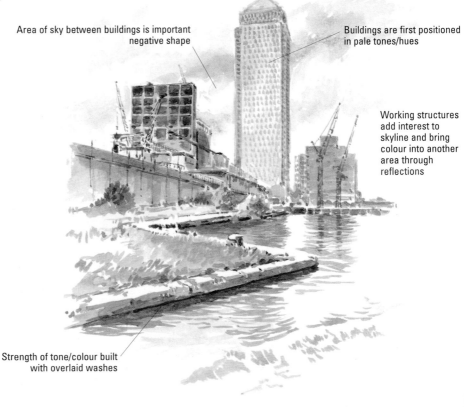

Area of sky between buildings is important negative shape

Buildings are first positioned in pale tones/hues

Working structures add interest to skyline and bring colour into another area through reflections

Strength of tone/colour built with overlaid washes

We not only see movement in water but also in cloud formations in the sky. Either or both can help soften the image of tall, solid tower-block structures, creating movement within the picture.

Getting to know your subject

Wherever possible, familiarize yourself with buildings from different aspects, at a distance and close up. Standing within a complex of this nature, you move your eyes from the base of the structures up towards the sky. Small detailed pencil studies depicting patterns in glass-fronted buildings will help you understand how to select and simplify from the complexity of shapes you are confronted with. What you choose to leave out of your interpretation is just as important as what you choose to include.

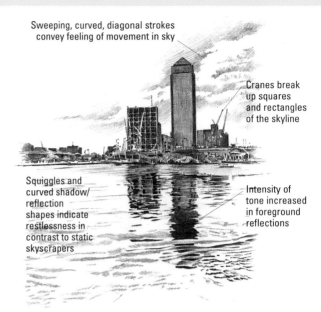

Sweeping, curved, diagonal strokes convey feeling of movement in sky

Cranes break up squares and rectangles of the skyline

Squiggles and curved shadow/reflection shapes indicate restlessness in contrast to static skyscrapers

Intensity of tone increased in foreground reflections

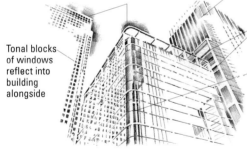

To enhance light forms against darker sky, apply pencil to outer edge of form and tone away

Tonal blocks of windows reflect into building alongside

Blending dark tone into light suggests light falling on subject

Simple abstract shapes indicate extreme perspective angles

Reflections of surrounding buildings

Curve of structure provides contrasting shape against verticals and angled horizontals of main building

The balance of busy areas

To comprehend the scale of buildings, freely interpreted sketches made while standing at the base of the structures enable you to introduce other relevant structures and the activity of figures. Both movement and scale should play a large part in your interpretation.

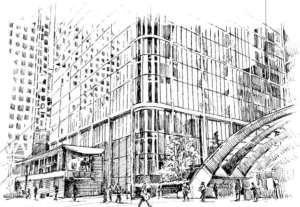

Glazing bars of main building drawn first

Reflection between bars (from separate buildings to the side) shows different perspective angle

Busy area at base of tower block introduces structures, trees, hedges and figures

Townscapes

An effective way to create an impression of town or city streets is to depict the view from a window above street level. As there is so much movement to cope with, it is advisable to take a photograph of the scene then use it as a reference to look for simple shapes, which should be your starting point.

If you wish to achieve a pure watercolour, you can still draw lightly on your watercolour paper and use

the faint pencil lines as a guide, erasing as many as possible after your first pale watercolour washes have dried. Before doing this, however, it is wise to get to know your subject by sketching the positions of buildings and other urban features with the use of vertical and horizontal guidelines.

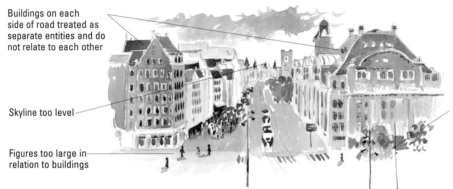

Buildings on each side of road treated as separate entities and do not relate to each other

Skyline too level

Figures too large in relation to buildings

Lampposts painted dark of necessity, but no white paper left to indicate highlighted side

Quick pen and ink sketch

Using a photograph as your guide, familiarize yourself with the juxtapositions of all of the components and introduce figures at random, complete with shadows.

Strongest vertical starting point

Interesting skyline

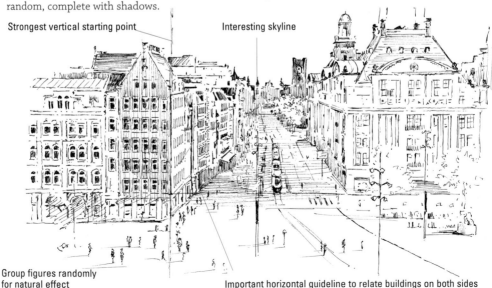

Group figures randomly for natural effect

Important horizontal guideline to relate buildings on both sides

In order to simplify, look for shapes – tonal blocks and colour blocks. In this illustration, I have painted over and within the first simple shapes directionally, to create an impression. You can see the various stages involved in building a composition that involves vast, busy areas, incorporating large, static buildings and smaller moving objects.

Because you are building a painting with overlaid washes – wet over dry – it is important to start with a drawing with which you are pleased, otherwise the tone/colour shapes you will be painting will not look convincing when the picture is complete. Remember to allow all the washes to dry completely before erasing any pencil marks.

Practise using more water with your pigment than you think you will need, as this will help you paint around the areas that are to remain white/light without creating watermarks. Should you go over one of these areas, you can correct the mistake by quickly blotting off, allowing the paper to dry and reapplying paint.

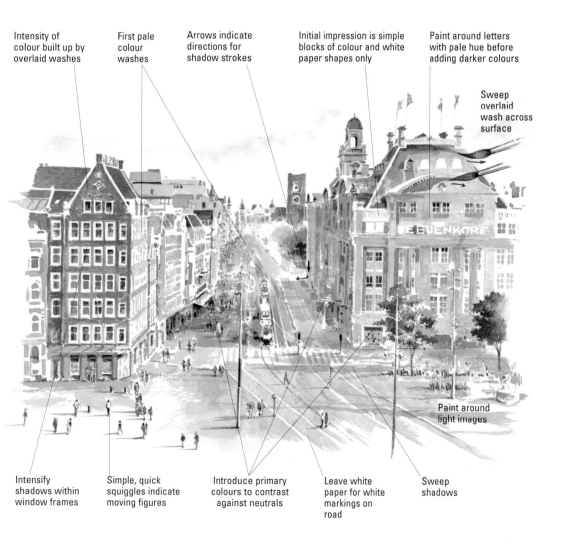

Intensity of colour built up by overlaid washes

First pale colour washes

Arrows indicate directions for shadow strokes

Initial impression is simple blocks of colour and white paper shapes only

Paint around letters with pale hue before adding darker colours

Sweep overlaid wash across surface

Intensify shadows within window frames

Simple, quick squiggles indicate moving figures

Introduce primary colours to contrast against neutrals

Leave white paper for white markings on road

Sweep shadows

Paint around light images

Small Structures Typical Problems

Small structures may not have the grandeur of their larger counterparts, as shown overleaf, but they do possess their own particular charm. A small stone bridge and a compact country cottage are depicted here in watercolour and show both methods of laying washes:

wet-on-dry, used for the cottage, and a controlled wet-into-wet approach, used for the bridge. You can also see problems relating to the inclusion (or, should I say, intrusion) of white paper and the overuse of outlines, as well as with the choice of colours.

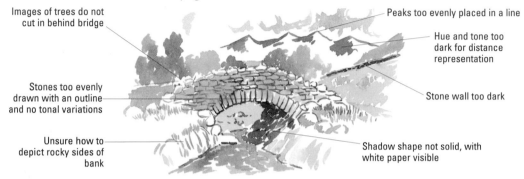

Images of trees do not cut in behind bridge

Peaks too evenly placed in a line

Hue and tone too dark for distance representation

Stones too evenly drawn with an outline and no tonal variations

Stone wall too dark

Unsure how to depict rocky sides of bank

Shadow shape not solid, with white paper visible

Solution

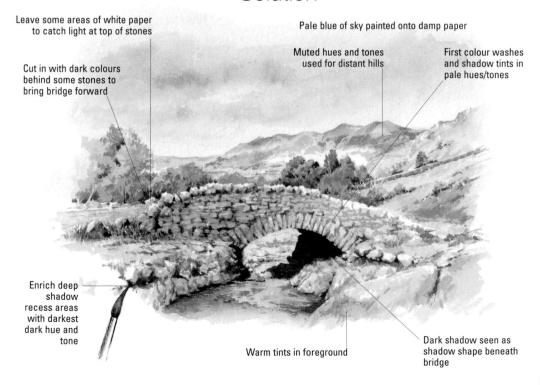

Leave some areas of white paper to catch light at top of stones

Pale blue of sky painted onto damp paper

Muted hues and tones used for distant hills

First colour washes and shadow tints in pale hues/tones

Cut in with dark colours behind some stones to bring bridge forward

Enrich deep shadow recess areas with darkest dark hue and tone

Warm tints in foreground

Dark shadow seen as shadow shape beneath bridge

Typical Problems

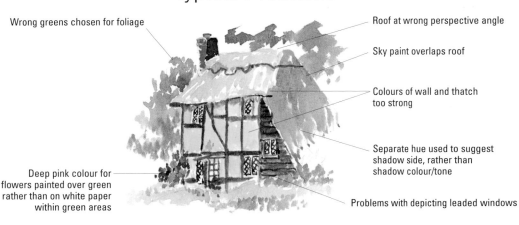

Wrong greens chosen for foliage

Roof at wrong perspective angle

Sky paint overlaps roof

Colours of wall and thatch too strong

Separate hue used to suggest shadow side, rather than shadow colour/tone

Deep pink colour for flowers painted over green rather than on white paper within green areas

Problems with depicting leaded windows

Solution

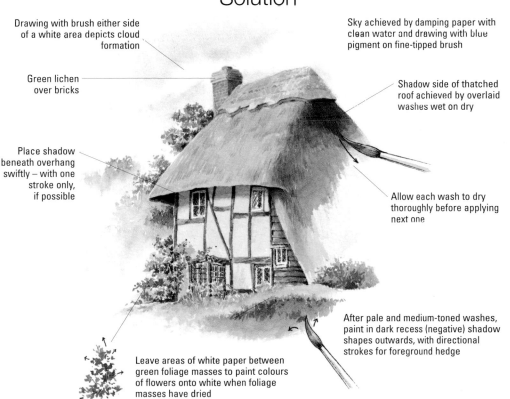

Drawing with brush either side of a white area depicts cloud formation

Sky achieved by damping paper with clean water and drawing with blue pigment on fine-tipped brush

Green lichen over bricks

Shadow side of thatched roof achieved by overlaid washes wet on dry

Place shadow beneath overhang swiftly – with one stroke only, if possible

Allow each wash to dry thoroughly before applying next one

After pale and medium-toned washes, paint in dark recess (negative) shadow shapes outwards, with directional strokes for foreground hedge

Leave areas of white paper between green foliage masses to paint colours of flowers onto white when foliage masses have dried

Problems

Buildings on Bridges

Towers on suspension bridges present a structure that offers height as well as width and length. This view depicts an angle from which the graceful lines of massive girders can be drawn to lead the observer's eye towards the focal point of the main tower block. This is enhanced by the contrasting, sharp-edged shape of a strong area of shadow.

Coloured pencils encourage a delicacy of interpretation in the form of detailed drawing, enhancing the subject. Problems may arise, however, if the chosen pencils are not the sort that are ideal for detailed work, as in the sketch below, where the width of the pencil's coloured strip combined with heavy-handed use prevents the delicacy required for this scale and interpretation from being achieved.

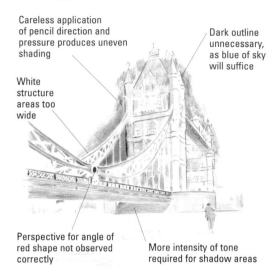

Careless application of pencil direction and pressure produces uneven shading

Dark outline unnecessary, as blue of sky will suffice

White structure areas too wide

Perspective for angle of red shape not observed correctly

More intensity of tone required for shadow areas

Pen and ink sketch

The sketch below was executed using the dot/dash approach combined with vertical- (parallel-) lined shading. I used a finer nib for the shadow areas.

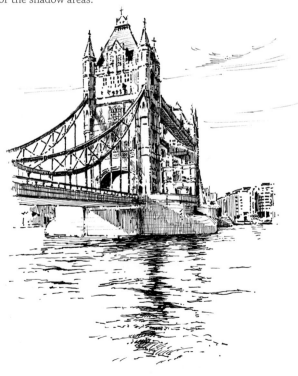

Solutions

In this drawing a change to 'studio' pencils, with their slim colour strips, has enabled a delicacy of detail to emerge as a result of careful handling and interpretation.

Some areas of white paper remain to suggest clouds

Work blue of sky either side of white poles

Place areas of blue sky within and around image

All drawing executed in bronze pencil before adding other hues to suggest stonework

Enhance shadow sides of white images with indigo over sepia

Bronze and sepia undercoat colours used for shadow area before indigo added to create intensity of tone

From yellow jacket eye travels to red and then to third primary colour, blue

Strong yellow of jacket leads into picture

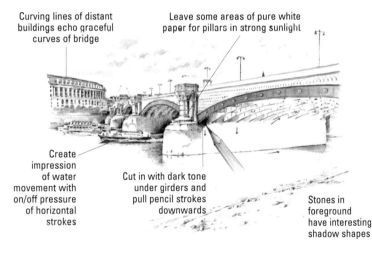

Curving lines of distant buildings echo graceful curves of bridge

Leave some areas of pure white paper for pillars in strong sunlight

Low arched bridge

Before progressing into full colour, you may wish to try a combination of graphite drawing with limited colour. Here, I shaded a dark flesh watercolour pencil direct onto Bristol board, and then gently added water to blend the pigment and enable me to include more drawing over the (dried) colour.

Create impression of water movement with on/off pressure of horizontal strokes

Cut in with dark tone under girders and pull pencil strokes downwards

Stones in foreground have interesting shadow shapes

Exploratory sketch

At whichever angle you choose to depict your image, it is helpful to view and sketch it from different angles.

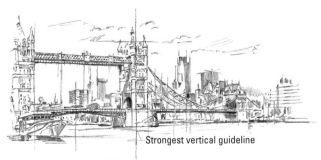

Strongest vertical guideline

Problems

Iron Bridges

Whether in a high arched bridge spanning a narrow waterway or a series of arches supported upon stone pillars crossing a wider expanse of water, the patterns created by positive and negative shapes can sometimes cause problems for novice artists. The numerous shapes, curves, contours and contrasts incorporated within the structure provide a maze that can mystify and confuse, but by concentrating on negative shapes and shadow shapes, as well as the more obvious positives, many problems can be solved.

Open ironwork structures are an excellent example of pattern, where consideration of the shapes between the ironwork, and their relationship with each other, will solve perspective problems.

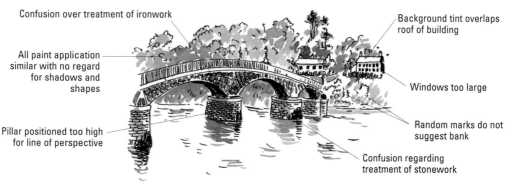

Confusion over treatment of ironwork

All paint application similar with no regard for shadows and shapes

Pillar positioned too high for line of perspective

Background tint overlaps roof of building

Windows too large

Random marks do not suggest bank

Confusion regarding treatment of stonework

Quick tonal sketch

Pen and ink with a monochrome tinted wash allows a gradual build-up of tones that results in exciting contrasts when the wider span pillars are viewed one in front of the other. In this study, the inclusion of buildings gives some idea of the scale of the bridge.

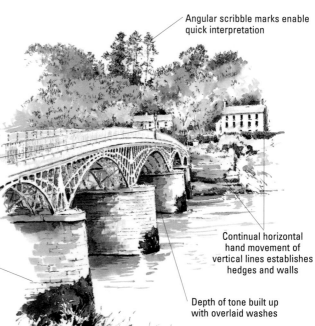

Angular scribble marks enable quick interpretation

Simple squiggle establishes form of lamppost quickly

Continual horizontal hand movement of vertical lines establishes hedges and walls

Shadow lines within blockwork indicated with tonal brush marks

Depth of tone built up with overlaid washes

Dark negative shapes within weeds and grass masses

Although the bridge may be a complex structure, a pencil sketch can simplify it. The tree-clad hills rising up behind the buildings are depicted in simply applied directional tonal blocks, and the bridge can be positioned accurately in relation to this backdrop using lightly drawn guidelines and observing the negative shapes. Bristol board is an ideal surface for this technique, as it is possible to add detail over the initial tonal blocks.

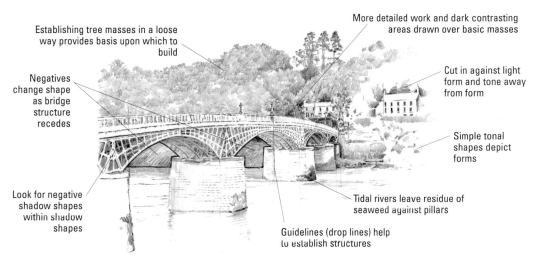

Establishing tree masses in a loose way provides basis upon which to build

More detailed work and dark contrasting areas drawn over basic masses

Negatives change shape as bridge structure recedes

Cut in against light form and tone away from form

Simple tonal shapes depict forms

Look for negative shadow shapes within shadow shapes

Tidal rivers leave residue of seaweed against pillars

Guidelines (drop lines) help to establish structures

Noticing the negatives

This drawing of a short-span iron bridge demonstrates the use of charcoal to create strong shadow shapes (the positive iron structure) and, by toning in the dark negatives, how the light positive shapes may be brought forward. I used soft charcoal pencil to enhance the darks to their full potential. Charcoal is also ideal when creating subtle areas of light and medium tones, such as over stonework in shadow, encouraging light shapes to stand forward on both sides of the bridge.

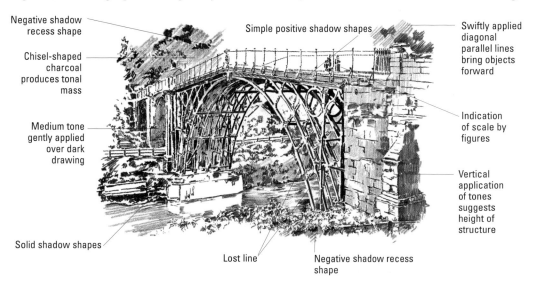

Negative shadow recess shape

Simple positive shadow shapes

Swiftly applied diagonal parallel lines bring objects forward

Chisel-shaped charcoal produces tonal mass

Indication of scale by figures

Medium tone gently applied over dark drawing

Vertical application of tones suggests height of structure

Solid shadow shapes

Lost line

Negative shadow recess shape

Old Buildings

Many urban landscapes contain pockets of character buildings – tree-lined streets with wide cobbled or slabbed pathways and spreads of grass offer us tranquillity and a glimpse of the past that is very enticing. A variety of façades that may include hanging tiles, weatherboarding, plain rendered walls or rendering within timbers, often painted in strong pastel hues, provides the artist with tantalizing textures to depict. In the autumn, when leaves change to bright coppers and yellows before falling to add their gems of colour to wet pathways, the combination of ink and wash as a medium to enhance this clarity of tone and colour seems an ideal choice.

Mixing the mediums of ink and wash can be approached in various ways. Three options are: placing tinted washes over an ink drawing, drawing over a wash painting, and working the two together right from the beginning as a planned progression. The first two – where ink drawing and first colour washes are minimal, to block in areas and establish the composition, before more pen-work and colour washes alternate in order to enhance tone and colour – are shown on this page, and the third method is described in the final demonstration opposite.

Wash over ink

I worked on Saunders Waterford 180gsm (90lb) Rough paper for the small study at right, using a 0.1 Profipen.

As the pen grazes the surface a soft-textured effect is created, over which fluid washes may be placed. My pressure is always light upon the paper for this technique, and the darks are enriched by overworking in the same area rather than by applying firmer

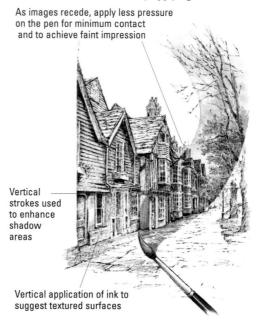

As images recede, apply less pressure on the pen for minimum contact and to achieve faint impression

Vertical strokes used to enhance shadow areas

Vertical application of ink to suggest textured surfaces

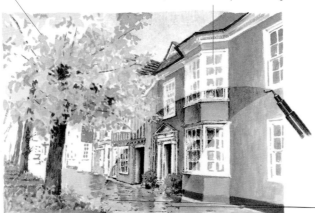

First washes painted loosely

First rough indication of positions of glazing bars, clarified later by ink drawing

Ink over wash

In the study at left, washes have been painted freely over images that were lightly placed in pencil. As much of the pencil as possible is removed after the paint is dry before a fine pen is used to draw in the details and textures, as well as to enrich the dark tonal contrasts.

Bright yellow of individual leaves in different areas unifies painting

Pencil sketch *(right)*
The composition was planned in pencil, with the use of guidelines to establish the correct relationships between the different types of building.

Ink and wash combination *(below)*
I chose another angle, showing the same row of buildings, in order to look closer at the textures on timbers. The surface of Rough paper works with the pen to create textures instantly. Because there was a different variety of tree in this area that possessed no leaves, I omitted its form and faded the edges of the painted inked images, rather than restricting the composition to a definite format.

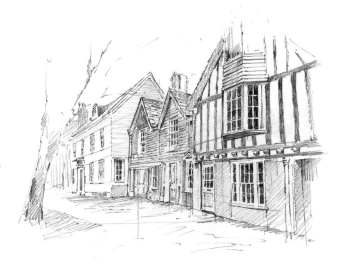

Main images lightly drawn in ink over faint pencil guide before erasing pencil

Avoid too much detail when depicting distant forms

Enhance areas of dark against light for full contrast

First pale colour washes swiftly placed to block in areas

Cut in to white/light forms and sweep strokes away to cover paper smoothly

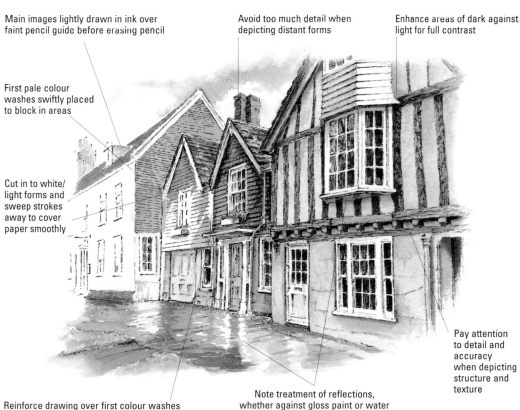

Pay attention to detail and accuracy when depicting structure and texture

Reinforce drawing over first colour washes

Note treatment of reflections, whether against gloss paint or water on surface

Drawing exercises

The strokes here can be applied smoothly or erratically, to create interest of line. Practise twisting the pencil between your fingers as you push the pencil along, initially with firm pressure, before reducing your hand pressure prior to lifting the pencil from the paper. This type of stroke encourages a loose approach for more natural images. Try to create angles when practising these lines.

Tonal block 5B pencil

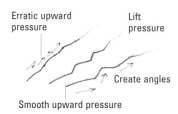

Erratic upward pressure

Lift pressure

Create angles

Smooth upward pressure

Keep pressure of pencil on paper and twist it as the stroke is drawn

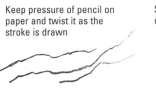

Sharpen pencil to create very fine lines

Single upward push stroke

Basic cross

Massed upward push strokes applied with firm pressure

Mass of crosses created by firm pressure on paper

Central area of massed crosses, disguised to lose initial image

Other tones and pressures with single upward push strokes around edges

Choosing Shapes

Positive and negative shapes are important considerations for any subject, and their relationships with each other can help you create interesting compositions. Some shapes may be more geometric and possess crisp edges, whereas others may be uneven, lack definition and be broken. The juxtaposition of all these should provide interest and contrasts. Try to observe your surroundings with an artist's eye in the form of positive and negative shapes – then practise drawing and painting them.

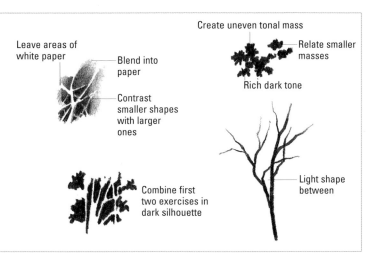

Leave areas of white paper

Blend into paper

Contrast smaller shapes with larger ones

Create uneven tonal mass

Relate smaller masses

Rich dark tone

Light shape between

Combine first two exercises in dark silhouette

Soft pencil drawing

Although they may appear to be very varied, all these studies are exercises in downward directional strokes. In each, the continuous up-and-down application of tone creates interesting masses.

Textured mass

Vertically applied, varied-pressure strokes may result in your pencils having blunt ends when the strokes are executed with continuous movements to form a textured mass (below right).

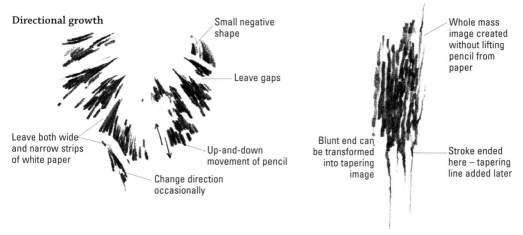

Directional growth

Small negative shape

Leave gaps

Leave both wide and narrow strips of white paper

Up-and-down movement of pencil

Change direction occasionally

Whole mass image created without lifting pencil from paper

Blunt end can be transformed into tapering image

Stroke ended here – tapering line added later

Recognizable image

A variety of strokes follows one after the other, with continuous application in order to create a recognizable image.

Recognizable mass

When depicting a mass area, you can travel from one shape to another without lifting pencil from paper by reducing the pressure to the extent that only fine wandering lines are visible before you reassert the pressure to make tonal shapes.

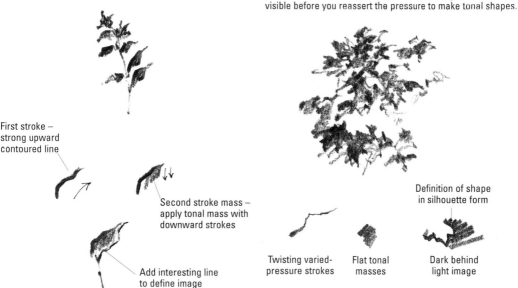

First stroke – strong upward contoured line

Second stroke mass – apply tonal mass with downward strokes

Add interesting line to define image

Definition of shape in silhouette form

Twisting varied-pressure strokes

Flat tonal masses

Dark behind light image

Coloured pencil exercises

The pencil exercises shown on the previous pages can also be effectively executed using coloured pencils. By gently increasing pressure in your stroke application for lines and masses, you will be able to enrich colours as well as tones.

It is by the depiction of contrasting areas that your work will most benefit. On these pages are some practice exercises to gain knowledge in the creation of contrasts by using white paper and light, bright colours against rich darks.

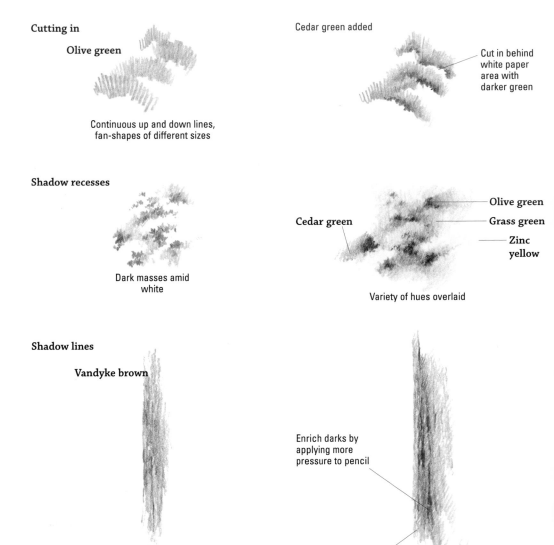

Cutting in

Olive green

Continuous up and down lines, fan-shapes of different sizes

Cedar green added

Cut in behind white paper area with darker green

Shadow recesses

Dark masses amid white

Cedar green

Olive green

Grass green

Zinc yellow

Variety of hues overlaid

Shadow lines

Vandyke brown

Lay textured area with varied pressure strokes

Enrich darks by applying more pressure to pencil

Overlay other hues

Watercolour exercises

The movements for the strokes in these exercises are similar to those used with pencils. By using a medium-sized brush – I used a No. 9 – their shapes will, however, appear different upon a watercolour paper surface.

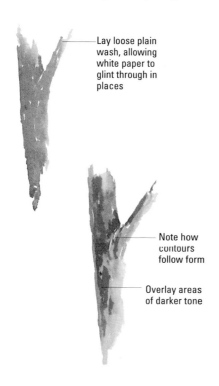

Lay loose plain wash, allowing white paper to glint through in places

Note how contours follow form

Overlay areas of darker tone

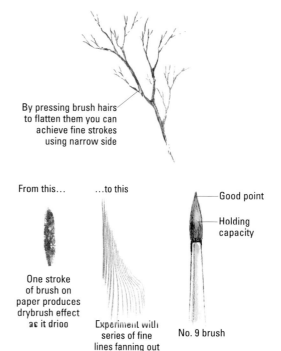

By pressing brush hairs to flatten them you can achieve fine strokes using narrow side

From this... ...to this Good point

Holding capacity

One stroke of brush on paper produces drybrush effect as it dries

Experiment with series of fine lines fanning out from central area

No. 9 brush

Foliage mass

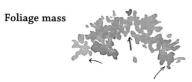

Push strokes upwards and outwards for interesting silhouette

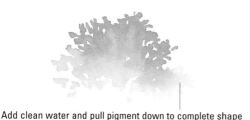

Add clean water and pull pigment down to complete shape

Drop in dark pigment to blend with damp surface, remaining crisp against white negative shape

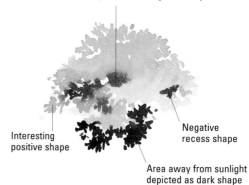

Interesting positive shape

Negative recess shape

Area away from sunlight depicted as dark shape

Problems

Single Trees

With so many varieties of tree to choose from, whether viewed in gardens, parks, clinging to steep hillsides or in open countryside, their depiction can prove problematic. In addition to the basic structure, you need also to be aware of leaf mass shapes and direction of growth to correctly represent the species. This can be achieved in a loose, free style or with a tighter, more botanical approach – whichever method you choose, a good starting point is to observe a few individual specimens in isolation.

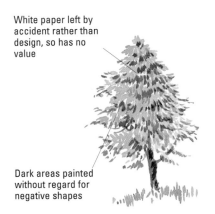

White paper left by accident rather than design, so has no value

Dark areas painted without regard for negative shapes

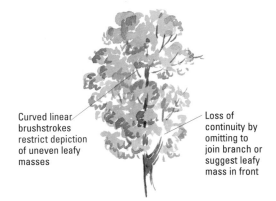

Curved linear brushstrokes restrict depiction of uneven leafy masses

Loss of continuity by omitting to join branch or suggest leafy mass in front

Small tree in garden

A slender garden specimen in its autumn splendour gives you an opportunity to consider colours other than green, as well as shapes (whether positive or negative) that can be abstracted and simplified.

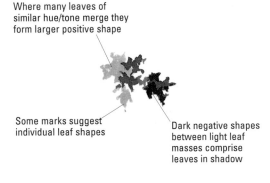

Where many leaves of similar hue/tone merge they form larger positive shape

Some marks suggest individual leaf shapes

Dark negative shapes between light leaf masses comprise leaves in shadow

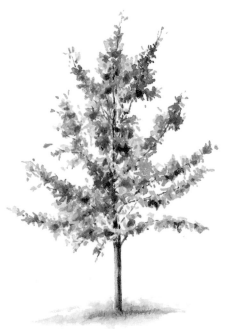

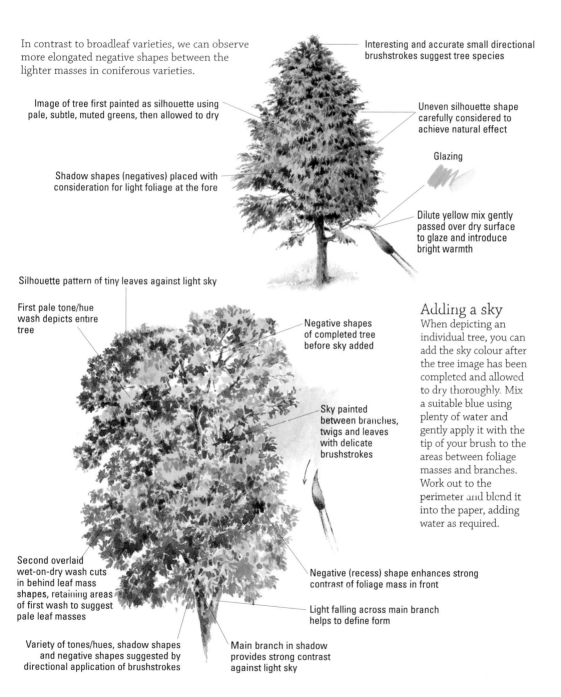

In contrast to broadleaf varieties, we can observe more elongated negative shapes between the lighter masses in coniferous varieties.

Interesting and accurate small directional brushstrokes suggest tree species

Image of tree first painted as silhouette using pale, subtle, muted greens, then allowed to dry

Uneven silhouette shape carefully considered to achieve natural effect

Glazing

Shadow shapes (negatives) placed with consideration for light foliage at the fore

Dilute yellow mix gently passed over dry surface to glaze and introduce bright warmth

Silhouette pattern of tiny leaves against light sky

First pale tone/hue wash depicts entire tree

Negative shapes of completed tree before sky added

Sky painted between branches, twigs and leaves with delicate brushstrokes

Adding a sky

When depicting an individual tree, you can add the sky colour after the tree image has been completed and allowed to dry thoroughly. Mix a suitable blue using plenty of water and gently apply it with the tip of your brush to the areas between foliage masses and branches. Work out to the perimeter and blend it into the paper, adding water as required.

Second overlaid wet-on-dry wash cuts in behind leaf mass shapes, retaining areas of first wash to suggest pale leaf masses

Negative (recess) shape enhances strong contrast of foliage mass in front

Light falling across main branch helps to define form

Variety of tones/hues, shadow shapes and negative shapes suggested by directional application of brushstrokes

Main branch in shadow provides strong contrast against light sky

Problems

Relationships

A mass of trees and their foliage in a woodland setting can appear confusing. The situation is made easier when another structure is present. A derelict cottage offers the perfect solution where, over the years,

nature has encroached upon the man-made form. This relationship provides the artist with a wealth of textures that require a variety of directional strokes to represent the different components convincingly.

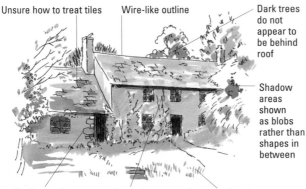

Unsure how to treat tiles

Wire-like outline

Dark trees do not appear to be behind roof

Shadow areas shown as blobs rather than shapes in between

Continuous line around each stone flattens forms and prevents appearance of lost lines

Squiggle line does not suggest creeper on wall

Grass depicted as individual strokes rather than clumps in mass

Pencil exercises

Light image in front of dark

Draw structure lines with gentle pencil pressure

Apply tone either side of line

Place areas of tone, leaving white paper as lines, without initial drawing

Foliage mass

Place series of short upward strokes

Mass strokes, pushing upwards and out, and pulling down to depict light images in front

Pen and ink exercises

Allow pen to travel lightly across paper to encourage texture

Directional push strokes create image of foliage mass

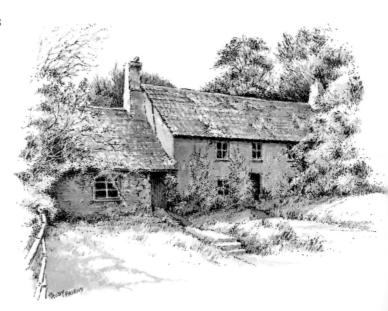

For this study the foreground has been simplified in order to make use of strong contrasting shadows falling across a wide expanse of lawn. This offers an area that rests the eye against the busy background. The building is overshadowed by the woodland, but a strong shaft of light gives us something to focus on.

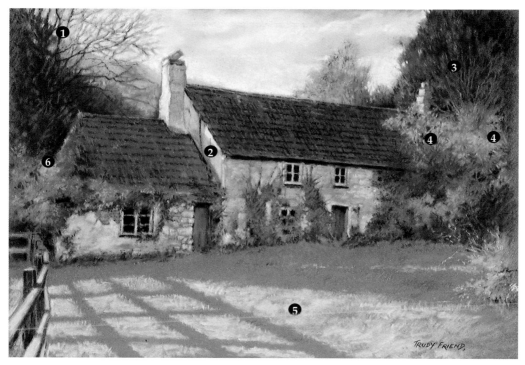

1 Where some trees have lost foliage, dark twigs against light sky offer contrast to other areas
2 Look for shadow shapes to add interest, and for highlighted areas among shadows
3 Strong contrast against rich darks of surrounding woodland
4 Mass of directional strokes uses subtle variety of tones and colour
5 Foreground treated loosely, allowing some background (support) colour to show through
6 Autumn tints among greens

Pastel exercises

Tree structure

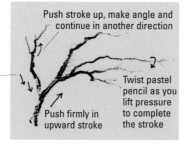

Erratic up-and-down movement as stroke pushed upwards will create interesting texture

Push stroke up, make angle and continue in another direction

Push firmly in upward stroke

Twist pastel pencil as you lift pressure to complete the stroke

Foliage mass

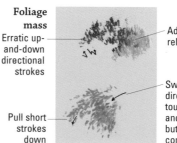

Erratic up-and-down directional strokes

Pull short strokes down

Add other related hues

Sweep strokes directionally, touching and lifting but keeping continuity

Problems

Summer and Winter Trees

Drawings of trees are most effective and naturalistic when the growth direction of branches, twig placement, and a realistic interpretation of leaf masses have been observed, considered and depicted. If the tree is in full leaf you will need to pay particular attention to the position of the main trunk and the leafless branch and twig structures. When the tree skeleton is exposed in the winter months, we can gain the most benefit for practice exercises, and can understand how the structure of the tree works.

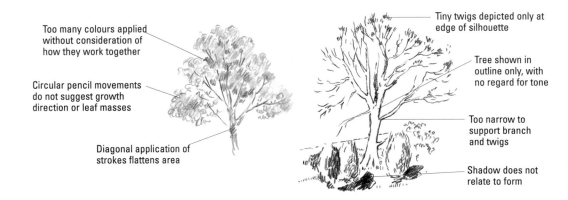

Too many colours applied without consideration of how they work together

Circular pencil movements do not suggest growth direction or leaf masses

Diagonal application of strokes flattens area

Tiny twigs depicted only at edge of silhouette

Tree shown in outline only, with no regard for tone

Too narrow to support branch and twigs

Shadow does not relate to form

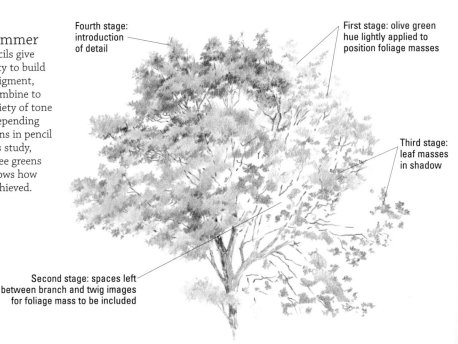

Tree in summer
Coloured pencils give an opportunity to build up layers of pigment, which may combine to produce a variety of tone and colour, depending upon variations in pencil pressure. This study, using just three greens and sepia, shows how this can be achieved.

Fourth stage: introduction of detail

First stage: olive green hue lightly applied to position foliage masses

Third stage: leaf masses in shadow

Second stage: spaces left between branch and twig images for foliage mass to be included

Solutions

Tree in winter

The thought of depicting masses of twigs on twisting branches can be daunting. In fact, All that is required is a sense of logic and patience. Logic: make it believable – depict the widest part of a twig nearest the branch and the widest part of the branch nearest the trunk. Patience: time taken does not matter.

Don't worry about how long an exercise like this may take – and if you are tired of it after a while, just put it on hold and return to it later.

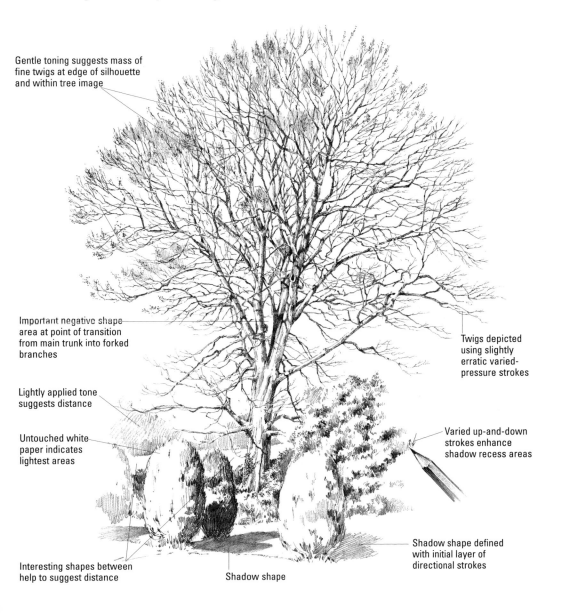

Gentle toning suggests mass of fine twigs at edge of silhouette and within tree image

Important negative shape area at point of transition from main trunk into forked branches

Lightly applied tone suggests distance

Untouched white paper indicates lightest areas

Interesting shapes between help to suggest distance

Shadow shape

Twigs depicted using slightly erratic varied-pressure strokes

Varied up-and-down strokes enhance shadow recess areas

Shadow shape defined with initial layer of directional strokes

Coniferous Woodland

Tall coniferous trees, with their strong vertical trunks and horizontal foliage masses, produce an infinite variety of negative shapes. Areas of dense shadow, contrasting with brilliant light foliage plateaux of feathery fronds amidst a maze of criss-crossed twigs, provide an irresistible combination.

In order to concentrate fully upon the negative shapes that guide us towards establishing the correct relationships between these majestic trees, I have chosen to take a close-up view of this subject, rather than a distant interpretation.

Diagrammatic Sketch

This sketch concentrates upon awareness of negative shapes to help you understand the relationships between vertical and horizontal forms. You can also discover more shapes within the shadow recesses and arrangements of fine twigs. Some of the main negative shapes have been outlined in red.

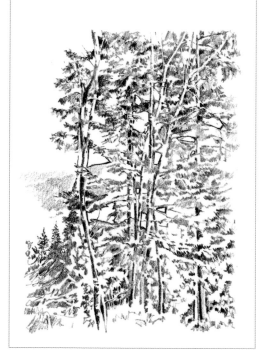

Twigs and background

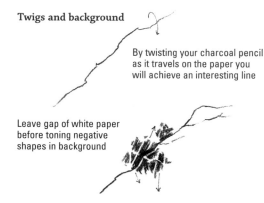

By twisting your charcoal pencil as it travels on the paper you will achieve an interesting line

Leave gap of white paper before toning negative shapes in background

Conifer foliage masses

Pull erratically applied strokes in direction of growth

Push short strokes upwards to cut in to light areas

Pull strokes down directionally

Trunks

Place strong, unevenly applied, thick line to suggest shadow side of trunk

Up-and-down strokes applied lightly to indicate distant background

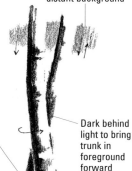

Leave light edge to avoid dark of tree trunk behind merging with shadow side of foreground trunk

Dark behind light to bring trunk in foreground forward

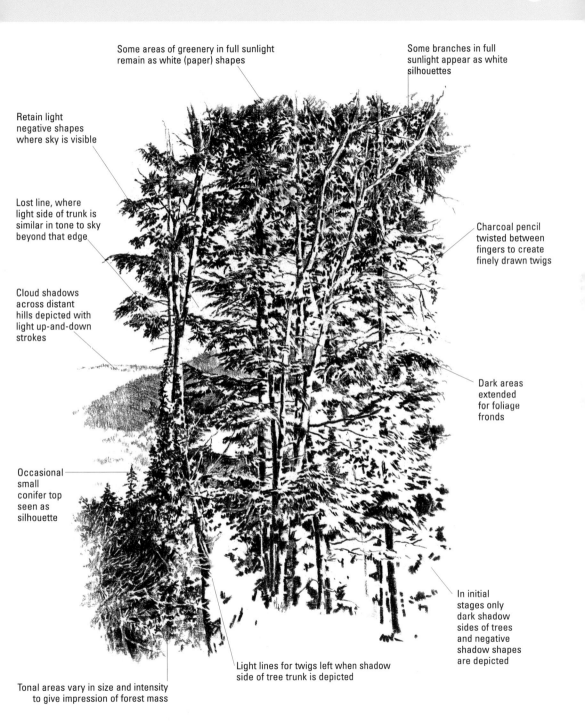

Some areas of greenery in full sunlight remain as white (paper) shapes

Some branches in full sunlight appear as white silhouettes

Retain light negative shapes where sky is visible

Lost line, where light side of trunk is similar in tone to sky beyond that edge

Charcoal pencil twisted between fingers to create finely drawn twigs

Cloud shadows across distant hills depicted with light up-and-down strokes

Dark areas extended for foliage fronds

Occasional small conifer top seen as silhouette

In initial stages only dark shadow sides of trees and negative shadow shapes are depicted

Light lines for twigs left when shadow side of tree trunk is depicted

Tonal areas vary in size and intensity to give impression of forest mass

Flowers

Whether grown in pots, window boxes or gardens, flowers are a delight to the senses. Individual blooms can give as much pleasure as a bouquet containing a profusion of sprays. They are an important part of our lives as we marvel at their intricacies, enjoy their scents, touch the delicacy of their petals and are filled with incredulity at the limitless diversity of flowers and plants.

In a book like this I can only briefly mention a few species but, in doing so, I hope I can help you, as an artist, to appreciate them even more and entertain some new thoughts and considerations in their depiction.

Colour

It is probably the vast array of vibrant hues that attracts many artists to choose flowers as subject matter. Whether drawing with coloured pencils or painting using the application of delicate, translucent washes, there is a sense of fulfilment in portraying such beauty. It is not only the blooms that offer a colour-mixing challenge; we also need to develop our skills for capturing leaves and stems, which are not always green in colour.

Another consideration is tonal values – the way in which we depict cast shadows and rich, dark negative shapes, and use techniques such as the retention of white paper to achieve the all-important highlights; these elements play a vital part in bringing artwork to life.

Texture

It may be the texture we try to achieve when depicting a mass of tiny flowers making up a plant, or the texture of one flower head that possesses a massed formation of petals – either way, we need to have regard for the individual components and their relationship with each other, as well as for the whole image.

When achieving loose, free interpretations we still benefit from developing drawing and painting skills based upon close observation and detailed execution.

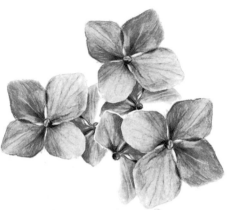

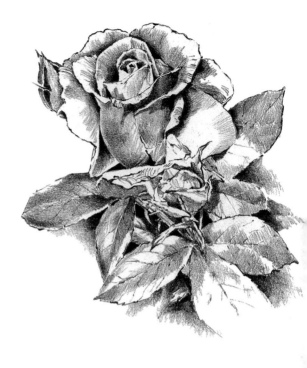

Line

Lines can be seen in the form of veins and markings – many of which 'follow form' and help us depict the flower convincingly – but the use of outlines in our representations requires thought and consideration regarding how and why we are applying them.

Lines can be the result of on/off pressure upon the pencil or brush, and are always interesting when applied in this way. However, for some botanical and illustrative interpretations, a delicate line of even pressure may be what is required.

With the use of a nib pen or a brush, other varieties of linear drawing present themselves in a variety of narrow and wide strokes.

Form

Lines that 'find form' are often applied initially, following contours. When drawn close together they create areas of tone; and a mixture of line and tone, with regard for highlighted areas, helps us achieve a three-dimensional representation. We need to be aware of structure as well as form to avoid our images of flowers becoming flat and therefore uninteresting.

With an artist's eye

Looking beyond the obvious and putting something of ourselves into our interpretations, rather than just drawing what we see, is coupled with how we, as artists, see in a certain way. Throughout this book, drawings and paintings demonstrate how I have been conscious of flowing forms and have imagined more than I can actually see in my subjects.

All these considerations, and many more, are presented within the following themes, and they combine to help us observe the world of flowers with an artist's eye.

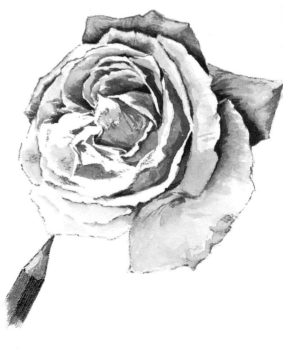

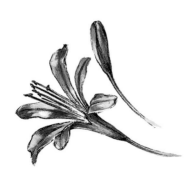

Basic Methods

Bright colourful pansies – with varieties that flower in the winter as well as summer-flowering plants – can be captured effectively in many media. For this reason I have chosen a few cheerful pansy faces, all drawn and painted from life, to demonstrate some of the methods you will find in the themes that follow. In the examples on this page I used Bristol board as a smooth surface support.

A hard H pencil is ideal for line drawing in the form of a simple bud; to tone for colour as well as tone, I used a softer B pencil for delicate directional strokes; softer pencil grades are ideal for quick sketches, and for this technique I used a 4B grade pencil.

Coloured pencils are effective for achieving bright hues, and I used the Derwent Studio range to demonstrate the use of two strong contrasting colours for petal and pattern respectively. Derwent Inktense and watercolour pencils can be used dry or wet, and opposite you can see the effect that can be achieved by adding water to the pigments.

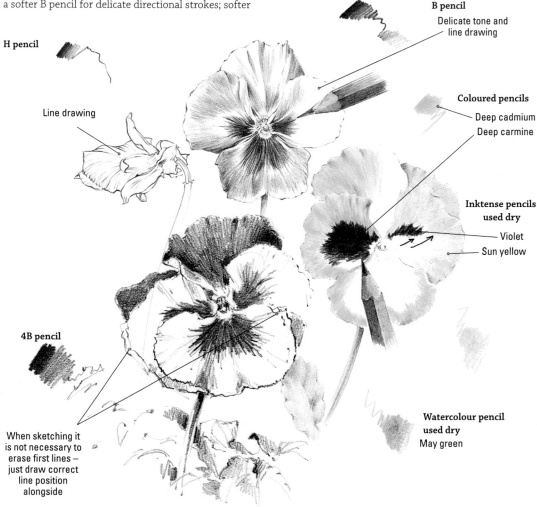

H pencil

Line drawing

B pencil
Delicate tone and
line drawing

Coloured pencils
Deep cadmium
Deep carmine

**Inktense pencils
used dry**
Violet
Sun yellow

4B pencil

When sketching it
is not necessary to
erase first lines –
just draw correct
line position
alongside

**Watercolour pencil
used dry**
May green

Wet media

These studies show three painting media methods: Derwent Inktense pencils, watercolour pencils and pure watercolour.

Inktense pencils

You can either gently sharpen the pencil strip into a palette and add water to mix, or hold it over a palette well and, with a wet brush, pull the pigment into the well.

Watercolour pencils

You can draw the image dry on dry and then add a clear water wash; the colours will blend on the paper when you add water. I have done this here and, with the green areas, added a little red or violet to change the basic colour.

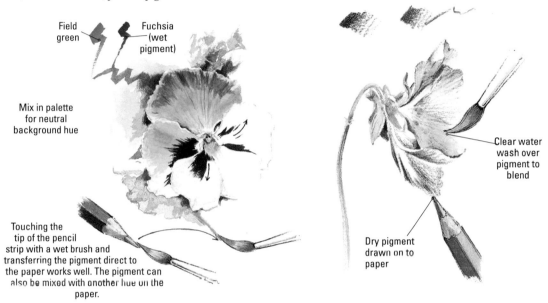

Field green

Fuchsia (wet pigment)

Mix in palette for neutral background hue

Touching the tip of the pencil strip with a wet brush and transferring the pigment direct to the paper works well. The pigment can also be mixed with another hue on the paper.

Clear water wash over pigment to blend

Dry pigment drawn on to paper

Watercolour

This study demonstrates the method of cutting in behind light forms and those that are dark yet possess light edges.

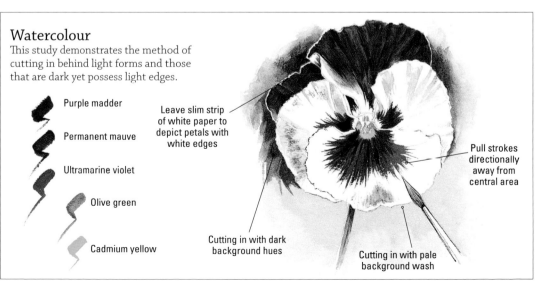

Purple madder

Permanent mauve

Ultramarine violet

Olive green

Cadmium yellow

Leave slim strip of white paper to depict petals with white edges

Pull strokes directionally away from central area

Cutting in with dark background hues

Cutting in with pale background wash

Working from Life

If you were to choose part of a garden as the subject matter for sketching, you might feel that there was so much to absorb visually that you would prefer to leave out certain areas. You can achieve this by simply not including them in your sketch – even though they are still visible in the scene before you.

In this demonstration I have gone one step further and physically removed parts of a pansy plant growing in a pot, so that the eye is not distracted in the final representation.

First sketch

Here I have sketched in everything, even the faded blooms. There was, however, such a profusion of flower heads, stems and leaves, that I decided to break some of them and remove them (to draw them as individual parts later). This left those that remained more clearly defined.

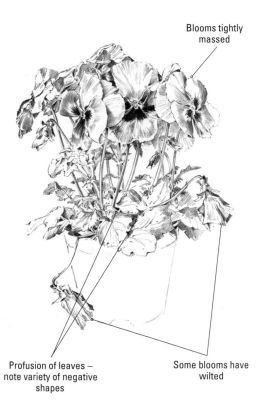

Blooms tightly massed

Profusion of leaves – note variety of negative shapes

Some blooms have wilted

Second sketch

Before making the second sketch I moved the blooms apart slightly. Remember that you can always twist the pot around a little in order to view the flowers from a different angle.

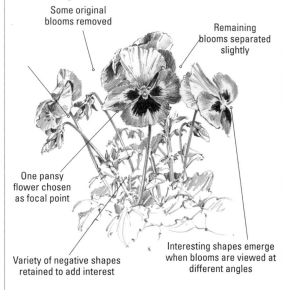

Some original blooms removed

Remaining blooms separated slightly

One pansy flower chosen as focal point

Variety of negative shapes retained to add interest

Interesting shapes emerge when blooms are viewed at different angles

Ink tracing

A tracing is useful in that you can draw over your lines on the reverse of the paper and transfer them lightly on to the prepared surface prior to placing the first areas of colour. In this tracing the lower area was simplified, with some shapes edited out.

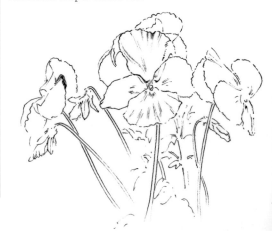

Using sketches

When you start painting you will have both the original sketch and the plant in front of you to refer to. This can be an advantage, as the plant may move slightly as you work if you are painting for any length of time. If it does move – and even a comparatively small amount of movement over a period of time can have a disconcerting effect – you will still have your sketch as a reference.

Blocking in colour

Before painting I prepared a sheet of Bockingford paper by placing a coloured flat wash upon the stretched surface; I used gouache in order to include white in my palette. In the painting I have indicated (a) the first, freely 'drawn' lines and areas of colour; (b) the second application, where hue and tone are intensified; and (c) the building of some initial areas of colour, upon which the final interpretation is placed.

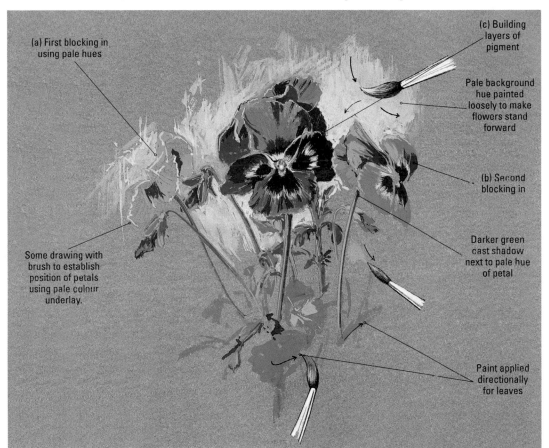

(a) First blocking in using pale hues

(c) Building layers of pigment

Pale background hue painted loosely to make flowers stand forward

(b) Second blocking in

Darker green cast shadow next to pale hue of petal

Some drawing with brush to establish position of petals using pale colour underlay.

Paint applied directionally for leaves

Observing details

There are many advantages to working from life, not least the fact that you can view specimens from various angles. You can also observe details and analyse further by removing individual parts to help you understand the plant's structure. You can hold a part in your free hand or place it on a flat sheet of paper, so you can observe and paint it from various angles.

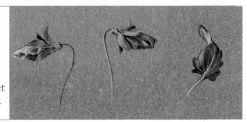

Working from Photographs

If you can obtain clear photographic reference of a plant that you are also able to observe from life, you have the best of both worlds. A two-dimensional image placed alongside your drawing or watercolour paper can be a great help; and to see the actual plant before you – where you can touch it, feeling the texture, and turn it to observe different angles – is an added bonus.

The first illustration shows some typical problems that may be experienced, even with the help of a photo, when beginners do not know how to suggest a three-dimensional form, or how to follow that form with pencil or brushstrokes. Obtaining fluidity of pigment can also be a problem when using watercolour, and overcoming this is explained within some of the following themes.

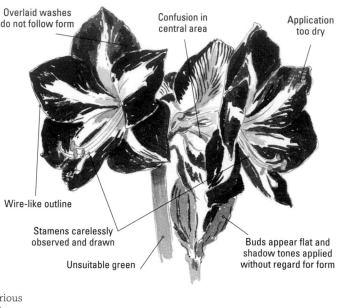

Overlaid washes do not follow form

Confusion in central area

Application too dry

Wire-like outline

Stamens carelessly observed and drawn

Unsuitable green

Buds appear flat and shadow tones applied without regard for form

Depicting detail

With the aid of a camera, you can record various stages of development of a plant such as this amaryllis, and can then use your photos to enable close observation of the intricacies of this fascinating plant, and its progression from bud to flower.

From the first tight bud, through its gentle opening into the revelation of four components emerging from one, these illustrations show in detail the variety of line and tone that combine to present these exciting forms.

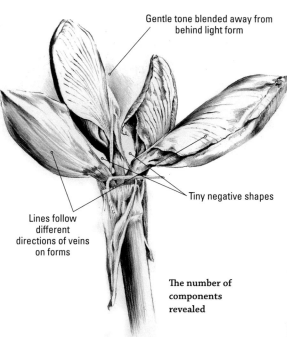

Gentle tone blended away from behind light form

Tiny negative shapes

Lines follow different directions of veins on forms

The number of components revealed

Single bud

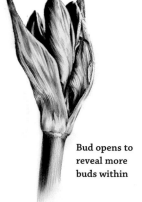

Bud opens to reveal more buds within

Presenting the image in pen and ink

In this study I used a Profipen 0.5 to graze the surface of cartridge paper for the depiction of buds gradually opening.

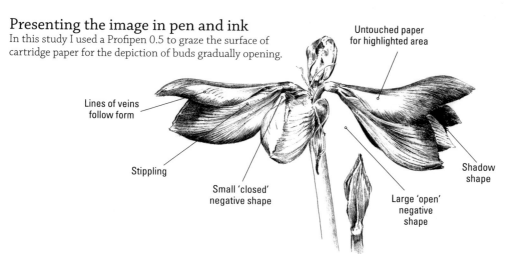

Untouched paper for highlighted area

Lines of veins follow form

Stippling

Small 'closed' negative shape

Large 'open' negative shape

Shadow shape

Working in colour

Watercolour pencils, enabling delicacy of interpretation, were the choice for the next stage, where the petals start spreading to reveal an array of stamens. Gently grazed across the paper's surface, these waxy-textured pencils can be overlaid dry on dry, establishing the image prior to the addition of water.

A great deal can be learnt and understood about plant structure and growth through an exercise like this, where the camera captures each stage of development. Intricately accurate representations using photographic references build a solid base from which we can later choose to move away into spontaneously loose impressions that are successful due to the depth of basic knowledge obtained in this way.

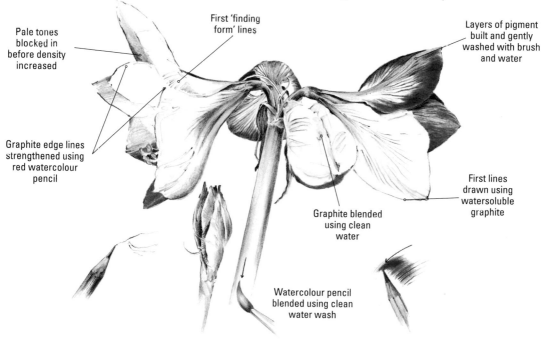

Pale tones blocked in before density increased

First 'finding form' lines

Layers of pigment built and gently washed with brush and water

Graphite edge lines strengthened using red watercolour pencil

First lines drawn using watersoluble graphite

Graphite blended using clean water

Watercolour pencil blended using clean water wash

Planning and Composition

There are a number of factors to take into consideration when planning your composition. On this page I have shown four format options within which you can make your composition – portrait, oval, landscape and circular – and, on the opposite page, the square format, which is less commonly used.

On pages 168–176 you can see a few of the problems that can arise in the drawings and paintings executed by beginners when they are unaware of the importance of planning the composition within which their flowers are to be presented. This section also covers the subjects of editing in and editing out.

Modifying the portrait format

The simple arrangement of a bouquet of flowers in a portrait format can present problems regarding the treatment of a background. These can be solved by using an oval format to contain the arrangement. You can guide the eye into your composition by placing the flowers in an S shape, shown here by the red contoured line.

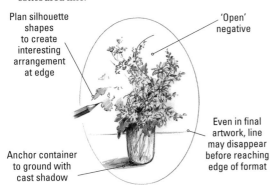

Plan silhouette shapes to create interesting arrangement at edge

'Open' negative

Even in final artwork, line may disappear before reaching edge of format

Anchor container to ground with cast shadow

Working off-centre

By placing the main object of interest slightly off-centre within a busy background, you can avoid the problem of blank, uninteresting areas.

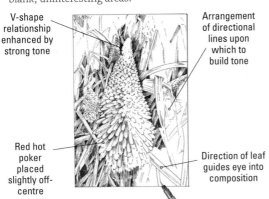

V-shape relationship enhanced by strong tone

Arrangement of directional lines upon which to build tone

Red hot poker placed slightly off-centre

Direction of leaf guides eye into composition

Landscape format

This format offers an opportunity to guide the observer's eye towards the main area of interest by the way the blooms are placed in relation to each other and their foliage background.

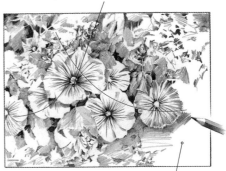

Eye is taken towards focal point of dominant bloom

Area has less content to rest the eye

Circular format

To make a simple circular format more interesting you can bring part of the composition out of the circle by drawing or painting the component on to the mount; if composing your picture within a drawn line, you can go beyond that edge.

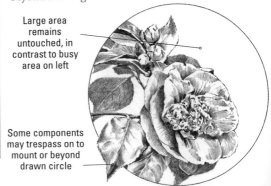

Large area remains untouched, in contrast to busy area on left

Some components may trespass on to mount or beyond drawn circle

Focusing in

Working from a photo reference, this exercise shows how you can change the composition and create more impact by moving in closer to a particular area.

In the first study I decided that the landscape format was being divided in a way that afforded too much consideration for foliage and too little for the splendid blooms of the poppies.

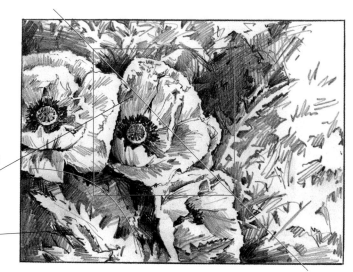

Composition cut in half diagonally

Arrangement of leaves in this area cuts corner off

To solve the problem I decided to concentrate upon one flower in particular, by observing it in close-up and relating it to the format of a square. This produced more interesting comparisons and contrasts of shapes and also limited the amount of green. (See page 166 for the first stages of building this image.)

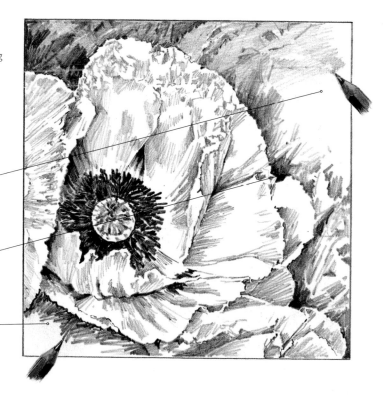

This area does not possess as much content and rests the eye

Cut in crisply – dark against light – to achieve interesting contrasts

Area will be in rich green for strong contrast against pale hue of poppy petal

DEPICTING DETAIL

Whether or not you wish to include in your work every detail you see, close observation of the forms of flowers, stems and leaves is essential. Even if you wish to paint or draw freely, expressing spontaneity and mastering a loose approach, time spent in mastering the basic discipline of sound observational drawing gives a good grounding for which there is no substitute. Without this, there will always be something lacking in freely executed work; with it you can be as free as you wish, and your drawings and paintings will still have conviction.

On the following pages, a variety of media have been used: coloured pencils, watersoluble Graphitint and graphite with watercolour overlay, as well as hard graphite F pencil on Bristol board and B pencil on thin card. When sharpened to a fine point, a softer B pencil provides a delicacy that is suitable for executing smooth contoured tonal strokes.

Pencil exercises

To achieve exciting contrasts of tone it is essential to incorporate a variety of tonal values within your representations and to place the darkest darks directly against white paper (the lightest light). Practise drawing a very fine line first and then tone up to it, cutting in crisply, before toning away to blend into the paper.

The gentle blending involved may be a problem at first, but with practice in varying pencil pressure as you work, your skills will improve. These exercises relate to the methods used for the water lily on page 125.

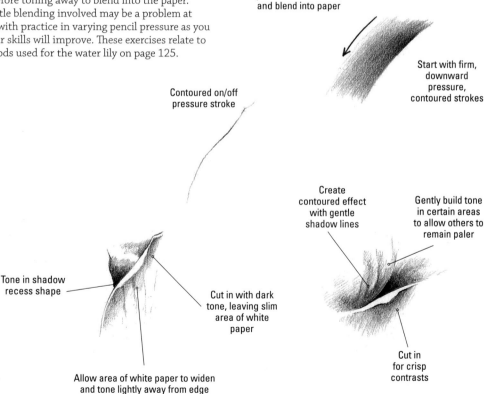

Work across, lifting pressure all the time, and blend into paper

Start with firm, downward pressure, contoured strokes

Contoured on/off pressure stroke

Create contoured effect with gentle shadow lines

Gently build tone in certain areas to allow others to remain paler

Tone in shadow recess shape

Cut in with dark tone, leaving slim area of white paper

Cut in for crisp contrasts

Allow area of white paper to widen and tone lightly away from edge

There are few flat surfaces in botanical subjects, so it is especially important to be aware of which direction you need to tone in order to represent the relevant forms.

Toning exercise

This is a simple exercise to try if you have not yet mastered what I refer to as the 'up to and away' form of toning. For this exercise, draw a firm pressure guideline similar to a petal shape. Starting a little way from the line, use a zigzag movement of the pencil to tone towards (up to) the line. Cut in crisply against the line before toning with a similar movement away from the line. Allow your tone to blend out smoothly, either into another form or a background area. By leaving a strip of paper before doing the same on the other side, you will achieve the effect of a slim petal edge that has been highlighted.

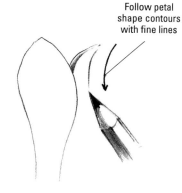

Follow petal shape contours with fine lines

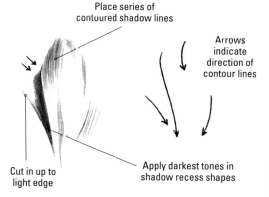

Place series of contoured shadow lines

Arrows indicate direction of contour lines

Cut in up to light edge

Apply darkest tones in shadow recess shapes

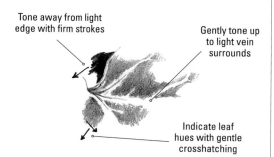

Tone away from light edge with firm strokes

Gently tone up to light vein surrounds

Indicate leaf hues with gentle crosshatching

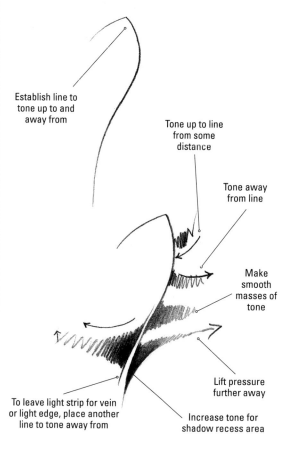

Establish line to tone up to and away from

Tone up to line from some distance

Tone away from line

Make smooth masses of tone

Lift pressure further away

Increase tone for shadow recess area

To leave light strip for vein or light edge, place another line to tone away from

Coloured pencil exercises

A natural progression from monochrome drawing is to introduce colour using the same techniques.

The exercises here demonstrate how delicacy of application can produce sensitive detail drawing and how retention of the white paper surface introduces effective highlights.

Starting with a pale underlay, you can gradually build stronger hue and tone in subsequent overlays to increase intensity as you describe the form with directional application of pigment.

Watersoluble pencil exercises

The subtle hues that result from using pencil as both a wet and a dry medium – can be exciting to work with and are particularly suitable for flowers and foliage.

It is always a good idea to experiment first with different paper surfaces before committing to one in particular. These examples were made on Saunders Waterford HP paper; other papers will produce different results.

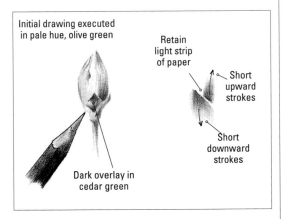

Initial drawing executed in pale hue, olive green

Retain light strip of paper

Short upward strokes

Short downward strokes

Dark overlay in cedar green

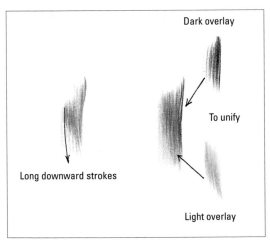

Dark overlay

To unify

Long downward strokes

Light overlay

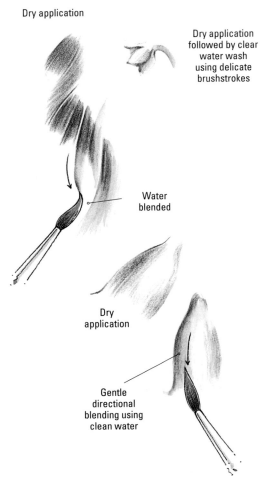

Dry application

Dry application followed by clear water wash using delicate brushstrokes

Water blended

Dry application

Gentle directional blending using clean water

Mixed media

A detailed graphite pencil drawing can be enhanced by the application of watercolour painted overlays, as shown on page 127. A smooth white paper surface was used here so that a fine detail drawing could be established before adding directionally placed watercolour wash overlays.

The pencil and brush movements are similar – with the exception of upward and downward pressure strokes with the brush, which produce wide brushstrokes that can be swept across areas of the paper to indicate the delicacy of veins and petals.

Be careful to mix enough water with your pigment and to make enough to last through the entire painting. When all washes have dried, you can add further pencil strokes to enhance the depth of tone in certain areas.

Pencil movements

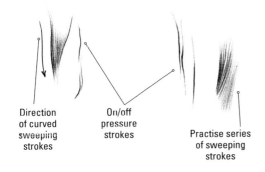

Direction of curved sweeping strokes

On/off pressure strokes

Practise series of sweeping strokes

Fine vein strokes

Direction of delicate on/off pressure vein stroke

Brush movements

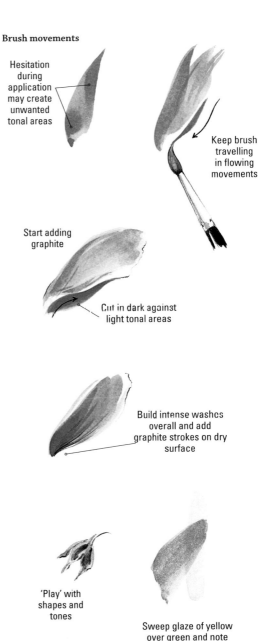

Hesitation during application may create unwanted tonal areas

Keep brush travelling in flowing movements

Start adding graphite

Cut in dark against light tonal areas

Build intense washes overall and add graphite strokes on dry surface

'Play' with shapes and tones

Sweep glaze of yellow over green and note effect

Problems

Foxglove

Foxgloves have many attributes that make them interesting subjects. The study here looks at the detail of pattern within the bell-shaped blooms and how the pattern marks follow the shape of the flower.

Beginners sometimes experience problems when attempting to depict the interiors of these flowers and the way the pattern follows the contoured recesses.

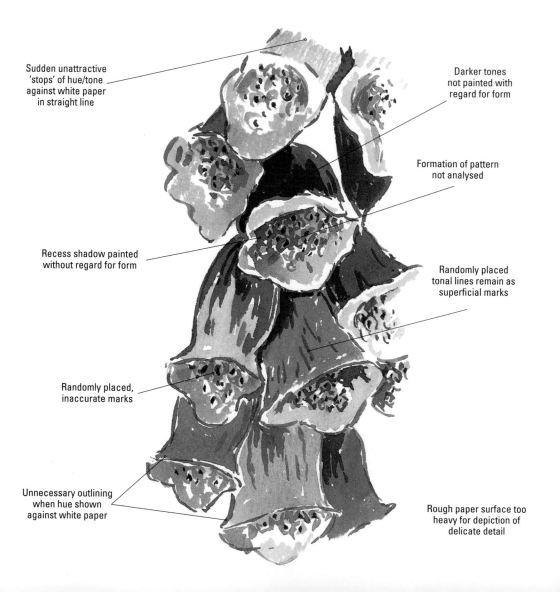

Sudden unattractive 'stops' of hue/tone against white paper in straight line

Darker tones not painted with regard for form

Formation of pattern not analysed

Recess shadow painted without regard for form

Randomly placed tonal lines remain as superficial marks

Randomly placed, inaccurate marks

Unnecessary outlining when hue shown against white paper

Rough paper surface too heavy for depiction of delicate detail

I have chosen one main bloom to demonstrate in detail how the prolific pattern is arranged within the bell-shaped flower. It is helpful to treat a subject like this as a monochrome study, concentrating more fully upon tonal values, but I have introduced a blue (to mix with the purple madder) to help indicate shadow areas.

Tonal values in purple madder

Shadow tones

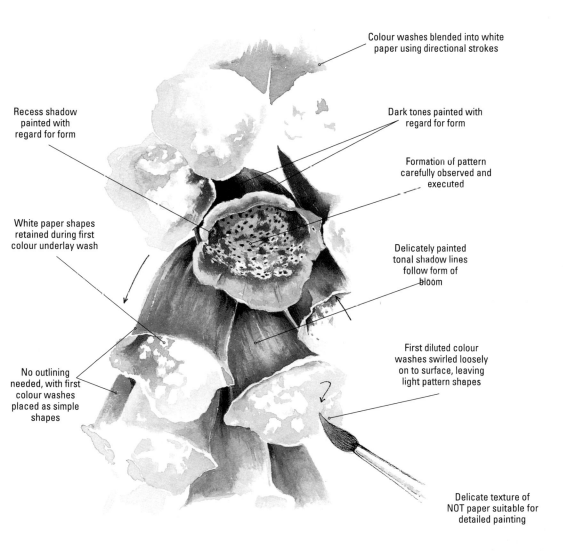

Colour washes blended into white paper using directional strokes

Recess shadow painted with regard for form

Dark tones painted with regard for form

Formation of pattern carefully observed and executed

White paper shapes retained during first colour underlay wash

Delicately painted tonal shadow lines follow form of bloom

First diluted colour washes swirled loosely on to surface, leaving light pattern shapes

No outlining needed, with first colour washes placed as simple shapes

Delicate texture of NOT paper suitable for detailed painting

Problems

Water Lily

This popular water plant, with its large floating leaves, allows the artist to make interesting comparisons between the two different forms of flower and leaf.

The numerous petals, which open out to reveal an array of tiny forms within, offer exciting contrasts to the large, flat leaves, floating above submerged shapes that can just be discerned below the water's surface.

Beginners may not be aware of the vast choice of materials available or how important it is to experiment in order to choose the most suitable combinations for their own style.

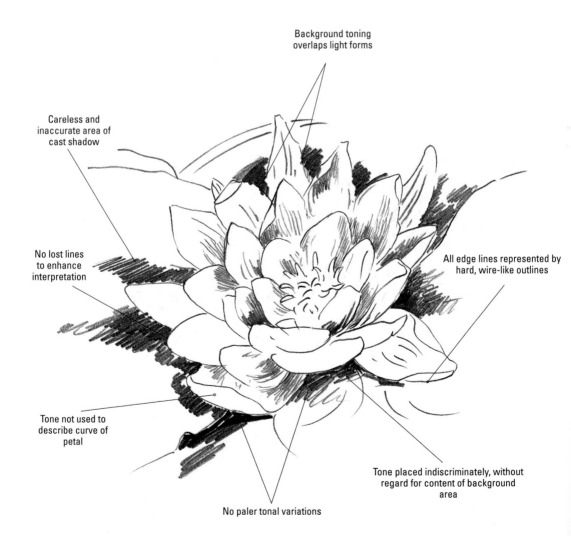

Background toning overlaps light forms

Careless and inaccurate area of cast shadow

No lost lines to enhance interpretation

All edge lines represented by hard, wire-like outlines

Tone not used to describe curve of petal

Tone placed indiscriminately, without regard for content of background area

No paler tonal variations

Solutions

Delicate application is essential for detailed drawings of this nature – to indicate tone or fine edge lines that describe the form. Some of the latter can subsequently be absorbed into the tonal areas, while others can be enhanced to add interest.

Highlighted petals contrasting with dark shadow recess shapes and areas of cast shadow can be depicted in detail using a finely sharpened graphite pencil; I used a hard F pencil on Bristol Board to achieve a smooth impression.

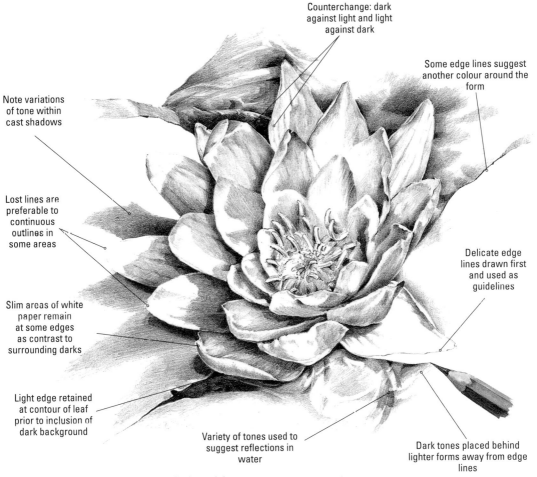

Counterchange: dark against light and light against dark

Some edge lines suggest another colour around the form

Note variations of tone within cast shadows

Lost lines are preferable to continuous outlines in some areas

Delicate edge lines drawn first and used as guidelines

Slim areas of white paper remain at some edges as contrast to surrounding darks

Light edge retained at contour of leaf prior to inclusion of dark background

Variety of tones used to suggest reflections in water

Dark tones placed behind lighter forms away from edge lines

Test a variety of pencils to discover which work best for you. These marks were made with Derwent Graphic pencils on Bristol Board.

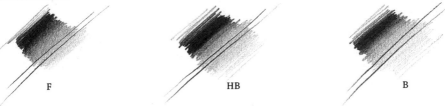

F HB B

Problems

Sweet Pea

The delicacy of a sweet pea plant can be captured using a detailed pencil drawing that has a tinted overlay painted with watersoluble pencils.

Problems can often arise when a paper is used that is unsuitable for this approach: lightweight drawing paper is inclined to cockle under the application of water, and even thin white card can often be preferable to the more textured surfaces of some drawing papers.

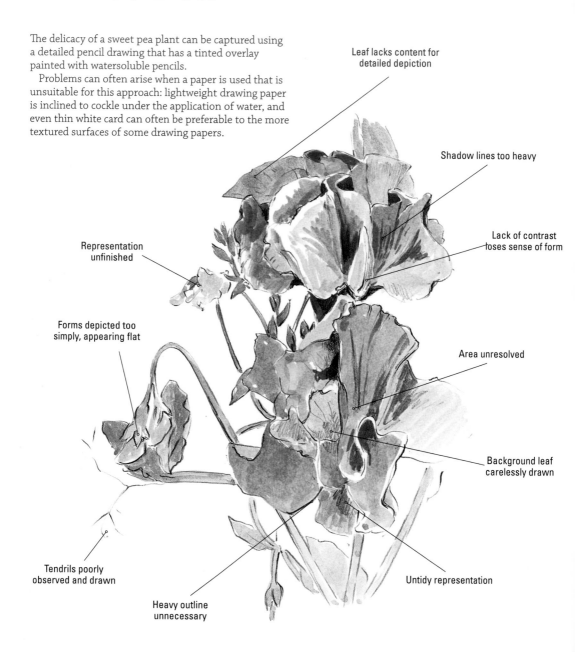

Leaf lacks content for detailed depiction

Shadow lines too heavy

Lack of contrast loses sense of form

Representation unfinished

Forms depicted too simply, appearing flat

Area unresolved

Background leaf carelessly drawn

Tendrils poorly observed and drawn

Heavy outline unnecessary

Untidy representation

Solutions

Derwent Inktense pencils were used as overlay pigment on the pencil drawing here, and both pencil and brushstrokes follow the contours of petals and leaves. Intensity of hue and tone were built with wet-on-dry overlaid washes, which were not too wet to control. A smooth white paper surface combined with a relatively hard pencil – a 2B – can help retain a crispness of drawing that is not lost with the introduction of a tint.

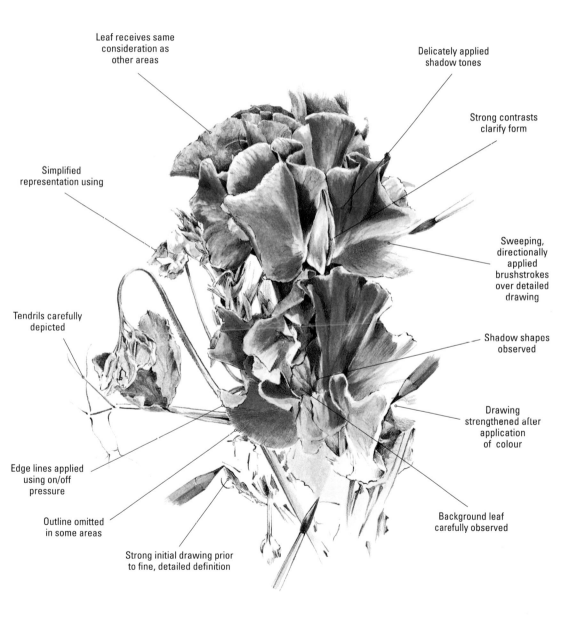

Leaf receives same consideration as other areas

Delicately applied shadow tones

Strong contrasts clarify form

Simplified representation using

Sweeping, directionally applied brushstrokes over detailed drawing

Tendrils carefully depicted

Shadow shapes observed

Drawing strengthened after application of colour

Edge lines applied using on/off pressure

Outline omitted in some areas

Strong initial drawing prior to fine, detailed definition

Background leaf carefully observed

Drawing exercises

This theme covers the importance of accurate observation and representation, established in preliminary drawings, where guidelines and negative shapes help in setting the relationship between components.

When working from photographs, guidelines are easy to use. When working from life, you may experience difficulties if the plant moves: in this situation, quick investigative sketches are an advantage. Wandering lines and guidelines can be worked alongside accurate observation of negative shapes and 'shapes between' to achieve a correct placing of blooms, stems and leaves.

Here I have drawn an arrangement of dahlia blooms presented at different angles, using just a few essential guidelines to place the flower heads in relation to each other, the leaves and stems. The pencil exercises relate to the strokes used for the dahlia on page 133.

Defining negative shapes

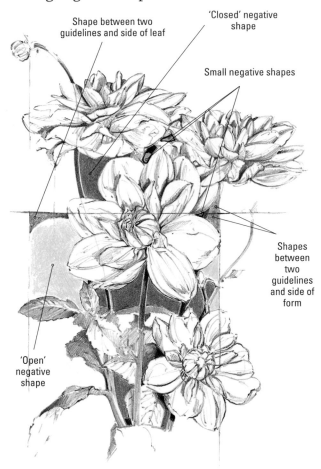

Shape between two guidelines and side of leaf

'Closed' negative shape

Small negative shapes

Shapes between two guidelines and side of form

'Open' negative shape

Transferring the image to watercolour paper

You can place tracing paper over the initial pencil drawing – either at a window or using a lightbox – and trace on to the tracing paper using pen and ink. Next, lay watercolour paper over the tracing paper and draw over your ink lines with pencil to imprint the image on to the paper. This method is quicker and more accurate than the method of using pencil on both sides of the tracing paper.

Pen and ink exercises

Graphite pencil exercises
These exercises relate to the image of the dahlia on page 133.

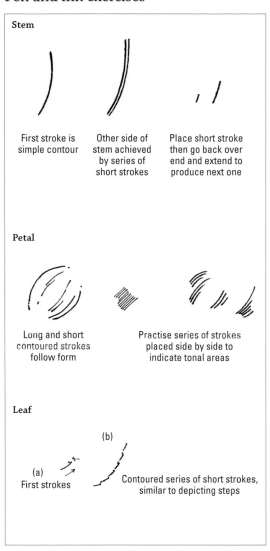

Stem

First stroke is simple contour

Other side of stem achieved by series of short strokes

Place short stroke then go back over end and extend to produce next one

Petal

Long and short contoured strokes follow form

Practise series of strokes placed side by side to indicate tonal areas

Leaf

(a) First strokes

(b)

Contoured series of short strokes, similar to depicting steps

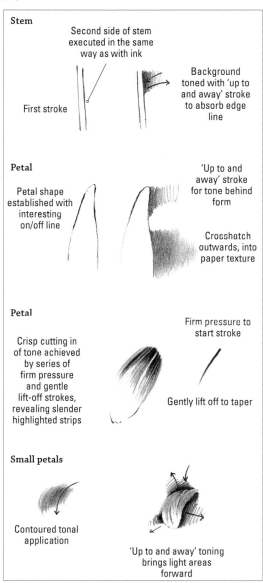

Stem

Second side of stem executed in the same way as with ink

First stroke

Background toned with 'up to and away' stroke to absorb edge line

Petal

Petal shape established with interesting on/off line

'Up to and away' stroke for tone behind form

Crosshatch outwards, into paper texture

Petal

Crisp cutting in of tone achieved by series of firm pressure and gentle lift-off strokes, revealing slender highlighted strips

Firm pressure to start stroke

Gently lift off to taper

Small petals

Contoured tonal application

'Up to and away' toning brings light areas forward

Watercolour exercises

It is often helpful to use black-and-white photographic reference in order to understand tonal values, and once you are familiar with the method of overlaying washes of diluted pigment – wet over dry – you can have fun with them.

Monochrome mix

A useful neutral hue can be obtained by mixing two colours, and this example shows how it appears when gradated; it is presented here in abstract form, while on page 137 it is used in relation to a complex arrangement of leaves behind white daisy petals. Start with one of the paler tones and apply sweeping brushstrokes loosely in different directions. Allow to dry before crisscrossing subsequent strokes. Finally, fill in some really dark areas as shadow recess negative shapes – these will be the darkest darks of a background and will cut in against light petals, leaves and stems.

Brown madder alizarin Winsor blue Useful neutral

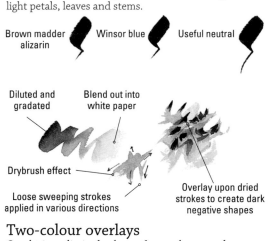

Diluted and gradated

Blend out into white paper

Drybrush effect

Loose sweeping strokes applied in various directions

Overlay upon dried strokes to create dark negative shapes

Two-colour overlays

Overlaying a limited palette of two colours produces more variety, as you can see on page 135. Practise building overlays using two colours; here I used purple madder and rose madder genuine.

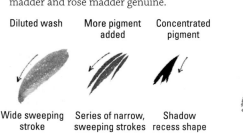

Diluted wash More pigment added Concentrated pigment

Wide sweeping stroke Series of narrow, sweeping strokes Shadow recess shape

Overlaying watercolour

Using the same colour throughout for both blooms and leaves, various tones are produced by the overlay method.

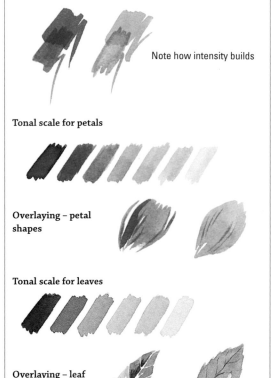

Note how intensity builds

Tonal scale for petals

Overlaying – petal shapes

Tonal scale for leaves

Overlaying – leaf shapes

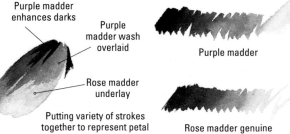

Purple madder enhances darks

Purple madder wash overlaid

Purple madder

Rose madder underlay

Putting variety of strokes together to represent petal

Rose madder genuine

Graphitint pencil

The delicate hues in the exercises shown here relate to the image on page 165.

Watersoluble coloured pencil with graphite pencil

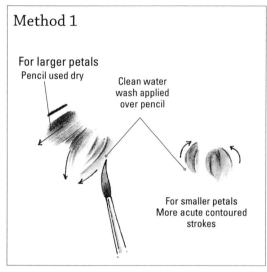

Method 1

For larger petals
Pencil used dry

Clean water wash applied over pencil

For smaller petals
More acute contoured strokes

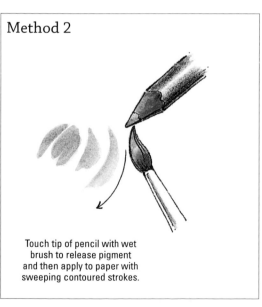

Method 2

Touch tip of pencil with wet brush to release pigment and then apply to paper with sweeping contoured strokes.

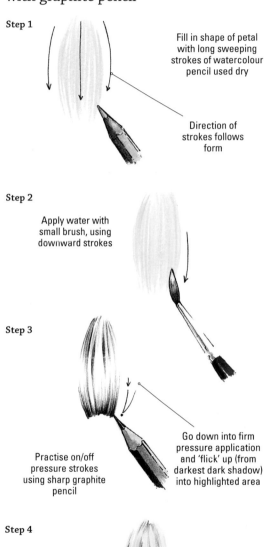

Step 1

Fill in shape of petal with long sweeping strokes of watercolour pencil used dry

Direction of strokes follows form

Step 2

Apply water with small brush, using downward strokes

Step 3

Practise on/off pressure strokes using sharp graphite pencil

Go down into firm pressure application and 'flick' up (from darkest dark shadow) into highlighted area

Step 4

Tone overlay cuts in against areas of white paper retained to represent strongest highlights

Pull down into rich dark shadow recess areas, with regard for shape against which strokes are placed

Problems

Dahlia Heads

Pencil is an excellent medium for defining the delicate forms of petals accurately. Two methods are shown here. The first uses pencil, gently overlaying tone upon tone to increase intensity; in the second example, watercolour pencil is overlaid with graphite pencil.

Problems that may occur with both styles of representation, some of which are caused by lack of close observation or lack of understanding relating to plant formation, are illustrated on this page.

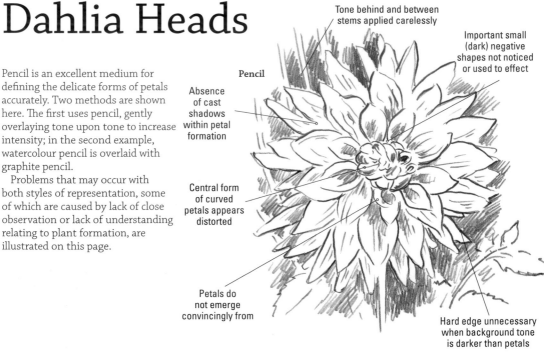

Pencil

Tone behind and between stems applied carelessly

Important small (dark) negative shapes not noticed or used to effect

Absence of cast shadows within petal formation

Central form of curved petals appears distorted

Petals do not emerge convincingly from

Hard edge unnecessary when background tone is darker than petals

Pencil and watersoluble pencils

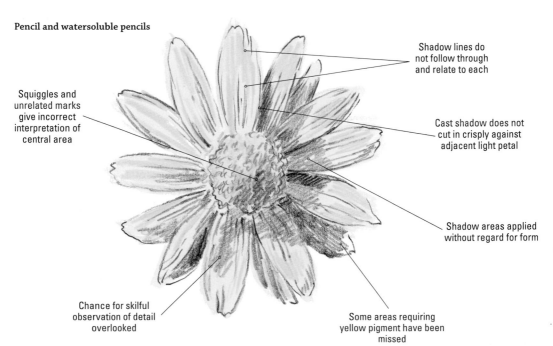

Squiggles and unrelated marks give incorrect interpretation of central area

Shadow lines do not follow through and relate to each

Cast shadow does not cut in crisply against adjacent light petal

Shadow areas applied without regard for form

Chance for skilful observation of detail overlooked

Some areas requiring yellow pigment have been missed

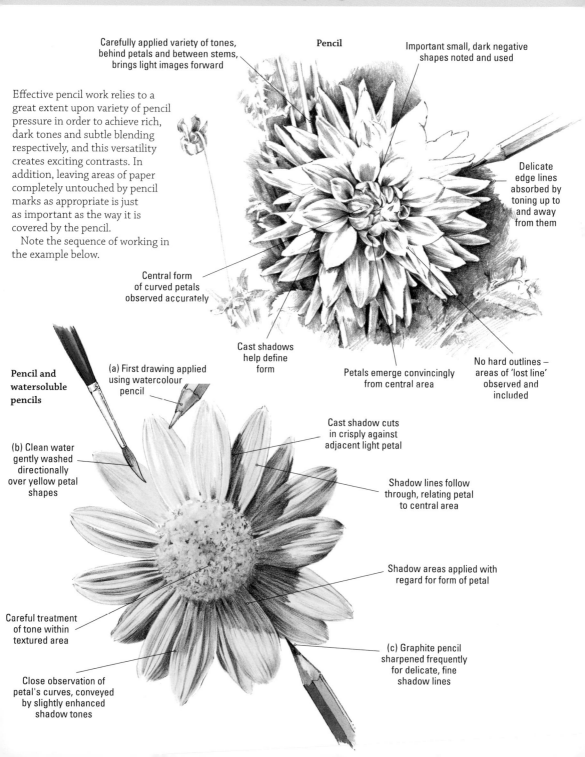

Pencil

Carefully applied variety of tones, behind petals and between stems, brings light images forward

Important small, dark negative shapes noted and used

Effective pencil work relies to a great extent upon variety of pencil pressure in order to achieve rich, dark tones and subtle blending respectively, and this versatility creates exciting contrasts. In addition, leaving areas of paper completely untouched by pencil marks as appropriate is just as important as the way it is covered by the pencil.

Note the sequence of working in the example below.

Delicate edge lines absorbed by toning up to and away from them

Central form of curved petals observed accurately

Cast shadows help define form

Petals emerge convincingly from central area

No hard outlines – areas of 'lost line' observed and included

Pencil and watersoluble pencils

(a) First drawing applied using watercolour pencil

Cast shadow cuts in crisply against adjacent light petal

Shadow lines follow through, relating petal to central area

(b) Clean water gently washed directionally over yellow petal shapes

Shadow areas applied with regard for form of petal

Careful treatment of tone within textured area

(c) Graphite pencil sharpened frequently for delicate, fine shadow lines

Close observation of petal's curves, conveyed by slightly enhanced shadow tones

Problems

Chrysanthemum

Limiting a palette to only two colours allows you to concentrate fully upon tonal values and the method of paint application. If you divide your chosen colour into different strengths in separate palette wells, you can keep working and maintain flow without having to break off to remix paint. After the initial drawing has been transferred to watercolour paper, a diluted mix of the shadow colour can be applied within the shadow shape areas, leaving quite a lot of white paper. Beginners often experience problems by covering too much white paper and losing the opportunity to retain highlighted areas, resulting in a flat overall interpretation.

There can also be problems with regard to the inclusion of rich dark shadow areas, resulting in lack of contrast and, again, a flat interpretation.

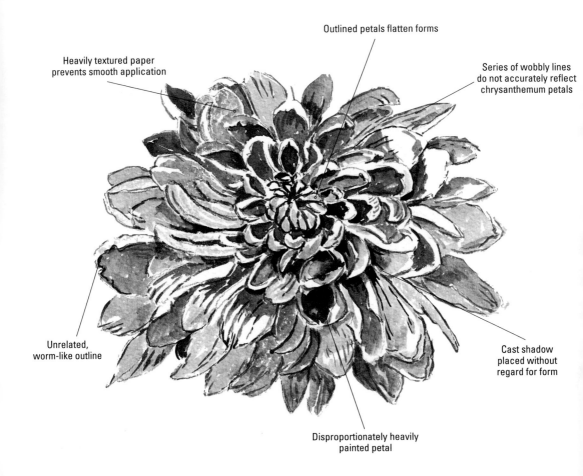

Outlined petals flatten forms

Heavily textured paper
prevents smooth application

Series of wobbly lines
do not accurately reflect
chrysanthemum petals

Unrelated,
worm-like outline

Cast shadow
placed without
regard for form

Disproportionately heavily
painted petal

By observing the shapes of shadows – both shadow recess shapes and cast shadow shapes – and forgetting the subject matter when you start the painting, you will be able to interpret an image accurately.

Here I started by depicting contoured shapes to establish the relationships of the petals and provide a base for the painting: I used guidelines to help place the petals (a), painted a first coat in the shadow tone areas (b), erased the pencil marks when the coat was dry (c), and washed over the petal shapes, retaining some of the untouched paper to represent highlighted areas (d). When this wash was dry, I applied a strong mix of the first colour to the dark areas (e), and lightly indicated the impression of other background blooms using sweeping brushstrokes (f).

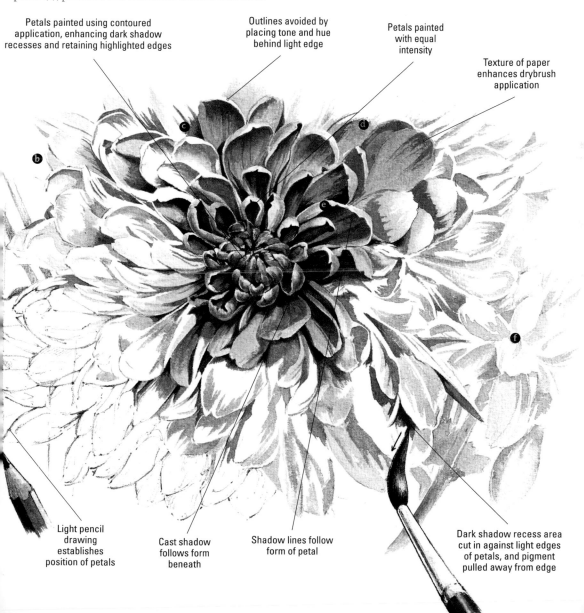

Petals painted using contoured application, enhancing dark shadow recesses and retaining highlighted edges

Outlines avoided by placing tone and hue behind light edge

Petals painted with equal intensity

Texture of paper enhances drybrush application

Light pencil drawing establishes position of petals

Cast shadow follows form beneath

Shadow lines follow form of petal

Dark shadow recess area cut in against light edges of petals, and pigment pulled away from edge

Problems

Daisies

Some of the problems encountered by beginners in their representation of background areas are experienced due to the inclusion of unnecessary outlines as they attempt to indicate each leaf in its entirety – resulting in a flat pattern effect. Lack of knowledge regarding tonal values, and failing to notice the numerous negative shapes in background areas, will result in confusion and can cause the artwork to be abandoned in frustration.

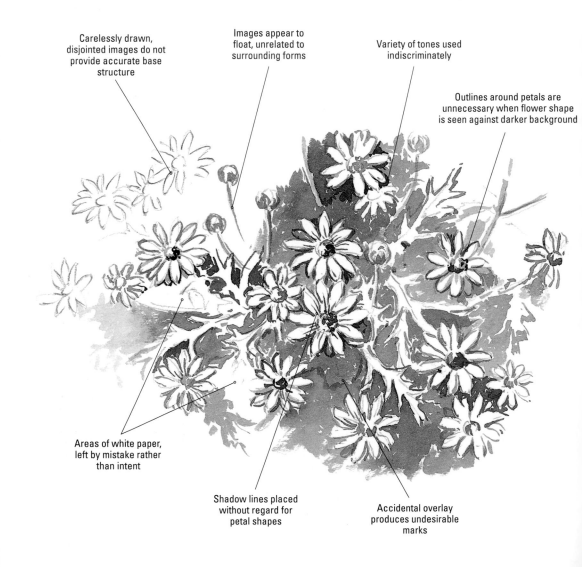

Carelessly drawn, disjointed images do not provide accurate base structure

Images appear to float, unrelated to surrounding forms

Variety of tones used indiscriminately

Outlines around petals are unnecessary when flower shape is seen against darker background

Areas of white paper, left by mistake rather than intent

Shadow lines placed without regard for petal shapes

Accidental overlay produces undesirable marks

Here swiftly applied brushstrokes, overlaying tonal washes, combine with more considered strokes applied to negative shadow shapes between the leaves and the flower petals.

I am not trying to depict every leaf behind the blooms in detail, but aiming to achieve an overall impression of the foliage background to make the startling contrast of the white daisies apparent. The blooms are seen against a broad spectrum of tonal values that have been painted quite quickly and loosely, as a support to the main subject matter, the flower heads.

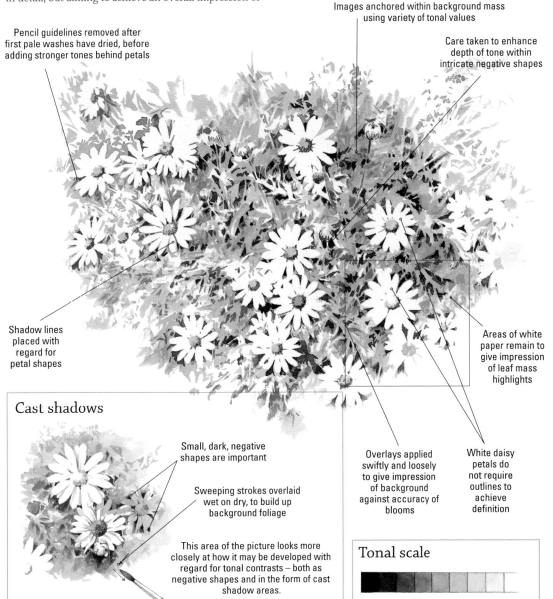

Images anchored within background mass using variety of tonal values

Care taken to enhance depth of tone within intricate negative shapes

Pencil guidelines removed after first pale washes have dried, before adding stronger tones behind petals

Shadow lines placed with regard for petal shapes

Areas of white paper remain to give impression of leaf mass highlights

Cast shadows

Small, dark, negative shapes are important

Sweeping strokes overlaid wet on dry, to build up background foliage

This area of the picture looks more closely at how it may be developed with regard for tonal contrasts – both as negative shapes and in the form of cast shadow areas.

Overlays applied swiftly and loosely to give impression of background against accuracy of blooms

White daisy petals do not require outlines to achieve definition

Tonal scale

MONOCHROME AND
COLOUR CO-ORDINATED

Working in monochrome, in whatever medium you choose, encourages consideration for tonal values. This theme also covers toning for colour as well as tone, and demonstrates a combination of graphite pencil drawing as a background for watercolour painting. Working with a limited palette is to be encouraged as part of

the learning process – see pages 143 (within a single plant) and 145 (a single species, but different coloured blooms), and in profusion of growth on pages 149 and 151. On page 145 I have also related monochrome toning to colour.

Pencil exercises

The white flowers on page 147 are drawn in monochrome, and it is with this that the exercises here start, showing how darker background drawing, behind light petals, encourages them to come forward.

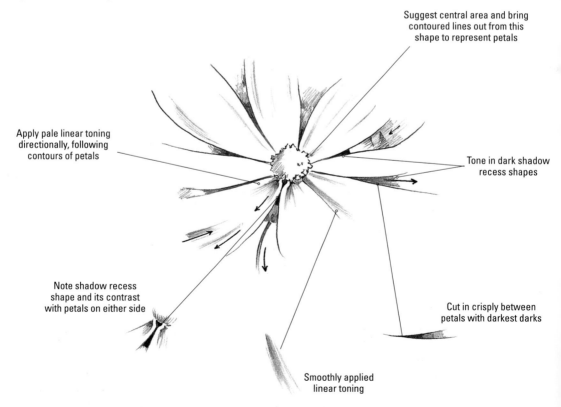

Suggest central area and bring contoured lines out from this shape to represent petals

Apply pale linear toning directionally, following contours of petals

Tone in dark shadow recess shapes

Note shadow recess shape and its contrast with petals on either side

Cut in crisply between petals with darkest darks

Smoothly applied linear toning

Making studies

Preliminary studies can also take the form of exercises, and on page 143 you will see the painting that resulted from these two investigative sketches. When you have a plant that possesses numerous buds at the same time as open flowers, such as a lupin, it is a good idea to separate the two by executing detailed observational studies of the respective areas.

Preliminary monochrome sketches will help you understand the structure and formation of buds, blooms and leaves. All these then need to be considered in relation to each other and to the supporting stem.

Monochrome study
showing tight formation
of topmost buds

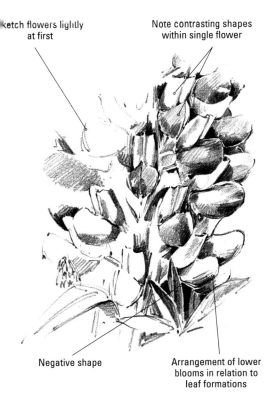

ketch flowers lightly
at first

Note contrasting shapes
within single flower

Negative shape

Arrangement of lower
blooms in relation to
leaf formations

Hydrangea

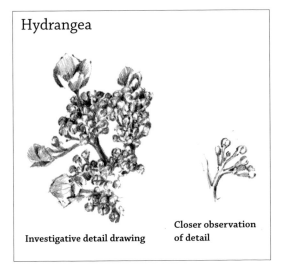

Investigative detail drawing

Closer observation
of detail

Watercolour exercises

After the observational drawings on the previous pages,
analysing the structure of individual parts, some simple
brush exercises to help with the depiction of the plant
are shown here.

One-stroke leaf shape

Leaves can be executed with sweeping strokes, and it
is a good idea to loosen up by practising these brush
movements before attempting to paint a finished study.

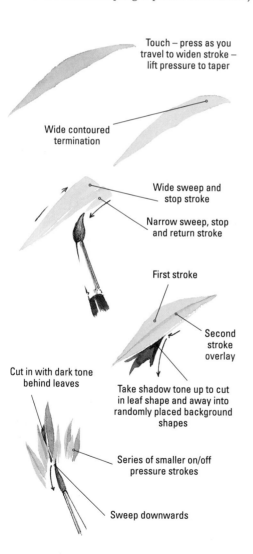

Touch – press as you
travel to widen stroke –
lift pressure to taper

Wide contoured
termination

Wide sweep and
stop stroke

Narrow sweep, stop
and return stroke

First stroke

Second
stroke
overlay

Cut in with dark tone
behind leaves

Take shadow tone up to cut
in leaf shape and away into
randomly placed background
shapes

Series of smaller on/off
pressure strokes

Sweep downwards

Directional tonal application

Short, sweeping strokes, applied in a different way to
those used for lupin leaves, work together to create
images of delicate sweet pea flowers, cutting in
behind the forms.

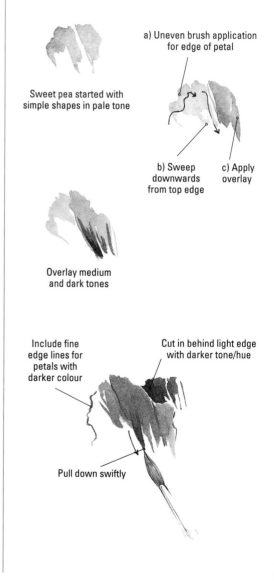

a) Uneven brush application
for edge of petal

Sweet pea started with
simple shapes in pale tone

b) Sweep
downwards
from top edge

c) Apply
overlay

Overlay medium
and dark tones

Include fine
edge lines for
petals with
darker colour

Cut in behind light edge
with darker tone/hue

Pull down swiftly

Retaining white paper

Many beginners experience problems with the method of initially leaving white paper within areas of profuse activity (shapes and colours) in order to paint in lighter hues as the picture progresses. Preliminary considerations and the method are explained on pages 149 and 151; in order to clarify this process further, here are a few exercises to try. I have simplified shapes and accentuated angles: the latter give strength to structure and crispness to images.

Two methods are demonstrated here in the form of simple brush exercises: (a) painting foliage hue around (and away from) the shapes you intend to paint in other colours; (b) painting flower shapes first in order to create a foliage mass effect behind. In both methods, some white paper is still retained to add sparkle and crispness to the execution.

Should you wish to reduce the effect of these areas, delicate overlays can be added in the final stages of the painting – but do not subdue them all if you wish to retain a lively effect.

Painting around flower shapes

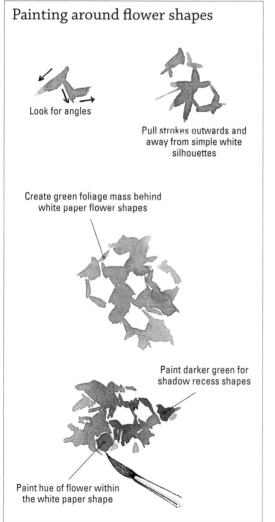

Look for angles

Pull strokes outwards and away from simple white silhouettes

Create green foliage mass behind white paper flower shapes

Paint darker green for shadow recess shapes

Paint hue of flower within the white paper shape

Flower shapes painted first

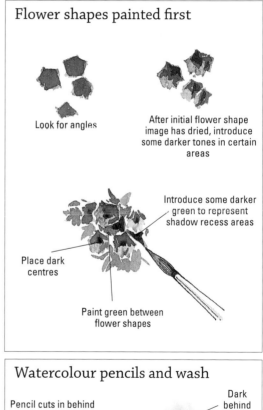

Look for angles

After initial flower shape image has dried, introduce some darker tones in certain areas

Introduce some darker green to represent shadow recess areas

Place dark centres

Paint green between flower shapes

Watercolour pencils and wash

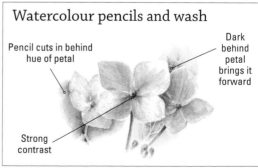

Pencil cuts in behind hue of petal

Dark behind petal brings it forward

Strong contrast

Problems

Lupin

Lupins comprise highly ornamental flower racemes or
spikes. The flowers are pea-like and have many colour
variations, some in contrasting colours.

Beginners can have problems when representing
such many-flowered plants, and these can include
painting too many outlines and painting them too
heavily; negative and background shapes can also
be troublesome.

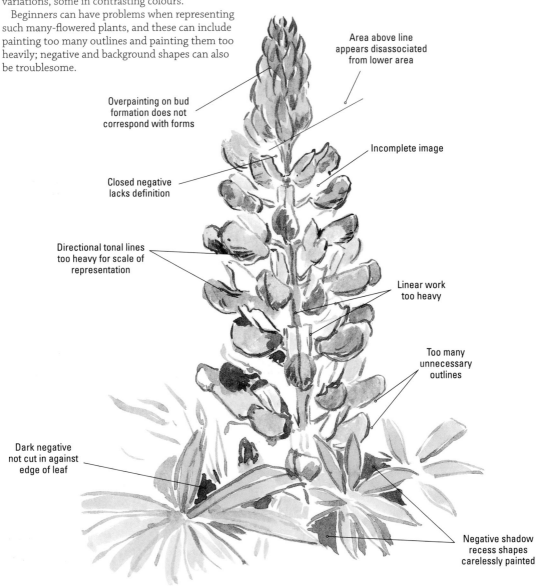

Overpainting on bud
formation does not
correspond with forms

Area above line
appears disassociated
from lower area

Incomplete image

Closed negative
lacks definition

Directional tonal lines
too heavy for scale of
representation

Linear work
too heavy

Too many
unnecessary
outlines

Dark negative
not cut in against
edge of leaf

Negative shadow
recess shapes
carelessly painted

Overlaying hue and tone in the form of translucent washes – wet over dry – with regard for directional application helps define forms in relation to each other. A series of contoured arrows within the central area of this illustration shows how these forms developed.

Lightweight papers are suitable for small watercolour wash areas: this was executed on Saunders Waterford 180gsm (90lb) Rough paper.

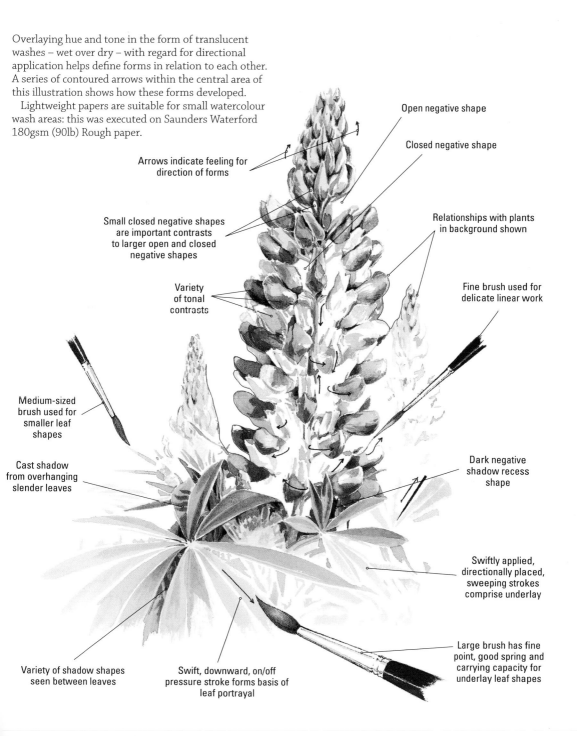

Open negative shape

Closed negative shape

Arrows indicate feeling for
direction of forms

Relationships with plants
in background shown

Small closed negative shapes
are important contrasts
to larger open and closed
negative shapes

Fine brush used for
delicate linear work

Variety
of tonal
contrasts

Medium-sized
brush used for
smaller leaf
shapes

Cast shadow
from overhanging
slender leaves

Dark negative
shadow recess
shape

Swiftly applied,
directionally placed,
sweeping strokes
comprise underlay

Variety of shadow shapes
seen between leaves

Swift, downward, on/off
pressure stroke forms basis of
leaf portrayal

Large brush has fine
point, good spring and
carrying capacity for
underlay leaf shapes

Sweet Peas

These pea-shaped blooms demonstrate how a range of similar hues co-ordinates when flowers are displayed in a vase. The delicately curved petals vie with each other in swirls of visual movement, interspersed by contoured stems.

Monochrome studies lose clarity if consideration for colour and tone are omitted, and the artist needs to decide where to place tonal areas that indicate shadow recess and cast shadows, and where to apply tone that suggests one bloom is stronger, brighter or darker than another. These considerations frequently present problems for beginners, who find they are portraying a confusion, rather than a profusion, of blooms.

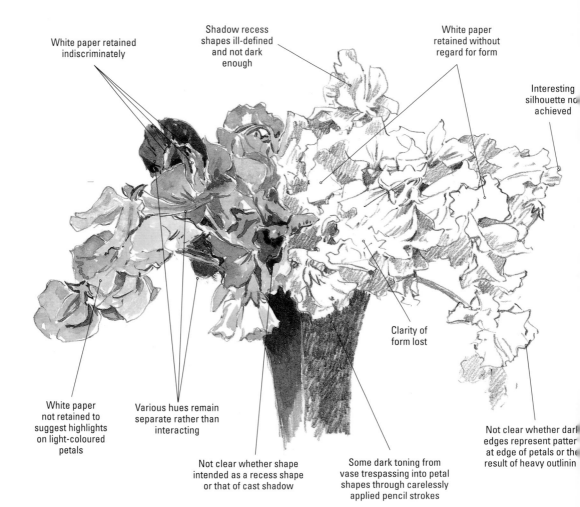

White paper retained indiscriminately

Shadow recess shapes ill-defined and not dark enough

White paper retained without regard for form

Interesting silhouette no achieved

Clarity of form lost

White paper not retained to suggest highlights on light-coloured petals

Various hues remain separate rather than interacting

Not clear whether shape intended as a recess shape or that of cast shadow

Some dark toning from vase trespassing into petal shapes through carelessly applied pencil strokes

Not clear whether darl edges represent patter at edge of petals or the result of heavy outlinin

By combining colour and monochrome representation within a single study, you can incorporate both a regard for tonal values in a colour representation and a regard for colour within a tonal representation. This can be particularly rewarding and lead to rich, exciting results.

Whether you are portraying a number of sprays in a large container or a couple in a specimen vase, the same considerations apply: try to retain a sense of movement in the arrangement and use negative shapes – both dark and light – to hold the display together.

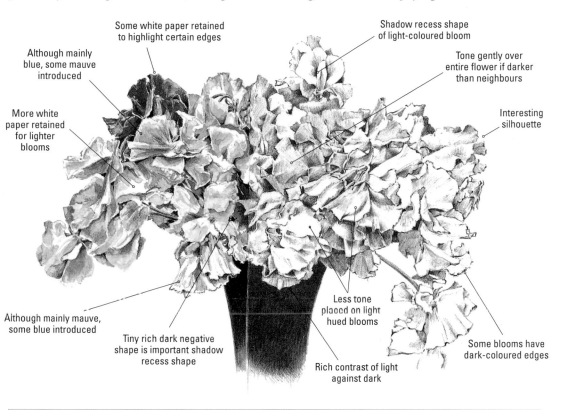

Some white paper retained to highlight certain edges

Shadow recess shape of light-coloured bloom

Although mainly blue, some mauve introduced

Tone gently over entire flower if darker than neighbours

More white paper retained for lighter blooms

Interesting silhouette

Although mainly mauve, some blue introduced

Tiny rich dark negative shape is important shadow recess shape

Less tone placed on light hued blooms

Rich contrast of light against dark

Some blooms have dark-coloured edges

Pen and ink
Executed on a lightweight textured surface using a 0.1 pigment liner, this little study demonstrates how pen and ink can also be used with regard for colour – even when no colour is used.

Toning for colour

Gentle grazing of pen over greater surface area suggests darker or brighter hue

Light negative shape holds arrangement together

Shadow recess area

Tiny shadow shape

Toning for tone

Fewer pen strokes suggest shadow shapes only

White Flowers

White flowers are ideal as subjects for monochrome representation, especially when viewed against a background of massed foliage, giving an opportunity to make full use of a variety of tonal values.

Beginners often experience difficulties with this type of representation – white petals against a background of foliage – and consequently resort to the use of wire-like outlines around the former and even more unnecessary lines within the background foliage mass.

By practising the tonal scale in the form of gently shaded gradation, a familiarity with the different blending techniques can help to overcome this problem.

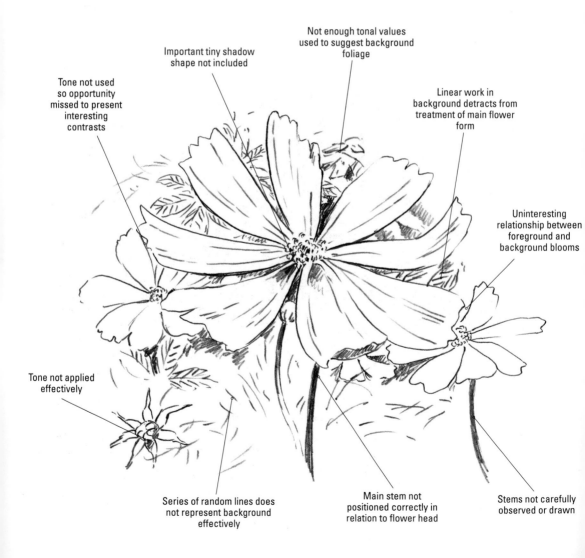

Tone not used so opportunity missed to present interesting contrasts

Important tiny shadow shape not included

Not enough tonal values used to suggest background foliage

Linear work in background detracts from treatment of main flower form

Uninteresting relationship between foreground and background blooms

Tone not applied effectively

Series of random lines does not represent background effectively

Main stem not positioned correctly in relation to flower head

Stems not carefully observed or drawn

Long, slightly separated, petals encourage the use of the darkest tonal values against pure white paper, giving maximum contrast. By cutting in crisply with a very sharp pencil, clean edges make the pure white petals stand forward beautifully against the busy background tones.

The profusion of background shapes here has been executed with minimum use of line. Faint guidelines were placed initially in some areas, but these were soon absorbed by tonal block application.

The relationships between the large flower head in the foreground, smaller ones in the middle ground and massed foliage in the background provide an interesting arrangement of shapes. In a monochrome drawing, consider the vast variety of tonal shapes and avoid hard outlining.

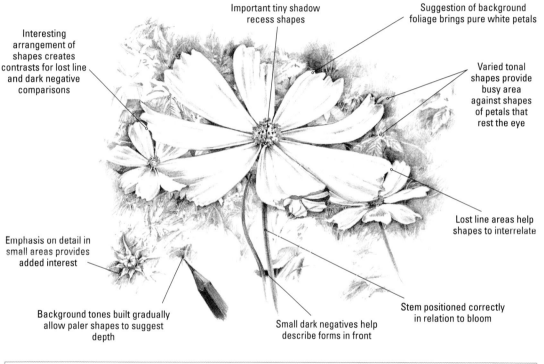

Important tiny shadow recess shapes

Suggestion of background foliage brings pure white petals

Interesting arrangement of shapes creates contrasts for lost line and dark negative comparisons

Varied tonal shapes provide busy area against shapes of petals that rest the eye

Emphasis on detail in small areas provides added interest

Lost line areas help shapes to interrelate

Background tones built gradually allow paler shapes to suggest depth

Small dark negatives help describe forms in front

Stem positioned correctly in relation to bloom

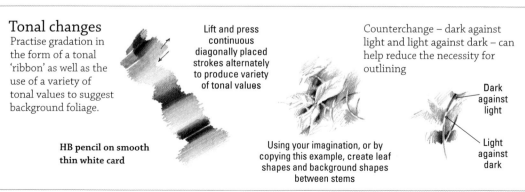

Tonal changes
Practise gradation in the form of a tonal 'ribbon' as well as the use of a variety of tonal values to suggest background foliage.

HB pencil on smooth thin white card

Lift and press continuous diagonally placed strokes alternately to produce variety of tonal values

Using your imagination, or by copying this example, create leaf shapes and background shapes between stems

Counterchange – dark against light and light against dark – can help reduce the necessity for outlining

Dark against light

Light against dark

Problems

Colourful Basket

Some subjects can be represented effectively using a combination of monochrome background and colour. Here, the lack of hue in the graphite background allows the full effect of the watercolour paint to be appreciated, co-ordinating the pinks, blues, purples and mauves of the flowers and surrounding them with various foliage greens. Two main problems are noticeable in the study below, one being the perspective angles of the supporting building and the other the inclusion of white paper in areas where this is not required and does nothing to enhance the effect.

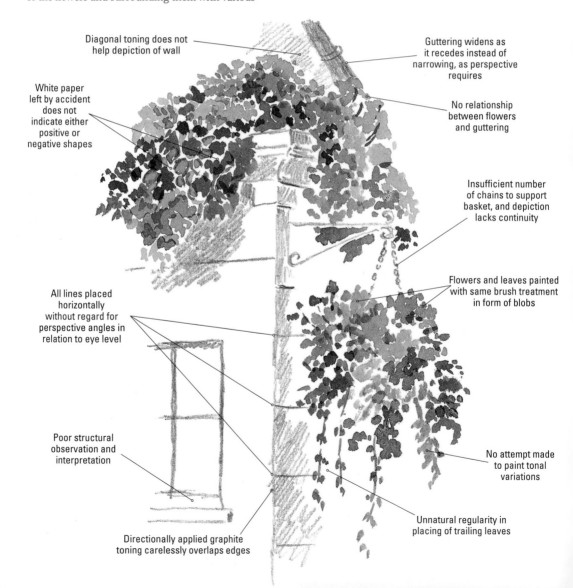

Diagonal toning does not help depiction of wall

Guttering widens as it recedes instead of narrowing, as perspective requires

White paper left by accident does not indicate either positive or negative shapes

No relationship between flowers and guttering

Insufficient number of chains to support basket, and depiction lacks continuity

Flowers and leaves painted with same brush treatment in form of blobs

All lines placed horizontally without regard for perspective angles in relation to eye level

Poor structural observation and interpretation

No attempt made to paint tonal variations

Unnatural regularity in placing of trailing leaves

Directionally applied graphite toning carelessly overlaps edges

This study demonstrates how effective strong contrasts can be and how highlighted areas, when placed at the correct perspective angle (here, the corner of the building), add strength to the composition.

Note how the massed tumbling flower heads comprise a variety of tonal shapes and values and how tonal contrasts have been used to full effect, within both the graphite monochrome drawing and the watercolour painting. I have taken the top area through to its conclusion but have left the hanging basket below unfinished so that you can see how the painting was started.

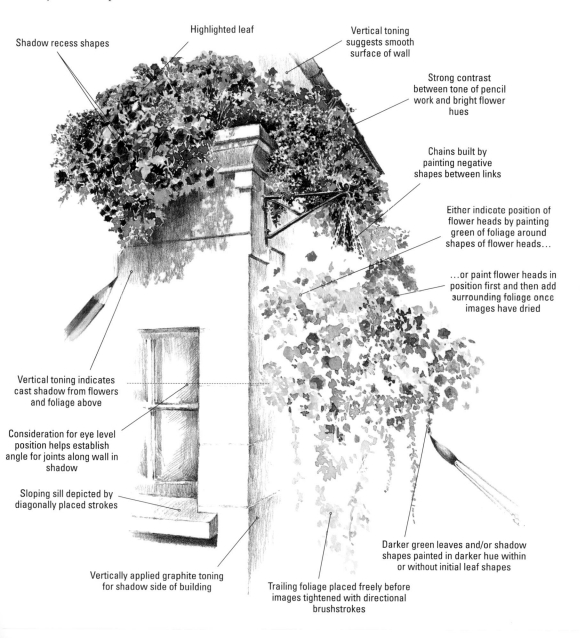

Shadow recess shapes

Highlighted leaf

Vertical toning suggests smooth surface of wall

Strong contrast between tone of pencil work and bright flower hues

Chains built by painting negative shapes between links

Either indicate position of flower heads by painting green of foliage around shapes of flower heads...

...or paint flower heads in position first and then add surrounding foliage once images have dried

Vertical toning indicates cast shadow from flowers and foliage above

Consideration for eye level position helps establish angle for joints along wall in shadow

Sloping sill depicted by diagonally placed strokes

Darker green leaves and/or shadow shapes painted in darker hue within or without initial leaf shapes

Vertically applied graphite toning for shadow side of building

Trailing foliage placed freely before images tightened with directional brushstrokes

Hanging Basket

In this hanging basket some flowers grow up towards overhead light, some mass as they emerge from dense foliage, while others trail down on slender stems to present delicate heads at interesting angles. There is a profusion of colour and shapes where the contrasts of rich, dark shadow recess areas cause the vibrant hues of numerous petals to become clearly defined within the diversity of leaf formations.

While green is the predominant colour, the other hues are co-ordinated so that they comfortably work together: warm reds, oranges and yellows are presented both in groups of flowers and as individual blooms.

I used loosely applied watercolour strokes to suggest an impression of all these elements, and some areas have been illustrated separately opposite as detail enlargements in order that you can see how the whole hanging basket image actually comprises simple shapes – nothing more. The key to success is the arrangement of these shapes with due regard to the plants' form and growth.

Preliminary drawing
For a relatively complex subject experiment with the placing of tonal shapes, using a soft pencil to establish the proportions of the flowers and foliage mass.

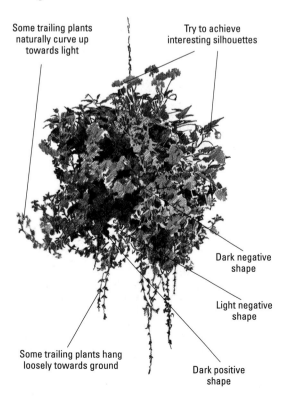

Some trailing plants naturally curve up towards light

Try to achieve interesting silhouettes

Dark negative shape

Light negative shape

Some trailing plants hang loosely towards ground

Dark positive shape

Exploratory drawing
This type of drawing, comprising wandering lines as well as tonal areas, can be executed in order to familiarize yourself with the subject matter.

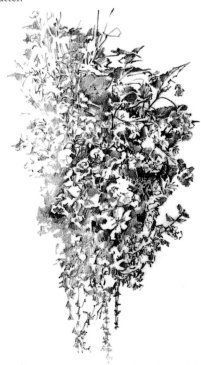

A soft pencil, sharpened to a fine point, enables crisp representation in line and tone

First washes

From the tonal sketch you can establish (and differentiate between) floral and foliage areas. A linear tracing around the main images can be used to transfer them on to watercolour paper – Saunders Waterford HP was used here – prior to painting in the basic colour shapes as simple flat areas, and a few darker hues can be added in some areas to overlay the colour/tone.

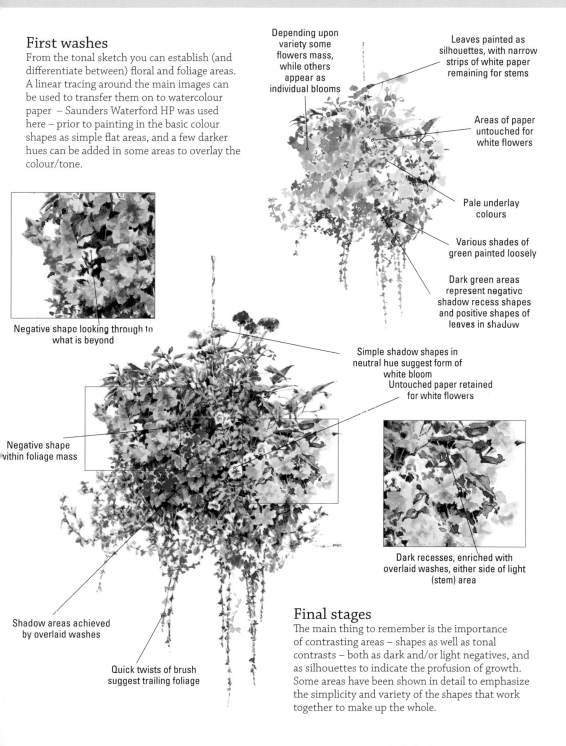

Negative shape looking through to what is beyond

Negative shape within foliage mass

Depending upon variety some flowers mass, while others appear as individual blooms

Leaves painted as silhouettes, with narrow strips of white paper remaining for stems

Areas of paper untouched for white flowers

Pale underlay colours

Various shades of green painted loosely

Dark green areas represent negative shadow recess shapes and positive shapes of leaves in shadow

Simple shadow shapes in neutral hue suggest form of white bloom
Untouched paper retained for white flowers

Dark recesses, enriched with overlaid washes, either side of light (stem) area

Shadow areas achieved by overlaid washes

Quick twists of brush suggest trailing foliage

Final stages

The main thing to remember is the importance of contrasting areas – shapes as well as tonal contrasts – both as dark and/or light negatives, and as silhouettes to indicate the profusion of growth. Some areas have been shown in detail to emphasize the simplicity and variety of the shapes that work together to make up the whole.

COLOUR

This theme features comparisons between pencil toning and watercolour painting, and linear toning in pen and ink with the introduction of watercolour washes. I have also included the use of counterchange and the way a neutral background hue helps to bring forward areas painted in colour. In each of these examples we are considering hue and tone.

Many people produce paintings in colour without an understanding of tonal values, so I have included monochrome representations to help build an awareness of the importance of consideration for tonal values, not only in monochrome drawings and paintings, but also in colour representations. Inability to understand the use of tone can lead beginners to rely upon outlines as they try to differentiate between forms, instead of creating tonal contrasts to separate the images.

In some instances, for example botanical illustration, the use of outlines is desirable, but even in this situation care needs to be taken that they do not appear too heavy or 'wire-like' and detract from the delicate treatment necessary when executing this type of study.

French ultramarine

Mix

With more blue added

Lemon yellow

With more yellow added

Cobalt blue

Mix

With more blue added

Lemon yellow

With more yellow added

By adding a little burnt umber to this mix a different green is obtained

Cobalt blue and lemon yellow mix

Cobalt blue, lemon yellow and burnt umber mix

Create a silhouette image of foliage to get an idea of how the mix will appear in your paintings

The colours of green

Many beginners experience problems with the mixing of suitable greens. Whether these are to represent areas of background foliage or for the larger leaves of the plant itself, the correct hues and tones are very important.

When mixing greens, take time to recognize and mix the correct green for the foliage you are depicting. Experiment with various mixes and match colours with care and consideration, rather than approximating in your excitement to start the painting.

These exercises demonstrate colour mixing with named hues as well as showing how the addition of just a small amount of other colours added to those mixed can give many interesting variations.

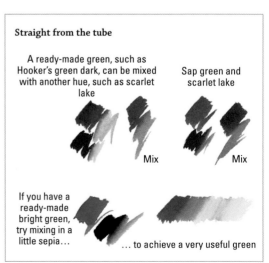

Straight from the tube

A ready-made green, such as Hooker's green dark, can be mixed with another hue, such as scarlet lake

Mix

Sap green and scarlet lake

Mix

If you have a ready-made bright green, try mixing in a little sepia…

… to achieve a very useful green

Counterchange

If you are particularly interested in ways of avoiding too many outlines, this exercise, which relates to the poppy image on page 161, can be helpful.

Dark image against light background; image appears to be in front of background

Dark background behind light part of image also brings image forward

Light against dark, followed by dark against light, ensures image appears separate from background

Using the white paper surface

Working in monochrome, whether using the dry medium of graphite or wet watercolour painting, requires you to make use of the white paper among your tonal values in order to achieve maximum contrast when placing the darkest dark tone against the lightest light. This can take the form of a flower that is actually white – where the shadow tones are the primary

consideration – or a flower or leaf that has a colour but on which you wish to indicate strong highlights. In this case you need to retain some untouched paper surface to depict the highlights. White paper can also be retained as slender strips in order to represent divisions between one hue or tone and another. Some of the methods used to paint the camellia on page 157 are explored here.

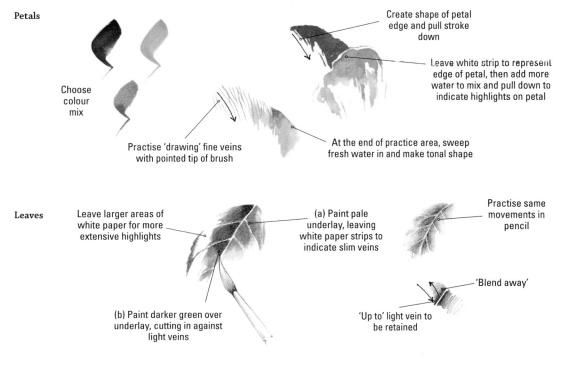

Petals

Choose colour mix

Create shape of petal edge and pull stroke down

Leave white strip to represent edge of petal, then add more water to mix and pull down to indicate highlights on petal

Practise 'drawing' fine veins with pointed tip of brush

At the end of practice area, sweep fresh water in and make tonal shape

Leaves

Leave larger areas of white paper for more extensive highlights

(a) Paint pale underlay, leaving white paper strips to indicate slim veins

Practise same movements in pencil

(b) Paint darker green over underlay, cutting in against light veins

'Up to' light vein to be retained

'Blend away'

Incorporating white paper

The honeysuckle study on page 163 demonstrates the advantages of retaining white paper strips between painted forms. These are not only retained to help define the edges of leaves and flowers, to encourage them to stand forward from a background area, but also help in the definition of slender stems.

The latter, seen among a profusion of blooms and foliage, can be highlighted by painting up to and away from either side of them, using the darker background hue. 'Up to and away' strokes enable the slimmest of stems to be depicted, and their clarity can be retained by keeping them as untouched white paper.

For delicate plants of this sort it is useful to practise the application of sweeping strokes that define the forms. The study here shows the first basic strokes prior to building the overlays that will intensify hue and tone.

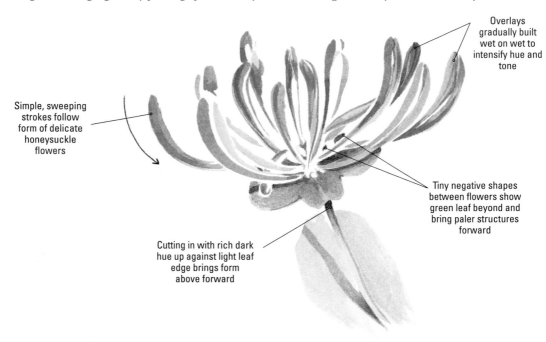

Overlays gradually built wet on wet to intensify hue and tone

Simple, sweeping strokes follow form of delicate honeysuckle flowers

Tiny negative shapes between flowers show green leaf beyond and bring paler structures forward

Cutting in with rich dark hue up against light leaf edge brings form above forward

Understanding tone

Without knowledge of tonal values and how they may be used to create the all-important contrasts within your artwork, you will be at a disadvantage. These colour swatches show a scale of tonal values in one of the flower hues and another in a useful green.

A rich crimson lake or similar hue produces a variety of tonal values: each tonal block is produced by adding a little more water to the concentrated hue

Lemon yellow and French ultramarine mixed produce useful greens

Vibrant colours

The image of the antirrhinums on page 159 demonstrates Inktense watersoluble pencils applied as overlays over pen and ink. They can also be used over outliner pencils which, on a rough watercolour paper surface, produces an interesting textured tonal base upon which to overlay hues. Because it is a soft pencil, the outliner is also capable of producing rich, dark tones that contrast effectively with the more vibrant hues of the Inktense range of pencils.

Establishing forms in a monochrome medium prior to applying exuberant washes of colour can be an exciting way to work, and with this method, as with many others, the direction in which you apply the brushstrokes is another important factor.

In the exercises on this page I have drawn a series of arrows to indicate the directions in which the strokes were placed – both for the execution of the brushwork and for the pen and ink underlay.

Derwent Inktense pencils were used to colour the ink drawing.

Touch tip of pencil with wet brush and pull pigment down into palette, diluting as required

To create rich dark areas, move pen gently while remaining in same area

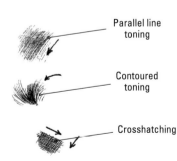

Arrow indicates direction of 'edge' stroke

Parallel line toning

Contoured toning

Crosshatching

Use directional stroke application of pen and brush

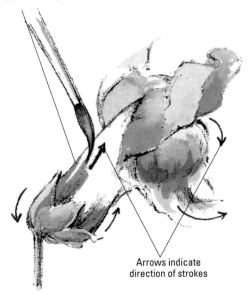

Arrows indicate direction of strokes

Saunders Waterford CP (NOT) paper created the textured effect of strokes as the pen was gently grazed across the surface.

Problems

Camellia

A burst of colour early in the year is a welcome sight. The impressive camellia, with its bright blooms and rich green shiny leaves, provides an excellent opportunity to observe tonal values as well as colour.

The solid forms of dormant buds resting throughout the winter months allow form to be represented by careful pencil toning. Delicate veins, which indicate direction and structure, require close observation and careful treatment, and this often proves to be a problem. A brush with a fine point is required for these areas in order to define veins, as well as cutting in dark shadow recess areas crisply against white petal edges.

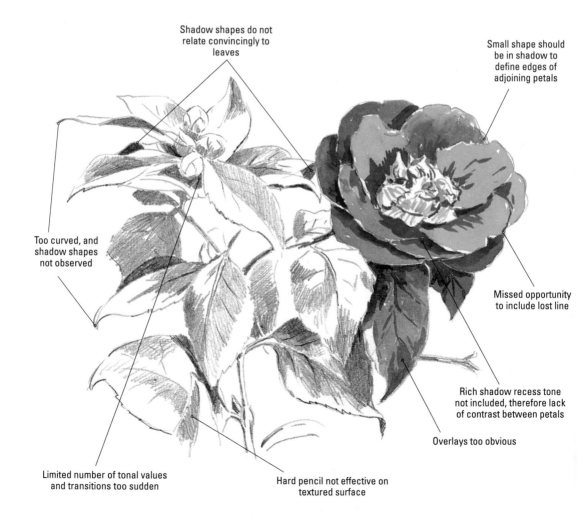

Shadow shapes do not relate convincingly to leaves

Small shape should be in shadow to define edges of adjoining petals

Too curved, and shadow shapes not observed

Missed opportunity to include lost line

Rich shadow recess tone not included, therefore lack of contrast between petals

Overlays too obvious

Limited number of tonal values and transitions too sudden

Hard pencil not effective on textured surface

Solutions

When blooms burst into colour, observation and understanding of tonal values helps the depiction of overlapping petals and the achievement of all-important contrasts. Light petal edges can enhance this effect.

The forms of buds, leaves and petals are defined by the way the light hits them, and it is important to be aware of how to incorporate the white paper surface – in order to achieve the effect of strong highlights, it may be necessary to leave large areas of unmarked paper to contrast with shadow shapes and cast shadow areas.

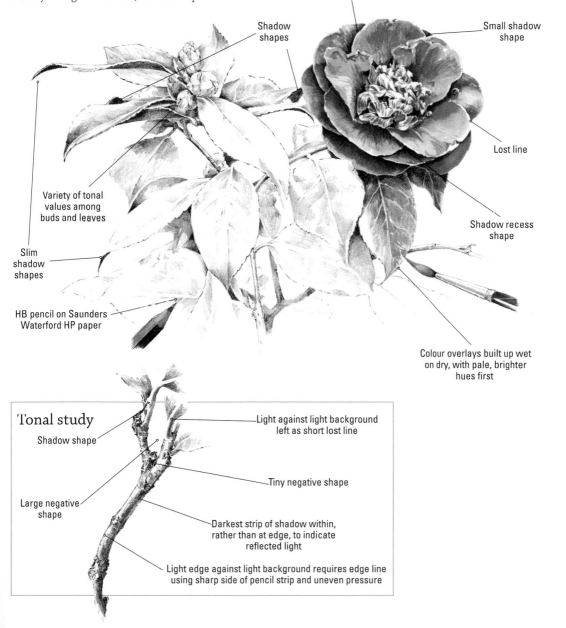

Cut in crisply and leave light edges to petals

Shadow shapes

Small shadow shape

Lost line

Variety of tonal values among buds and leaves

Shadow recess shape

Slim shadow shapes

HB pencil on Saunders Waterford HP paper

Colour overlays built up wet on dry, with pale, brighter hues first

Tonal study

Shadow shape

Light against light background left as short lost line

Large negative shape

Tiny negative shape

Darkest strip of shadow within, rather than at edge, to indicate reflected light

Light edge against light background requires edge line using sharp side of pencil strip and uneven pressure

Problems

Antirrhinums

When drawing or painting closely massed plants, such as antirrhinums, trying to visually separate one from another can sometimes prove to be problematic: recognizable shapes of blooms, leaves and stems become lost as a result of too much linear and tonal activity. You may draw what you see, and what you know to be there, but when it is confronted with numerous lines and tonal areas, the inexperienced eye can become confused.

Another problem experienced by beginners when confronted by a complicated arrangement is that they panic – fear of making mistakes or of having to give up in frustration often prevents them from even making a start.

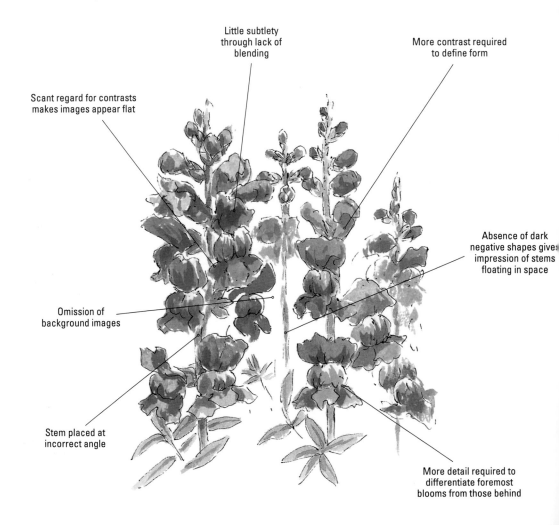

Little subtlety through lack of blending

More contrast required to define form

Scant regard for contrasts makes images appear flat

Absence of dark negative shapes gives impression of stems floating in space

Omission of background images

Stem placed at incorrect angle

More detail required to differentiate foremost blooms from those behind

The best way to start is to do just that! Find a shape you can clearly define, understand and manage, then draw it. Relate this image to its neighbour, noting the shape of the negative between them, then continue to work out and away from the original image on either side.

When you gradually introduce gentle colour washes to complement areas of tone, the image will become clarified. Colour can bring pen and ink drawings to life: the effective addition of colour separates one image from its neighbour, and the problem is solved.

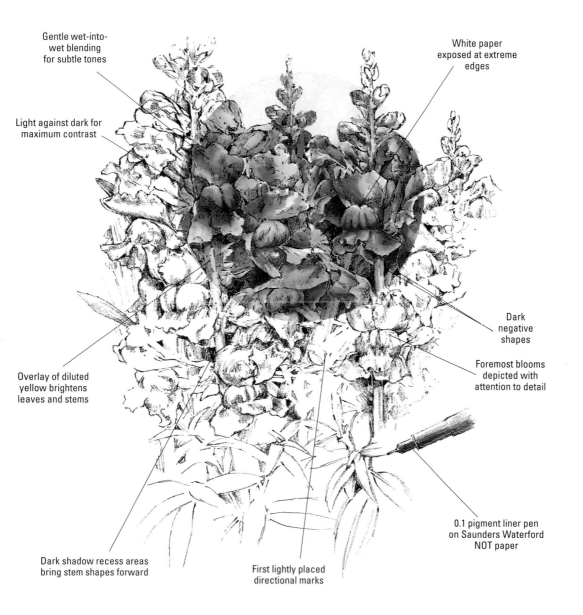

Gentle wet-into-wet blending for subtle tones

White paper exposed at extreme edges

Light against dark for maximum contrast

Dark negative shapes

Foremost blooms depicted with attention to detail

Overlay of diluted yellow brightens leaves and stems

0.1 pigment liner pen on Saunders Waterford NOT paper

Dark shadow recess areas bring stem shapes forward

First lightly placed directional marks

Problems

Poppies

Different poppy varieties present us with numerous tonal contrast considerations – some possess an array of pale stamens against the rich dark hues of the pattern on the petals, while others have dark stamens that contrast with petals of a lighter colour.

The technique of counterchange, using contrasts of hue and tone, effectively separates components and background areas from each other. When using this method, care must be taken that transitions work smoothly in order to produce the desired result and to make the whole image visually acceptable. Beginners who are unaware of the counterchange method often resort to outlining the forms, but this presents a flattened image rather than the three-dimensional representation they desire.

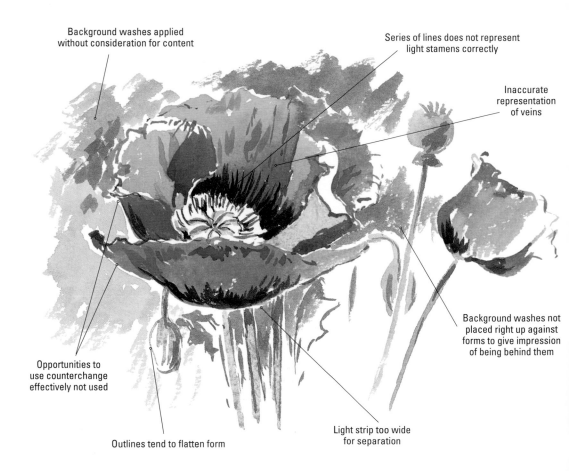

Background washes applied without consideration for content

Series of lines does not represent light stamens correctly

Inaccurate representation of veins

Background washes not placed right up against forms to give impression of being behind them

Opportunities to use counterchange effectively not used

Outlines tend to flatten form

Light strip too wide for separation

Subtle yellow glaze brightens and unifies area

Effect of light stamens achieved by cutting in between and around them with darker hue

Raised, highlighted veins receive dark hue on either side of lighter strips

With two dark hues together, very narrow light strip of paper is retained to separate form from background

Background painted loosely with criss-cross strokes to suggest leaf masses behind main form

Counterchange: light form against dark background and dark form against light background

Some images unfinished in light areas where highlights merge

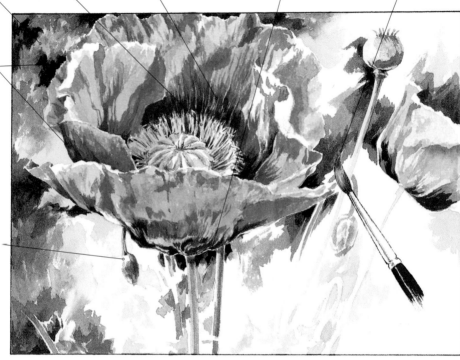

This painting shows how dark hue cuts in up to the edge of the stamens and, to some extent, within their mass. The value of contrasts in achieving a three-dimensional impression has been mentioned in other themes, and this demonstrates how counterchange also plays an important part in the process, both in colour and in monochrome representations.

In order to take full advantage of contrasts – whether this is in watercolour or pencil work – you need to incorporate the white paper support as an integral part of your representations. Areas of white paper are often there because the artist is unsure how to use the area, rather than by choice. You need to decide where white paper will be effective – for example on areas where you wish to suggest the lightest highlights.

Tonal counterchange in monochrome
This pencil study gives an example of overlaying dark over lighter tones.

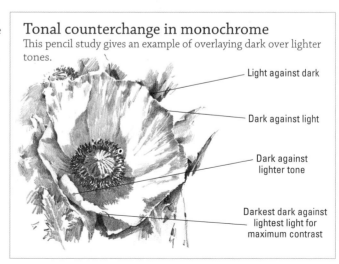

Light against dark

Dark against light

Dark against lighter tone

Darkest dark against lightest light for maximum contrast

Problems

Honeysuckle

The sweet-smelling honeysuckle, with its numerous tendrils and thicker supporting stems intermingled with flowers and leaves, can appear very complicated when viewed en masse. Inexperienced painters sometimes draw with a brush in outline or are tempted to exclude much of what they see, being unsure how to depict all the visual activity of the components.

Disjointed leaf and stem do not relate

No variety of tonal values within neutral background hue

Application of pigment too dry

Absence of any tiny negatives gives no sense of depth

White edges too wide, making images appear flat

Neutral linear drawing with brush does not enhance study

Different greens used without pale underlays on which to build

Images lack structure because no preliminary pencil work used to position them

Positions of flowers and stems take eye through and out of composition rather than towards focal point

One way of addressing the problem is to treat the background areas in a neutral hue, incorporating various tonal values. This has the effect of bringing the colours of the main flowers, leaves and stems to the fore. If these positive shapes are painted first, in the palest of colours to establish their positions, the negative shapes between them can be established in pale neutral hues. In this way both the main plant shapes and the background shapes can be built up together and related to each other as the painting progresses.

Areas in this study have been left unfinished to show how overlaying of hue and tone builds the images. The first, very pale underlay washes are used to position flowers, leaves and stems; the latter are mainly created by applying a neutral tone either side of slim areas of white paper.

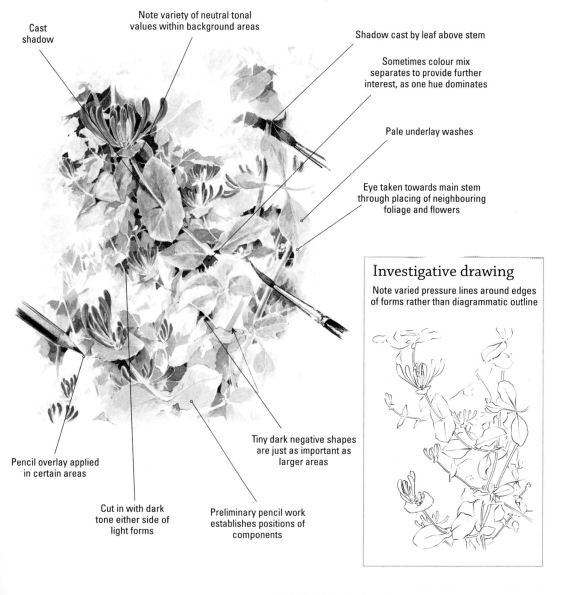

Cast shadow

Note variety of neutral tonal values within background areas

Shadow cast by leaf above stem

Sometimes colour mix separates to provide further interest, as one hue dominates

Pale underlay washes

Eye taken towards main stem through placing of neighbouring foliage and flowers

Pencil overlay applied in certain areas

Cut in with dark tone either side of light forms

Preliminary pencil work establishes positions of components

Tiny dark negative shapes are just as important as larger areas

Investigative drawing

Note varied pressure lines around edges of forms rather than diagrammatic outline

COMPOSITION
AND ARRANGEMENT

Finding the focus

Because composition and arrangement are such important considerations, this theme starts with a detailed drawing that contains many of the elements conducive to creating a successful study.

On page 177 you can see a preliminary sketch for the detailed drawing below. In the quick sketch – which was executed in order to compose the arrangement – there are many areas of the drawing that receive the same type of treatment, whether in the foreground or background images. In the drawing below more thought has been given as to how the foreground and background areas can appear separate, and how to enhance the focal point – which is different in the study on page 177.

Here, the observer's eye is directed towards the focal point and anchored there by introducing a strong contrast on the left. I also reduced the tonal values of distant images on the right, encouraging them to remain in recession.

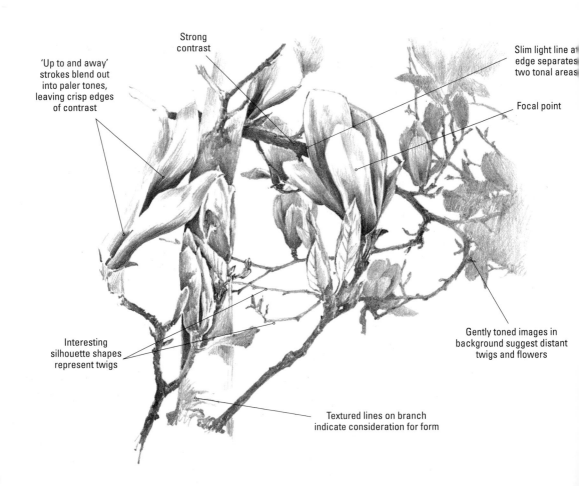

Strong contrast

'Up to and away' strokes blend out into paler tones, leaving crisp edges of contrast

Slim light line at edge separates two tonal areas

Focal point

Interesting silhouette shapes represent twigs

Gently toned images in background suggest distant twigs and flowers

Textured lines on branch indicate consideration for form

Composing with massed foliage

Another study containing many components can
be seen on page 171. Here are a few exercises to try,
relating to that pencil and wash study of primroses.
Instead of light negative shapes helping to hold the
composition together (as in the drawing opposite), the
dark negative shapes have come into play in this sketch.
 In these studies I used a wandering line to find and
position the forms, retaining pencil contact with the
paper as much as possible throughout the drawing.

All strokes applied directionally

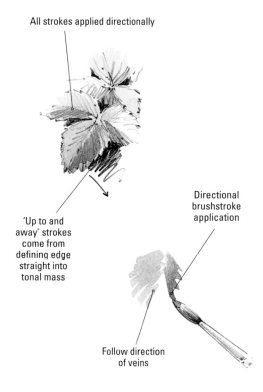

From line into tone – pencil
does not leave surface of paper

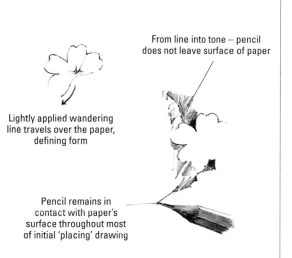

Lightly applied wandering
line travels over the paper,
defining form

'Up to and
away' strokes
come from
defining edge
straight into
tonal mass

Directional
brushstroke
application

Pencil remains in
contact with paper's
surface throughout most
of initial 'placing' drawing

Follow direction
of veins

Dahlia

Note the composition of tightly packed
petals in a round form.

Graphitint watersoluble pencils

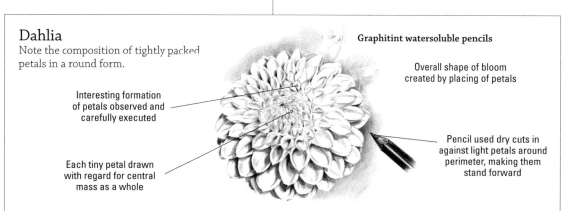

Overall shape of bloom
created by placing of petals

Interesting formation
of petals observed and
carefully executed

Each tiny petal drawn
with regard for central
mass as a whole

Pencil used dry cuts in
against light petals around
perimeter, making them
stand forward

Moving in closer

A colourful poppy is observed in close-up on page 167, and demonstrates how you can edit in insects to add interest to your composition. That study was executed in Inktense pencils, and the following exercises are to help you practise the execution of three different areas in the composition.

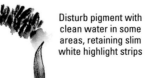

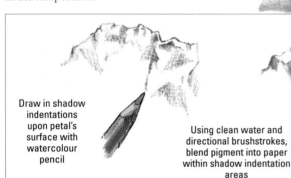

Draw in shadow indentations upon petal's surface with watercolour pencil

Using clean water and directional brushstrokes, blend pigment into paper within shadow indentation areas

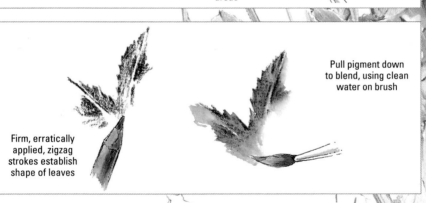

Pull pigment down to blend, using clean water on brush

Firm, erratically applied, zigzag strokes establish shape of leaves

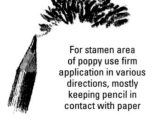

For stamen area of poppy use firm application in various directions, mostly keeping pencil in contact with paper

Disturb pigment with clean water in some areas, retaining slim white highlight strips

Complicated formations

Close observation is essential when depicting plant forms and formations. The complex arrangement of elegant agapanthus blooms upon slender stems emanating from a single main supporting stem is the subject of the demonstration on pages 178–9.

Agapanthus flowers are worthy of close study, and practice drawings of the individual flowers and buds, using pen, ink and wash, are included here. These small ink studies help you to understand the structure of the flowers when seen from different angles.

Working in monochrome

Penwork is also ideal for monochrome representation, especially where a looser interpretation is enjoyed. I used a fine 0.4 coloured watersoluble pen here, which is ideal for sketchbook studies. These exercises relate to the drawing of a greenhouse interior on page 175.

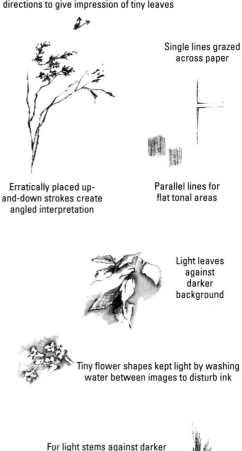

Place tip of pen on paper and move in different directions to give impression of tiny leaves

Single lines grazed across paper

Erratically placed up-and-down strokes create angled interpretation

Parallel lines for flat tonal areas

Light leaves against darker background

Tiny flower shapes kept light by washing water between images to disturb ink

For light stems against darker background: (a) draw lines either side of form; (b) fill in areas between with penwork; (c) wash clean water over penwork

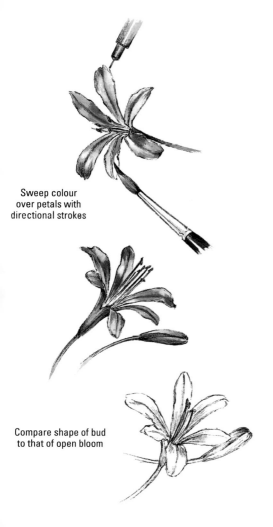

Sweep colour over petals with directional strokes

Compare shape of bud to that of open bloom

Problems

Poppy

In this study, the expanse of petal to the right, among an array of other petals, lends itself to the addition of an extra component. A hovering bee has been added, and this leads the eye towards the focal point of massed stamens in the centre of the flower. Combined with the dark pattern on the petal just below the insect and that seen in the inverted V shape above, this adds a feeling of movement to the arrangement. When making additions of this kind, beginners may experience problems that arise from not being sure of scale and lack of knowledge concerning the additional components. In this case it is advisable to seek reference from other sources in order to make comparisons.

Overlays not used to create intensity of hue and tone in shadow recess area

Initial guideline trespasses on to adjoining petal

White paper used just for areas untouched by colour

Loosely washed water and outline do not give impression of massed foliage

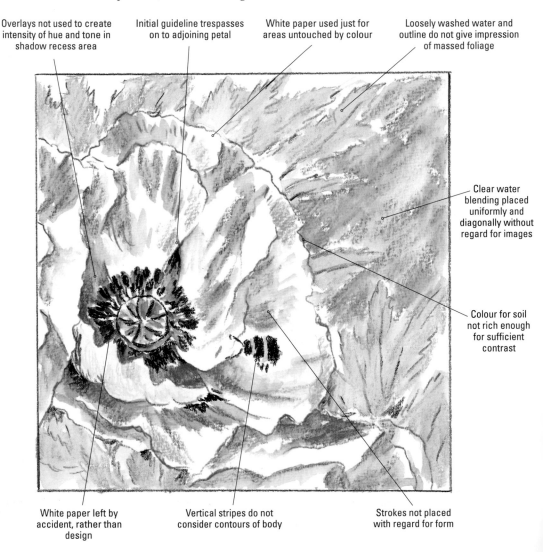

Clear water blending placed uniformly and diagonally without regard for images

Colour for soil not rich enough for sufficient contrast

White paper left by accident, rather than design

Vertical stripes do not consider contours of body

Strokes not placed with regard for form

Watercolour pencils and Inktense pencils have been combined here to build layers of dry application, followed by clear water blending and more dry-on-dry work. The Inktense orange and yellows were used sparingly and applied as overlaid translucent washes to add vibrancy and glow.

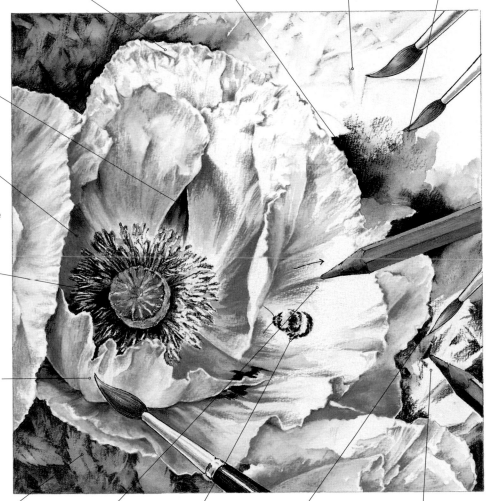

Highlighted creases in petals achieved by retaining white paper

Rich soil hue cut in against crisp light edge of petal

Clear water wash over lightly drawn background shapes gives impression of massed leaves

Clear water blended over colour as underlay

Shadow recess shape

Overlays of different hues built to increase intensity of hue

Shadow shapes used in addition to intricate drawing

Glazed with yellow pencil wash

Shape between part of flower and edge of painting considered

Directional pencil strokes follow form of petal

Additional components enhance composition

Clear water washes applied with criss-cross movements

Criss-cross pencil strokes represent shadow recess shapes between background leaves

Problems

Primroses

When confronted by a profusion of flowers and foliage, you may find the prospect of portraying so many positive and negative shapes rather daunting. One of the problems often experienced by beginners is that of how to arrange blooms and leaves in irregular, natural presentations, and to show the relationships between the positive and negative shapes. When left without consideration for why they have been retained, such as for highlights, white paper areas tend to flatten the forms and give a disjointed appearance.

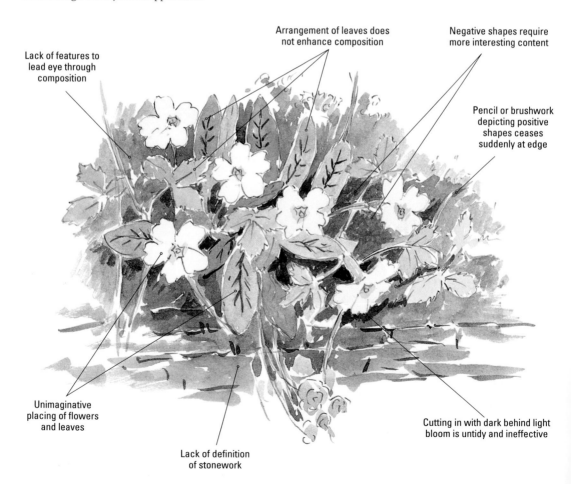

Lack of features to lead eye through composition

Arrangement of leaves does not enhance composition

Negative shapes require more interesting content

Pencil or brushwork depicting positive shapes ceases suddenly at edge

Unimaginative placing of flowers and leaves

Lack of definition of stonework

Cutting in with dark behind light bloom is untidy and ineffective

For the study here, I started by relating the primroses and their leaves. This was followed by the wild strawberry leaves and trailing plant with grasses. The whole arrangement rests above a shallow stone wall. In some areas I edited in a few extra negative shapes to provide contrasts and, in turn, edited out various leaves that did not help the composition. Using pencil and watercolour together on smooth white paper can work well: place the images in pencil first, before washing over with appropriate colours. When this is dry, you can add further pencil drawing to enhance the contrasts.

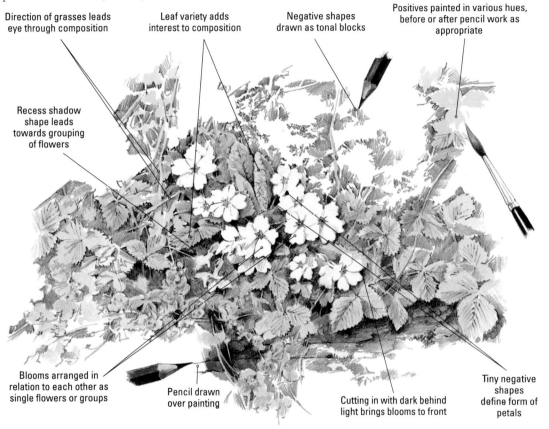

Direction of grasses leads eye through composition

Leaf variety adds interest to composition

Negative shapes drawn as tonal blocks

Positives painted in various hues, before or after pencil work as appropriate

Recess shadow shape leads towards grouping of flowers

Blooms arranged in relation to each other as single flowers or groups

Pencil drawn over painting

Cutting in with dark behind light brings blooms to front

Tiny negative shapes define form of petals

Looking for detail

These two studies were also executed in pencil and watercolour. For the full-on view I started with the central area and worked outwards, grazing the pencil gently over the paper's surface. The darker central area was then painted, followed by the pale petal hue. Finally a pale neutral background hue was painted up to the petal edges. As the second image was to be presented against white paper, I used a heavier, on/off pressure edge line to define the forms.

Holding blooms in one hand and drawing or painting with the other enables close observation of the form.

Problems

Garden Scene

Problems arise for beginners when the chosen format does not fit in with the view. Working in portrait rather than landscape format for a scene of this nature prevents full appreciation of the garden's layout – distortions may occur not only from lack of perspective knowledge but also from trying to squeeze in components on the edge of your vision.

In addition, problems in the portrayal of cast shadows may be encountered if you lack the confidence to place bold directional (shadow shape) tonal areas. Shadows can enhance or destroy the effects achieved within a pencil drawing and need careful consideration, not only in their placing but in the method of execution.

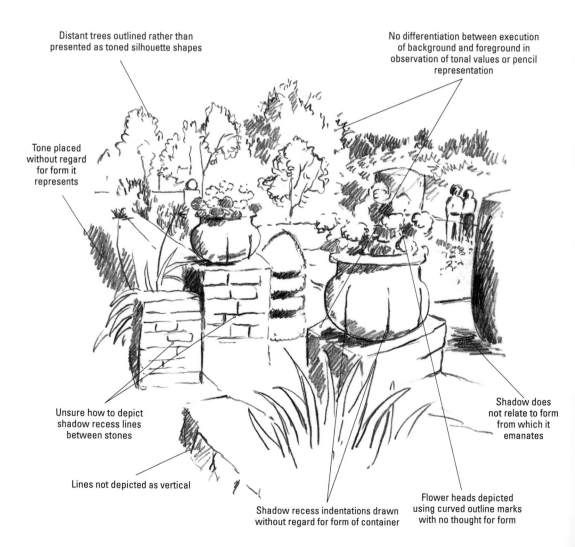

Distant trees outlined rather than presented as toned silhouette shapes

No differentiation between execution of background and foreground in observation of tonal values or pencil representation

Tone placed without regard for form it represents

Unsure how to depict shadow recess lines between stones

Lines not depicted as vertical

Shadow recess indentations drawn without regard for form of container

Flower heads depicted using curved outline marks with no thought for form

Shadow does not relate to form from which it emanates

The main aim in this drawing is to emphasize the importance of tonal values and the use of maximum contrast. This means that areas of rich dark against those that may remain as untouched white paper (representing highlights and surfaces in full sunlight, as well as white objects) take priority.

Remember to leave white paper (a) where you wish to indicate light negative shapes, such as sky visible through branches and leaf masses, and (b) where sunlight causes a surface to appear as the lightest light

area. This may initially look as if there has been a fall of snow, which is resting along the top of the forms, but continue working down (placing the first areas of tone) until the 'undercoat' has been laid.

Lines may be sweeping, such as when depicting sword-shaped leaves in the foreground, or as on/off pressure lines such as those indicating joints in the stonework. The final stage comprises overlaying detail strokes.

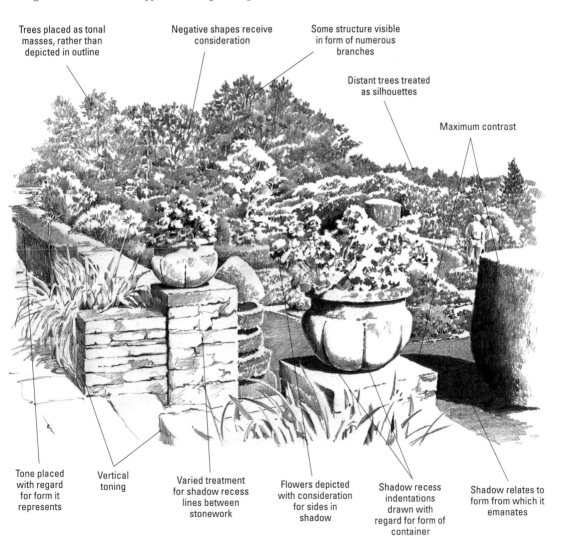

Trees placed as tonal masses, rather than depicted in outline

Negative shapes receive consideration

Some structure visible in form of numerous branches

Distant trees treated as silhouettes

Maximum contrast

Tone placed with regard for form it represents

Vertical toning

Varied treatment for shadow recess lines between stonework

Flowers depicted with consideration for sides in shadow

Shadow recess indentations drawn with regard for form of container

Shadow relates to form from which it emanates

Problems

Greenhouse

Positioning yourself comfortably in an area where you can take your time – for example, in a greenhouse – gives you the opportunity to execute a variety of sketchbook studies. Including an area of floor, panes of glass and visible parts of flowerpots provides contrasts to the profusion of foliage.

Relating shapes of positive and negative forms within these masses can present problems for beginners unsure how to fill the spaces. Too much untouched paper remains, and the relationships between components in the composition are lost. Perspective angles can also cause problems.

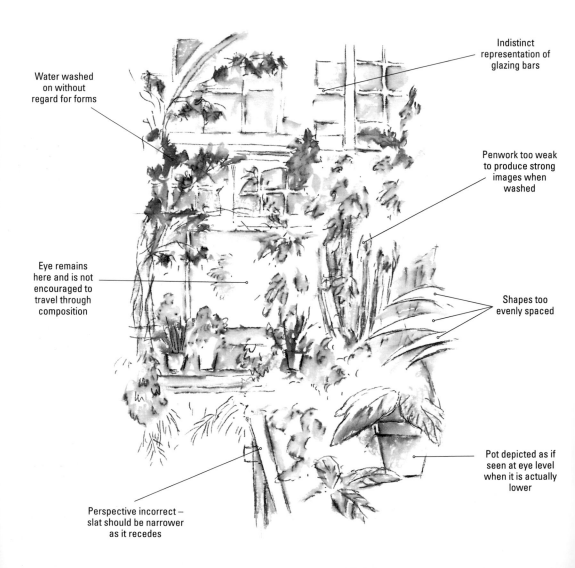

Water washed on without regard for forms

Indistinct representation of glazing bars

Penwork too weak to produce strong images when washed

Eye remains here and is not encouraged to travel through composition

Shapes too evenly spaced

Pot depicted as if seen at eye level when it is actually lower

Perspective incorrect – slat should be narrower as it recedes

Try to sketch from an angle where certain lines, such as those of the supporting slats on which pots of plants are placed, can take your eye into the composition. Look for areas that rest the eye, in contrast to the busy foliage masses.

Working on a textured surface, such as Saunders Waterford CP (NOT) paper, will enhance your penwork and encourage subsequent washes to work successfully, as long as they are applied with care and consideration.

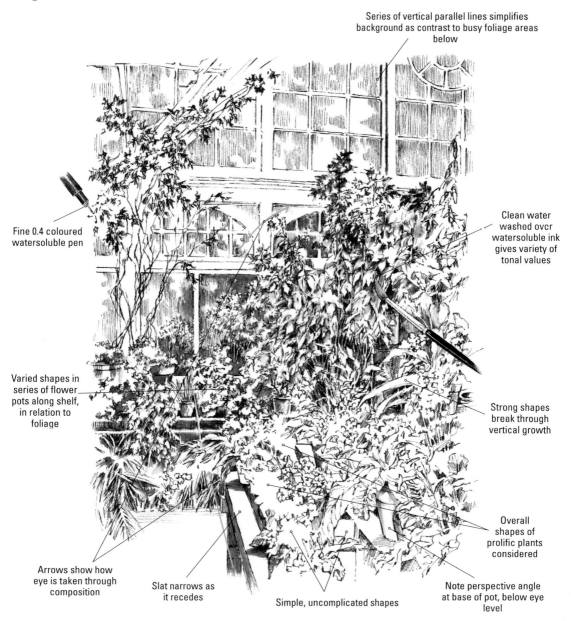

Series of vertical parallel lines simplifies background as contrast to busy foliage areas below

Fine 0.4 coloured watersoluble pen

Clean water washed over watersoluble ink gives variety of tonal values

Varied shapes in series of flower pots along shelf, in relation to foliage

Strong shapes break through vertical growth

Arrows show how eye is taken through composition

Slat narrows as it recedes

Simple, uncomplicated shapes

Overall shapes of prolific plants considered

Note perspective angle at base of pot, below eye level

Problems

Magnolia

By observing and drawing a single section of a magnolia tree we are editing out quite an extensive area of the rest of the plant. It is therefore important to consider the arrangement of flowers, leaves and twigs in relation to the main branch supporting them.

One of the problems experienced by beginners is that of how to apply tone in a way that describes form effectively, such as long, sweeping on/off strokes to tone flower petals, and shorter, erratic strokes to indicate tonal texture on twigs (seen as silhouettes) and branches.

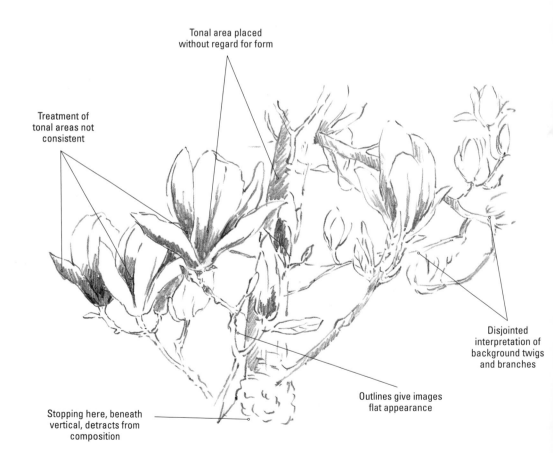

Tonal area placed without regard for form

Treatment of tonal areas not consistent

Disjointed interpretation of background twigs and branches

Outlines give images flat appearance

Stopping here, beneath vertical, detracts from composition

Here, I have chosen an S-shaped composition to take the observer's eye through this little study, by working on an area where the angles of the flowers concentrate that effect. This is a preliminary sketch, using a 4B pencil, which could be used for a painting or a more detailed drawing (see page 165).

Keeping the pencil sharpened throughout the execution of the drawing enables rich dark tonal areas to be quickly established. When depicting twigs of this nature as silhouettes, it is important to consider the uneven appearance of the edges, as this helps to define the species.

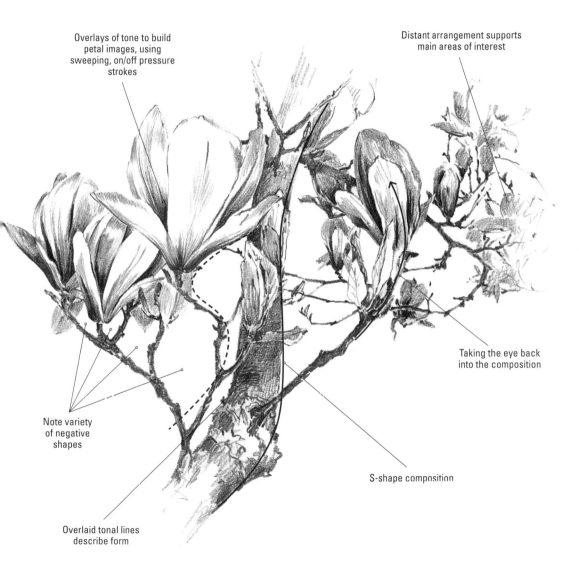

Overlays of tone to build petal images, using sweeping, on/off pressure strokes

Distant arrangement supports main areas of interest

Taking the eye back into the composition

Note variety of negative shapes

S-shape composition

Overlaid tonal lines describe form

Demonstration

Agapanthus

The elegant agapanthus plant has a long flowering season and can grace borders in a garden or be grown in pots. In the preliminary investigative sketch I chose the latter and included the cascade of leaves; however, for the demonstration study I concentrated on the natural arrangement of flowers, in the form of buds and open blooms emerging from the single main stem.

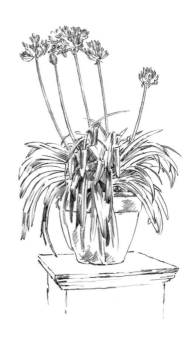

Preliminary drawing

By turning the pot and sketching the arrangement from different angles you can decide which viewpoint offers the most interest of presentation. Always look for a variety of negative shapes, as well as the positive blooms and buds with their supporting slender stems. This preliminary sketch was made to understand the structure of the complete plant.

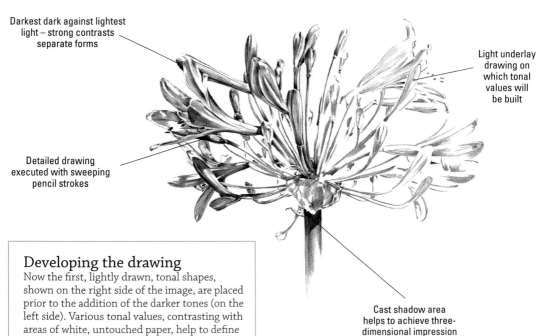

Darkest dark against lightest light – strong contrasts separate forms

Light underlay drawing on which tonal values will be built

Detailed drawing executed with sweeping pencil strokes

Cast shadow area helps to achieve three-dimensional impression

Developing the drawing

Now the first, lightly drawn, tonal shapes, shown on the right side of the image, are placed prior to the addition of the darker tones (on the left side). Various tonal values, contrasting with areas of white, untouched paper, help to define the forms.

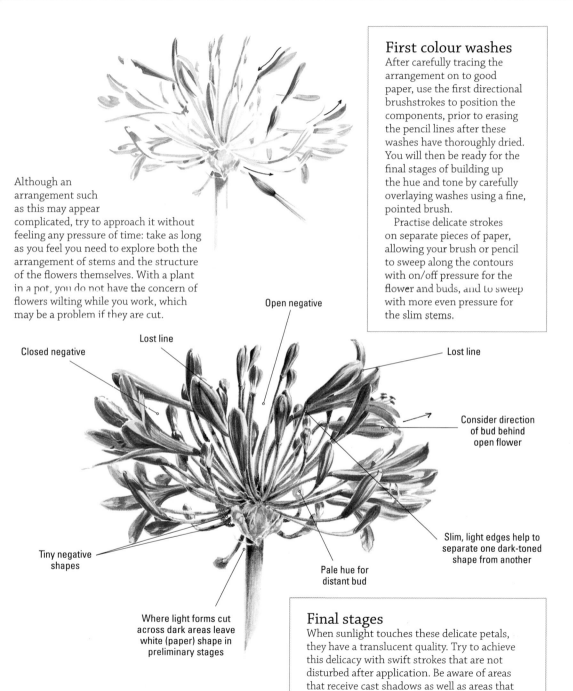

First colour washes

After carefully tracing the arrangement on to good paper, use the first directional brushstrokes to position the components, prior to erasing the pencil lines after these washes have thoroughly dried. You will then be ready for the final stages of building up the hue and tone by carefully overlaying washes using a fine, pointed brush.

Practise delicate strokes on separate pieces of paper, allowing your brush or pencil to sweep along the contours with on/off pressure for the flower and buds, and to sweep with more even pressure for the slim stems.

Although an arrangement such as this may appear complicated, try to approach it without feeling any pressure of time: take as long as you feel you need to explore both the arrangement of stems and the structure of the flowers themselves. With a plant in a pot, you do not have the concern of flowers wilting while you work, which may be a problem if they are cut.

Open negative

Lost line

Closed negative

Lost line

Consider direction of bud behind open flower

Tiny negative shapes

Slim, light edges help to separate one dark-toned shape from another

Pale hue for distant bud

Where light forms cut across dark areas leave white (paper) shape in preliminary stages

Final stages

When sunlight touches these delicate petals, they have a translucent quality. Try to achieve this delicacy with swift strokes that are not disturbed after application. Be aware of areas that receive cast shadows as well as areas that are naturally in shadow.

Animals

With this book I will be helping you...
to love your art,
to live your art
and see the world go by
as colour, texture, line and form
and with an 'artist's eye'.

A love of animals inspires many artists to include them in their drawings and paintings, even if they choose not to specialize in animal portraiture.

For some their desire to draw and paint the animal world is accompanied by a fear of misrepresentation, due to lack of knowledge. Whether it is the inclusion of sheep or cattle in a pastoral landscape or the portrayal of a pet cat or dog, it is often the fear of 'spoiling' the former or even how to start the latter that inhibits progress or prevents these avenues from being explored.

Getting past the problems

With knowledge and understanding, however, fear recedes and confidence takes its place. It is also true that discipline leads to freedom, and by learning the basic disciplines of close observation and practising accurate representation, the freedom to draw and paint animals in any medium is achieved.

Observation and accuracy

To this end the importance of close observation is mentioned frequently in this book, both in the introductions and the themes themselves; exercises in accuracy are also included in relation to many of the animals within the themed sections. Once correct proportions of

the animal have been achieved, the use of directional strokes in pencil, pen or brush will give the impression of three-dimensional form.

The artist can work from life, photographs or memory (imagination), but it is wise to practise the former in order to build a 'memory bank' for future reference before attempting the latter – otherwise, disappointment may result from lack of awareness.

With an artist's eye

Learning to look 'with an artist's eye' increases an awareness of the fact that portraying animal subjects may be approached in the same way as with any other subject – by looking for shapes (both positive and negative) and using guidelines that help place components correctly. This forms the scaffolding upon which the image is built, and the feeling for animals, which is what prompts their depiction in the first instance, can then take over so that they can be portrayed in the artist's own individual style.

Choosing a medium

When considering how to portray the subject of animals, it is often the

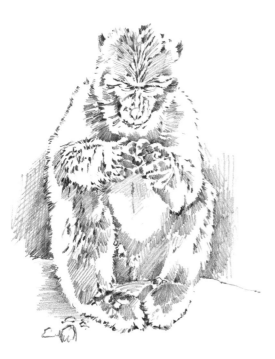

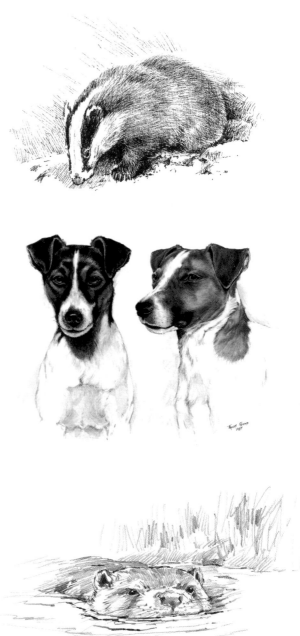

feeling we have for a particular species that encourages us to use a certain medium. For example, soft, fluffy fur may suggest pastel, and smooth shining coats with strong highlights may lead to using watercolour. Solid areas of wrinkled skin may be depicted with the use of acrylic – enhancing textured detail – and herds of animals against desert backgrounds may suggest the use of gouache.

Detailed drawings could present small mammals in a delicate way by the use of coloured pencils, tinted ink drawings or watercolour pencils. In addition, any animal subject benefits from initial monochrome drawings and sketches; for these, there is a vast choice, including graphite pencil, carbon and charcoal pencils, Conté pencils and sticks, as well as Graphitint (coloured soluble graphite pencils). Black animal fur can be successfully suggested by the use of watersoluble graphite – either alone or mixed with watercolour for a hint of hue in the highlights.

There are numerous opportunities for mixing media, and I have included a few mixed-media options in the themes, sometimes as simply as enhancing watercolours with pencil.

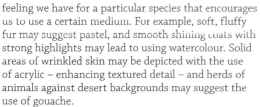

Mixing Colour Media

Watercolour

Mixing watercolour for depicting fur

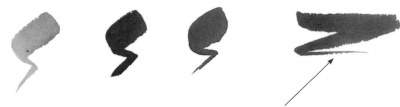

Using the three primary colours, yellow, red and blue, mix a neutral hue

This exercise shows you how to create the shadow shapes that form between lighter areas of fur.

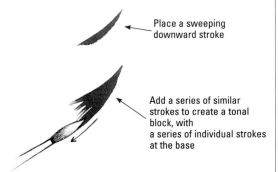

Place a sweeping downward stroke

Add a series of similar strokes to create a tonal block, with a series of individual strokes at the base

In this exercise you can see how to achieve shadow texture and highlight on the pad of an animal's paw.

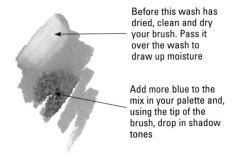

Before this wash has dried, clean and dry your brush. Pass it over the wash to draw up moisture

Add more blue to the mix in your palette and, using the tip of the brush, drop in shadow tones

Blending a background colour around an image can be practised in this little exercise.

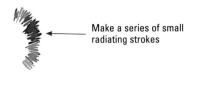

Make a series of small radiating strokes

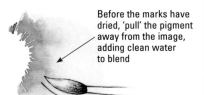

Before the marks have dried, 'pull' the pigment away from the image, adding clean water to blend

Practise long hair impressions with curved strokes.

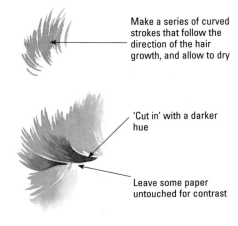

Make a series of curved strokes that follow the direction of the hair growth, and allow to dry

'Cut in' with a darker hue

Leave some paper untouched for contrast

Acrylic

Mixing colour

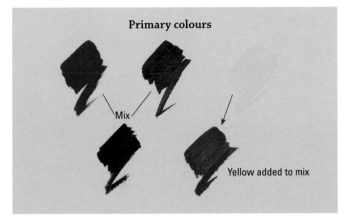

Primary colours

Mix

Yellow added to mix

Applying acrylic

After you have practised mixing a variety of hues in acrylic, these can be used for different effects.

Flat brush application – useful for plain backgrounds

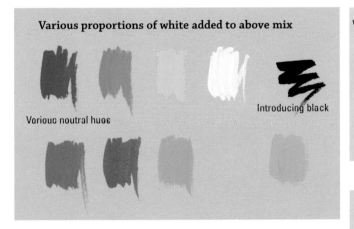

Various proportions of white added to above mix

Various neutral hues

Introducing black

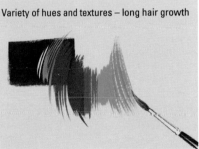

Variety of hues and textures – long hair growth

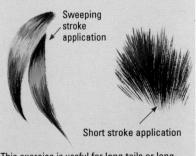

Sweeping stroke application

Short stroke application

This exercise is useful for long tails or long-haired breeds (see page 213)

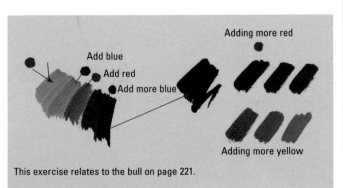

Adding more red

Add blue

Add red

Add more blue

Adding more yellow

This exercise relates to the bull on page 221.

Tone

Introducing tonal values

Tonal values, from the darkest dark to the lightest light (usually white paper), need careful consideration. Creating contrasts, whether in monochrome media or colour, is what makes images come alive – a very important factor in animal representations.

A tonal scale – from the richest hue to the palest – can be practised in any media and on all sorts of surfaces. Just a few are shown here, and these have varied application to add interest, showing, in some, how they can be used in context to represent hair contours.

Demonstrating tonal variations within hair effect – rich darks against white paper

Three shades using Stabilo Fineliner pens, showing build-up of tone by overlaying and the introduction of white paper between strokes

Derwent Graphitint – midnight black With water applied

Derwent Graphic Sketching 8B – dark wash

With water applied

Derwent Artists – burnt umber on smooth surface

Derwent Graphitint – cool brown With water applied

Derwent watercolour pencil – chocolate With water ap|

Note how colour changes with application of water

Watercolour pencil

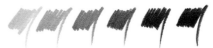

A mix of two hues sharpened into palette – water mixed with sharpenings to produce rich hue, and added in increasing quantities to introduce paler tones.

A variety of tonal values achieved with six Pitt Artist's pens in shades of grey. The two darkest shades were achieved by overlaying a second application of ink

Derwent Artists pencil – burnt umber on textured surface

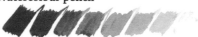

Derwent pastel pencil – chocolate with white added

Winsor & Newton Designers Gouache

Burnt sienna diluted with water to blend into pale tones

White gouache added to produce paler tones

Watercolour tonal 'ribbon'

Watercolour tonal blocks

Tone in composition

Tone adds interest and credibility to interpretations, working with lines to produce interesting effects, and its use in composition is demonstrated in these sketches of cattle in their fields. Here you can see a variety of tonal values working together – paler to depict distance, and stronger for foreground foliage, against which the animal's image contrasts, to bring it forward. Rich, dark, connecting cast shadows lead our eye through the composition.

Problems
Even if this drawing were to receive tone, the composition would prevent interest of presentation

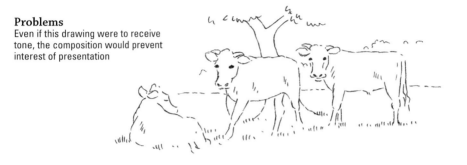

Solutions
Rich darks behind light forms bring animals forward in composition

The three numbered arrows show how our eye is led through the composition by the use of tone.

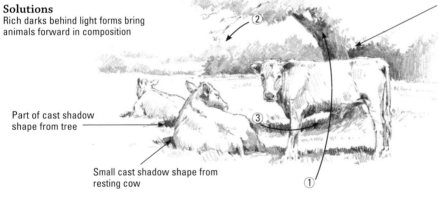

Part of cast shadow shape from tree

Small cast shadow shape from resting cow

Note the variety of tonal values used in just one area of background (the hedge) and within the animal forms

Small tonal shape immediately describes positions of both front legs in relation to chest

Textures

Hair and wool
Two totally different textures, hair and wool, make an interesting comparison. The former can be achieved by the use of lines, and the latter with more regard for tonal shapes.

Problems
The illustration on the right demonstrates the difficulties some artists experience when attempting to depict smooth hair on an animal with a short coat and sheep's wool (see page 227) or a curly-coated effect (see page 218).

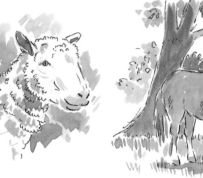

Pencil
In the illustrations below you can see how line and tone can be used for both different textured surfaces. Lines that indicate folds of wool-covered skin on a sheep need to be depicted unevenly in order to give a natural effect.

Watercolour
Using watercolour you can introduce various hues in the form of washes, over which brushstrokes can be applied, in the form of contoured lines as well as tonal masses.

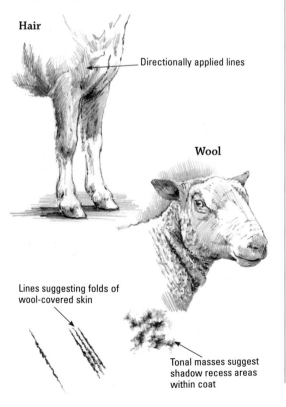

Hair

Directionally applied lines

Wool

Lines suggesting folds of wool-covered skin

Tonal masses suggest shadow recess areas within coat

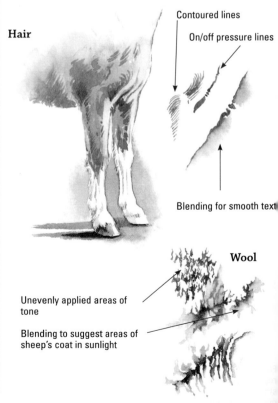

Hair

Contoured lines

On/off pressure lines

Blending for smooth text

Wool

Unevenly applied areas of tone

Blending to suggest areas of sheep's coat in sunlight

Mixed media

By retaining watercolour washes as underlay, as well as some softened contoured brush marks, you can then apply ink drawing to enhance the effect.

In the illustration below I have used contoured strokes that follow form, crosshatching to enhance areas in shadow, and stippling. The latter shows how identical treatment can be applied to both animal form and background areas.

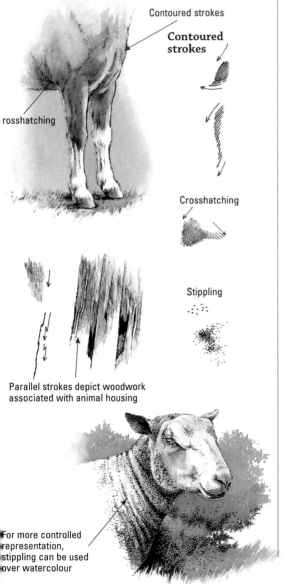

Contoured strokes

Contoured strokes

rosshatching

Crosshatching

Stippling

Parallel strokes depict woodwork associated with animal housing

For more controlled representation, stippling can be used over watercolour

Detail studies

Pencil is an excellent medium for discovering the intricacies of textured animal skin, and this example shows how close observation of an elephant's body skin and the trunk folds can be depicted by using a combination of line and tone.

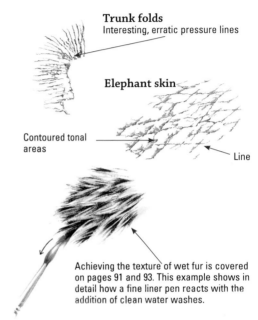

Trunk folds
Interesting, erratic pressure lines

Elephant skin

Contoured tonal areas

Line

Achieving the texture of wet fur is covered on pages 91 and 93. This example shows in detail how a fine liner pen reacts with the addition of clean water washes.

Textured supports

To help you achieve the rough texture of animal fur you can also use a variety of papers that have regular, or irregular, textured surfaces. The examples below show the use of soft coloured pencils upon plain brown wrapping paper.

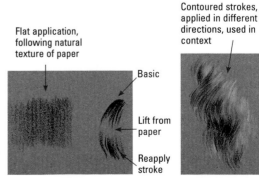

Flat application, following natural texture of paper

Basic

Lift from paper

Reapply stroke

Contoured strokes, applied in different directions, used in context

Line and Form

Wandering lines

Line drawing that defines form can be executed in a variety of ways. A 'wandering' line is useful for quick sketches, as the pen or pencil need not be removed from the paper's surface until the image is complete. This allows continuity to be retained throughout the drawing as well as providing an exciting method of working. The first illustration of the duck below was executed using a continuous line (with no variation of pressure placed upon the pen), and from beginning to end the pen remained upon the paper's surface, not being lifted until the image was complete – this line wanders around the form, going back over itself in places where necessary before moving onwards again.

This way of line drawing is very helpful for practising sketchbook work, where you often need to draw swiftly, and where lifting a drawing tool from the paper would break continuity. When used as a method for drawing from life, you can also vary pencil pressure to produce interesting lines.

Interest of line

The series of mouse studies below was drawn using a soft pencil to create rich tones. I made very few marks within the images, except for a few essential contours that help define form. The main interest of line remains around the edge of each animal's shape, and these lines are executed with on/off uneven pressure to achieve interest of representation.

Interesting on/off pressure 'edge' lines

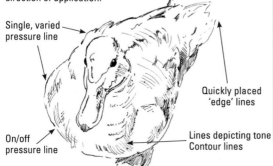

A wandering line finds form
Imagine this to be one continuous piece of brown thread. If you were to pull it, the whole image of the duck would unravel and disappear

A variety of lines create form
This image shows how a variety of lines describe form by their direction of application.

Single, varied pressure line

On/off pressure line

Quickly placed 'edge' lines

Lines depicting tone
Contour lines

Ink on tinted paper

Pen and ink drawing is very popular
and there are numerous methods of
application, using a variety of pens on
many different surfaces.

The tinted Bockingford paper used here,
combined with a mapping pen nib dipped
in acrylic ink (raw sienna), enhances linear
representation by tint and texture.

On/off pressure lines are combined with
a series of tiny strokes on some areas
of muzzle and longer, curved strokes
depicting the untidy hair found on top
of the camel's head and around the neck.
Sometimes pressure is lifted completely
from the paper to introduce 'lost lines',
which usually indicate highlighted areas.

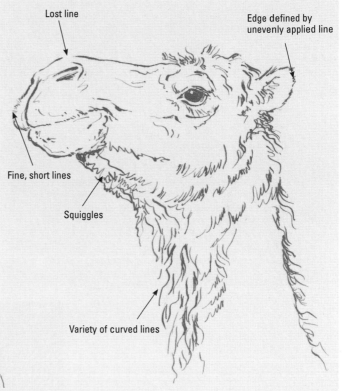

Lost line

Edge defined by
unevenly applied line

Fine, short lines

Squiggles

Variety of curved lines

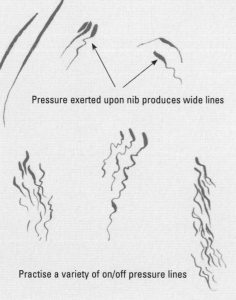

Pressure exerted upon nib produces wide lines

Practise a variety of on/off pressure lines

Pencil Sketch

Showing importance of:
a) Negative shape in a relationship
b) Relationship of dark tones against light

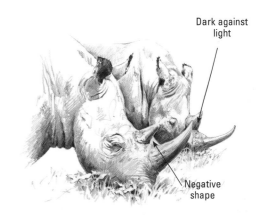

Dark against
light

Negative
shape

Markings

Lines may also be used to indicate markings – for example, the tabby effect on a cat's fur or, as here, on the fur of a short-coated dog. A series of short strokes (separate lines) are applied in a way that follows contours of pattern over the animal's form – in this instance, outlining the image is unnecessary. Note how much white paper remains untouched by pen on the dog's form, which is mostly defined by the direction of small strokes depicting pattern.

Around the perimeter of the study I have indicated the various considerations necessary for different marks of the pen; establishing a strength of background hues limited the amount of drawing necessary on the dog itself.

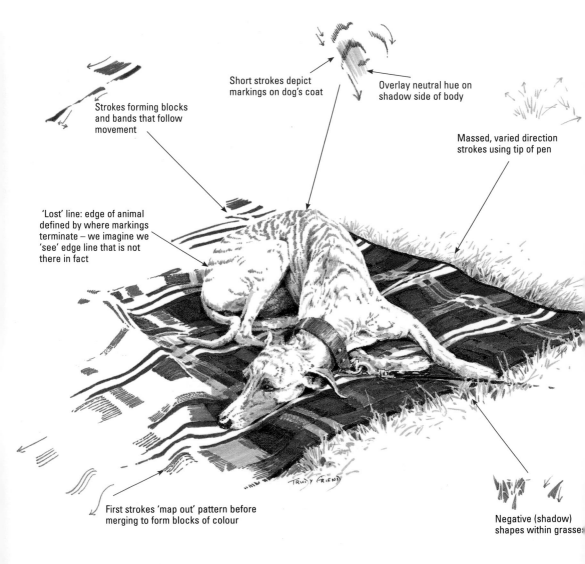

Short strokes depict markings on dog's coat

Overlay neutral hue on shadow side of body

Strokes forming blocks and bands that follow movement

Massed, varied direction strokes using tip of pen

'Lost' line: edge of animal defined by where markings terminate – we imagine we 'see' edge line that is not there in fact

First strokes 'map out' pattern before merging to form blocks of colour

Negative (shadow) shapes within grasses

TRUDY FRIEND

Pen and watercolour wash

The versatility of pigment liner pens can be seen in these two illustrations, where undermarkings of stripes and pattern are achieved by overlaying ink strokes, to makes lines of varied width for the zebra and blocks of strong tone and hue to indicate patterns in the cat's fur. In both cases a textured paper surface enhances the effect, which is achieved by placing stroke upon and next to stroke, following the form to create contoured impressions.

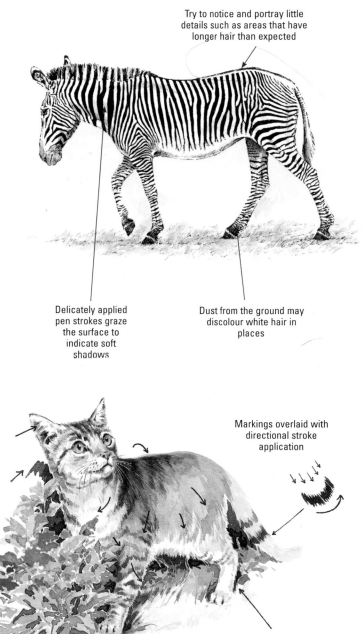

Try to notice and portray little details such as areas that have longer hair than expected

Delicately applied pen strokes graze the surface to indicate soft shadows

Dust from the ground may discolour white hair in places

Markings overlaid with directional stroke application

Heads and Features

In the themed sections of this book you will find a variety of animals, birds and reptiles depicted. Here I have given a few examples of various animals' heads to demonstrate the wide range of forms and textures you may encounter in your animal studies.

Pencil study

The delightful, slightly comical, expression on a guinea pig's face, of which a side view is demonstrated in colour on page 213, is drawn below seen from the front to show how the eyes appear when viewed at this angle. The ears on long-coated guinea pigs can be partially hidden behind the thick, silky hair. To depict this, 'cut in' with dark tones to bring the light areas forward.

Always remember to leave strong, clear highlights in the dark eyes and use the whole tonal scale to provide the contrast of darkest darks against lightest lights (the white paper) – as well as the intermediate tones.

Directional strokes

The guinea pig study is a completed drawing, but I have left the one on the above right, the head of a goat, unfinished in order to include a series of arrows indicating directional stroke application to show how this defines the form beneath.

Within the longer hair of the beard you can see dark negative shapes. When working in monochrome, consider how white paper works within the tonal range.

Direction of hair growth

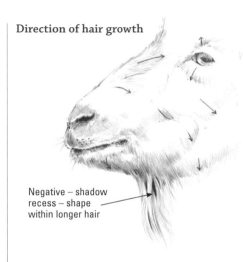

Negative – shadow recess – shape within longer hair

Watercolour study

White paper also plays an important part in watercolour studies, and the illustration below, of a goat's head seen in front of the dark recess of its hut, demonstrates the strong contrast of a white form against an area in shadow.

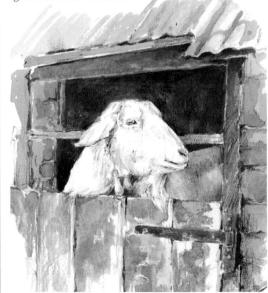

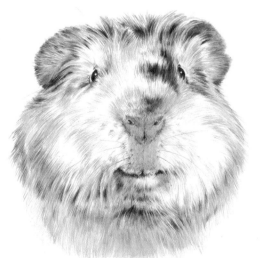

2B and 3B pencils on Bristol board

Pen and ink

Working with pen and ink you can produce different effects, depending upon the surface texture of the paper and method used. This ink drawing of a chicken's head, drawn on smooth-surface paper, demonstrates how stippling on the comb area contrasts successfully with longer, contoured strokes used to depict feathered areas.

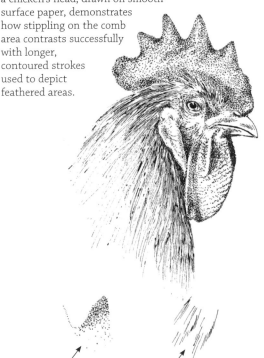

Stippling for comb Long strokes for feathers

Soft and subtle

The softness of a duck's plumage is echoed in the softer appearance of its bill as opposed to the chicken's sharp beak. This image was executed on the same smooth paper as that of the chicken on the left, yet you can see a textured effect on the background area as the pencil grazes the surface to build intensity of pigment. I used Derwent Signature coloured pencils, which are highly lightfast.

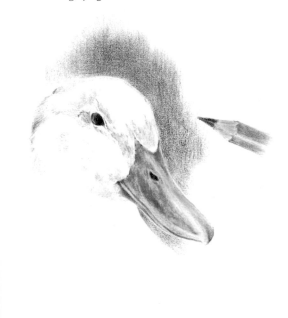

Pen, ink and wash

By gently grazing a pen over the surface of textured watercolour paper a delicacy of line can be achieved, as demonstrated in this head study of a crocodile.

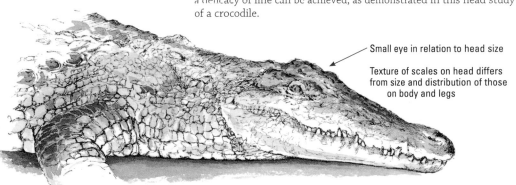

Small eye in relation to head size

Texture of scales on head differs from size and distribution of those on body and legs

Movement

Noticing nuances

We are all familiar
with obvious animal
movements, such as
walking, running
and jumping – it is
the smaller ones that
can easily escape our
notice. Animals that climb
trees and jump from branch to branch,
such as a squirrel (page 243) or monkey,
are familiar to us and can be observed in
the garden or zoo respectively. These,
and others, may also appear on our
TV screens, where we can watch them
in the comfort of our homes and learn to
understand how they appear when viewed
from different angles –
as demonstrated in
these sketches of
a lion and lioness
prowling.

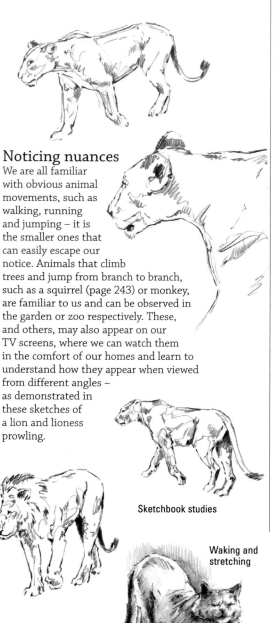

Sketchbook studies

Waking and
stretching

Small movements

It is helpful to be aware of the smaller, often
unnoticed, movements in order to understand more
about respective species. This detailed monochrome
drawing of a cow cleaning itself shows one of the small
movements that can catch our eye and add interest to
the animals we observe.

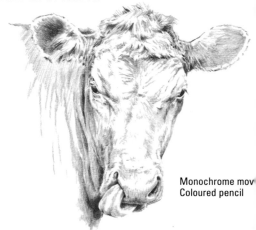

Monochrome mov
Coloured pencil

Close to home

We also have the opportunity to observe domestic cats,
both at home or out of doors. My sketches of an old
farm cat stretching after waking, prior
to wandering off to find a comfortable
place to rest or lie
in wait for an
unsuspecting mouse
or bird, show obvious
movement in the first two
studies. The third sketch
contains a movement that is
less discernible – a turn of the
ear to catch an elusive sound.

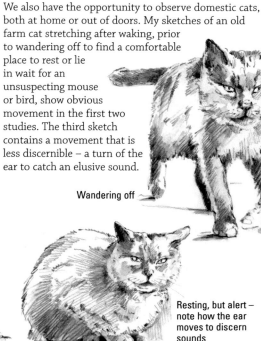

Wandering off

Resting, but alert –
note how the ear
moves to discern
sounds

Other movements

In the sections that follow, you will find other opportunities to notice movement within some of the animal studies: on page 229, where a horse is depicted grazing, there is a slow progression of one leg being placed after another, with a few moments elapsing in between each movement. This allows us to be aware of bodyweight being transferred in a more leisurely way from one limb to another.

Movement and weight

These two pen studies of an elephant walking show not only leg and shoulder movement at this pace but (in the upper study) how the animal may rest its trunk on a tusk while travelling – a small thing to notice, yet this tells us a great deal about the animal and the way it controls its body parts for convenience or to take weight from certain areas.

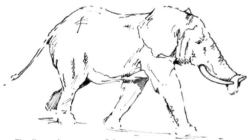

Fineliner pigment pen 0.1

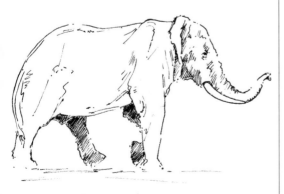

Noticing negatives

Sometimes an animal or bird's movement can create a negative shape that adds interest to its depiction. This becomes more exciting when related to a background that is also moving – such as the water in which the bird stands – giving you even more shapes to notice and include in your artwork (see page 251).

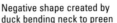

Negative shape created by duck bending neck to preen

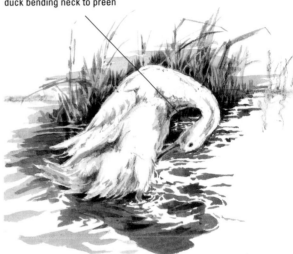

Unseen movement

We cannot see the swan's feet so we are only aware of their movement by observing the bow wave in the water as it travels.

Ripples on surface of water show that legs are moving

Body Mass and Limb Relationships

Body mass in relation to limbs

I hope that you are as fascinated as I am by the diverse shapes, colours, textures and unusual conformations of many animal species – the long neck of a giraffe and a swan, the short necks of a pig and a hippo, the wide, heavy horn of a rhino and the delicate antlers of a deer are but a few interesting comparisons, as are the length of a mouse's tail in relation to that of its body, the way a monkey uses its hands to eat in the same way that we do, the extraordinary elephant's trunk and the striped coat of a zebra. All these marvellous creatures offer artists endless opportunity for media exploration and methods of execution.

Here I can only briefly cover relationships of body mass; and, for this purpose, I have chosen a pig as my first subject. With a heavy head on an almost non-existent neck, massive shoulders and a bulky body – all supported on short, stocky legs and small trotters – this highly strung, gregarious and naturally curious animal is both clean and responsive to tactile stimulation.

A pig at rest offers an ideal opportunity for detailed drawing and for observing the underside of the trotters. The illustration below depicts forelimbs, and the one above right the hind legs. The latter, when stretched out, can easily be mistaken for the former, were it not for the knobbly hock joints and the teats on either side of the limbs.

Derwent Graphitint pencils were chosen for this subject; I used port for the underdrawing in the study below and as a monochrome hue for the drawing above right.

Pencil used dry

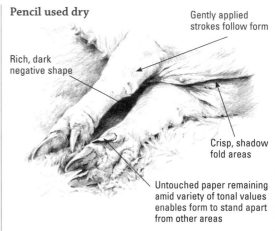

Gently applied strokes follow form

Rich, dark negative shape

Crisp, shadow fold areas

Untouched paper remaining amid variety of tonal values enables form to stand apart from other areas

Detail of head

The acrylic illustration of the pig's head below demonstrates the weight of the fascinating form with its numerous folds (causing the eyes to close), lop ears and permanent 'smile' in repose. Compared with the bland appearance of the pig's body, its head and feet are remarkably complex.

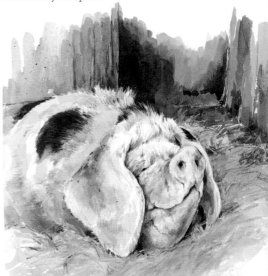

Derwent graphitint blended with water

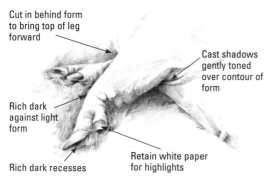

Cut in behind form to bring top of leg forward

Cast shadows gently toned over contour of form

Rich dark against light form

Rich dark recesses

Retain white paper for highlights

Soft and furry

In comparison to a pig, a rabbit, where the first impression may be of short legs beneath a bulky, furry body mass, undergoes a transformation when the powerful extended hind legs propel it forward at great speed or, alternatively, form a firm support for the animal to sit erect and survey its surroundings (see page 211).

Watersoluble pencil and wash

A rabbit's neck appears short within folds of hair but elongates when the animal feeds or stretches forwards.

Short ears, long neck

Both pigs and rabbits may have erect ears or be lop-eared, and this also applies to different breeds of goat. Whether covered in short or longer hair, depending upon the breed, a goat's neck is slender compared to that of a pig or rabbit.

Pen and ink
The long, slender neck of a goat is exposed as the head is turned

Compilation

The illustration below, of a group of swans, includes elements of colour, texture, line and form, as well as body mass in relation to the supporting structure of the legs. You can see negative shapes and how our eyes can be led through the composition: a little colour on the bills; some feather texture on the necks and body areas; line in the form of shadow lines within wing feathers; and form where both the sides and rear-view aspects of the body bulk are shown.

The Graphitone range of watersoluble pencils includes white; I executed this study on paper that had received a watercolour tinted wash so that I could include a variety of tonal values, both within the forms of the birds and the areas of background that relate to them. A little water was used to blend hues in some areas, with more drawing overlaid to increase the intensity of dark tones.

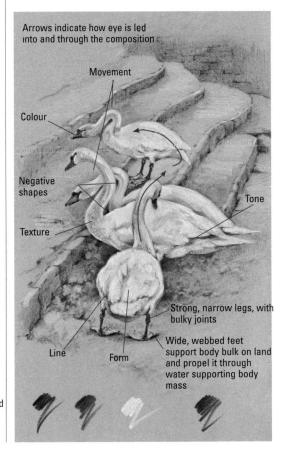

Arrows indicate how eye is led into and through the composition

Movement

Colour

Negative shapes

Texture

Line

Form

Tone

Strong, narrow legs, with bulky joints

Wide, webbed feet support body bulk on land and propel it through water supporting body mass

Exercises in Accuracy

One animal and more

Using photographic references, these exercises are designed to help you understand the importance of observing shapes to depict animal images.

Building shapes

Think of this as building an image upon a scaffold of lines – your guidelines – in order to see (and use) the shapes between. These images may be:

• negative shapes
• shapes between parts of the animal
• shapes between your guidelines and parts of the animal
• shapes between something attached to the animal

Negative shapes

These may be 'open' or 'closed': on the facing page I have indicated examples of both in blue. The important 'closed' negative does the job of relating two beasts and depicting the correct perspective angle of the upper pole under which the cows are tied.

The 'open' negative positions the nearest animal correctly in relation to the upper pole. The open end is only there because there is no clear definition as to where the image itself ends.

Shapes between parts

These are not negatives but they are between parts of the animal, within the form. An example of this can be seen on the drawing of the lion below left, with the relationship between the nose, mouth and the side of the muzzle; I have annotated this small 'shape between'. Shapes within the animal's form are particularly helpful to establish when depicting three-quarter views like this.

Shapes between guidelines and parts

Shapes between guidelines and 'edge' lines of the animal help to establish an accurate silhouette. When vertical and horizontal lines have been placed in 'key' positions (below left) and are crossing each other, you need only concentrate upon the third side of the triangle to establish accuracy. Look at where the strongest vertical and important horizontal cross: the former actually touches part of the lion's eye. The third side of the triangle is the upper part of the profile.

Shapes between attachments

An example of this is the ring of the head collar on page 200. Look at the shape inside the ring, which consists of two straight lines and one curved. If you forget the fact that you are drawing a ring with leather attached and just look at the internal shape, you can place the attached leather straps at correct angles.

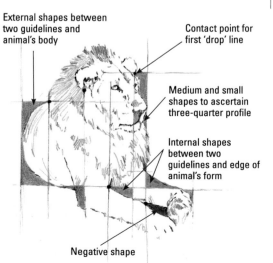

External shapes between two guidelines and animal's body

Contact point for first 'drop' line

Medium and small shapes to ascertain three-quarter profile

Internal shapes between two guidelines and edge of animal's form

Negative shape

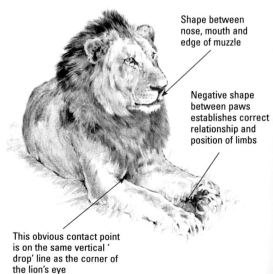

Shape between nose, mouth and edge of muzzle

Negative shape between paws establishes correct relationship and position of limbs

This obvious contact point is on the same vertical 'drop' line as the corner of the lion's eye

Guidelines

To solve the problem of where to start in a complicated arrangement of images, even of a single animal, you need to decide where to place the strongest vertical ('drop') line, cross it with an important horizontal line and see it in relation to one of the above shapes.

On the preliminary drawing of the lion (opposite far left) my initial drop line was drawn from the base of the farthest ear, where there is visual contact with the top of the head.

If we were to walk around in front of this animal, we would see that this part of the ear is not in physical contact with the head at the point we see from the three-quarter view, being joined lower down. The contact is visual only, when we view it from the angle depicted. On the preliminary drawing of the lion I chose this starting point in order to establish the head angle first, using small and medium shapes, between the animal's profile and another guideline (shown in green).

In the more complicated composition of the cattle on page 200 I used the important negative shape from which my strongest vertical could drop, thereby helping me place the eye with the use of small contour lines following form.

Running the important horizontal guideline through the visual contact point where the noseband of the nearest animal and the collar of its neighbour meet immediately placed the level of the second beast's eye. The basis of my personal grid was then established.

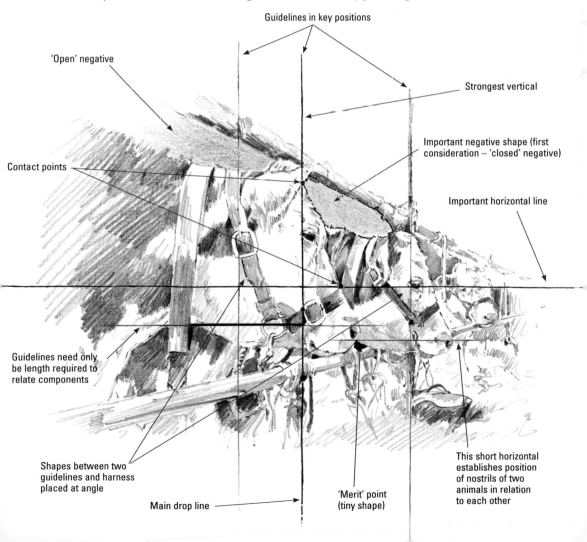

Guidelines in key positions

'Open' negative

Strongest vertical

Contact points

Important negative shape (first consideration – 'closed' negative)

Important horizontal line

Guidelines need only be length required to relate components

Shapes between two guidelines and harness placed at angle

Main drop line

'Merit' point (tiny shape)

This short horizontal establishes position of nostrils of two animals in relation to each other

Contact points

In addition to visual contact points, where things overlap (cross) within our vision, there are also physical contact points. An obvious example is the bend of a limb – indicated on the lion drawing on page 198, far left.

Take a copy of one of your animal photographs (so that you do not damage the actual photo) and look for obvious contact points similar to those in the cattle picture here. Draw freehand your own 'drop' lines and horizontal guidelines on this copy, and you will discover how many components actually line up with each other; for example, the short horizontal line from the lowest part of the animal's nostril lines up with the upper part of the next animal's nostril in the

drawing. Think of this exercise as if it were a jigsaw puzzle, fitting one piece into another until the whole is complete.

Although I have specified the parts of the animals to which I am referring on my drawings, the best way to place components correctly in your first investigative drawing/sketch is by not being conscious of the subject you are drawing – only the shapes involved.

By placing photographic reference upside down, many people find it easier to obtain accuracy, as they are less likely to recognize certain areas and thus rely on observing the shapes alone. When working from life this is not possible, and we need to try to forget the subject matter in order to place components (shapes) correctly in relation to each other.

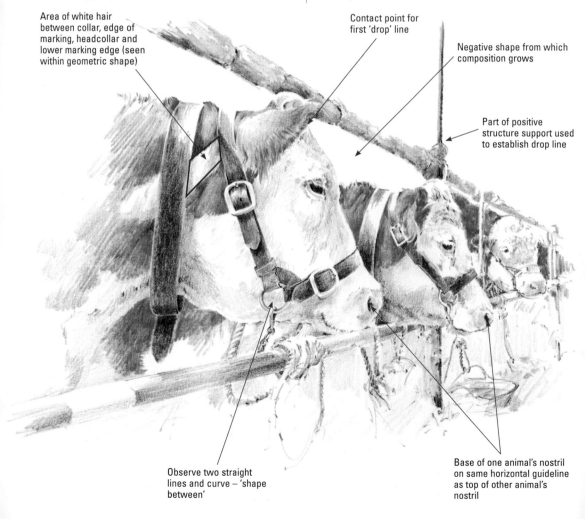

Area of white hair between collar, edge of marking, headcollar and lower marking edge (seen within geometric shape)

Contact point for first 'drop' line

Negative shape from which composition grows

Part of positive structure support used to establish drop line

Observe two straight lines and curve – 'shape between'

Base of one animal's nostril on same horizontal guideline as top of other animal's nostril

With an Artist's Eye

Throughout the following pages I frequently stress the importance of close observation and understanding of subject matter by the inclusion of investigative sketches, drawings and diagrammatic representations. Each animal species requires careful thought and a degree of understanding regarding form, confirmation, movement, skin/fur texture and so on, if it is to be depicted convincingly by the artist.

Sketchbook work

Sketching from life is essential, even if you know you will be working mainly from photographic reference; and to be effective, a sketchbook needs to be used on a regular basis.

Try to keep your sketchbook for personal reference, rather than for others to see. This will remove some of the pressure you may place upon yourself to produce 'finished' images, and will allow you to tentatively discover and develop your skills as well as being bold and spontaneous, at times resulting in what you may feel are drawing disasters. They are, in fact, not disasters, just you finding your feet – and they are all part of the learning process. Whether you place just an interesting line (or mark) on your paper as a result of what you see, or manage to give a convincing impression of the animal's form, you will be learning all the time. Try to welcome problems and enjoy the challenge of solving them, rather than being afraid of them.

Extreme distortion
Distortion not so apparent at this angle suitable for head and shoulder study

Observation and composition

Two or more animals in relation to each other present an obvious need for composition. However, whether or not a background environment is included, it is still necessary to compose a single animal's position on your paper in relation to the format or within a mount.

The obvious consideration of allowing more space in front of the profile, in order that the head is not placed too close to the edge of the format on one side, with too much space behind the form, needs to be combined with other considerations. It is important to be aware of angles within the animal's pose, suggesting balance and weight distribution, and to ensure that the subject is convincingly grounded or anchored to its support – even if very little of this is actually shown.

Working from photographs

One of the main problems when working from photographic reference is that of coping with distortions: enlarged animal heads behind which body sizes decrease disproportionately produce unsatisfactory representations when copied directly from the reference material. Photographic reference is best used for just that, not copied exactly, and if you have already made sketches from life to accompany your photos, you will achieve more pleasing results. If, however, you have only a couple of photographs, and no other reference, you may need to limit the area you depict.

The extra – and vital – ingredient is an understanding of your subject. This may have been gained by watching the animal at play, at rest or doing normal activities, as well as a variety of photographs that enable you to visualize it from different angles.

In these two photographs and the sketches I made directly from them you can see an example of distortion. However, even with limited reference such as this you can use part of the image to create a drawing or painting.

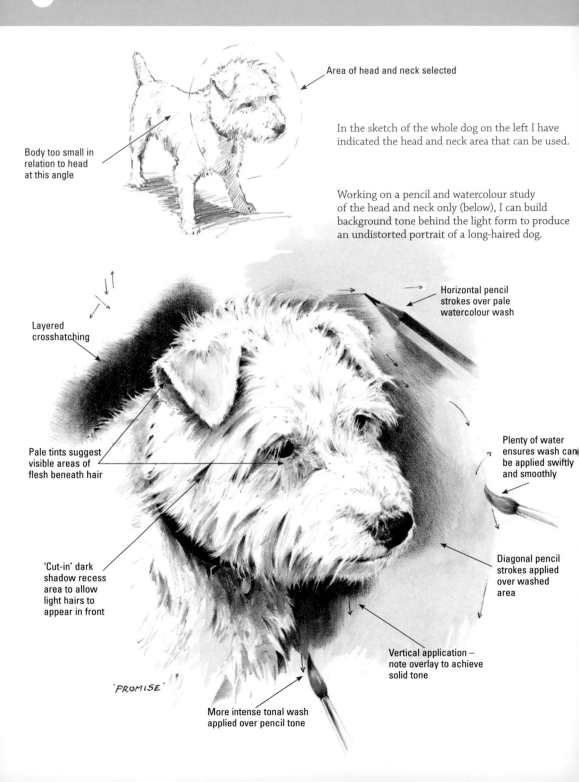

Area of head and neck selected

Body too small in relation to head at this angle

In the sketch of the whole dog on the left I have indicated the head and neck area that can be used.

Working on a pencil and watercolour study of the head and neck only (below), I can build background tone behind the light form to produce an undistorted portrait of a long-haired dog.

Layered crosshatching

Horizontal pencil strokes over pale watercolour wash

Pale tints suggest visible areas of flesh beneath hair

Plenty of water ensures wash can be applied swiftly and smoothly

'Cut-in' dark shadow recess area to allow light hairs to appear in front

Diagonal pencil strokes applied over washed area

Vertical application – note overlay to achieve solid tone

'PROMISE'

More intense tonal wash applied over pencil tone

Choose an easy angle

When photographing your subject, try to choose an angle that presents the fewest problems to start with. A simple side view for the body, with the head turned towards you, provides enough interest for your study; it may be necessary to edit in a tail or to change the tail's position to add interest to the composition, and a background can be adapted to suit the pose.

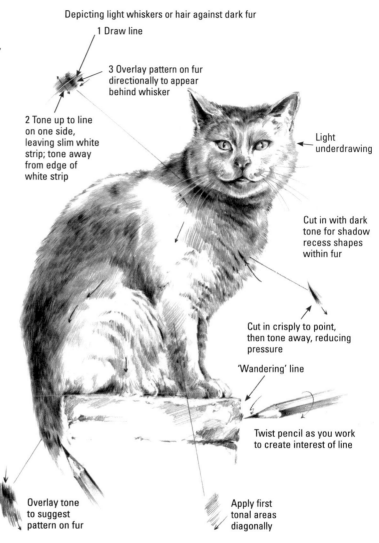

Depicting light whiskers or hair against dark fur

1 Draw line

3 Overlay pattern on fur directionally to appear behind whisker

2 Tone up to line on one side, leaving slim white strip; tone away from edge of white strip

Light underdrawing

Cut in with dark tone for shadow recess shapes within fur

Cut in crisply to point, then tone away, reducing pressure

'Wandering' line

Twist pencil as you work to create interest of line

Overlay tone to suggest pattern on fur

Apply first tonal areas diagonally

Editing in and editing out

Using the same dog as a model, in the next sketch the lead has been excluded and a piece of cloth substituted that relates to the dog's position. The background has been excluded, and an indication of the two furthest limbs has been included to help give stability to the pose.

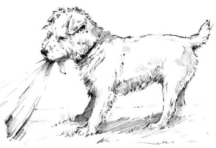

The exercises on these two pages relate to the theme of domestic pets. Of all the groupings of animals featured in this book, domestic pets are often the best subjects for the artist, as familiarity with their owners means that they can be drawn and painted when they are relaxed and not poised for escape from what they see as a threat; you can probably also get near to your pet for interesting close-ups.

Pencil Exercises

Watersoluble graphite

Watersoluble graphite pencils are available in different grades; each reacts differently when water is added, depending upon which paper is used.

The pencils can be equally effective used alone or mixed with another media, and used wet or dry. The exercise here demonstrates how to lift pencil pressure a little while applying strokes, to achieve the effects of highlighted areas, and how to lift the pencil completely from the paper while continuing the stroke to depict white markings on a coat.

Basic strokes

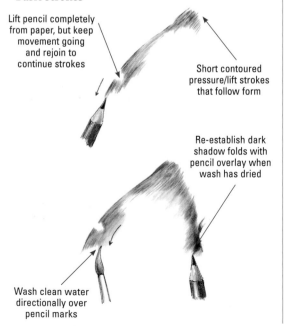

Lift pencil completely from paper, but keep movement going and rejoin to continue strokes

Short contoured pressure/lift strokes that follow form

Re-establish dark shadow folds with pencil overlay when wash has dried

Wash clean water directionally over pencil marks

Graphite (drawing) pencil

Wandering line

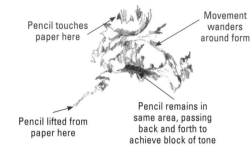

Pencil touches paper here

Movement wanders around form

Pencil lifted from paper here

Pencil remains in same area, passing back and forth to achieve block of tone

Combination lines

Here, the pencil produces contoured lines and tonal areas to suggest layers of thick fur and shadow recesses (page 209).

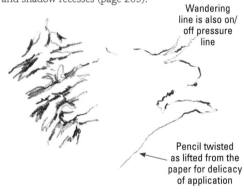

Wandering line is also on/ off pressure line

Pencil twisted as lifted from the paper for delicacy of application

Individual 'pull down' lines

To achieve tabby markings (or marking effect), single contoured strokes are massed

Single contoured strokes

Massed to produce block of tone

Carbon pencils

These pencils produce rich contrasts when used upon brilliant white paper – for example, Bristol board. When sharpened to a fine point they can be used to achieve a great level of detail (see page 215).

Soft pencil

A soft 6B carbon pencil on smooth white paper is ideal for rich black strokes that, when massed, can achieve the effect of irregular patches on a mouse's coat.

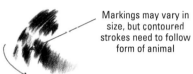

Contoured strokes using finely sharpened pencil create dark patches

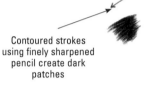

Markings may vary in size, but contoured strokes need to follow form of animal

Hard pencil

A hard (B) carbon pencil can produces exciting linear variations if you twist the pencil from time to time while working. This exercise also relates to the previous wandering line interpretations.

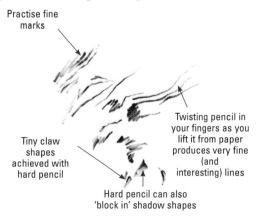

Practise fine marks

Tiny claw shapes achieved with hard pencil

Twisting pencil in your fingers as you lift it from paper produces very fine (and interesting) lines

Hard pencil can also 'block in' shadow shapes

Brush Exercises

Watercolour

Arguably one of the most versatile of media, whether used on its own, with pencil or with a variety of other media, watercolour can be either subtle and subdued or vital, bright and exciting. In this section I have used it in a monochrome representation of a rabbit (see pages 210–11) by mixing just two colours to produce a neutral hue, and for a more colourful image of a 'coloured' (skewbald) Shetland pony (see pages 216–17).

Blending fur

This first exercise is very simple and relates to contoured stroke application that follows form. Use plenty of water, as your strokes need to be fluid. Once you have established this area of tone (and before it starts to dry), practise a few little experiments around its edges.

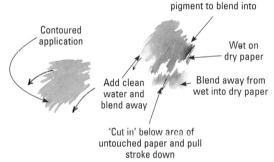

Contoured application

Introduce darker pigment to blend into

Wet on dry paper

Add clean water and blend away

Blend away from wet into dry paper

'Cut in' below area of untouched paper and pull stroke down

Hair details

A mixture of raw and burnt sienna produce the bright hue of the pony's markings. As these equines possess thick coats, we have an opportunity to observe hair direction and have fun depicting the various swirls that occur.

This little exercise demonstrates how, by pulling pigment away from areas that are to be depicted as the white hairs, we can suggest light in front of dark.

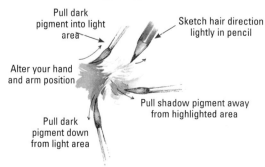

Pull dark pigment into light area

Sketch hair direction lightly in pencil

Alter your hand and arm position

Pull shadow pigment away from highlighted area

Pull dark pigment down from light area

Problems

Dog

Smooth-coated dogs, such as this beagle puppy, give the artist an opportunity to observe the animal's structure as well as skin folds and highlights on a glossy coat. A straightforward pose can be enhanced by an angled head position, but this can present a few problems for the novice artist.

The depiction of the black fur of an animal's coat can also present problems for beginners. This can be overcome by the use of watersoluble graphite in conjunction with watercolour paints. Giving strength to white areas without the use of a continuous outline can be a further problem faced by those who do not give enough consideration to the relevance of a background against which forms are placed.

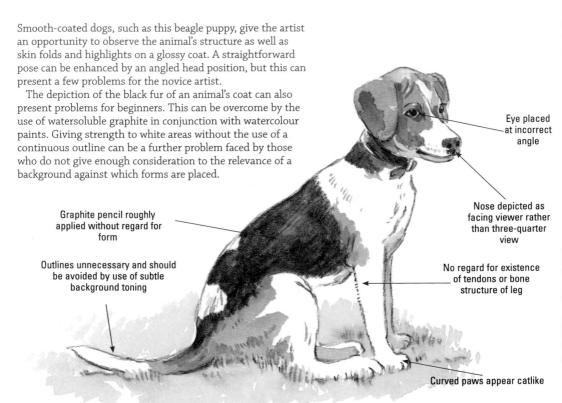

Eye placed at incorrect angle

Nose depicted as facing viewer rather than three-quarter view

Graphite pencil roughly applied without regard for form

Outlines unnecessary and should be avoided by use of subtle background toning

No regard for existence of tendons or bone structure of leg

Curved paws appear catlike

Techniques

Mixing basic browns

Blending watercolours to create natural browns.

Basic colours

Mix of two basic colours

Fur blends

Method for dark fur of dog's back.

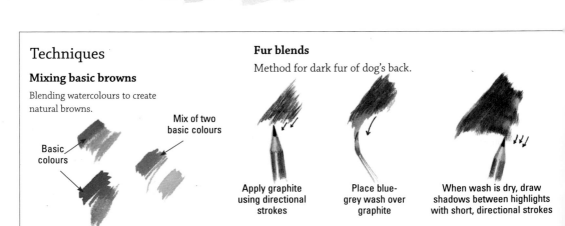

Apply graphite using directional strokes

Place blue-grey wash over graphite

When wash is dry, draw shadows between highlights with short, directional strokes

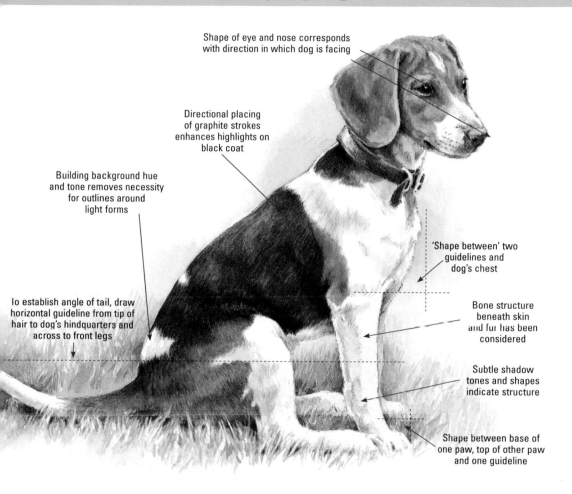

Shape of eye and nose corresponds with direction in which dog is facing

Directional placing of graphite strokes enhances highlights on black coat

Building background hue and tone removes necessity for outlines around light forms

'Shape between' two guidelines and dog's chest

To establish angle of tail, draw horizontal guideline from tip of hair to dog's hindquarters and across to front legs

Bone structure beneath skin and fur has been considered

Subtle shadow tones and shapes indicate structure

Shape between base of one paw, top of other paw and one guideline

Suggested palette

A limited palette of two colours is all that is needed alongside the graphite.

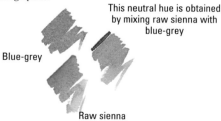

This neutral hue is obtained by mixing raw sienna with blue-grey

Blue-grey

Raw sienna

Tonal variations of background hue used to demonstrate painting behind white areas of fur, indicating presence of background and bringing white area forwards

Problems

Cat

Whether the animal is smooth- or long-haired, the subtle grace of a cat lends itself to being sketched in a loose style. Although capable of swift movements, a cat also has its languid moments. It is at these times that we are able to draw from life in our sketchbooks, capturing informal moments when the animal is relaxed in an expressive pose.

Tight, diagrammatic lines around the image, as well as disconnected marks at the edges that do not relate to those within the form, contribute to the flat appearance of form in these two sketches.

Features do not relate successfully, so face has flat appearance

Hard, uninteresting outline

Outlined limbs appear stiff, not relaxed

Paws viewed incorrectly and depicted at similar angles

Worm-like marks do not give impression of shadow shapes within fur mass

Cast shadow placed incorrectly

Techniques

Water-soluble graphite

A dark wash of 8B water-soluble graphite responds effectively to the addition of water when placed on Rough surface paper.

Continuous, varied pressure line

Water pulled away from line

Water washed across area

Lifting from drawn and toned image

Lifting from tonal block

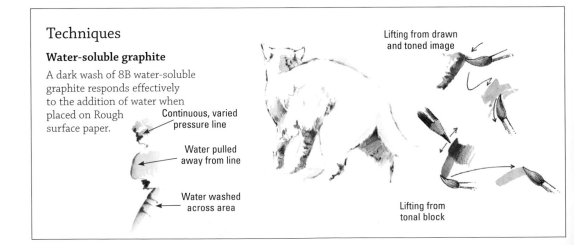

The use of a 'wandering line' (where the 4B pencil hardly ever leaves the paper during the execution of the sketch) establishes these images loosely. If the cat remains in the same pose for some time, certain areas may then be enhanced with stronger lines and tones.

Try not to become too involved with the fluffy fur to the detriment of the structure beneath. Contour your tonal patterns to 'follow the form'.

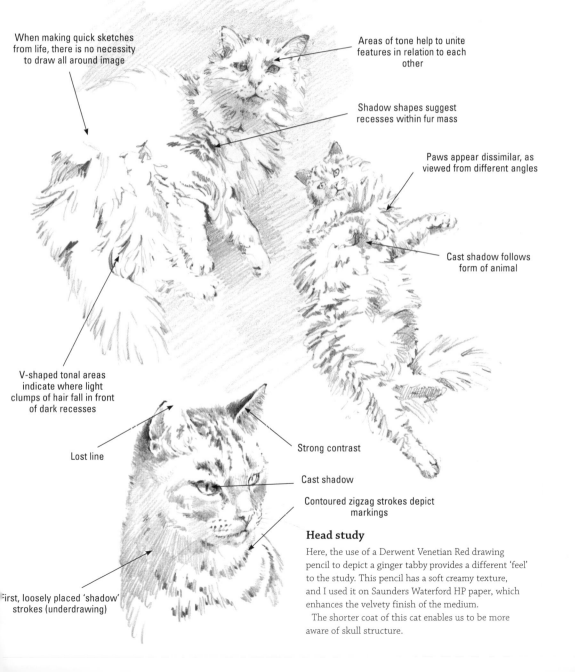

When making quick sketches from life, there is no necessity to draw all around image

Areas of tone help to unite features in relation to each other

Shadow shapes suggest recesses within fur mass

Paws appear dissimilar, as viewed from different angles

Cast shadow follows form of animal

V-shaped tonal areas indicate where light clumps of hair fall in front of dark recesses

Lost line

Strong contrast

Cast shadow

Contoured zigzag strokes depict markings

First, loosely placed 'shadow' strokes (underdrawing)

Head study

Here, the use of a Derwent Venetian Red drawing pencil to depict a ginger tabby provides a different 'feel' to the study. This pencil has a soft creamy texture, and I used it on Saunders Waterford HP paper, which enhances the velvety finish of the medium.

The shorter coat of this cat enables us to be more aware of skull structure.

Problems

Rabbit

There are many types of pet rabbit, and they may be a variety of colours with different markings. Soft fur makes watercolour a natural choice for their depiction, where blending achieved by the 'dropping in' method can enrich dark fur recesses. 'Cutting in' and blending will bring forward the pale hairs and create strong contrasts.

The rabbit's large eye needs careful observation for highlights, and its soft, furry feet will be anchored by strong shadows beneath the form.

If only a suggestion of background is to be included, a delicately blended neutral hue behind, and 'cutting in' to the edge of a white fur area, will avoid areas unintentionally becoming 'lost'.

The main image opposite is unfinished in order to show the use of overlaid washes (wet on dry) that will gradually build form with subsequent layers of hue.

Application of colour up to this stage has taken time and thought, to ensure each layer is correctly placed and blended where necessary. When depicting a large expanse of one colour, if no thought is given to contours of form and the way some areas will appear lighter and others darker (due to highlights and shadow areas) the colour will appear flat and not suggest form. There is also the possibility of water marks occurring as one part of the wash dries while the remainder is still being applied.

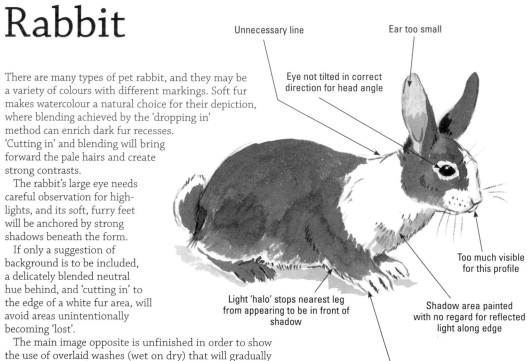

Unnecessary line

Ear too small

Eye not tilted in correct direction for head angle

Too much visible for this profile

Light 'halo' stops nearest leg from appearing to be in front of shadow

Shadow area painted with no regard for reflected light along edge

Feet too large and not anchored

Techniques

'Dropping in'

In this context, 'dropping in' involves touching an already wet area with a brush to which a darker tone of the same pigment has been added. When this pigment is 'dropped in' to the damp paper it will spread out and 'bleed', causing interesting effects as it meets damp or dry paper respectively.

These examples, showing part of a rabbit's hind leg, show the basic exercise executed with smoothly applied washes. When painting actual images, aim to allow the texture of the paper to influence the effects spontaneously.

Paint shape behind which you intend to 'drop in'

'Cut in' up to edge that is to remain as white paper, then pull pigment down

Overlaid washes of wet-into-wet, blended and 'dropped in', have slowly built this image to the level of development you see here. A few more overlays are required before the desired intensity of hue and tone is achieved.

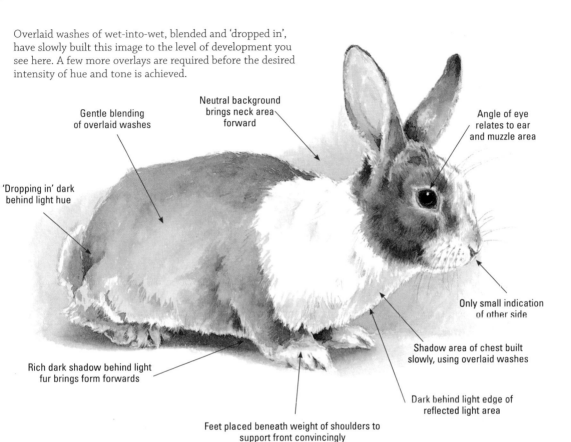

Gentle blending of overlaid washes

Neutral background brings neck area forward

Angle of eye relates to ear and muzzle area

'Dropping in' dark behind light hue

Only small indication of other side

Rich dark shadow behind light fur brings form forwards

Shadow area of chest built slowly, using overlaid washes

Dark behind light edge of reflected light area

Feet placed beneath weight of shoulders to support front convincingly

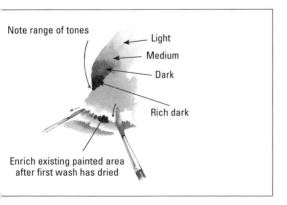

Note range of tones

Light

Medium

Dark

Rich dark

Enrich existing painted area after first wash has dried

Sitting upright

This study used watercolour, watercolour pencil and gouache on tinted Bockingford paper; some overdrawing in pencil, in addition to the initial drawing, was also done.

Problems

Guinea Pigs

The species of wild guinea pigs found in South America are a speckled brown hue, while the colours and markings of domesticated guinea pigs or cavies can vary considerably, as can the texture, length and growth direction of their fur. Whether they have smooth, long hair or rosetted fur, these attractive little animals are popular pets. The babies, born with their eyes open and with all their fur, look like small adults, but have heads a little disproportionate to their bodies.

One of the problems beginners sometimes experience with quick-drying, permanent acrylic paint is that of retaining delicacy of stroke application in areas of fine detail. Highlights in eyes may easily be placed too heavily, and 'feathery' edges to overlay fur masses can appear as blocks rather than thin hair.

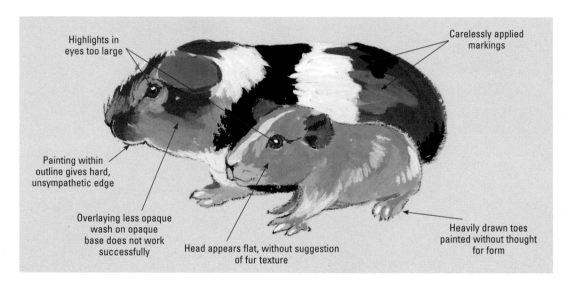

Highlights in eyes too large

Carelessly applied markings

Painting within outline gives hard, unsympathetic edge

Overlaying less opaque wash on opaque base does not work successfully

Head appears flat, without suggestion of fur texture

Heavily drawn toes painted without thought for form

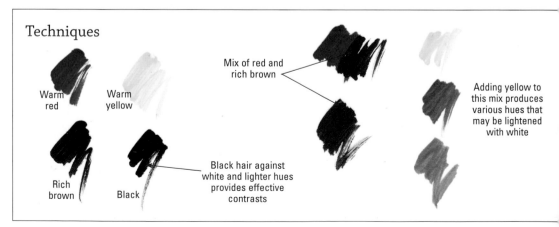

Techniques

Warm red

Warm yellow

Mix of red and rich brown

Adding yellow to this mix produces various hues that may be lightened with white

Rich brown

Black

Black hair against white and lighter hues provides effective contrasts

Contoured stroke application indicates the form beneath the hair, and the transitions between the markings – light over dark and dark over light – need to be treated with consideration for that form. Markings of pure white against tan and black can be effectively depicted in acrylic upon a tinted ground. This enables layers of paint to indicate light hair over dark and vice versa – suggesting a thick, silky coat.

It is important to choose your brushes with care – you will need a good point for the fine details – and to wash them thoroughly both during and after use.

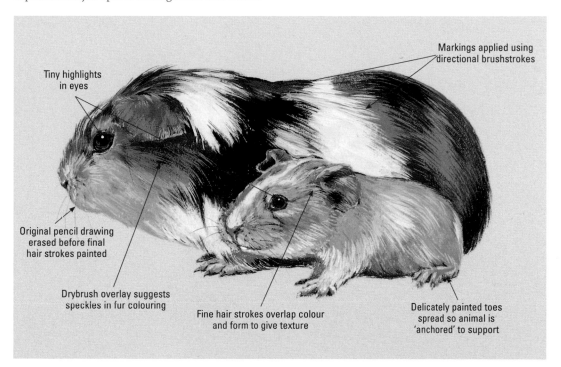

Tiny highlights in eyes

Markings applied using directional brushstrokes

Original pencil drawing erased before final hair strokes painted

Drybrush overlay suggests speckles in fur colouring

Fine hair strokes overlap colour and form to give texture

Delicately painted toes spread so animal is 'anchored' to support

Acrylic

Acrylic is a water-based medium that produces permanent colour, as you are unable to reconstitute the pigment. Although it can be used in many ways, from thin washes to thicker application, here I have taken the middle road: it is opaque enough to cover (light over dark), yet fluid enough to be placed using sweeping strokes.

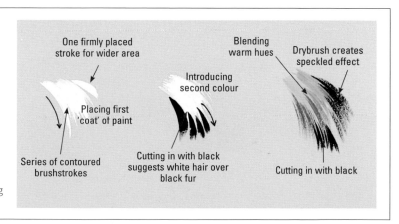

One firmly placed stroke for wider area

Placing first 'coat' of paint

Series of contoured brushstrokes

Introducing second colour

Cutting in with black suggests white hair over black fur

Blending warm hues

Drybrush creates speckled effect

Cutting in with black

Problems

Mouse

Some domestic mice differ from their wild cousins in that the former are found with a wide range of colours and markings. In addition, the size of the eyes in relation to their heads may be smaller than some species, such as the tiny harvest mouse with its prominent 'beady' eyes.

Apart from the common white mouse, various different colours of patched mice give the artist an opportunity to use the rich contrasts that can be achieved with carbon pencil on pure white paper.

Lack of understanding with regard to the form of this tiny creature often leads to heavily drawn, disproportionate limbs. The depiction of patches can also be a problem if the fur texture has not been observed with regard to the way it follows the form.

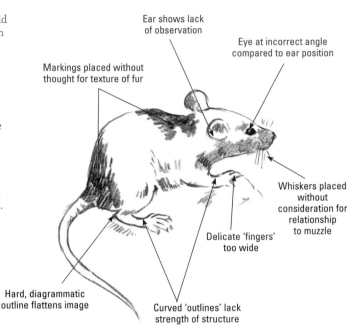

Ear shows lack of observation

Eye at incorrect angle compared to ear position

Markings placed without thought for texture of fur

Whiskers placed without consideration for relationship to muzzle

Delicate 'fingers' too wide

Hard, diagrammatic outline flattens image

Curved 'outlines' lack strength of structure

Techniques

Understanding form
While establishing the main position you have chosen to depict, observe how the limbs appear when seen at different angles and in relation to various surfaces.

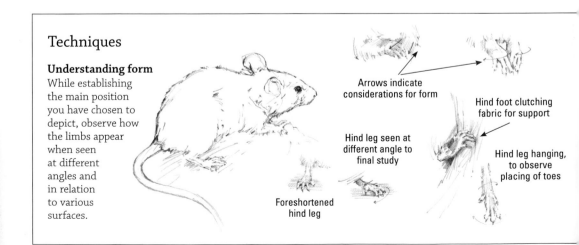

Arrows indicate considerations for form

Hind foot clutching fabric for support

Hind leg seen at different angle to final study

Hind leg hanging, to observe placing of toes

Foreshortened hind leg

There are various methods that can be used to find form: the inclusion of markings in fur is one, and another is to look for angles when depicting limbs. Although this small animal can be held in your hand, it is still important to be aware of structure and form.

Delicate limbs are often hidden beneath overlapping fur, but handling these rodents and observing them close up will lead to a deeper understanding of their body proportions.

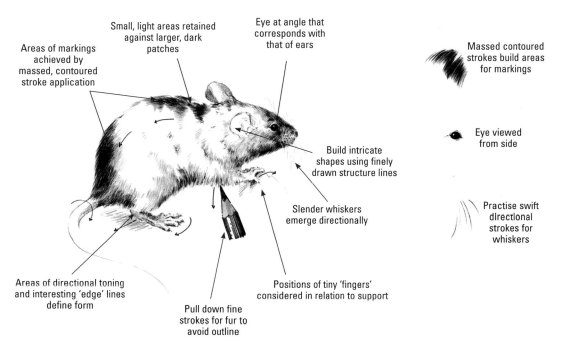

Small, light areas retained against larger, dark patches

Eye at angle that corresponds with that of ears

Areas of markings achieved by massed, contoured stroke application

Massed contoured strokes build areas for markings

Build intricate shapes using finely drawn structure lines

Eye viewed from side

Slender whiskers emerge directionally

Practise swift dIrectIonal strokes for whiskers

Areas of directional toning and interesting 'edge' lines define form

Positions of tiny 'fingers' considered in relation to support

Pull down fine strokes for fur to avoid outline

Details
When sharpened to a fine point, great delicacy of detail may be achieved with carbon pencils.

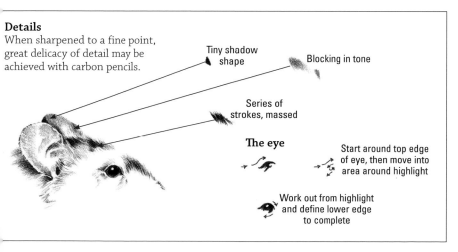

Tiny shadow shape

Blocking in tone

Series of strokes, massed

The eye

Start around top edge of eye, then move into area around highlight

Work out from highlight and define lower edge to complete

Problems

Shetland Pony

With its compact body, deep girth and short back, combined with short muscular limbs, the Shetland pony's strength is disproportionate to its size. This makes it an excellent harness pony (in the 19th century it was used as a pit pony in coal mines).

When depicting a specific breed of pony, such as a Shetland, it is important to establish correct characteristics. If the legs are drawn too long, giving a greater distance between ground and body than is accurate for the breed type, identity will be lost. As the weather on the Shetland islands can be hostile, these ponies possess thick winter coats. When painting this type of hair you need to be conscious of the direction of hair growth in order to direct your brushstrokes accordingly.

Incorrect shape for eye within profile of head

Hard outline unnecessary

Paint applied without regard for form or direction or hair growth

Negative shape to help establish proportions between legs not considered

Legs too long for this type of pony

Relationship of pony's feet to ground and cast shadow not considered

Structure of hind legs incorrect

Techniques

Using greens
Mixing yellow green and raw umber produces a useful green. Apply this as a pale wash first before 'cutting in' with a darker hue behind the white hair on the legs. The same method (in reverse) applied to dark hooves will leave light areas in front of this form; these may then be painted in green when the hoof area has dried.

Draw image in pencil

Paint areas in shadow using neutral mix

Place pale green wash around light forms

Cut in with darker hues between light hairs

Indicate grasses in front of hoof

Cut in with dark hue of foot between grasses

Yellow green

Raw umber

Green-brown mix

Application for grass

Colours
A limited palette makes up the basic hues for the pony. Experiment with different proportions of colour to achieve variation of hues and the neutral tones.

Red violet

Raw sienna

Black neutral

Burnt sienna

Black-violet mix

Neutral mix

Solutions

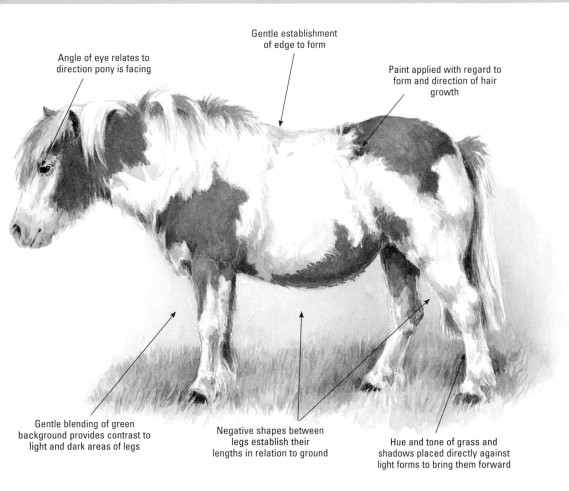

Gentle establishment
of edge to form

Angle of eye relates to
direction pony is facing

Paint applied with regard to
form and direction of hair
growth

Gentle blending of green
background provides contrast to
light and dark areas of legs

Negative shapes between
legs establish their
lengths in relation to ground

Hue and tone of grass and
shadows placed directly against
light forms to bring them forward

Rough sketch

Use a rough sketch to establish
the two important negative shapes
that will solve the problem of leg
length in relation to body mass.

Establish these two negative shapes
correctly to achieve proportions of legs
and body in relation to ground

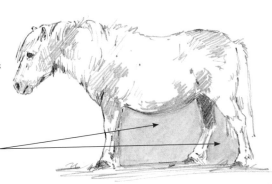

FARM ANIMALS

Pencil and Brush Exercises

These pencil and brush exercises, relating to farm animals, show a variety of contrasting strokes – from fine pen, coloured pencil and round brushwork to flat brush (blocking in) application.

Coloured pencil strokes upon a textured surface

Coloured pencils used on textured watercolour paper can achieve some exciting effects. To achieve the effect of a sheep's coat, emphasize the rich darks that are found within shadow recess areas of dense wool, using both linear strokes and blocking in. Combine varied pressure upon the pencil with frequent sharpening of the strip to achieve variety of application and resulting impressions (see page 226).

Bull: acrylic on acrylic-painted support

The versatility of this medium, where large areas may be covered using large brushes or small details enhanced using smaller brushes for detail, makes it ideal for depicting larger animals.

Although the depiction of the bulk of a bull may require the use of firm, sweeping strokes or blocking in with thicker paint, the further addition of water to the pigment with the use of a fine brush enables details, such as eyes, ears and fine hairs around hooves, to be treated with a delicately controlled approach. These exercises, applied over a prepared acrylic ground, show the two main stroke application methods used on the bulk of the bull's body on page 221.

Shadow lines within woolly coat

Basic on/off pressure stroke

Shadow shapes within woolly coat

Wispy, hanging areas of wool

On/off pressure 'band' using texture of paper as guide

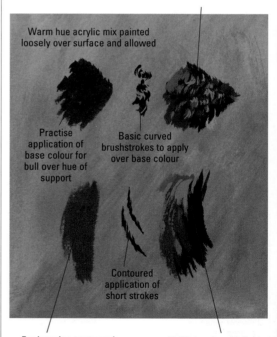

Build various contoured strokes using a variety of hues to indicate curly coat

Warm hue acrylic mix painted loosely over surface and allowed

Practise application of base colour for bull over hue of support

Basic curved brushstrokes to apply over base colour

Contoured application of short strokes

For broader, contoured areas, such as a massive shoulder area, curve long brushstrokes to follow form

Build density with lights (highlighted areas) and darks (shadow recess shapes) between folds of skin and hair

Allowing pale hue to disperse over wet ground

Unlike acrylic, watercolour can be reconstituted and manoeuvred with ease if kept wet (or moist) for a while. A wet flat wash allows pigment to be lifted by suction (cotton-wool bud or squeezed-dry brush) as well as producing paler areas where clean water has been dropped on to a wet or damp surface; the latter produces the lighter marks on dark wash ground. In order to achieve the soft, dappled effect on the coat of a horse, gently place pigment in a pattern over a clean water wash (see page 228). The following exercise demonstrates both these methods.

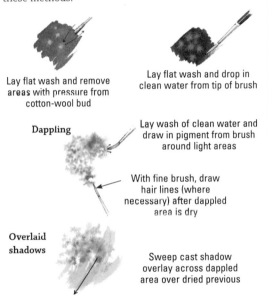

Lay flat wash and remove areas with pressure from cotton-wool bud

Lay flat wash and drop in clean water from tip of brush

Dappling

Lay wash of clean water and draw in pigment from brush around light areas

With fine brush, draw hair lines (where necessary) after dappled area is dry

Overlaid shadows

Sweep cast shadow overlay across dappled area over dried previous

Fine drawing and blocking in

Gouache has the advantages of both watercolour and acrylic. Although it is apt to dry quickly when used thickly, it can be reconstituted where necessary and applied as a thick, opaque wash. Layers can be built in the same way as with acrylic (see page 233). When an image is primarily white, as here, it may be advisable to use a rich, dark support. These exercises are painted on an acrylic wash, which means that the surface will not 'lift' when a further water-based medium is painted on top.

Round-brush 'drawing' using white paint establishes the position of the form, which is followed by overpainting using a flat brush to depict the various planes of the duck's surface feathers/forms using the blocking-in method.

First coat Second coat

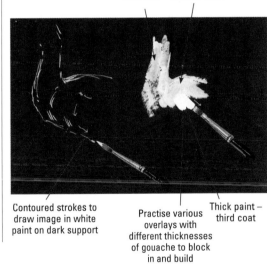

Contoured strokes to draw image in white paint on dark support

Practise various overlays with different thicknesses of gouache to block in and build

Thick paint – third coat

Forming feathers

A completely different watercolour approach to the above is that of considered strokes. This series of exercises shows the development from an initial curved feather stroke, through painting the 'up to and away from' stroke that places a central 'vein', and on to fine directional strokes 'pulling away' from that area. Practise leaving slim gaps and V-shaped gaps and painting solid areas to understand the intricacies of one single feather (see page 230).

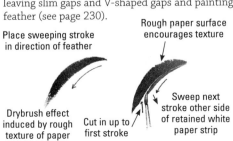

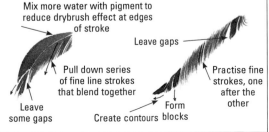

Place sweeping stroke in direction of feather

Rough paper surface encourages texture

Mix more water with pigment to reduce drybrush effect at edges of stroke

Leave gaps

Drybrush effect induced by rough texture of paper

Cut in up to first stroke

Sweep next stroke other side of retained white paper strip

Pull down series of fine line strokes that blend together

Leave some gaps

Create contours

Form blocks

Practise fine strokes, one after the other

Problems

Bulls

To depict one animal in a number of poses or separate animals within a composite representation, it is important to consider relationships. We need to encourage the eye to travel through our composition, not meet with a barrier during that journey.

Scale is also a major consideration: although the animals may not literally relate to each other regarding their scale, they should still work successfully together. The way you treat the background is also vital, and images should sit comfortably within its content.

The sheer body mass of bulls makes viewing these impressive creatures from a few different angles a tempting proposition. For this reason composite presentation seems a natural choice; the problem of how to arrange images within a composite representation can be overcome by making preliminary sketches.

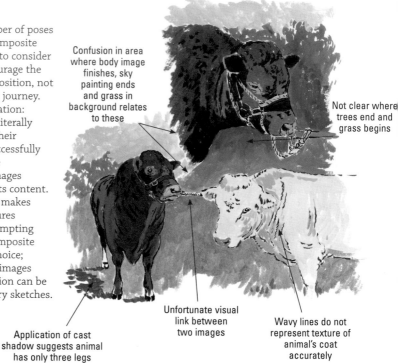

Confusion in area where body image finishes, sky painting ends and grass in background relates to these

Not clear where trees end and grass begins

Unfortunate visual link between two images

Wavy lines do not represent texture of animal's coat accurately

Application of cast shadow suggests animal has only three legs

Techniques

Acrylic colour mixing

Burnt umber

Ultramarine added to previous mix

Hooker's green

Mix from two previous hues

Cadmium yellow medium

Mix of the three hues

Resulting mix

Cadmium yellow medium

White added to previous mix

Cadmium red medium

Black

White

Solutions

Because white can be mixed with pigments in acrylic painting, it is helpful to work upon a tinted or coloured support. Coloured paper or board can be used, but it is possible to paint your own choice of hue in an acrylic wash over white watercolour paper.

If you do not feel confident enough to draw/paint directly on to an acrylic base wash, follow this method: first, establish the layout of images in relation to each other in pencil on drawing paper, then trace or copy them on to watercolour paper. Using a fine pen and waterproof ink, draw loosely over the drawn pages, and when dry, erase your pencil marks. Wet and stretch the paper on to a board. When it is dry, mix a translucent acrylic wash (in your chosen hue) and paint it loosely over the gently blotted paper. When the paper is completely dry (and flat), you will see enough of your ink images through the wash to start your painting.

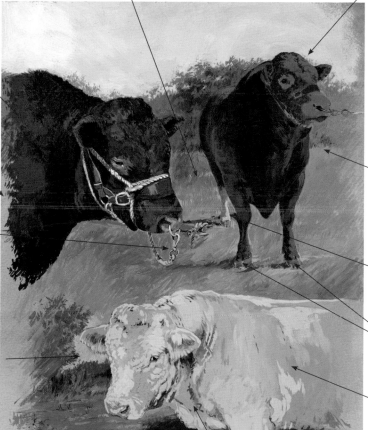

Interesting negative shape between animals relates forms

Unfinished head shows first blocking-in stages over coloured support

Image blends off paper

Base colour wash retained to demonstrate how warm support contributes to painting

Close observation contributes to accurate representation

Exclusion of sky behind lower bull helps continuity

Area where trees end and grass begins relates to position of both animals

Cast shadow from hind leg hidden behind

Ink underdrawing still visible in early stages

Loose application of paint shows how drawing and blocking in work together to build image

Varied application of lines and tonal areas form base for subsequent painted layers

Problems

Pig

The bulky heads and massive bodies of fully mature Gloucester Old Spot pigs, supported upon dainty trotters, present interesting front views; the intricacies of head structure can be captured to great effect with pastel pencils. A variety of directional pencil strokes used in the depiction of the animals can then be taken into the inclusion of a background that relates the pigs to their environment.

By incorporating the hue of pastel-board support within background image application, unity is achieved. It is also important to use a support colour that enhances rather than detracts from the pastel images.

As white, and light, shades are readily available in this medium, offering contrasts of hue and tone against darker areas, outlines may be easily avoided.

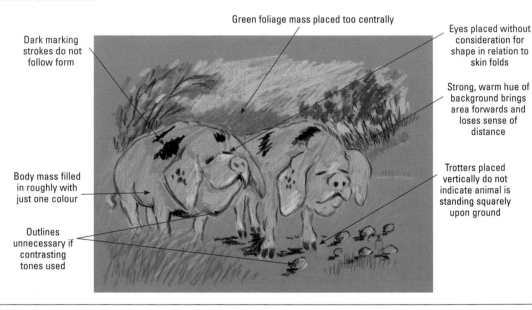

Green foliage mass placed too centrally

Eyes placed without consideration for shape in relation to skin folds

Dark marking strokes do not follow form

Strong, warm hue of background brings area forwards and loses sense of distance

Body mass filled in roughly with just one colour

Trotters placed vertically do not indicate animal is standing squarely upon ground

Outlines unnecessary if contrasting tones used

Techniques

Delicate treatment

Pastel pencils can be applied in a way that encourages the support colour to remain visible (inducing texture), or overlaid for smoother blending effects. Sharpened, they provide a fine drawing tool to be used alongside pastel sticks, where fine detail is required; and used blunt they can produce wide bands and blocks of colour for larger areas.

Firm pencil pressure produces solid pigment

Gentle pencil pressure encourages texture of paper to show

Short, firm, downward strokes

Blending different hues softens transitions

Contoured application for solid mass

Firm downward strokes fill in form

Basic, contoured, directional strokes

Two similar hues placed side by side, for gentle transition of colour

Directional strokes establish flat areas

Directional application of strokes for dark markings follows form

Dark foliage mass, situated more behind one pig than other, brings form forwards

Subtle, neutral hues encourage background to remain in distance

Eyes enclosed by skin folds

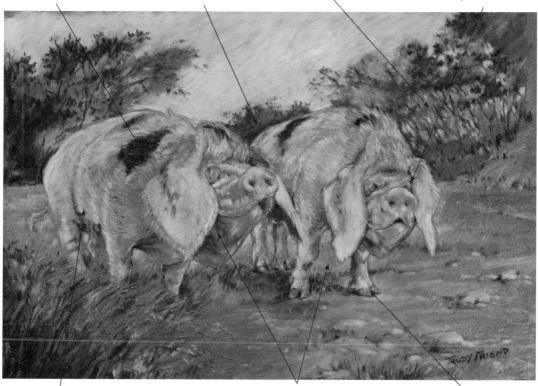

Coarse-hair body mass indicated by directional strokes

Dark against light and light against dark images (look for areas of counterchange) make outlines unnecessary

Trotter faces direction that offers support to bulk of pig

Note the amount of directional stroke application, which gives a feeling of movement to the composition even though the animals are static. Observe interesting negative shapes between the legs, through which grass can be seen, bringing the warmer hues of the pigs forwards. There are also 'busy' areas and shapes that 'rest the eye', such as sky (restful), foliage masses (busy).

Pastel sketch

This quick sketch demonstrates how the hue and texture of the support can enhance and enliven a study.

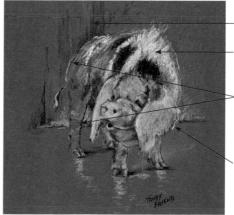

Suggestion of background

Loosely applied strokes

Interesting application of 'edge' lines

Fine strokes

Problems

Goat

Goats roaming in a paddock can make an interesting few pages in your sketchbook, perhaps drawn with a pen. If the animal remains in one position for long enough to portray the whole body, this is a bonus. If not, even just a study of the head can be an interesting exercise.

There are many different breeds of goat; a long-haired breed, or one that has a thicker coat in winter, provides an opportunity to create interesting line effects. Hair may form into 'rosettes' in places, or stand erect at the shoulder, down the back of the neck or on the hindquarters. Observing and depicting these areas with quickly applied loose strokes of the pen will enhance your drawing.

When drawing from life, especially if the animal is moving around, beginners often experience difficulties as the pose changes. There is also a tendency to draw around the image rather than within the form. This can lead to a series of lines creating an outline effect, with very few marks within the form.

Smoothly curved 'edge' lines do not successfully indicate bone structure beneath

No relationship between feet and grass

Eyes facing front are incorrectly observed

Muzzle appears flat

Collar appears too flat; some hair may overlap in places

Outline created by too many lines – image appears flattened

Image of head appears disjointed

Legs appear too long at this angle

Techniques

Pen strokes

Pen and ink, used here in the form of pigment liner drawing and writing pens, is a convenient way to work in a sketchbook. When used upon a smooth white surface with directional application that follows the form of the animal, exciting images result.

These exercise strokes show transitions from straight to contoured lines and how, by going back over marks made, lines can be thickened and textured, contrasting with the more delicately applied strokes.

Straight lines

Contoured lines

Movement along 'edge' of form – occasionally lift pen from paper

Look at angles

Short up-and-down strokes

Going back over strokes will intensify some line

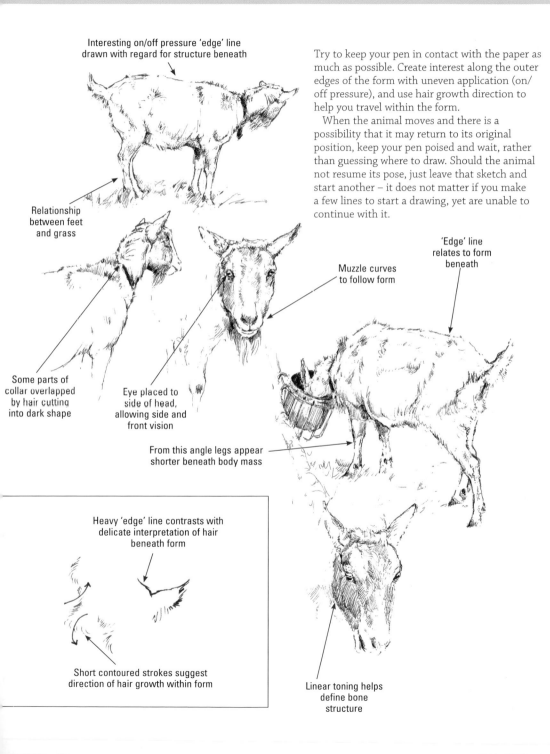

Interesting on/off pressure 'edge' line drawn with regard for structure beneath

Try to keep your pen in contact with the paper as much as possible. Create interest along the outer edges of the form with uneven application (on/off pressure), and use hair growth direction to help you travel within the form.

When the animal moves and there is a possibility that it may return to its original position, keep your pen poised and wait, rather than guessing where to draw. Should the animal not resume its pose, just leave that sketch and start another – it does not matter if you make a few lines to start a drawing, yet are unable to continue with it.

Relationship between feet and grass

'Edge' line relates to form beneath

Muzzle curves to follow form

Some parts of collar overlapped by hair cutting into dark shape

Eye placed to side of head, allowing side and front vision

From this angle legs appear shorter beneath body mass

Heavy 'edge' line contrasts with delicate interpretation of hair beneath form

Short contoured strokes suggest direction of hair growth within form

Linear toning helps define bone structure

Problems

Sheep

The light hue and woolly texture of sheep give us the opportunity to consider how little, rather than how much, to include in their depiction.

The role of a background, in this instance, is an important element – where we can place as much, or more, emphasis upon working *around* the animal shapes than within the forms – the latter comprising mainly neutral hues. A hard outline, whether smooth or corrugated, does little to enhance the depiction of form, and a disjointed background relationship with the ground upon which the animals are standing only makes the flattened images more obvious.

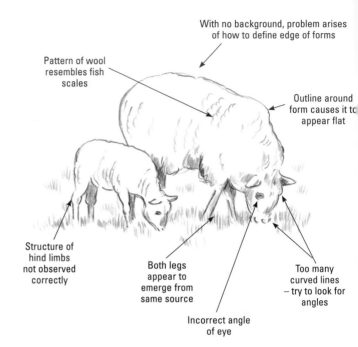

With no background, problem arises of how to define edge of forms

Pattern of wool resembles fish scales

Outline around form causes it to appear flat

Structure of hind limbs not observed correctly

Both legs appear to emerge from same source

Too many curved lines – try to look for angles

Incorrect angle of eye

Techniques

Preliminary sketch
In order to establish the correct scale and proportions of the two animals, look for:
- Shapes between – an abstract shape between one of your guidelines and part of the animal.
- Negative shapes – areas where it is possible to pass between parts of the animal, such as the shape that can be seen between body and legs in relation to grass.

Abstract shapes relating guidelines to part of sheep: shapes between

Squares help to establish proportions

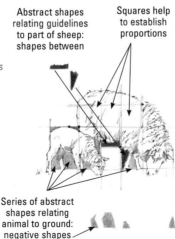

Series of abstract shapes relating animal to ground: negative shapes

| Grass green | Olive green | Cedar green | Raw sienna |

| Raw umber | Burnt umber | Gunmetal |

Colours

A number of greens were used for the background. The woolly coats were mainly composed of pale shadow tones and retention of the untouched paper surface.

You can establish the position, scale and structure of animals with the use of vertical and horizontal guidelines; look for ways to help you find the correct proportions (see opposite). The problem of depicting hind limbs correctly has been overcome by observing negative shapes, rather than just thinking of the positive forms, and by closing the relating eye and ear positions, the eye angle has been corrected.

Although depicting the sheep's woolly coat may encourage the use of curved strokes, try to look for angles when working on areas where bone structure is apparent, primarily the face and legs.

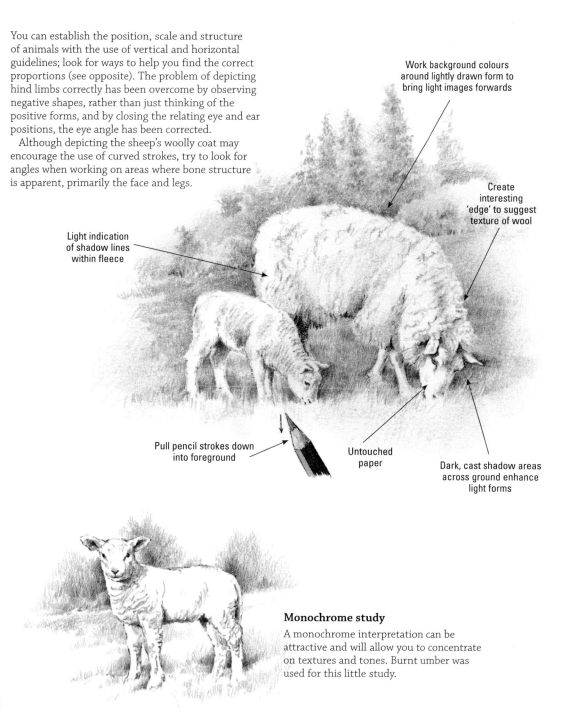

Work background colours around lightly drawn form to bring light images forwards

Create interesting 'edge' to suggest texture of wool

Light indication of shadow lines within fleece

Pull pencil strokes down into foreground

Untouched paper

Dark, cast shadow areas across ground enhance light forms

Monochrome study

A monochrome interpretation can be attractive and will allow you to concentrate on textures and tones. Burnt umber was used for this little study.

Problems

Horse

Between the tiny Shetland pony (see page 216) and larger heavy horses is the cob type, used for general farm work with its 'feathered' feet (longer hair that protects the foot while working in muddy conditions), a stocky body and a thick winter coat.

In addition to the obvious difficulty of producing a dappled effect on the animal's coat, the main problem experienced by beginners when depicting light dappled coats is how to avoid the necessity for outlines.

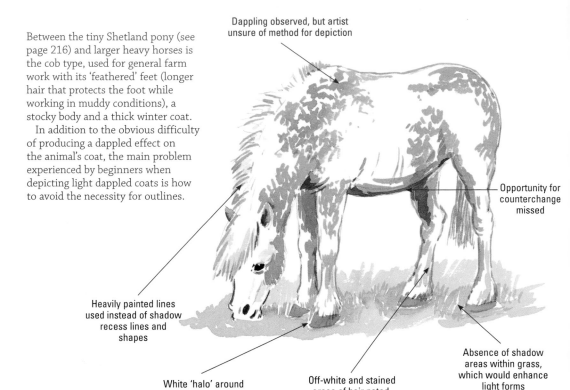

Dappling observed, but artist unsure of method for depiction

Opportunity for counterchange missed

Heavily painted lines used instead of shadow recess lines and shapes

White 'halo' around image means animal appears not to be anchored to ground

Off-white and stained areas of hair noted, but pigment carelessly applied

Absence of shadow areas within grass, which would enhance light forms

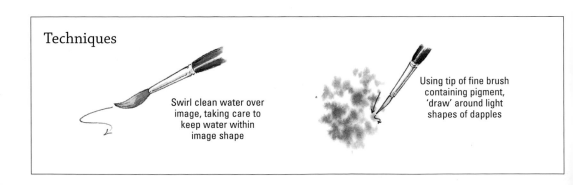

Techniques

Swirl clean water over image, taking care to keep water within image shape

Using tip of fine brush containing pigment, 'draw' around light shapes of dapples

When depicting light or dappled coats, consider how counterchange (using dark against light and light against dark) can be incorporated to avoid the necessity to resort to outlining too much of the image. I have used this method on the underside of the horse's body, where a shadow area behind the elbow is dark, and lighter hair is visible, further along, against the 'off' hind leg, which is in shadow.

Painting a dappled coat

There are various ways of achieving a dappled effect with watercolour (see page 219). For this study the whole animal image received a wash of clean water and, while this was still damp, I 'drew' with a fine brush containing pigment, around the dappled shapes that were to remain as white paper.

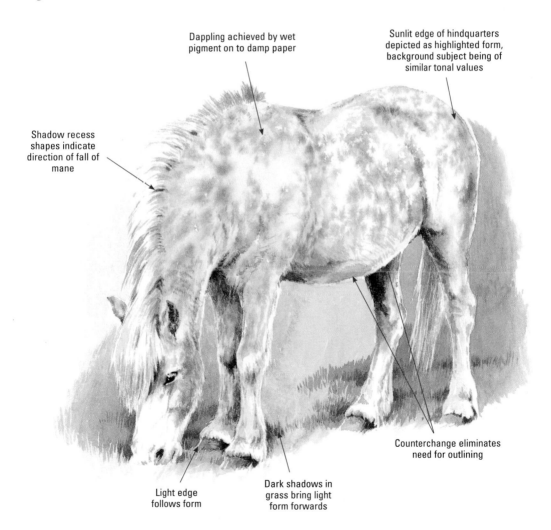

Dappling achieved by wet pigment on to damp paper

Sunlit edge of hindquarters depicted as highlighted form, background subject being of similar tonal values

Shadow recess shapes indicate direction of fall of mane

Light edge follows form

Dark shadows in grass bring light form forwards

Counterchange eliminates need for outlining

Problems

Cockerel

There is an angular feel to the
form of some birds beneath their
protecting feathered layers; strong
wings and legs, delicate necks and
bony body structure make an
interesting combination.

Suppressed strength within
a cockerel, quietly pecking at food
or standing alert, requires an
artist to be aware of angled forms
when depicting this subject. For this
reason we need to look for angles not
only in the basic shapes but also in how
feathers relate to these shapes and to each
other – and these may not always be obvious.
Feathers often cause problems for beginners,
who may resort to a superficial 'scale-like'
representation drawn in paint over a base colour.

White paper left by
accident rather than design

No feeling for eye
or head structure in
paint application

Heavy, flat line

Superficial marks to
indicate feathers do
not suggest form

Series of markings does
not represent accurately
long wing feathers

Curved shape of leg
lacks strength

Shadow applied carelessly
does not anchor form

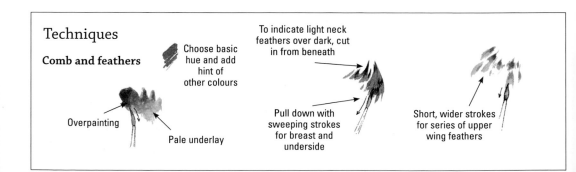

Techniques

Comb and feathers

Choose basic
hue and add
hint of
other colours

Overpainting

Pale underlay

To indicate light neck
feathers over dark, cut
in from beneath

Pull down with
sweeping strokes
for breast and
underside

Short, wider strokes
for series of upper
wing feathers

Solutions

It is helpful to study closely just one feathered area and observe the shadow recesses between feathered layers, giving thought to the various contours of form beneath. This study is unfinished in order to show the diverse arrangements of feathers on various parts of the bird in their early stages of depiction. I have placed different types of feather arrangements – short, medium and long – in position, using their basic hues, in order to build on them as the painting progresses. I have also indicated gentle angles that occur along the back of the neck.

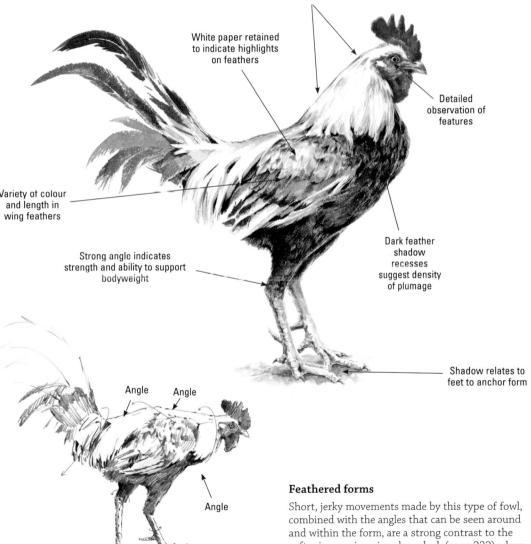

Slight angles need to be noticed

White paper retained to indicate highlights on feathers

Detailed observation of features

Variety of colour and length in wing feathers

Strong angle indicates strength and ability to support bodyweight

Dark feather shadow recesses suggest density of plumage

Shadow relates to feet to anchor form

Angle Angle

Angle

Arrows indicate the thought for form

Feathered forms

Short, jerky movements made by this type of fowl, combined with the angles that can be seen around and within the form, are a strong contrast to the softer impression given by a duck (page 232) where noticing less obvious angles aids depiction.

Problems

Duck

The softly contoured image of
a farmyard duck, with its white
plumage, is an inviting subject.
Feathers and fat (to aid heat retention)
cover the skeleton, and it is the latter
that requires consideration when
drawing and painting what outwardly
appear to be soft, curved forms.

One of the problems encountered
when trying to depict such a form
is that the structure beneath can be
forgotten. This can lead to numerous
curved lines and contoured strokes
(depicting tone) vying with flat
application shadow areas that are
unrelated, resulting in an image
whose shadow shapes appear as
pattern, rather than suggesting gentle
contoured toning resulting from
observation of angles.

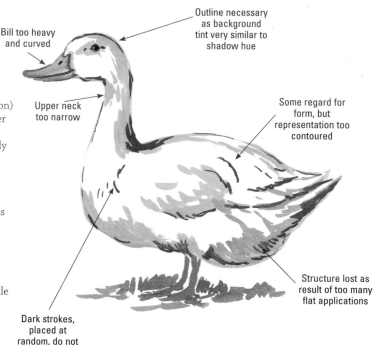

Bill too heavy
and curved

Outline necessary
as background
tint very similar to
shadow hue

Upper neck
too narrow

Some regard for
form, but
representation too
contoured

Structure lost as
result of too many
flat applications

Dark strokes,
placed at
random, do not
describe form

Techniques

Investigative drawing: contact points

Throughout the initial drawing and resulting
painting I remained conscious of angles and
used them as contact points, through which
guidelines pass, to help place components
accurately. Use your initial investigative drawing
to search for angles around and within the
form. At each angle make a mark to emphasize
this strength (angles = strength) and run your
guidelines from and through these points.

Look closely at the outer edges of the painted
image opposite and see how many (however
small) angles you can notice. I have indicated
with a * an example of an angled shape within
the form in the painting.

Look for angles and place contact
point marks at them to provide
anchor points for 'drop' lines

Toned shape between
two guidelines helps
establish angle and
length of neck

Angles not very
obvious, so
search for them
carefully

Convex angle
contact point

Concave angle
contact point

Solutions

The undercoat of small, very soft (down) feathers lies close to the skin and is covered by contour feathers whose density gives the duck's outline shape its smooth appearance. I used gouache over a support painted with a rich (acrylic) hue, which enables the white image to contrast and appear crisp and clear, and also means that the white gouache (depicting soft pale feathers and their shadow areas) can be shown to maximum effect.

Close observation and careful painting create delicacy in depiction of bill

No unnecessary outline drawing, so light edges (depicting reflected light on shadow sides) help to define form

Neck width considered in relation to head and body

Layering of feathers over wing and body placed with regard for form beneath

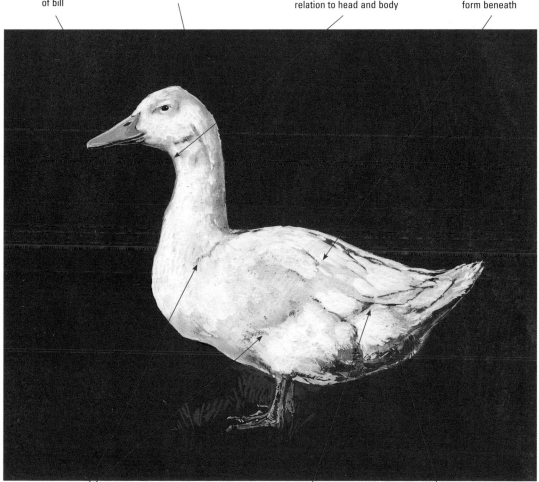

Tinted areas of gentle tone suggest undulating surface of form

* Example of angle within form

Blocked-in toning moulds structure

WILD ANIMALS

These exercises cover a variety of media from pencil, fibre-tip pens, watercolour pencils and pastel to watercolour.

Don't forget that all of these exercises can be applied to every kind of animal – fur is fur and claws are claws – so be aware of the possibilities in all your work.

Pencil

Used as a tool for creating quick impressions, pencil is a good place to start with most of your depictions. Even a few brief marks can convey the essence of an animal's character when correctly applied (see page 239).

Make tonal block

Take the tone into up-and-down application, working down the paper

Introduce rich darks and 'V' shapes to suggest wet fur

Strokes applied in opposite directions depict silhouette of underside of otter seen in

Varied pressure strokes that move into toned areas without pencil being lifted from the paper

Defining form

Used in abstract way for practice exercise

Fanned application suggesting contoured hair growth

Used solid is 'closed' application

Where white paper is visible is 'open' application

Watercolour pencils

These pencils supply us with an interesting variety of neutral hues, some of which are ideal for certain animals where the fur is comprised of mainly monochrome hues.

Pull clean water down from dark mass

Fill in dark area with watercolour pencil

With clean water flick brushstrokes upwards, away from dark mass

Fan area of tone using sharp pencil

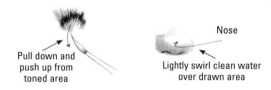

Pull down and push up from toned area

Nose

Lightly swirl clean water over drawn area

Watersoluble graphite

This is available in a variety of grades that respond when wet in various ways upon different surfaces (see page 247). Take time to experiment with them, one against the other, to discover which best suits your chosen subject as well as your personal style.

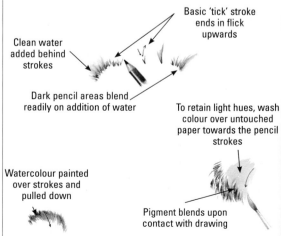

Basic 'tick' stroke ends in flick upwards

Clean water added behind strokes

Dark pencil areas blend readily on addition of water

To retain light hues, wash colour over untouched paper towards the pencil strokes

Watercolour painted over strokes and pulled down

Pigment blends upon contact with drawing

Fibre-tip pens

With their variety of strong colours, these pens can be used to produce bold interpretations (see page 240). Overlays on areas in shadow can subdue effects, as can the addition of a clean water wash – which may be more effective over some colours than others. The only way to discover various possibilities is to try a series of exercises and make notes as to the results.

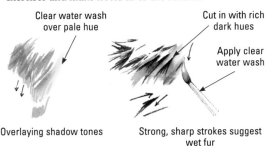

Clear water wash over pale hue

Cut in with rich dark hues

Apply clear water wash

Overlaying shadow tones

Strong, sharp strokes suggest wet fur

With heavyweight paper, it is possible to scrape back pigmented areas to reveal white paper beneath, a process called sgraffito (see page 241). Before doing this, practise building layers of colour and cutting in for shadow recesses within dense fur.

Pastels and pastel pencils

These can be used to cover paper, both swiftly (to establish blocks of colour) and delicately (to enhance detail), and it is also possible to introduce carbon pencil when enhancing delicate dark areas (see page 243).

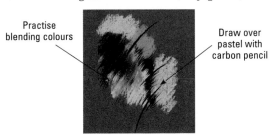

Practise blending colours

Draw over pastel with carbon pencil

Carbon pencils

When depicting small areas of rich tone or black, beady eyes, you can use a carbon pencil in addition to pastels and pastel pencils. Carbon pencils are also useful for working the shadow areas between digits on hands and feet, as well as whiskers and fine shadow recesses with fur. Practise placing solid areas of colour and drawing a sharpened carbon pencil across these to see how it contrasts with the paler hues.

Mixed media: draw, fix and paint

Place your palette of colours in small areas at the edge of your work or on a separate piece of paper. Using a brush dipped in clean water, 'lift' the colour(s), mix in a separate area and apply them to the relevant parts of your fixed drawing, following the form and/or hair-growth direction (see page 245).

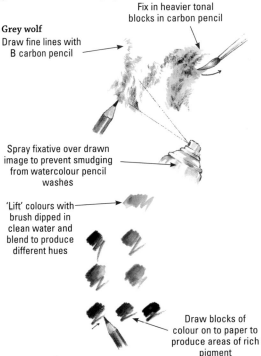

Fix in heavier tonal blocks in carbon pencil

Grey wolf
Draw fine lines with B carbon pencil

Spray fixative over drawn image to prevent smudging from watercolour pencil washes

'Lift' colours with brush dipped in clean water and blend to produce different hues

Draw blocks of colour on to paper to produce areas of rich pigment

Watercolour

The method of overlaying washes to produce richer hues and tones is referred to frequently in this book; in order to perfect the method and to understand how and why the application works, you may need to practise frequently.

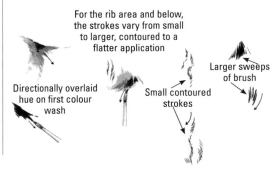

For the rib area and below, the strokes vary from small to larger, contoured to a flatter application

Larger sweeps of brush

Directionally overlaid hue on first colour wash

Small contoured strokes

Problems

Red Fox

Characteristics of the red fox are large, sensitive ears and a pointed snout with black nose. The colours of the soft, dense fur can vary from yellowish-red to red-brown – and usually a white tip to the bushy tail. Most active just after dusk and before dawn, the fox has yellow-brown eyes that glow green when a light is shone into them and are specially adapted to night vision.

Many novice painters are unfamiliar with the methods of overlaying washes and glazing, and this gives them problems with how to make the eyes 'come alive' once the obligatory highlight has been placed. They also experience difficulties establishing the correct eye shape when viewed from a three-quarter angle.

No consideration for light hairs growing in front of dark recess

Heavy lines where delicacy is required

Too much of eye visible for three-quarter view

Eye appears lifeless

Whiskers too evenly placed

Outline drawing of teeth unnecessary

Nose placed at wrong angle

Techniques

Eyes

There is no more delicate area to depict than the eye of an animal; without the sharp contrast of a carefully planned highlight, this important feature may appear lifeless in its depiction. The shape and size of the eyes within the framework of the head also require thought and concentration – when using watercolour, these are best painted initially over the 'support' of a pencil drawing. The latter can be carefully erased after the first watercolour brushstrokes have been positioned, before building the overlays.

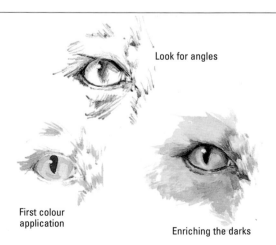

Look for angles

First colour application

Enriching the darks

Solutions

A fox's eyes may appear smaller in relation to other features when surrounded by thick winter fur than in a sleeker summer coat. Highlights in eyes can vary according to the intensity and angle of the light source, and whether the image has been captured photographically or observed in natural daylight.

This image demonstrates how an uneven area of white highlight can look on a head when we see it at a three-quarter angle.

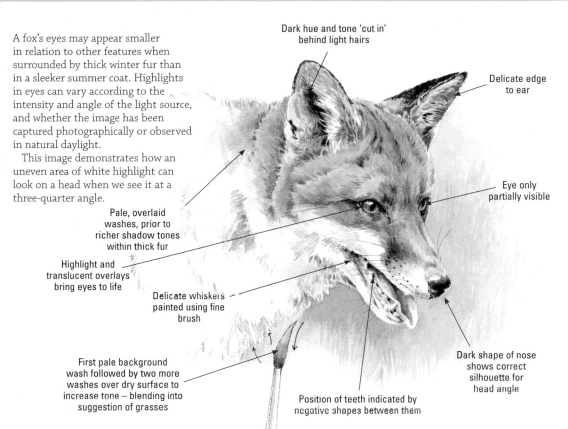

Dark hue and tone 'cut in' behind light hairs

Delicate edge to ear

Eye only partially visible

Pale, overlaid washes, prior to richer shadow tones within thick fur

Highlight and translucent overlays bring eyes to life

Delicate whiskers painted using fine brush

First pale background wash followed by two more washes over dry surface to increase tone – blending into suggestion of grasses

Position of teeth indicated by negative shapes between them

Dark shape of nose shows correct silhouette for head angle

Building the image

This full-face image shows how a circular highlight area appears when the head is viewed from the front. I placed the pale hues and areas of tone prior to building the image using overlaid washes in the order shown.

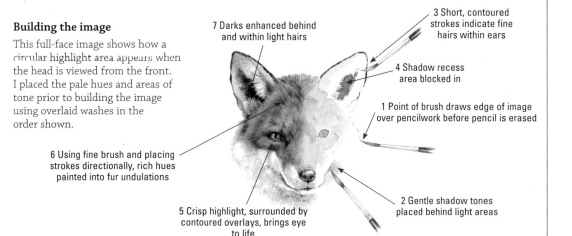

7 Darks enhanced behind and within light hairs

3 Short, contoured strokes indicate fine hairs within ears

4 Shadow recess area blocked in

1 Point of brush draws edge of image over pencilwork before pencil is erased

6 Using fine brush and placing strokes directionally, rich hues painted into fur undulations

5 Crisp highlight, surrounded by contoured overlays, brings eye to life

2 Gentle shadow tones placed behind light areas

Problems

Otter

An otter, standing alert and using its tail as a strut, appears to have a small head in relation to its body length, but this shape contributes towards its excellent swimming and diving skills. The webbed, paddle-like feet are spread wide to enable slow swimming, while for diving and fast movement below the water's surface, the front feet are trailed close to the body, which is swayed from side to side.

 When drawing images swiftly it is tempting to do so in the form of an outline – whether continuous or broken – and to indicate fur texture with individually drawn short lines. Toning within the form can also cause problems when applied in a way that flattens form rather than following contours.

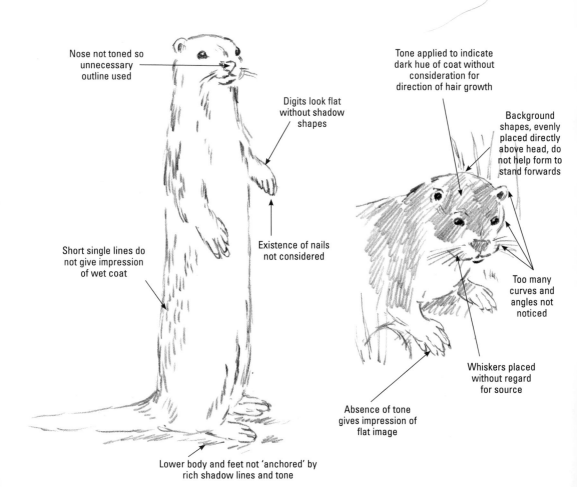

Nose not toned so unnecessary outline used

Digits look flat without shadow shapes

Short single lines do not give impression of wet coat

Existence of nails not considered

Tone applied to indicate dark hue of coat without consideration for direction of hair growth

Background shapes, evenly placed directly above head, do not help form to stand forwards

Too many curves and angles not noticed

Whiskers placed without regard for source

Absence of tone gives impression of flat image

Lower body and feet not 'anchored' by rich shadow lines and tone

By allowing the pencil to work up and down over the lightly drawn form (see page 234), the area of body mass can be swiftly covered; this allows more time for the careful positioning of on/off pressure shadow shapes between the toes and the inclusion of delicately drawn nails.

Because it spends most of its time in water, the otter's coat is usually in a damp or wet state; noticing the 'V' shapes of shadow tone helps its depiction in the form of quick pencil impressions.

Swiftly applied diagonal toning establishes shape of nose

On/off pressure strokes add interest to shadow lines

After toning with chisel side of pencil, turn tip and use sharp side to draw nails

Basic 'V' shapes help to give quick impression of wet fur

Lower body and feet 'anchored' by rich shadow line and directional toning

Indicating hue by toning

Indicating hue and tone using a contoured (fanned) application of massed strokes, applying the chisel side of the pencil, will quickly cover the paper. Keep the application loose and free, enhancing the darks of the eyes, ears and nostrils by applying firmer pressure in these areas.

Tone applied to indicate dark hue of coat with consideration for direction of hair growth

Look for suggestion of angles

Whiskers placed swiftly with regard for areas from which they grow

Untouched white paper indicates position of nail

On/off pressure lines indicate shadow tones within forms

Shadow shape

Problems

Beaver

Beavers thrive in deep, still waters which they dam to form ponds or lakes. Their fur colours can be anything from light tan to dark brown.

Beavers are adapted for life in the water, with the ears, eyes and nose located near the top of the skull. It is important to be aware of shadow recess shapes between clumps of wet fur and to depict them as

blocks rather than outlined V shapes. Problems occur when these areas have not been closely observed or understood.

Pen strokes depicting fur should follow the form of the animal – by applying them in a haphazard way, further problems will result when attempting to indicate highlights.

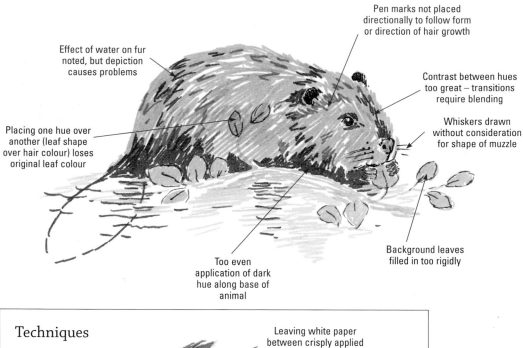

Effect of water on fur noted, but depiction causes problems

Pen marks not placed directionally to follow form or direction of hair growth

Contrast between hues too great – transitions require blending

Whiskers drawn without consideration for shape of muzzle

Placing one hue over another (leaf shape over hair colour) loses original leaf colour

Too even application of dark hue along base of animal

Background leaves filled in too rigidly

Techniques

Fur in detail

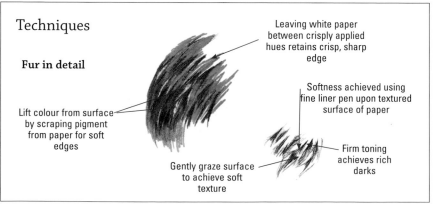

Leaving white paper between crisply applied hues retains crisp, sharp edge

Softness achieved using fine liner pen upon textured surface of paper

Lift colour from surface by scraping pigment from paper for soft edges

Firm toning achieves rich darks

Gently graze surface to achieve soft texture

Solutions

You can be bold with your interpretation of a great range of brown fur by overlaying hues using fibre-tip pens and drawing into the dark shadow recess areas with fine liner pens in browns and blacks.

The bright hues presented in ranges of fibre-tip pens offer you the opportunity to use strong colours which,

when overlaid, provide a rich base. Upon this base the sgraffito method of gently scraping the surface of the paper to reveal white beneath can enhance the effect of highlights on clumps of wet fur.

The annotation for this illustration shows the development of the stages of working.

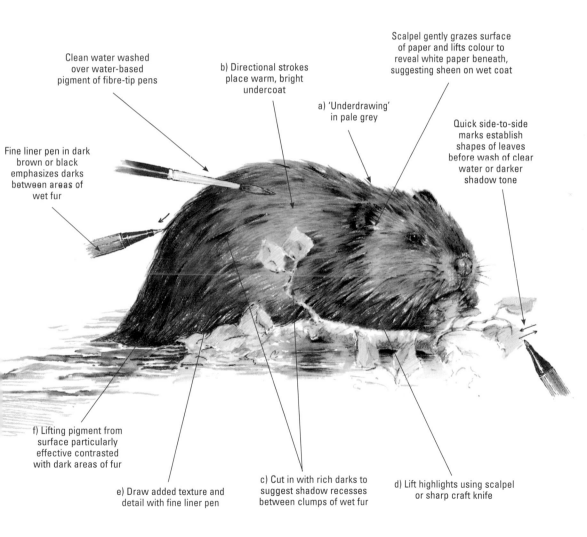

Clean water washed over water-based pigment of fibre-tip pens

b) Directional strokes place warm, bright undercoat

a) 'Underdrawing' in pale grey

Scalpel gently grazes surface of paper and lifts colour to reveal white paper beneath, suggesting sheen on wet coat

Fine liner pen in dark brown or black emphasizes darks between areas of wet fur

Quick side-to-side marks establish shapes of leaves before wash of clear water or darker shadow tone

f) Lifting pigment from surface particularly effective contrasted with dark areas of fur

e) Draw added texture and detail with fine liner pen

c) Cut in with rich darks to suggest shadow recesses between clumps of wet fur

d) Lift highlights using scalpel or sharp craft knife

Problems

Grey Squirrel

The grey squirrel, introduced into the British Isles from eastern North America, resides within coniferous and deciduous woodlands, and is also a common visitor to parks and gardens. For this reason it is easy to observe and photograph.

Although referred to as grey, this species has a sprinkling of other hues within its coat, and the depiction of these can sometimes cause problems for the novice pastel artist. The choice of support can present other problems; if an unsuitable background colour is used and left untouched, this can cause the image to appear rather stark.

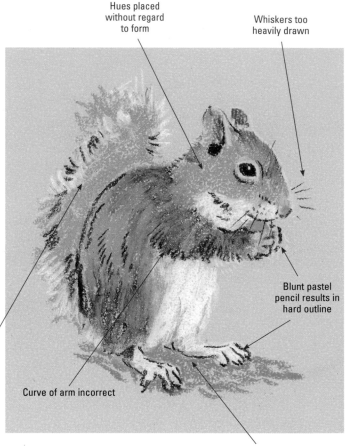

Hues placed without regard to form

Whiskers too heavily drawn

Blunt pastel pencil results in hard outline

Problems with depiction of tail

Curve of arm incorrect

Without use of shadow areas, squirrel's form does not relate to support

Techniques

Derwent pastel colours

Chinese white	Brown ochre 57F	Chocolate 66D	Olive green 51F	French grey 70B	French grey 70D	Brown ochre 57B	Terre verte 77D

Solutions

Tinted textured Ingres paper responds well to pastel pencils, making it possible to produce delicate lines using a fine point as well as the broader application of a blunt colour strip. Both these applications are combined within this study, and I have chosen to introduce the second media of carbon pencil for even finer overdrawing.

A rich neutral hue was chosen for the support, as this allows a green background of pastel to contrast with neutral greys and warm tints in the squirrel's coat. It also adds a unity to the interpretation. Pastel pencils mix comfortably with carbon pencil, which is used as overlay for the depiction of fine hairs and in the dark shadow recesses.

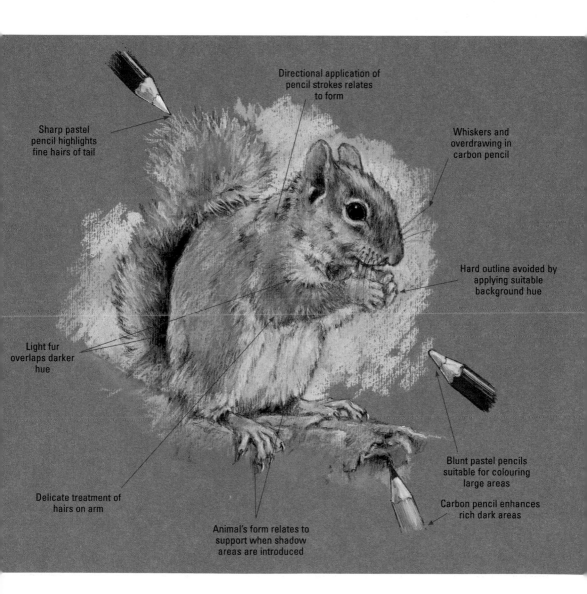

Directional application of pencil strokes relates to form

Sharp pastel pencil highlights fine hairs of tail

Whiskers and overdrawing in carbon pencil

Hard outline avoided by applying suitable background hue

Light fur overlaps darker hue

Delicate treatment of hairs on arm

Animal's form relates to support when shadow areas are introduced

Blunt pastel pencils suitable for colouring large areas

Carbon pencil enhances rich dark areas

Problems

Grey Wolf

Most wolves are smoky grey with tawny-coloured legs and flanks. The light underfur consists of short, thick, soft hair and is protected by thick, hard, smooth guard hairs that act in a similar way to beaver fur (see page 240), shedding moisture and preventing ice collecting on the fur in winter.

Blending subtle colours can cause problems, as the pale washes need to be overlaid with care and consideration for the form. Achieving the effect of the dense coat found on a wolf causes difficulties when the artist is unsure how to suggest the dark areas in recesses and the cast shadows.

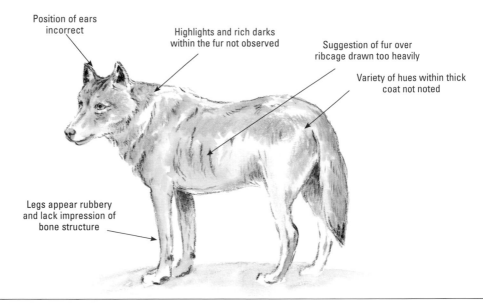

Position of ears incorrect

Highlights and rich darks within the fur not observed

Suggestion of fur over ribcage drawn too heavily

Variety of hues within thick coat not noted

Legs appear rubbery and lack impression of bone structure

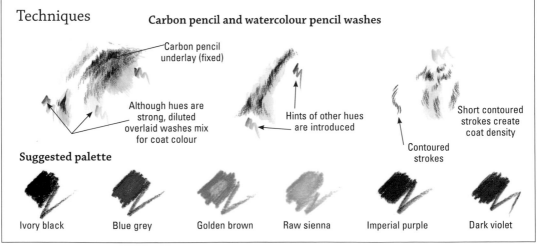

Techniques

Carbon pencil and watercolour pencil washes

Carbon pencil underlay (fixed)

Although hues are strong, diluted overlaid washes mix for coat colour

Hints of other hues are introduced

Contoured strokes

Short contoured strokes create coat density

Suggested palette

Ivory black Blue grey Golden brown Raw sienna Imperial purple Dark violet

Solutions

Three important steps are to draw, fix and paint: first, make your drawing using carbon pencil; next, fix the image to prevent it being disturbed by the addition of water; then apply washes of watercolour pencil directly over the fixed image.

If, on completion, you feel some of the dark areas require further enhancement, you can redraw over the painting and fix again, to prevent smudging. I used the mixed media of carbon pencil and watercolour pencils, the latter being applied as washes picked up from a 'palette' made on the paper.

A variety of ochre, brown and grey watercolour pencils were combined to produce subtle colours to paint over the fixed drawing.

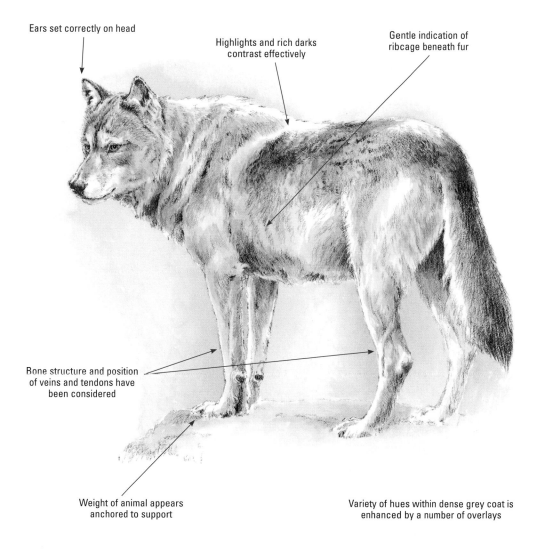

Ears set correctly on head

Highlights and rich darks contrast effectively

Gentle indication of ribcage beneath fur

Bone structure and position of veins and tendons have been considered

Weight of animal appears anchored to support

Variety of hues within dense grey coat is enhanced by a number of overlays

Problems

Grizzly Bear

The long, silver-tipped hairs on its brown back and shoulders give the grizzly bear its name. Grizzlies have an excellent sense of smell and good hearing, compensating for poor eyesight. The paws are broad and flat with non-retractile claws that are used for breaking open logs, digging, tearing food apart, climbing and acting as a club on prey.

The problem of depicting thick ruffs of fur is often encountered by inexperienced artists who, unaware of how to define these areas, resort to individual strokes of the pencil, which can present a flat appearance to the image. Cutting in behind the V-shapes of shadow recess areas within the thick fur helps to solve this problem.

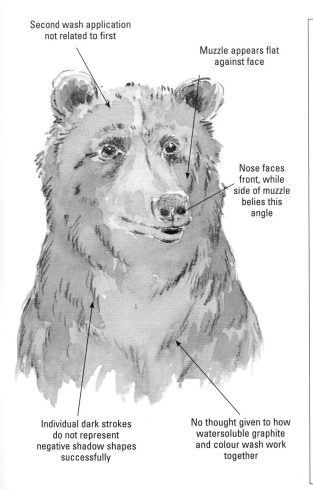

Second wash application not related to first

Muzzle appears flat against face

Nose faces front, while side of muzzle belies this angle

Individual dark strokes do not represent negative shadow shapes successfully

No thought given to how watersoluble graphite and colour wash work together

King of all he surveys
A grizzly is one of the world's most powerful animals, but when standing on its hind legs, it is not usually being aggressive, just viewing the surroundings. This pose offers an excellent opportunity to observe the paws with their strong nails and the texture of the thick fur.

Light edge lines drawn first using sharp pencil – to be absorbed later as drawing progresses

Contours of thick fur follow form

Shadow recess shape within fur

Solutions

It is important to be aware of structure and form beneath the dense layers of fur; by overlaying watersoluble graphite over watercolour after the initial drawing has been established as well as watercolour over itself, in a considered application, the effect of a three-dimensional image emerges.

Be prepared to build a number of layers – especially within shadow areas where dark recesses contrast with areas of light forms – using directional brush and pencil strokes.

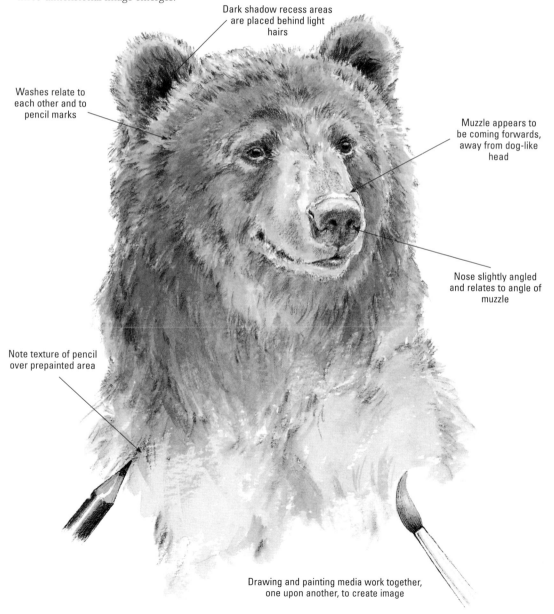

Dark shadow recess areas are placed behind light hairs

Washes relate to each other and to pencil marks

Muzzle appears to be coming forwards, away from dog-like head

Nose slightly angled and relates to angle of muzzle

Note texture of pencil over prepainted area

Drawing and painting media work together, one upon another, to create image

Problems

Golden Eagle

Basically a dark brown bird, the magnificent golden eagle gets its name from the gold-coloured feathers that develop on the bird's head and neck as it ages. Powerful talons capture and kill prey, while the curved beak can open tough animal hide for it to feed – it depends on carrion as well as killing birds and mammals.

When using brush pens, one main problem is heavy-handed application: very light contact with the paper is required, both for the stippling effect and that of fine lines used to depict feather forms. The problem of which paper to choose can also be resolved if you practise on a variety of different surfaces prior to making a decision. Even if your basic drawing of the bird has been carefully observed and placed, insufficient knowledge of the media and careless application can spoil the effect.

Stark contrasts of colours against brilliant white background prevent subtle interpretation

Colour filled in like colouring book, not applied with consideration for form

Density of feathers lost when white allowed to show through strokes indiscriminately

Blocks of white paper, if not intended to represent highlights, need to be covered

Untidy strokes

Techniques

Quick sketch showing width of head

We often see images of a golden eagle in profile – observing the head from a different angle gives an awareness of the width across the skull.

Basic angle established in shades of grey

Brown used for overdrawing

Solutions

An eagle's eyesight is said to be eight times better than man's, and the characteristic stare from the hooded eyes invites artists to capture its expression.

Colourful brush pens can also be used for rich hues by building layers of colour, using two or three together, or as a monochrome interpretation. Rather than restrict application to 'filling in' the image, you can practise a variety of techniques upon different surfaces, with which you can suggest forms and textures. In many instances the paper chosen can make a great difference to the effects achieved; here, I used soft-textured cream Somerset Velvet to encourage subtle contrasts, rather than the starkness of strong colour against white; this surface is also sympathetic to the medium of brush pens.

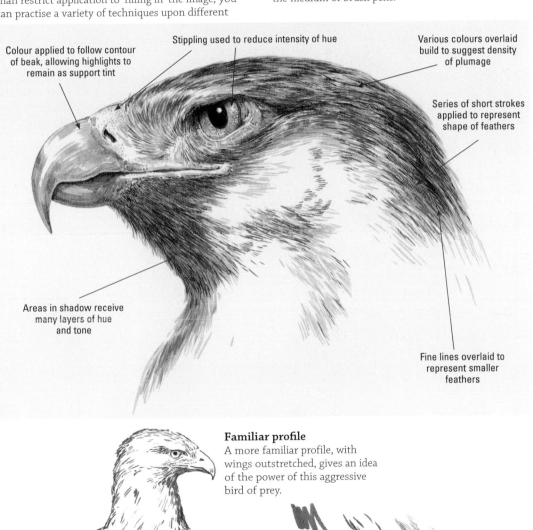

Colour applied to follow contour of beak, allowing highlights to remain as support tint

Stippling used to reduce intensity of hue

Various colours overlaid build to suggest density of plumage

Series of short strokes applied to represent shape of feathers

Areas in shadow receive many layers of hue and tone

Fine lines overlaid to represent smaller feathers

Familiar profile
A more familiar profile, with wings outstretched, gives an idea of the power of this aggressive bird of prey.

Variety of strokes used

Problems

Mute Swan

Although named the 'mute' swan, this bird does make a variety of hisses and other sounds. A common sight on rivers and freshwater areas, the graceful swan, with its curved wing carriage, makes a delightful subject for pastels; however, knowing which surface to use for pastel work can prove a problem. Sometimes a white is chosen, but this may not enhance the subject matter – particularly a white-feathered bird – thus encouraging the use of outlines in the drawing. The opposite may also apply: a suitable colour may have been chosen for the support, making an outline unnecessary, but the absence of any background will mean that the image is not anchored.

Another problem is the surface texture – if this is too strong and indented, it can detract from the image itself.

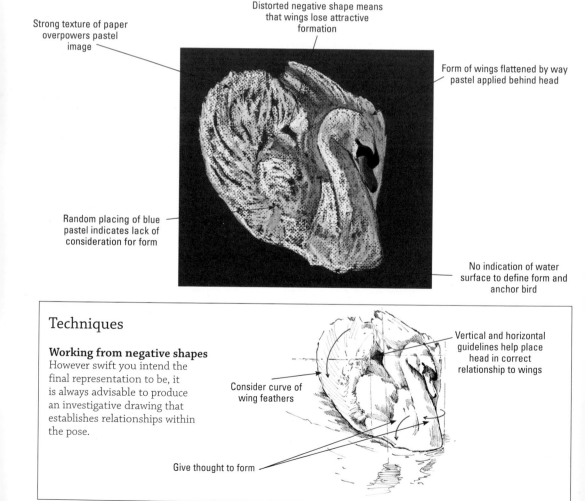

Strong texture of paper overpowers pastel image

Distorted negative shape means that wings lose attractive formation

Form of wings flattened by way pastel applied behind head

Random placing of blue pastel indicates lack of consideration for form

No indication of water surface to define form and anchor bird

Techniques

Working from negative shapes
However swift you intend the final representation to be, it is always advisable to produce an investigative drawing that establishes relationships within the pose.

Consider curve of wing feathers

Vertical and horizontal guidelines help place head in correct relationship to wings

Give thought to form

Solutions

The quick, sweeping application of pastel sticks in a simple representation can be enhanced by consideration for the support upon which the strokes are placed. The marks on this image were quickly placed to produce an impression rather than a detailed study. By choosing a rich coloured support, a unity may be achieved.

One of the most common views of swans is to look down on them from a bridge or a river bank as they glide majestically by. To enhance this I have chosen an angle seen as the observer looks down at the array of plumage contrasting with the water – here a strong negative shape between the wings leads the eye to the correct placing of head and neck.

Colour of pastel board support enhances image

Strong negative shape forms basis of pose

Slightly contoured strokes with light tips describe curve of wing

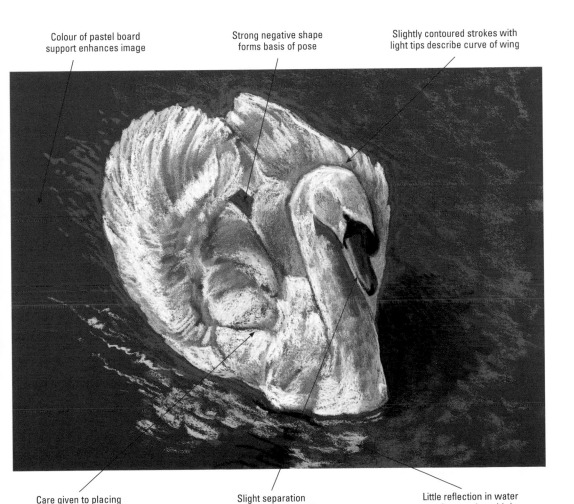

Care given to placing shadow tone areas

Slight separation between bill and neck brings these forwards

Little reflection in water surface anchors bird

Problems

Emperor Penguins

The heaviest and hardiest of all seabirds is the emperor penguin, which can stand over 1m (3¼ft) tall and weigh up to 41kg (90lb). These birds rarely set foot on anything but ice, and it is in this environment, where the head, back and wings appear black against the stark blue-white of their surroundings, that the artist places their forms (the exception is in a zoo environment).

It is sometimes difficult to preplan the stages in which a painting can be built – from choice of support and its colour, through first drawings and composition to the building of overlaid paint to achieve texture and patterns, culminating in the finishing touches and knowing when to stop. There is another factor to consider – whether to make the painting entirely representational or more of an illustrative design.

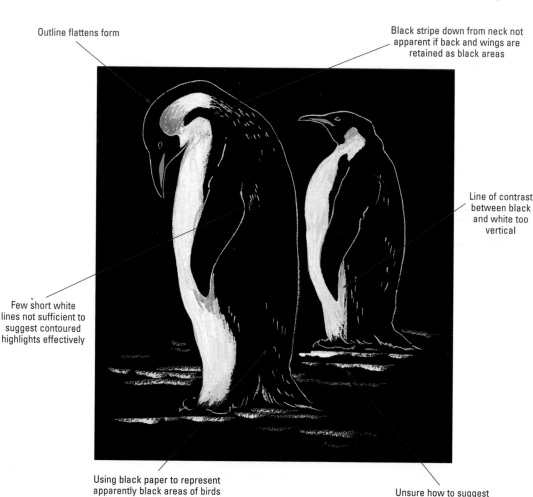

Outline flattens form

Black stripe down from neck not apparent if back and wings are retained as black areas

Line of contrast between black and white too vertical

Few short white lines not sufficient to suggest contoured highlights effectively

Using black paper to represent apparently black areas of birds requires light outline

Unsure how to suggest icy surface

Solutions

Penguins' streamlined appearance, which enables them to dive to great depths to feed (where they can stay underwater for up to 18 minutes), has a stark beauty of its own, and simple curved shapes lend themselves to depiction in acrylic.

Here, I have simplified the two forms, emphasizing pattern in the glossy backs, rather than approaching

them representationally. It is still important to relate the two penguins by considering the shapes between (the white breast of the far bird and the back of the near one) and the negative shapes, and to give thought to planning both the composition and the execution in detail before commencing the painting.

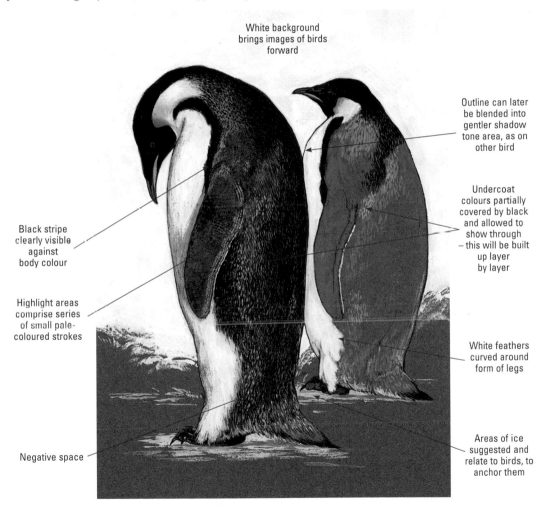

White background brings images of birds forward

Outline can later be blended into gentler shadow tone area, as on other bird

Undercoat colours partially covered by black and allowed to show through – this will be built up layer by layer

Black stripe clearly visible against body colour

Highlight areas comprise series of small pale-coloured strokes

White feathers curved around form of legs

Negative space

Areas of ice suggested and relate to birds, to anchor them

Use of support colour

When painting a light hue behind forms to give them clarity and bring them forwards, you can avoid the problem of when to stop that application by drawing a format, up to which you can paint, that only applies to the upper part of the work. At the base of the picture it is only necessary to indicate a suggestion of the environment – enough to anchor the subjects.